# FILMS FROM THE FUTURE

# PRAISE FOR FILMS FROM THE FUTURE

"What an unexpected and compelling combination of art and science. Using creativity, from the minds of filmmakers, to examine the potential pitfalls of technology, to show humanity a better path—pure genius!"

—Danielle Feinberg, Director of Photography at Pixar

"Maynard will have you questioning the most rational assumptions, not just those featured in movies. While the future cannot be predicted from 'exponential trends of the past,' this book shines with hallmark traits of a bestseller."

—Darlene Cavalier, founder of SciStarter

"The speed at which science is progressing means that today's science fiction will quickly become tomorrow's science, so what better way to consider science and our future than by going to the movies? Maynard's book is an engaging and important read for anyone who wants to understand not just today's cutting-edge science, but also the ethical issues scientists—and all of us—must deal with if we're to avoid a real-life dystopia."

—Ariel Conn, Future of Life Institute

"We humans have a profound ability to imagine the world we want to live in, and the ones we don't. And though we share these visions in movies, the strange truth is that we continually fail to build that wonderful world we can imagine. What is that chasm between imagining and creating? Andrew Maynard challenges us to walk that brave path through that thus-far uncharted countryside, and build that positive future."

—Lindy Elkins-Tanton, leader of the NASA "Psyche Mission"

"If you like science fiction, you are already studying risk: that's the alluring premise of this highly readable book. It's bound to get film buffs pondering philosophical quandaries posed by movies that have real analogues with the highest of moral stakes in the world today."

—Nathaniel Johnson, senior writer at *Grist*

"Thoughtfully composed and delightful to read, *Films from the Future* ushers us on a whirlwind tour through decades of science fiction, shedding light on some of the most extraordinary achievements of our time. Maynard explores the incredible possibilities and dire consequences of boundless human innovation, imagination and ambition…and may just change the way you go to the movies."

—Sheril Kirshenbaum, author of *The Science of Kissing* and Executive Director of Science Debate

"Art imitates life, but life also imitates art. Some technologies that existed only in science fiction are now becoming real. So, it makes sense that those movies can also help anticipate ethical and social problems arising from new technologies. This book walks us through some of the most iconic films—pointing out things, with an expert eye, that most of us had missed the first time around. It makes me want to watch those movies again."

—Patrick Lin, co-editor of the book *Robot Ethics 2.0: From Autonomous Cars to Artificial Intelligence*

"*Films from the Future* takes the reader on a fascinating, thought-provoking exploration of the most compelling and confounding ideas in popular sci-fi films of the past thirty years—but with a twist! Maynard unwittingly gives us an inspiring road map for how to think creatively about solving the problems of the future and what it means to be human."

—Charlie Oliver, CEO of Tech 2025

"Andrew has captured the foresight of science fiction filmmaking with *Films from the Future*. Using clear examples of current emerging technologies to show just how accurate many of the future scenarios were in these films Andrew is able to prove just how close we are to the future we see in many of these films. Sci-fi is a mirror into the heart of our species. It is also often a self-fulfilling prophecy. *Films from the Future* is a perfect mix of these two ideas. It is both techno-philosophical and at the same time grounded in tangible research and foresight."

—Gray Scott, futurist and author of *The Automated, Digitized, and Simulated Future*

"As the breakneck advance of technology takes us into a world that is both exciting and menacing, sci-fi films give us an inkling of what is to come, and what we should avoid. Andrew Maynard explores our near-term future through the crystal ball of cinema sci-fi, and deftly shows how a seemingly frivolous film genre can guide us in shaping tomorrow's world."

—Seth Shostak, senior astronomer at the SETI Institute, and host of *Big Picture Science*

"Through the lens of great sci-fi movies, Andrew Maynard explores the dramatic possibilities, ethical tensions, and unanswered philosophical dilemmas that naturally arise with the deployment of disruptive technologies. This vast territory is matched by his comprehensive understanding of technology's promise, pitfalls and predicaments. He is deeply committed to finding pathways for responsible innovation and the creation of a meaningful future. Andrew Maynard is a guide you can trust. His wonderful feel for the issues that will engage most readers and fascinating examples are all made accessible through remarkably clear and succinct writing. If you love sci-fi and want to know more about emerging technologies, this is the book to read first, and a book to return to time and again as we all navigate an uncertain future."

—Wendell Wallach, author of *A Dangerous Master* and co-author of *Moral Machines*

"This is a book everyone in tech innovation should read—from inventors and investors, to developers and CEOs. Under the guise of twelve popular science fiction movies, Maynard weaves a thought-provoking narrative around the wonders and complexities of emerging technologies, and their responsible and beneficial development. Whether you're curious about what the future holds, fascinated by the relationship between technology and society, or you're simply trying to succeed as an ethical tech company, there's something here for you."

—Cori Lathan, CEO and co-founder of AnthroTronix

"With the insightful use of science fiction movies, Andrew Maynard raises some deep philosophical issues about who we are and want to be as human beings while graphically illustrating what could go badly wrong, and he raises the difficult question 'Is there research that shouldn't be done and are there technologies that shouldn't be developed?' We may not all agree with his take on these questions but raising them is a worthy endeavor. This book is one way to spread the word and get the conversation started. It should be widely read by scientists, engineers, physicians, business and political leaders and other professionals, indeed everyone who cares about the future of humanity."

—Neal Lane, former science advisor to President Bill Clinton

"This marvelous book is among the most engaging and insightful that I've read in many years. It's the sort of book that you keep reading because of the inherently fascinating topics that it covers—from resurrecting dinosaurs to enhancing human cognition, from mind-uploading to contacting extraterrestrial intelligences—and then before you know it, you've learned something crucial about emerging technologies, ethics, and the future of humanity in this infinitely strange place we call 'the universe.' Perhaps the single most important feature of the book is its use of fiction and storytelling to bridge the chasm between different political and religious views that often make public discussions about the ethics of technology impossible. Thus, Maynard explores—with skillful eloquence—human ingenuity through human imagination, scientific discovery through artistic expression, and our rapidly changing present through the anticipated futures of sci-fi narratives. It is for this reason especially that I hope this book will be widely read by conservatives, liberals, Christians, Muslims, and atheists alike."

—Phil Torres, author of *Morality, Foresight, and Human Flourishing: An Introduction to Existential Risks*

# FILMS FROM THE FUTURE

## The Technology and Morality of Sci-Fi Movies

Andrew D. Maynard

*Mango Publishing*
Coral Gables

Copyright © Andrew Maynard

Cover & Layout Design: Jermaine Lau

Mango is an active supporter of authors' rights to free speech and artistic expression in their books. The purpose of copyright is to encourage authors to produce exceptional works that enrich our culture and our open society. Uploading or distributing photos, scans or any content from this book without prior permission is theft of the author's intellectual property. Please honor the author's work as you would your own. Thank you in advance for respecting our authors' rights.

For permission requests, please contact the publisher at:

Mango Publishing Group
2850 Douglas Road, 3rd Floor
Coral Gables, FL 33134 USA
info@mango.bz

For special orders, quantity sales, course adoptions and corporate sales, please email the publisher at sales@mango.bz. For trade and wholesale sales, please contact Ingram Publisher Services at customer.service@ingramcontent.com or +1.800.509.4887.

Films from the Future: The Technology and Morality of Sci-Fi Movies
Library of Congress Cataloging
ISBN: (print) 978-1-63353-907-5 (ebook) 978-1-63353-906-8

Library of Congress Control Number: 2018955574

BISAC category code: SCI075000—SCIENCE / Philosophy & Social Aspects

Printed in the United States of America

*To Clare, for believing in me.*

# TABLE OF CONTENTS

## Chapter One

### In the Beginning — 14
Beginnings — 14
Welcome to the Future — 16
The Power of Convergence — 18
Socially Responsible Innovation — 21
A Common Point of Focus — 25
Spoiler Alert — 26

## Chapter Two

### Jurassic Park: The Rise of Resurrection Biology — 27
When Dinosaurs Ruled the World — 27
De-Extinction — 31
Could We, Should We? — 36
The Butterfly Effect — 39
Visions of Power — 43

## Chapter Three

### Never Let Me Go: A Cautionary Tale of Human Cloning — 46
Sins of Futures Past — 46
Cloning — 51
Genuinely Human? — 56
Too Valuable to Fail? — 62

## Chapter Four

### Minority Report: Predicting Criminal Intent — 63
Criminal Intent — 63
The "Science" of Predicting Bad Behavior — 68
Criminal Brain Scans — 73

| Machine Learning-Based Precognition | 76 |
| Big Brother, Meet Big Data | 78 |

## Chapter Five

| **Limitless: Pharmaceutically-enhanced Intelligence** | **85** |
| A Pill for Everything | 85 |
| The Seduction of Self-Enhancement | 88 |
| Nootropics | 90 |
| If You Could, Would You? | 96 |
| Privileged Technology | 100 |
| Our Obsession with Intelligence | 104 |

## Chapter Six

| **Elysium: Social Inequity in an Age of Technological Extremes** | **109** |
| The Poor Shall Inherit the Earth | 109 |
| Bioprinting Our Future Bodies | 114 |
| The Disposable Workforce | 118 |
| Living in an Automated Future | 123 |

## Chapter Seven

| **Ghost in the Shell: Being Human in an Augmented Future** | **128** |
| Through a Glass Darkly | 128 |
| Body Hacking | 134 |
| More than "Human"? | 136 |
| Plugged In, Hacked Out | 141 |
| Your Corporate Body | 146 |

## Chapter Eight

### Ex Machina: AI and the Art of Manipulation     153
Plato's Cave     153
The Lure of Permissionless Innovation     159
Technologies of Hubris     163
Superintelligence     168
Defining Artificial Intelligence     171
Artificial Manipulation     174

## Chapter Nine

### Transcendence: Welcome to the Singularity     179
Visions of the Future     179
Technological Convergence     183
Enter the Neo-Luddites     189
Techno-Terrorism     193
Exponential Extrapolation     199
Make-Believe in the Age of the Singularity     202

## Chapter Ten

### The Man in the White Suit: Living in a Material World     207
There's Plenty of Room at the Bottom     207
Mastering the Material World     212
Myopically Benevolent Science     218
Never Underestimate the Status Quo     223
It's Good to Talk     226

## Chapter Eleven

### Inferno: Immoral Logic in an Age of Genetic Manipulation  230
Decoding Make-Believe  230
Weaponizing the Genome  233
Immoral Logic?  237
The Honest Broker  241
Dictating the Future  247

## Chapter Twelve

### The Day After Tomorrow: Riding the Wave of Climate Change  250
Our Changing Climate  250
Fragile States  254
A Planetary "Microbiome"  257
The Rise of the Anthropocene  259
Building Resiliency  261
Geoengineering the Future  265

## Chapter Thirteen

### Contact: Living by More than Science Alone  271
An Awful Waste of Space  271
More than Science Alone  276
Occam's Razor  279
What If We're Not Alone?  282

## Chapter Fourteen

### Looking to the Future  287

### Acknowledgments  292

## CHAPTER ONE

# IN THE BEGINNING

> *"I'm sorry, Dave, I'm afraid I can't do that."*
> —HAL

## Beginnings

I first saw Stanley Kubrick's *2001: A Space Odyssey* on a small black-and-white TV, tucked into a corner of my parents' living room. It was January 1, 1982, and I was sixteen years old.

I wasn't a great moviegoer as a teenager. In fact, at that point, I could probably count the number of times I'd been to the cinema on one hand. But I was an avid science fiction reader, and having read Arthur C. Clarke's short story *The Sentinel*, I was desperate to see the movie Kubrick and Clarke had crafted from it—so much so, that every ounce of my teenage brattishness was on full display.

My parents had friends around for dinner that evening, and, as usual, the drill was that I was either polite or invisible. But there was a problem. The only TV in the house was in the living room, which was precisely where, at 7:35 that evening, everyone else would be.

I must have been especially awkward that day, because my parents agreed to let me put on my headphones and watch the TV while they entertained. And so, I snuggled into a corner of the sofa, pulled the black-and-white portable up, and became selfishly absorbed in Kubrick's world of the future.

Goodness knows what our guests were thinking!

*2001: A Space Odyssey* is a movie that's rich with metaphors that explore our relationship with technology. So much so that, if I could reach back and talk to my sixteen-year-old self, I'd say, "Take note—this is important." I'd also add, "Don't be such a jerk" for good measure. However, despite being awed by the opening sequence, with its primitive apes and inscrutable black monolith, enthralled by the realistic space scenes, and shocked by the computer HAL's

instinct for self-preservation, it would be another thirty years before I began to realize how powerful the medium of film is, especially when thinking about the future of science and technology in a complex human society.

Back in 1982, I was entranced by *2001: A Space Odyssey* because it exposed me to new ideas and new ways of imagining the future. Like many fans, I suspect, I ended up with quotes from the movie branded into my brain, like, "Open the pod bay doors, HAL," along with HAL's response, "I'm sorry, Dave, I'm afraid I can't do that." Without my realizing it, Kubrick's movie made me think about a future where smart computers might decide that their self-preservation was more important than the humans who created them. Fast-forward to the present, and—as we grapple with living in an increasingly complex world—I'm more convinced than ever that, for all their flaws, science fiction movies are a powerful way of exploring the technological futures we face and how to navigate them. Of course, it can be irritating when scriptwriters and directors play fast and loose with scientific and engineering reality for the sake of telling a good story. But getting too wrapped up in the minutiae of how accurate a science fiction movie is misses the point—these are stories about our relationship with the future, and, like all good storytelling, they sometimes play around with reality to reveal deeper truths. As it turns out, this creative freedom can be surprisingly powerful when it comes to thinking about the social benefits and consequences of new technologies and how we can steer technology innovation toward more beneficial and equitable outcomes.

It's this human dimension of science fiction movies that I'm particularly interested in. What these movies do rather well is provide us with a glimpse around the corner of our collective near future, to help us see what might be coming down the pike and start thinking how we might respond to it. And they manage to do this *because* their scriptwriters and directors aren't encumbered by the need to stick to today's reality. Viewed in the right way—and with a good dose of critical thinking—science fiction movies can help us think about and prepare for the social consequences of technologies we don't yet have, but that are coming faster than we imagine.

This is precisely what this book sets out to do. Using the twelve movies it's built around, the book provides glimpses into the technological capabilities we're building now, and how we might start to think about their beneficial and responsible development

and use. Naturally, it only scratches the surface of the vast array of technologies that are beginning to emerge, and the opportunities and challenges they present. But through the lens of these movies, the book sets out on a journey to explore what can go wrong with new technologies, and how we can all help nudge them toward a future that looks better than the present we're currently in. And it continues that personal journey I started in 1982 with that first, barely conscious glimpse into how science fiction movies can reveal hidden connections between who we are, the society we live in, and the technologies we create.

## Welcome to the Future

Google "top science fiction movies," and you'll probably be overwhelmed by a deluge of "top 100" lists, "best ever" compilations, and page upon page of the last word (supposedly) on must-watch movies. People are passionate about their science fiction movies, and they have strong opinions about what should be on everyone's watch list, and what should not. Some of the movies in this book appear regularly on these lists, *Jurassic Park* (chapter two) and *Minority Report* (chapter four), for instance. Some are hidden gems that only the most dedicated fans cherish, including films like *The Man in the White Suit* (chapter ten), and the anime movie *Ghost in the Shell* (chapter seven). Others are likely to raise eyebrows, and I suspect there'll be a few movie buffs wondering why the collection includes films like *Transcendence* (chapter nine) and *Inferno* (chapter eleven).

This is a fair question. After all, why write a book about science fiction movies that aren't listed as being amongst the best there are? The answer is that this is *not* a book about great science fiction movies, but a book about how science fiction movies can inspire us to see the world around us and in front of us differently. Each of the movies here has been selected because it provides a jumping-off point for exploring new and intriguing technological capabilities, and the challenges and opportunities these raise. Some of the resulting stories are life-affirming and heart-warming, while others are deeply disturbing. Individually, they provide fascinating accounts of the sometimes-weird and complex landscape around emerging technologies. Together, though, they paint a much broader picture of how our technological world is changing, and what this might mean to us and the generations that come after us.

The movies themselves were selected after many hours of watching and soul-searching. There are some quite wonderful science fiction movies that didn't make the cut because they didn't fit the overarching narrative (*Blade Runner* and its sequel *Blade Runner 2049*, for instance, and the first of the *Matrix* trilogy). There are also movies that bombed with the critics, but were included because they ably fill a gap in the bigger story around emerging and converging technologies. Ultimately, the movies that made the cut were chosen because, together, they create an overarching narrative around emerging trends in biotechnologies, cybertechnologies, and materials-based technologies, and they illuminate a broader landscape around our evolving relationship with science and technology. And, to be honest, they are all movies that I get a kick out of watching.

In pulling these movies together and writing the book, I wanted to explore the often complex relationship we have with emerging technologies. But I also wanted to highlight some of the amazing advances we see beginning to emerge in science and technology. We truly do live in incredible times. Scientists are learning how to write and rewrite genetic code with increasing precision and efficiency. Nanotechnologists are designing and engineering materials that far exceed the properties of anything that occurs in nature. We are already creating artificial intelligence systems that can operate faster and smarter than any human. There are self-driving cars on our roads, with autonomous people-carrying drones just around the corner. Researchers are working on brain-computer interfaces and mapping the human brain down to its individual neurons. And we may well see people walking on the surface of Mars within the next decade. Until recently, these and many more scientific and technological marvels were the stuff of science fiction, yet the frenetic pace of innovation is rapidly catching up with some of our wildest imaginings.

This is heady stuff to the physicist in me—at heart, I must confess, I'm still a technology geek. And yet this stupendous technological power comes with a growing obligation to learn how to handle it responsibly. Despite the speed with which we're hurtling toward our technological future, we are still grappling with how to do this in ways that don't end up causing more harm than good. This isn't because scientists and engineers don't care about who gets hurt—most of them care deeply—but because we're charging headlong into a future that's so complex, it's becoming increasingly challenging to work out what could go wrong and how to avoid it.

Navigating this future is going to require every ounce of insight we can squeeze out of our collective brains. And because the consequences of how we use new and emerging technologies will end up affecting us all, we all have a role to play here, including individuals who are all too easily overlooked by scientists and engineers—in fact, especially these individuals.

Faced with this task, science fiction movies simultaneously remove barriers to people talking together about the future, and reveal possibilities that might otherwise remain hidden. Every one of the movies here can be appreciated as much by someone who flunked high school as by a Nobel Prize winner. Because of this, they are tremendously powerful for getting people from very different backgrounds and perspectives thinking and talking together. But more than this, they have a way of slipping past our preconceived ideas of the world and revealing things to us that we could so easily miss.

It's these unexpected insights that I've tried to draw out from each of the movies, building on my own work and experiences, as well as those of others. In doing so, I've been amazed at how powerful they are at revealing connections and ideas that aren't always obvious. I've been surprised and delighted at how these reflections have taken unexpected and serendipitous turns, opening up new ideas around how to approach beneficial and responsible technology innovation. But I've also been taken aback at times by the very real harm we could cause if we get things wrong—not just to humanity as a whole, but to communities that all too easily slip between the cracks. And as I immersed myself in these movies, I've become more certain than ever that, fascinating as the minutiae of individual technologies can be, it's when they begin to converge that the really interesting stuff begins to happen.

## The Power of Convergence

In June 2007, the first generation of the Apple iPhone was released to the public. From the perspective of today's crowded smartphone marketplace, it's hard to realize how seismic an event this was at the time. Yet, looking back, it started a trend in how we use and interact with technology that continues to reverberate through society to this day.

The iPhone stands as an iconic example of technological convergence—what happens when different strands of innovation

intertwine together (a topic we'll come back to in chapter nine)—and the social and technological transformations that can occur as a result. These days, smartphones integrate hundreds of different technologies: nanoscale-featured processors and memory chips, advanced materials, cloud computing, image processing, video communication, natural language processing, rudimentary artificial intelligence, biometrics. They'll even allow you to make phone calls. They are a triumph of our ability to weave together separate technologies to make devices that are not only more than the sum of their parts, but are also transforming the ways we live our lives. But as the capabilities of smartphones and other personal electronics expand, there's a growing fear of serious unintended consequences, so much so that, in 2018, JANA Partners LLC and the California State Teachers' Retirement System—two investors in Apple—requested the company actively address the potential impacts of iPhone use on teenagers.[1]

Smartphones are a useful, but still rather crude, example of technological convergence. Expanding on this, we're now beginning to see convergence between biotechnologies, materials science, robotics, artificial intelligence, neurotechnologies, and other areas that are rapidly catching up with what used to be limited to deeply futuristic science fiction. This is seen across the movies in this book, from the use of genetic engineering in *Jurassic Park* (chapter two) to human augmentation in *Ghost in the Shell* (chapter seven). The power of convergence between different technological trends particularly stands out in the movie *Transcendence* (chapter nine). Here, the technology we see on the screen is firmly rooted in Hollywood fantasy. Despite this, the film captures the scale of technological leaps that become possible when technical knowhow from one area is used to solve problems and accelerate progress in another.

*Transcendence* is, at heart, a movie about transcending our biological and evolutionary heritage. Inspired by the ideas of transhumanists like Ray Kurzweil, it imagines a future where convergence between biotechnology, neurotechnology, nanotechnology, and artificial intelligence leads to a profound shift in capabilities—albeit one with sobering consequences. There's a scene relatively early on in the movie where artificial-intelligence (AI) genius Will Caster (played by Johnny Depp) is dying, and his only hope is for his consciousness to be uploaded

---

[1] An open letter from JANA partners and CALSTRS to Apple, Inc., January 6, 2018. Accessible at https://thinkdifferentlyaboutkids.com/

into a revolutionary new artificial-intelligence-powered computer. But, to achieve this, his colleagues need to use equally cutting-edge neuroscience and sensor technology to record and store every nuance of Caster's brain. In true movie fashion, they succeed just before he passes away, and Caster becomes a human-machine chimera who transcends his biological roots.

The science and technology in *Transcendence* are fanciful. But as you peel away the Hollywood hyperbole, the movie hints at a coming level of technological convergence that could radically change the world we live in. This is rooted in our growing ability to blur the lines between physical technologies like materials, machines, and electronics; biological technologies like gene editing and biomanipulation; and cyber technologies like machine learning, natural language processing, and massive-scale data collection and manipulation. What unfolds in *Transcendence* is scientifically impossible. But what is *not* impossible—and what scientists and engineers are becoming increasingly adept at—is our growing ability to merge together and integrate seemingly different technologies, to transform the world we live in.

This is perhaps most apparent in emerging gene-editing technologies, where scientists are developing the abilities to rewrite the DNA-based code that underpins every living organism, something that is only possible through converging technologies. But we're also seeing this convergence leading to massive advances in areas like designer materials, artificial intelligence, human-machine interfaces, and many others. For perhaps the first time, we are getting close to being able to far outstrip nature in how we design and engineer the world around us.

This is where the true transformative power of convergence lies, and it's also where some of the greatest potential pitfalls are. Through converging technologies, we're developing capabilities that could radically improve lives by eradicating diseases, providing cheap and plentiful renewable energy, and ensuring everyone has access to nutritious food and clean water. At the same time, there are tremendous risks. We don't yet know how large-scale automation will affect jobs in the future, for instance, or how access to technologies may simply lead to the poor getting poorer and the rich richer. We have little idea how to wield increasingly powerful gene-editing technologies responsibly. And we're not sure yet whether the rapid development of artificial intelligence is going to make the world a better place or lead to the end of humanity as we

know it! The harsh reality is that, while convergence is massively accelerating our technological capabilities, we still have little if any idea what might go wrong, or what the unintended consequences could be.

This is a theme that runs deeply through this book, and it's one that gets to the heart of the morality and the ethics of the science and the technologies we develop and use. If we're going to navigate the world of these converging technologies successfully, we're going to have to start thinking more creatively and innovatively about where we're going as a species, what could go wrong, and what we need to do to make things go right. Of course, movies are not the most reliable guide here, and I'd hate to give the impression that surviving and thriving in the twenty-first century is as easy as watching a few films. But they do provide a platform for exploring some of the more intriguing and important emerging and converging trends in technology innovation, and the tension between developing them responsibly and ensuring they reach their full potential. And here they touch on another common theme that threads through the following chapters: the challenges and opportunities of socially responsible innovation.

## Socially Responsible Innovation

The movie *The Man in the White Suit* (chapter ten) is perhaps one of the less well-known films in this book, but it is one that admirably highlights this tension between impactful and often well-intentioned innovation and unforeseen social consequences. In the movie, Sidney Stratton is a scientist with a vision. And that vision is to create the perfect fabric, one that's incredibly strong, doesn't wear out, and never needs washing. There's only one problem: He never bothered to ask anyone else what they thought of his invention. As a result, he finds himself attracting the ire of his co-workers, the textile industry, the local union, and even his landlady. Stratton made the classic mistake of thinking that, just because he could do something, others would love it.

Even though the movie was made back in 1951, it eloquently captures the idea of socially responsible innovation. This is another theme that threads through this book, and it's one that is deeply intertwined with the opportunities and challenges presented by converging technologies.

Responsible Innovation (sometimes referred to as Responsible Research and Innovation) is a hot topic these days. There's even an academic journal devoted to it. The thinking behind responsible innovation is that we don't always have a second or third chance to get things right when developing new technologies, and so it's better to think about the potential consequences as early as we can, and take action to avoid the bad ones as early in the development process as possible. There are plenty of formal definitions for responsible innovation.[2] But many of these boil down to ensuring that anyone who is potentially impacted by technological innovation has a say in how it's developed and used, and taking steps to ensure innovation that leads to a better future for as many people as possible, without causing undue harm. This is easy to say, of course, but fiendishly difficult to put into practice.

This idea of social responsibility comes up time and time again in the movies here. In many cases, a film's dramatic tension draws directly on some person or organization not thinking about the consequences of what they are doing, or being too arrogant to see their blind spots (this is apparent straight out of the gate with *Jurassic Park* in chapter two). This makes for compelling narratives, but it also opens the way for surprisingly nuanced approaches to exploring what might go wrong with emerging technologies if we don't think of who they will impact (and how), and how we can steer them toward better outcomes. And it opens the door to delving into something that is near and dear to my heart: grappling with the risks of new and unusual technologies.

---

Most of my professional life has been involved with risk in one way or another. Much of my early published scientific research was aimed at reducing the health risks from inhaling airborne particles. I've worked extensively on understanding and reducing the health and environmental risks of nanotechnology and other emerging technologies. I've taught risk assessment, I've written about risk, and I've run academic centers that are all about risk. And if there's one thing I've learned over the years, it's that I have less and less patience for how many people tend to think about risk.

The problem is that, while established approaches to risk work reasonably well when it comes to protecting people and the

---

2   For a good working definition of responsible research and innovation, I'd recommend a 2013 paper by Jack Stilgoe, Richard Owen, and Phil Macnaghten. "Developing a framework for responsible innovation." *Research Policy* **42**(9): 1568-1580. http://doi.org/10.1016/j.respol.2013.05.008

environment from conventional technologies, they run out of steam rather fast when we're facing technologies that can achieve things we never imagined. To coopt a Biblical metaphor, we're in danger of desperately trying to squeeze the new wine of technological innovation into the old wineskins of conventional risk thinking, and at some point, something's going to give. If we're to develop new technologies in socially responsible ways, we need to realign how we think about risk with the capabilities of the innovations we're creating.

This is the idea behind the concept of Risk Innovation, which is where much of my current work lies.[3] Over the past couple of hundred years—pretty much since the beginning of the Industrial Revolution—we've become quite adept at developing new ways of causing harm. And over time we've become equally adept at developing ways of assessing and managing the risks associated with innovation, whether they arise from mining and manufacturing, exposure to new chemicals and materials, or pollution. But these approaches to risk belong to a different world than the one we're now creating. With emerging and converging technologies, it's becoming increasingly apparent that, in order to navigate a radically shifting risk landscape, we need equally radical innovation in how to think about and act on risk.

Perhaps not surprisingly, risk is at the core of all the movies here. Each of these films has a risk-based narrative tension that keeps its audience hooked. Yet it's not always apparent that it's risk that keeps you glued to the screen, or holding your breath, or even reaching for the tissues in places. Most of us are used to thinking about risk in terms of someone's life being put in danger, or perhaps the environment and ecosystems being threatened, and there's plenty of this in the book. But these movies also explore other, subtler risks, including threats to dignity, belonging, identity, belief, even what it means to be human.

These are rather unconventional ways of thinking about risk, and they get at what is so important to us that our lives are diminished if it's denied us, or taken from us. Because of this, they make considerable sense as we begin to think about how new technologies will potentially affect our lives and how to develop and use them responsibly. This is a way of thinking about risk that revolves around threats to what is important to us, whether it's

---

3   For more on risk innovation, I'd recommend reading this 2015 article. "Why we need risk innovation." *Nature Nanotechnology* 10: 730–731. http://doi.org/10.1038/nnano.2015.196

something we have and can't face losing, or something we aspire to and cannot bear to lose sight of. This includes our health, our well-being, and the environment we live in, but it also extends to less tangible but equally important things that we deeply value.

In each of the movies here, the characters we follow risk either losing something of great importance to them, or being unable to gain something that they aspire to. In many of the movies, the types of risks these characters face aren't always immediately obvious, but they profoundly impact the consequences of the technologies being developed and used, and it's this insight that opens up interesting and new ways of thinking about the social consequences of technological innovation. And so we discover that, in *Jurassic Park* (chapter two), John Hammond's dream of creating the world's most amazing theme park is at risk. In the movie *Never Let Me Go* (chapter three), it's the threat to Tommy's hope for the future that brings us to tears. And in *Ghost in the Shell* (chapter seven), it's Major Kusanagi's sense of who and what she is. There are also more conventional risks in each of these movies. Yet, by revealing these less obvious risks, these movies reveal new and often powerful ways to think about developing new technologies without causing unnecessary and unexpected harm.

In this way, the movies here provide what are often quite startling insights into the social challenges and opportunities surrounding emerging technologies. Watching them with an open mind and a critical eye can reveal subtle connections between irresponsible innovation and threats to what people value or aspire to, which in turn have profound implications for society more broadly. And this is where their creativity and imagination have the power to lift us out of the rut of conventional thinking, and allow us to see opportunities and dangers that extend beyond the world of make-believe and into the technological future we are striving to create.

In other words, I'm a sucker for using the imagination in science fiction movies to stimulate new ways of thinking about risk, and in turn, new ways of thinking about socially responsive and responsible innovation. But there's another aspect to these movies that also gets me excited, and that's their ability to break down the barriers between "experts" and "non-experts" and open the door to everyone getting involved in talking about where technology innovation is taking us, and what we want from it.

# A Common Point of Focus

I was recently invited to a meeting convened by the World Economic Forum, where I was asked to moderate a discussion about how governments, businesses, and others can respond to the potential risks presented by new technologies. Much of our discussion was around regulations and policies, and what governments and companies can do to nip problems in the bud without creating unnecessary roadblocks. But one question kept recurring: How can we ensure the safe and beneficial development of new technologies in a world that is so deeply and divisively divided along ideological lines?

To my surprise, one of the participants suggested something that didn't involve politics, regulations, or more effective education: art.

Naturally, we still need technical experts, laws, and policies if we're going to get new technologies right. But the question that was put forward was an intriguing complement to these: Can we use art (including all forms of creative expression) to pull people out of their entrenched ideas and get them thinking and talking about how they can work together to build the future they want? Obviously, we're never going to reach world peace and prosperity by insisting everyone contemplate Da Vinci's *Mona Lisa* or one of Damien Hirst's pickled cows.[4] Yet art provides a common point of focus that allows people to express their ideas, thoughts, and opinions, while being open to those of others. And it allows the possibility of being able to do this without slipping into ideological ruts. Art, in all its forms, is a medium that can mitigate our tendency to close down our imagination (together with our humility and empathy), and it's one that opens us up to seeing the world in new and interesting ways. In this context, science fiction movies are, without a doubt, a legitimate form of art, and one that has the power to bring people together in imagining how to collectively create a future that is good for society, rather than a dystopian mess—as long as that imagination is grounded in reality where it matters.

This isn't to say that technical education and skills aren't important—they most certainly are. Developing technologies that work and are safe demands incredible technical skills, and it would be naïve and irresponsible to discount this. No matter how inclusive we want to be, we can't expect a random person plucked from the

---

[4] In 1993, the British artist Damien Hirst produced an exhibit with the title "Mother and Child (Divided)." It consisted of a cow and calf, each sliced in half, pickled in formaldehyde, and mounted in a display cabinet. http://damienhirst.com/mother-and-child-divided-1

street to have the skills necessary to genetically engineer organisms safely, or to design aircraft that don't fall out of the sky. That would be crazy. But one thing we're *all* qualified to do is think about what the possible consequences of technology innovation might mean to us and the people we care for. And here, pretty much everyone has something to contribute to the socially responsible and responsive development of new technologies.

This is something that I hope will become increasingly clear through the remainder of this book. But before we dive into the movies themselves, I do need to say something about spoilers.

## Spoiler Alert

This is a book that contains spoilers. You have been warned. It's not a book to read if you're one of those people who can't stand to know what happens before you watch a movie. But I can guarantee that if you read the book before seeing the movies, your experience will be all the richer for it. Even if you're familiar with the movies, you'll see them through new eyes after reading the book. And if you decide not to watch the movies at all, that's okay as well. Certainly, the movies are engaging and entertaining, but at the end of the day, it's the technologies that are the stars here.

Each chapter starts with a brief overview of the movie it's built around. This is partly to orient you if you haven't seen the movie, or you aren't particularly interested in watching it—although I'd hope that, after reading the chapter, you head out to your preferred streaming service to get the full effect. But it's also to help set the scene for what's to come. If you know these movies well, you'll realize that the summaries are idiosyncratic, to say the least. They let you know what I think is interesting and relevant about each film, what grabs my attention when watching them and makes me think. But they don't give everything away. In fact, I'd hope that, watching any of the movies after reading the book, you'd still be surprised and delighted by unexpected plot twists and turns.

With that said, it's time to start the journey, starting with genetic engineering, resurrection biology, and the folly of entrepreneurial arrogance that is so adeptly captured by Stephen Spielberg's original *Jurassic Park*. So buckle up, hang on, and enjoy the ride!

## CHAPTER TWO

# JURASSIC PARK: THE RISE OF RESURRECTION BIOLOGY

> *"God help us, we're in the hands of engineers!"*
> —Dr. Ian Malcolm

## When Dinosaurs Ruled the World

I was a newly minted PhD when I first saw *Jurassic Park*. It was June 1993, and my wife and I were beginning to enjoy our newfound freedom, after years of too much study and too little money. I must confess that we weren't dinosaur geeks. But there was something about the hype surrounding the movie that hooked us. Plus, we fancied a night out.

That summer, dinosaurs ruled the world. Wherever you looked, there were dinosaurs. Dinosaur books, dinosaur parks, dinosaurs on TV, dinosaur-obsessed kids. *Jurassic Park* seemingly tapped into a dinosaur-obsessed seam buried deep within the human psyche. This was helped along, of course, by the groundbreaking special effects the movie pioneered. Even now, there's a visceral realism to the blended physical models and computer-generated images that brings these near-mythical creatures to life in the movie.

This is a large part of the appeal of *Jurassic Park*. There's something awe-inspiring—*awe-full* in the true sense of the word—about these "terrible lizards" that lived millions of years ago, and that are utterly alien to today's world. This sense of awe runs deep through the movie. Listening to John Williams' triumphant theme music, it doesn't take much to realize that under the gloss of danger and horror, *Jurassic Park* is at heart a celebration of the might and majesty of the natural world.

*Jurassic Park* is unabashedly a movie about dinosaurs. But it's also a movie about greed, ambition, genetic engineering, and human folly—all rich pickings for thinking about the future, and what could possibly go wrong.

---

*Jurassic Park* opens at a scientific dig in Montana, where paleontologists Alan Grant (played by Sam Neill) and Ellie Sattler (Laura Dern) are leading a team excavating dinosaur fossils. Just as the team discovers the fossilized skeleton of a velociraptor, a dinosaur that Grant is particularly enamored with, the dig is interrupted by the charming, mega-rich, and, as it turns out, rather manipulative John Hammond (Richard Attenborough). As well as being founder of International Genetic Technologies Incorporated (InGen for short), Hammond has also been backstopping Grant and Sattler's digs. On arriving, he wastes no time offering them further funding in exchange for a quick weekend mini-break to his latest and greatest masterpiece, just off the coast of Costa Rica.

We quickly learn that, beneath the charm, Hammond is fighting for the future of his company and his dream of building the ultimate tourist attraction. There's been an unfortunate incident between a worker and one of his park's exhibits, and his investors are getting cold feet. What he needs is a couple of respected scientists to give him their full and unqualified stamp of approval, which he's sure they will, once they see the wonders of his "Jurassic Park."

Grant and Sattler agree to the jaunt, in part because their curiosity has been piqued. They join Hammond, along with self-styled "chaotician" Dr. Ian Malcolm (Jeff Goldblum) and lawyer Donald Gennaro (Martin Ferrero), on what turns out to be a rather gruesome roller-coaster ride of a weekend.

From the get-go, we know that this is not going to end well. Malcolm, apart from having all the best lines in the movie, is rather enamored with his theories about chaos. These draw heavily on ideas that were gaining popularity in the 1980s, when Crichton was writing the novel the movie's based on. Malcolm's big idea—and the one he was riding the celebrity-scientist fame train on—is that in highly complex systems, things inevitably go wrong. And just as predicted, Hammond's Jurassic Park undergoes a magnificently catastrophic failure.

The secret behind Hammond's park is InGen's technology for "resurrecting" long-extinct dinosaurs. Using cutting-edge gene-editing techniques, his scientists are able to reconstruct dinosaurs from recovered "dino DNA." His source for the dino DNA is the remnants of prehistoric blood that was sucked up by mosquitoes before they were caught in tree resin and preserved in the resulting amber as the resin was fossilized.[5] And his grand plan is to turn the fictitious island of Isla Nublar into the world's first living dinosaur theme park.

Unfortunately, there were a few holes in the genetic sequences that InGen was able to extract from the preserved blood, so Hammond's enterprising scientists filled them with bits and pieces of DNA from living species. They also engineered their dinosaurs to be all females to prevent them from breeding. And just to be on the safe side, the de-extinct dinosaurs were designed to slip into a coma and die if they weren't fed a regular supply of the essential amino acid lysine.[6]

The result is a bunch of enterprising scientists reengineering nature to create the ultimate theme park and thinking they've put all the safeguards they need in place to prevent something bad happening. Yet, despite their best efforts, the dinosaurs start breeding and multiplying, a compromised security system (and security specialist) allows them to escape, and they start eating the guests.

Even before the team of experts get to Jurassic Park, a disgruntled employee (Dennis Nedry, played by Wayne Knight) has planned to steal and sell a number of dinosaur embryos to a competitor. Nedry is the brains behind the park's software control systems and believes he's owed way more respect and money than he gets. At an opportune moment, he disrupts the park with what he intends to be a temporary glitch that will allow him to steal the embryos, get them off the island, and return to his station before anyone notices. Unfortunately, an incoming hurricane[7] interferes with his plans, resulting in catastrophic failure of the park's security systems and a bunch of hungry dinosaurs roaming free. To make things worse, two of the guests are Hammond's young nephew and niece, who find their trip to the theme park transformed into a life-and-

---

5 A 2013 study tried to extract DNA from copal, an ancient form of resin that precedes full fossilization into amber. The scientists failed, and as a result claimed that it's exceedingly unlikely that DNA could be extracted from amber, which is millions of years older than copal. *Jurassic Park* has a great scientific premise. Sadly, it's not a realistic one. Penney D, et al. (2013). "Absence of Ancient DNA in Sub-Fossil Insect Inclusions Preserved in 'Anthropocene' Colombian Copal." *PLoS One* **8**(9). http://doi.org/10.1371/journal.pone.0073150

6 There is just a passing mention of the *Jurassic Par*k dinosaurs' dependence on lysine in the movie. In the original book, though, lysine dependence plays a substantial role in the ensuing story.

7 During filming, there was an actual hurricane that hit the site. Some of the storm footage is real.

death race against a hungry *Tyrannosaurus rex* and a pack of vengeful velociraptors.

Fortunately, Sattler and Grant come into their own as paleontologists-*cum*-action-heroes. They help save a handful of remaining survivors, including Hammond, Malcolm, and his nephew and niece, but not before a number of less fortunate characters have given their lives in the name of science gone badly wrong. And as they leave the island, we are left in no doubt that nature, in all its majesty, has truly trounced the ambitions of Hammond and his team of genetic engineers.

*Jurassic Park* is a wonderful Hollywood tale of derring-do. In fact, it stands the test of time remarkably well as an adventure movie. It also touches on themes that are, if anything, more important today than they were back when it was made.

In 1993, when *Jurassic Park* was released, the idea of bringing extinct species back from the dead was pure science fiction. Back then, advances in understanding DNA were fueling the fantasy that, one day, we might be able to recode genetic sequences to replicate species that are no longer around, but but, by any stretch of the imagination, this was beyond the wildest dreams of scientists in the early 1990s. Yet, since the movie was made, there have been incredible strides in genetic engineering, so much so that scientists are now actively working on bringing back extinct species from the dead. The field even has its own name: de-extinction.

More than the technology, though, *Jurassic Park* foreshadows the growing complexities of using powerful new technologies in an increasingly crowded and demanding world. In 1993, chaos theory was still an emerging field. Since then, it's evolved and expanded to include whole areas of study around complex systems, especially where mixing people and technology together leads to unpredictable results.

What really stands out with *Jurassic Park*, over twenty-five years later, is how it reveals a very human side of science and technology. This comes out in questions around when we should tinker with technology and when we should leave well enough alone. But there is also a narrative here that appears time and time again with the movies in this book, and that is how we get our heads around the

sometimes oversized roles mega-entrepreneurs play in dictating how new tech is used, and possibly abused.

These are all issues that are just as relevant now as they were in 1993, and are front and center of ensuring that the technology-enabled future we're building is one where we want to live, and not one where we're constantly fighting for our lives.

## De-Extinction

In a far corner of Siberia, two Russians—Sergey Zimov and his son Nikita—are attempting to recreate the Ice Age. More precisely, their vision is to reconstruct the landscape and ecosystem of northern Siberia in the Pleistocene, a period in Earth's history that stretches from around two and a half million years ago to eleven thousand years ago. This was a time when the environment was much colder than now, with huge glaciers and ice sheets flowing over much of the Earth's northern hemisphere. It was also a time when humans coexisted with animals that are long extinct, including saber-tooth cats, giant ground sloths, and woolly mammoths.

The Zimovs' ambitions are an extreme example of "Pleistocene rewilding," a movement to reintroduce relatively recently extinct large animals, or their close modern-day equivalents, to regions where they were once common. In the case of the Zimovs, the father-and-son team believe that, by reconstructing the Pleistocene ecosystem in the Siberian steppes and elsewhere, they can slow down the impacts of climate change on these regions. These areas are dominated by permafrost, ground that never thaws through the year. Permafrost ecosystems have developed and survived over millennia, but a warming global climate (a theme we'll come back to in chapter twelve and the movie *The Day After Tomorrow*) threatens to catastrophically disrupt them, and as this happens, the impacts on biodiversity could be devastating. But what gets climate scientists even more worried is potentially massive releases of trapped methane as the permafrost disappears.

Methane is a powerful greenhouse gas—some eighty times more effective at exacerbating global warming than carbon dioxide—and large-scale releases from warming permafrost could trigger catastrophic changes in climate. As a result, finding ways to keep it in the ground is important. And here the Zimovs came up with a rather unusual idea: maintaining the stability of the environment by reintroducing long-extinct species that could help prevent its

destruction, even in a warmer world. It's a wild idea, but one that has some merit.[8] As a proof of concept, though, the Zimovs needed somewhere to start. And so they set out to create a park for de-extinct Siberian animals: Pleistocene Park.[9]

Pleistocene Park is by no stretch of the imagination a modern-day Jurassic Park. The dinosaurs in Hammond's park date back to the Mesozoic period, from around 250 million years ago to sixty-five million years ago. By comparison, the Pleistocene is relatively modern history, ending a mere eleven and a half thousand years ago. And the vision behind Pleistocene Park is not thrills, spills, and profit, but the serious use of science and technology to stabilize an increasingly unstable environment. Yet there is one thread that ties them together, and that's using genetic engineering to reintroduce extinct species. In this case, the species in question is warm-blooded and furry: the woolly mammoth.

The idea of de-extinction, or bringing back species from extinction (it's even called "resurrection biology" in some circles), has been around for a while. It's a controversial idea, and it raises a lot of tough ethical questions. But proponents of de-extinction argue that we're losing species and ecosystems at such a rate that we can't afford *not* to explore technological interventions to help stem the flow.

Early approaches to bringing species back from the dead have involved selective breeding. The idea was simple—if you have modern ancestors of a recently extinct species, selectively breeding specimens that have a higher genetic similarity to their forebears can potentially help reconstruct their genome in living animals. This approach is being used in attempts to bring back the aurochs, an ancestor of modern cattle.[10] But it's slow, and it depends on the fragmented genome of the extinct species still surviving in its modern-day equivalents.

An alternative to selective breeding is cloning. This involves finding a viable cell, or cell nucleus, in an extinct but well-preserved animal and growing a new living clone from it. It's definitely a more appealing route for impatient resurrection biologists, but it does

---

8   You can read more about the quest to increase environmental resilience by resurrecting the woolly mammoth in Ben Mezrich's book "Woolly: The True Story of the Quest to Revive One of History's Most Iconic Extinct Creature" (2017, *Atira Books*).

9   This is a real project, with a real website. You can discover more at http://www.pleistocenepark.ru/en/

10  *The Tauros Program* is a Dutch initiative to create what they call a "true replacement" for the currently-extinct aurochs. You can find out more at http://taurosprogramme.com/

mean getting your hands on intact cells from long-dead animals and devising ways to "resurrect" these, which is no mean feat. Cloning has potential when it comes to recently extinct species whose cells have been well preserved—for instance, where the whole animal has become frozen in ice. But it's still a slow and extremely limited option.

Which is where advances in genetic engineering come in.

The technological premise of *Jurassic Park* is that scientists can reconstruct the genome of long-dead animals from preserved DNA fragments. It's a compelling idea, if you think of DNA as a massively long and complex instruction set that tells a group of biological molecules how to build an animal. In principle, if we could reconstruct the genome of an extinct species, we would have the basic instruction set—the biological software—to reconstruct individual members of it.

The bad news is that DNA-reconstruction-based de-extinction is far more complex than this. First you need intact fragments of DNA, which is not easy, as DNA degrades easily (and is pretty much impossible to obtain, as far as we know, for dinosaurs). Then you need to be able to stitch all of your fragments together, which is akin to completing a billion-piece jigsaw puzzle without knowing what the final picture looks like. This is a Herculean task, although with breakthroughs in data manipulation and machine learning, scientists are getting better at it. But even when you have your reconstructed genome, you need the biological "wetware"—all the stuff that's needed to create, incubate, and nurture a new living thing, like eggs, nutrients, a safe space to grow and mature, and so on. Within all this complexity, it turns out that getting your DNA sequence right is just the beginning of translating that genetic code into a living, breathing entity. But in some cases, it might be possible.

---

In 2013, Sergey Zimov was introduced to the geneticist George Church at a conference on de-extinction. Church is an accomplished scientist in the field of DNA analysis and reconstruction, and a thought leader in the field of synthetic biology (which we'll come back to in chapter nine). It was a match made in resurrection biology heaven. Zimov wanted to populate his Pleistocene Park with mammoths, and Church thought he could see a way of achieving this.

What resulted was an ambitious project to de-extinct the woolly mammoth. Church and others who are working on this have faced plenty of hurdles. But the technology has been advancing so fast that, as of 2017, scientists were predicting they would be able to reproduce the woolly mammoth within the next two years.

One of those hurdles was the lack of solid DNA sequences to work from. Frustratingly, although there are many instances of well-preserved woolly mammoths, their DNA rarely survives being frozen for tens of thousands of years. To overcome this, Church and others have taken a different tack: Take a modern, living relative of the mammoth, and engineer into it traits that would allow it to live on the Siberian tundra, just like its woolly ancestors.

Church's team's starting point has been the Asian elephant. This is their source of base DNA for their "woolly mammoth 2.0"—their starting source code, if you like. So far, they've identified fifty-plus gene sequences they think they can play with to give their modern-day woolly mammoth the traits it would need to thrive in Pleistocene Park, including a coat of hair, smaller ears, and a constitution adapted to cold.

The next hurdle they face is how to translate the code embedded in their new woolly mammoth genome into a living, breathing animal. The most obvious route would be to impregnate a female Asian elephant with a fertilized egg containing the new code. But Asian elephants are endangered, and no one's likely to allow such cutting-edge experimentation on the precious few that are still around, so scientists are working on an artificial womb for their reinvented woolly mammoth. They're making progress with mice and hope to crack the motherless mammoth challenge relatively soon.

It's perhaps a stretch to call this creative approach to recreating a species (or "reanimation" as Church refers to it) "de-extinction," as what is being formed is a new species. Just as the dinosaurs in *Jurassic Park* weren't quite the same as their ancestors, Church's woolly mammoths wouldn't be the same as their forebears. But they *would* be designed to function within a specific ecological niche, albeit one that's the result of human-influenced climate change. And this raises an interesting question around de-extinction: If the genetic tools we are now developing give us the ability to improve on nature, why recreate the past, when we could reimagine the future? Why stick to the DNA code that led to animals being weeded out because they couldn't survive in a changing environment, when

we could make them better, stronger, and more likely to survive and thrive in the modern world?

This idea doesn't sit so well with some people, who argue that we should be dialing down human interference in the environment and turning the clock back on human destruction. And they have a point, especially when we consider the genetic diversity we are hemorrhaging away with the current rate of biodiversity loss. Yet we cannot ignore the possibilities that modern genetic engineering is opening up. These include the ability to rapidly and cheaply read genetic sequences and translate them to digital code, to virtually manipulate them and recode them, and then to download them back into the real world. These are heady capabilities, and for some there is an almost irresistible pull toward using them, so much so that some would argue that *not* to use them would be verging on the irresponsible.

These tools take us far beyond de-extinction. The reimagining of species like the woolly mammoth is just the tip of the iceberg when it comes to genetic design and engineering. Why stop at recreating old species when you could redesign current ones? Why just redesign existing species when you could create brand-new ones? And why stick to the genetic language of all earth-bound living creatures, when you could invent a new language—a new DNA? In fact, why not go all the way, and create alien life here on earth?

These are all conversations that scientists are having now, spurred on by breakthroughs in DNA sequencing, analysis, and synthesis. Scientists are already developing artificial forms of DNA that contain more than the four DNA building blocks found in nature.[11] And some are working on creating completely novel artificial cells that not only are constructed from off-the-shelf chemicals, but also have a genetic heritage that traces back to computer programs, not evolutionary life. In 2016, for instance, scientist and entrepreneur Craig Venter announced that his team had produced a completely artificial living cell.[12] Venter's cell—tagged "JCVI-syn3.0"—is paving the way for designing and creating completely artificial life forms,

---

11  In 2009, a team of scientists synthesized an artificial form of DNA with six nucleotide building blocks, rather than the four found in naturally-occurring DNA (Georgiadis, M. M., et al. (2015). "Structural Basis for a Six-Nucleotide Genetic Alphabet." *Journal of the American Chemical Society* **137**(21): 6947-6955. http://doi.org/10.1021/jacs.5b03482). More recently, scientists reported in the journal *Nature* that they had created a semi-synthetic organism that used artificial six-letter DNA to store and retrieve information (Zhang, Y., et al. (2017). "A semi-synthetic organism that stores and retrieves increased genetic information." *Nature* **551**: 644. http://doi.org/10.1038/nature24659).

12  Venter's team's work is described in the journal *Nature* in 2016. Callaway, E. (2016). "'Minimal' cell raises stakes in race to harness synthetic life." Nature 531: 557–558. http://doi.org/10.1038/531557a

and the work being done here by many different groups is signaling a possible transition from biological evolution to biology by design.

One of the interesting twists to come out of this research is that scientists are developing the ability to "watermark" their creations by embedding genetic identity codes. As research here progresses, future generations may be able to pinpoint precisely who designed the plants and animals around them, and even parts of their own bodies, including when and where they were designed. This does, of course, raise some rather knotty ethical questions around ownership. If you one day have a JCVI-tagged dog, or a JCVI-watermarked replacement kidney, for instance, who owns them?

This research is pushing us into ethical questions that we've never had to face before. But it's being justified by the tremendous benefits it could bring for current and future generations. These touch on everything from bio-based chemicals production to new medical treatments and ways to stay healthier longer, and even designer organs and body-part replacements at some point. It's also being driven by our near-insatiable curiosity and our drive to better understand the world we live in and gain mastery over it. And here, just like the scientists in *Jurassic Park*, we're deeply caught up in what we can do as we learn to code and recode life.

But, just because we can now resurrect and redesign species, should we?

## Could We, Should We?

Perhaps one of the most famous lines from *Jurassic Park*—at least for people obsessed with the dark side of science—is when Ian Malcolm berates Hammond, saying, "Your scientists were so preoccupied with whether they could, they didn't stop to think if they should."

Ethics and responsibility in science are complicated. I've met remarkably few scientists and engineers who would consider themselves to be unethical or irresponsible. That said, I know plenty of scientists who are so engaged with their work and the amazing things they believe it'll lead to that they sometimes struggle to appreciate the broader context within which they operate.

The challenges surrounding ethical and responsible research are deeply pertinent to de-extinction. A couple of decades ago, they were largely academic. The imaginations of scientists, back when

*Jurassic Park* hit the screen, far outstripped the techniques they had access to at the time. Things are very different now, though, as research on woolly mammoths and other extinct species is showing. In a very real way, we're entering a world that very much echoes the "can-do" culture of Hammond's Jurassic Park, where scientists are increasingly able to do what was once unimaginable. In such a world, where do the lines between "could" and "should" lie, and how do scientists, engineers, and others develop the understanding and ability to do what is socially responsible, while avoiding what is not?

Of course, this is not a new question. The tensions between technological advances and social impacts were glaringly apparent through the Industrial Revolution, as mechanization led to job losses and hardship for some. And the invention of the atomic bomb, followed by its use on Nagasaki and Hiroshima in the second World War, took us into deeply uncharted territory when it came to balancing what we can and should do with powerful technologies. Yet, in some ways, the challenges we've faced in the past over the responsible development and use of science and technology were just a rehearsal for what's coming down the pike, as we enter a new age of technological innovation.

---

For all its scientific inaccuracies and fantastical scenarios, *Jurassic Park* does a good job of illuminating the challenges of unintended consequences arising from somewhat naïve and myopic science. Take InGen's scientists, for instance. They're portrayed as being so enamored with what they've achieved that they lack the ability to see beyond their own brilliance to what they might have missed.[13] Of course, they're not fools. They know that they're breaking new ground by bringing dinosaurs back to life, and that there are going to be risks. It would be problematic, for instance, if any of the dinosaurs escaped the island and survived, and they recognize this. So the scientists design them to be dependent on a substance it was thought they couldn't get enough of naturally, the essential amino acid lysine. This was the so-called "lysine contingency," and, as it turns out, it isn't too dissimilar from techniques real-world genetic engineers use to control their progeny.

---

13   Despite my portrayal of InGen's scientists as enthusiastically short-sighted, the company's Chief Scientist, Henry Wu (played by BD Wong), is increasingly revealed to have serious evil-scientist tendencies in subsequent movies in the series.

Even though it's essential to life, lysine isn't synthesized naturally by animals. As a result, it has to be ingested, either in its raw form or by eating foods that contain it, including plants or bacteria (and their products) that produce it naturally, for instance, or other animals. In their wisdom, InGen's scientists assume that they can engineer lysine dependency into their dinosaurs, then keep them alive with a diet rich in the substance, thinking that they wouldn't be able to get enough lysine if they escaped. The trouble is, this contingency turns out to be about as useful as trying to starve someone by locking them in a grocery store.

There's a pretty high chance that the movie's scriptwriters didn't know that this safety feature wouldn't work, or that they didn't care. Either way, it's a salutary tale of scientists who are trying to be responsible—at least their version of "responsible"—but are tripped up by what they don't know, and what they don't care to find out.

In the movie, not much is made of the lysine contingency, unlike in Michael Crichton's book that the movie's based on, where this basic oversight leads to the eventual escape of the dinosaurs from the island and onto the mainland. There is another oversight, though, that features strongly in the movie, and is a second strike against the short-sightedness of the scientists involved. This is the assumption that InGen's dinosaurs couldn't breed.

This is another part of the storyline where scientific plausibility isn't allowed to stand in the way of a good story. But, as with the lysine, it flags the dangers of thinking you're smart enough to have every eventuality covered. In the movie, InGen's scientists design all of their dinosaurs to be females. Their thinking: no males, no breeding, no babies, no problem. Apart from one small issue: When stitching together their fragments of dinosaur DNA with that of living species, they filled some of the holes with frog DNA.

This is where we need to suspend scientific skepticism somewhat, as designing a functional genome isn't as straightforward as cutting and pasting from one animal to another. In fact, this is so far from how things work that it would be like an architect, on losing a few pages from the plans of a multi-million dollar skyscraper, slipping in a few random pages from a cookie-cutter duplex and hoping for the best. The result would be a disaster. But stick with the story for the moment, because in the world of *Jurassic Park*, this naïve mistake led to a tipping point that the scientists didn't anticipate. Just as some species of frog can switch from female to male with the right

environmental stimuli, the DNA borrowed from frogs inadvertently gave the dinosaurs the same ability. And this brings us back to the real world, or at least the near-real world, of de-extinction. As scientists and others begin to recreate extinct species, or redesign animals based on long-gone relatives, how do we ensure that, in their cleverness, they're not missing something important?

Some of this comes down to what responsible science means, which, as we'll discover in later chapters, is about more than just having good intentions. It also means having the humility to recognize your limitations, and the willingness to listen to and work with others who bring different types of expertise and knowledge to the table.

This possibility of unanticipated outcomes shines a bright spotlight on the question of whether some lines of research or technological development should be pursued, even if they could. *Jurassic Park* explores this through genetic engineering and de-extinction, but the same questions apply to many other areas of technological advancement, where new knowledge has the potential to have a substantial impact on society. And the more complex the science and technology we begin to play with is, the more pressing this distinction between "could" and "should" becomes.

Unfortunately, there are no easy guidelines or rules of thumb that help decide what is probably okay and what is probably not, although much of this book is devoted to ways of thinking that reduce the chances of making a mess of things. Even when we do have a sense of how to decide between great ideas and really bad ones, though, there's one aspect of reality we can't escape from: Complex systems behave in unpredictable ways.

## The Butterfly Effect

Michael Crichton started playing with the ideas behind *Jurassic Park* in the 1980s, when "chaos" was becoming trendy. I was an undergraduate at the time, studying physics, and it was nearly impossible to avoid the world of "strange attractors" and "fractals." These were the years of the "Mandelbrot Set" and computers that were powerful enough to calculate the numbers it contained and display them as stunningly psychedelic images. The recursive complexity in the resulting fractals became the poster child for a growing field of mathematics that grappled with systems where, beyond certain limits, their behavior was impossible to predict. The field came to be known informally as chaos theory.

Chaos theory grew out of the work of the American meteorologist Edward Lorenz. When he started his career, it was assumed that the solution to more accurate weather prediction was better data and better models. But in the 1950s, Lorenz began to challenge this idea. What he found was that, in some cases, minute changes in atmospheric conditions could lead to dramatically different outcomes down the line, so much so that, in sufficiently complex systems, it was impossible to predict the results of seemingly insignificant changes.

In 1963, when he published the paper that established chaos theory,[14] it was a revolutionary idea—at least to scientists who still hung onto the assumption that we live in a predictable world. Much as quantum physics challenged scientists' ideas of how predictable physical processes are in the invisible world of atoms and subatomic particles, chaos theory challenged their belief that, if we have enough information, we can predict the outcomes of our actions in our everyday lives.

At the core of Lorenz's ideas was the observation that, in a sufficiently complex system, the smallest variation could lead to profound differences in outcomes. In 1969, he coined the term "the Butterfly Effect," suggesting that the world's weather systems are so complex and interconnected that a butterfly flapping its wings on one side of the world could initiate a chain of events that ultimately led to a tornado on the other.

Lorenz wasn't the first to suggest that small changes in complex systems can have large and unpredictable effects. But he was perhaps the first to pull the idea into mainstream science. And this is where chaos theory might have stayed, were it not for the discovery of the "Mandelbrot Set" by mathematician Benoit Mandelbrot.

In 1979, Mandelbrot demonstrated how a seemingly simple equation could lead to images of infinite complexity. The more you zoomed in to the images his equation produced, the more detail became visible. As with Lorentz's work, Mandelbrot's research showed that very simple beginnings could lead to complex, unpredictable, and chaotic outcomes. But Lorentz, Mandelbrot, and others also revealed another intriguing aspect of chaos theory, and this was that complex systems can lead to *predictable* chaos. This may seem counterintuitive, but what their work showed was that, even where

---

14  The paper was titled "Deterministic Nonperiodic Flow" and was published in the *Journal of the Atmospheric Sciences*. Edward N. Lorenz (1963). "Deterministic Nonperiodic Flow". *Journal of the Atmospheric Sciences*. 20 (2): 130–141. http://doi.org/10.1175/1520-0469(1963)020<0130:DNF>2.0.CO;2

chaotic unpredictability reigns, there are always limits to what the outcomes might be.

Mandelbrot fractals became all the rage in the 1980s. As a new generation of computer geeks got their hands on the latest personal computers, kids began to replicate the Mandelbrot fractal and revel in its complexity. Reproducing it became a test of one's coding expertise and the power of one's hardware. In one memorable guest lecture on parallel processing I attended, the lecturer even demonstrated the power of a new chip by showing how fast it could produce Mandelbrot fractals.

This growing excitement around chaos theory and the idea that the world is ultimately unpredictable was admirably captured in James Gleick's 1987 book *Chaos: Making a New Science*.[15] Gleick pulled chaos theory out of the realm of scientists and computer geeks and placed it firmly in the public domain, and also into the hands of novelists and moviemakers. In *Jurassic Park*, Ian Malcolm captures the essence of the chaos zeitgeist, and uses this to drive along a narrative of naïve human arrogance versus the triumphal dominance of chaotic, unpredictable nature. Naturally, there's a lot of hokum here, including the rather silly idea that chaos theory means being able to predict when chaos will occur (it doesn't). But the concept that we cannot wield perfect control over complex technologies within a complex world is nevertheless an important one.

Chaos theory suggests that, in a complex system, immeasurably small actions or events can profoundly affect what happens over the course of time, making accurate predictions of the future well-nigh impossible. This is important as we develop and deploy highly complex technologies. However, it also suggests that there are boundaries to what might happen and what will not as we do this. And these boundaries become highly relevant in separating out plausible futures from sheer fantasy.

Chaos theory also indicates that, within complex systems, there are points of stability. In the context of technological innovation, this suggests that there are some futures that are more likely to occur if we take the appropriate courses of action. But these are also futures that can be squandered if we don't think ahead about our actions and their consequences.

*Jurassic Park* focuses on the latter of these possibilities, and it does so to great effect. What we see unfolding is a catastrophic

---

15   James Gleick (1987) "Chaos: Making a New Science." *Viking*, New York.

confluence of poorly understood technology, the ability of natural systems to adapt and evolve, unpredictable weather, and human foibles. The result is a park in chaos and dinosaurs dining on people. This is a godsend for a blockbuster movie designed to scare and thrill its audiences. But how realistic is this chaotic confluence of unpredictability?

As it turns out, it's pretty realistic—up to a point. Chaos theory isn't as trendy today as it was back when *Jurassic Park* was made. But the realization that complex systems are vulnerable to big (and sometimes catastrophic) shifts in behavior stemming from small changes is a critical area of research. And we know that technological innovation has the capacity to trigger events and outcomes within the complex social and environmental systems we live in that are hard to predict and manage.

As if to press the point home here, as I'm writing this, Hurricane Harvey has just swept through Houston, causing unprecedented devastation. The broad strokes of what occurred were predictable to an extent—the massive flooding exacerbated by poor urban planning, the likelihood of people and animals being stranded and killed, even the political rhetoric around who was responsible and what could have been done better. In the midst of all of this, though, a chemical plant owned by the French company Arkema underwent an unprecedented catastrophic failure.

The plant produced organic peroxides. These are unstable, volatile chemicals that need to be kept cool to keep them safe, but they are also important in the production of many products we use on a daily basis. As Harvey led to widespread flooding, the plant's electric power supplies that powered the cooling systems failed one by one—first the main supply, then the backups. In the end, all the company could do was to remove the chemicals to remote parts of the plant, and wait for them to vent, ignite, and explode.

On its own, this would seem like an unfortunate but predictable outcome. But there's evidence of a cascade of events that exacerbated the failure, many of them seemingly insignificant, but all part of a web of interactions that resulted in the unintended ignition of stored chemicals and the release of toxic materials into the environment. The news and commentary site Buzzfeed obtained a logbook from the plant that paints a picture of cascading incidents, including "overflowing wastewater tanks, failing power systems, toilets that stopped working, and even a snake, washed in by rising

waters. Then finally: 'extraction' of the crew by boat. And days later, blasts and foul, frightening smoke."[16]

Contingencies were no doubt in place for flooding and power failures. Overflowing toilets and snakes? Probably not. Yet so often it's these seemingly small events that help trigger larger and seemingly chaotic ones in complex systems.

Such cascades of events leading to unexpected outcomes are more common than we sometimes realize. For instance, few people expect industrial accidents to occur, but they nevertheless do. In fact, they happen so regularly that the academic Charles Perrow coined the term "normal accidents," together with the theory that, in any sufficiently complex technological system, unanticipated events are inevitable.[17]

Of course, if Hammond had read his Perrow, he might have had a better understanding of just how precarious his new Jurassic Park was. Sadly, he didn't. But even if Hammond and his team had been aware of the challenges of managing complex systems, there's another factor that led to the chaos in the movie that reflects real life, and that's the way that power plays an oversized role in determining the trajectory of a new technology, along with any fallout that accompanies it.

## Visions of Power

Beyond the genetic engineering, the de-extinction, and the homage to chaos theory, *Jurassic Park* is a movie about power: not only the power to create and destroy life, but the power to control others, to dominate them, and to win.

Power, and the advantages and rewards it brings, is deeply rooted in human nature, together with the systems we build that reflect and amplify this nature. But this nature in turn reflects the evolutionary processes that we are a product of. *Jurassic Park* cleverly taps into this with the dinosaur-power theme. And in fact, one of the movie's more compelling narrative threads is the power and dominance of the dinosaurs and the natural world over their human creators, who merely have delusions of power. Yet this is also a movie about

---

16   Nidhi Subbaraman and Jessica Garrison (2017) "Here's What Happened In The Hours After Hurricane Harvey Hit A Chemical Plant, According To A Staff Log" *Buzzfeed*, November 16, 2017. https://www.buzzfeed.com/nidhisubbaraman/arkema-chemical-plant-houston-timeline

17   Charles Perrow developed his ideas in his 1984 book "Normal Accidents: Living with High-Risk Technologies," published by *Princeton University Press*.

human power dynamics, and how these influence the development, use, and ultimately in this case the abuse, of new technologies.

There are some interesting side stories about power here, for instance, the power Ian Malcolm draws from his "excess of personality." But it's the power dynamic between Hammond, the lawyer Donald Gennaro, and InGen's investors that particularly intrigues me. Here, we get a glimpse of the ability of visions of power to deeply influence actions.

At a very simple level, *Jurassic Park* is a movie about corporate greed. Hammond's investors want a return on their investment, and they are threatening to exert their considerable power to get it. Gennaro is their proxy, but this in turn places him in a position of power. He's the linchpin who can make or break the park, and he knows it.

Then there's Hammond himself, who revels in his power over people as an entertainer, charmer, and entrepreneur.

These competing visions of power create a dynamic tension that ultimately leads to disaster, as the pursuit of personal and corporate gain leads to sacrificed lives and morals. In this sense, *Jurassic Park* is something of a morality tale, a cautionary warning against placing power and profit over what is right and good. Yet this is too simplistic a takeaway from the perspective of developing new technologies responsibly.

In reality, there will always be power differentials and power struggles. Not only will many of these be legitimate—including the fiduciary responsibility of innovators to investors—but they are also an essential driving force that prevents society from stagnating. The challenge we face is not to abdicate power, but to develop ways of understanding and using it in ways that are socially responsible.

This does not happen in *Jurassic Park,* clearly. But that doesn't mean that we cannot have responsible innovation, or corporate social responsibility, that works, or even ethical entrepreneurs. It's easy to see the downsides of powerful organizations and individuals pushing through technological innovation at the expense of others. And there are many downsides; you just need to look at the past two hundred years of environmental harm and human disease tied to technological innovation to appreciate this. Yet innovation that has been driven by profit and the desire to amass and wield power has also created a lot of good. The challenge we face is how we

harness the realities of who we are and the world we live in to build a better future for as many people as we can, without sacrificing the health and well-being of communities and individuals along the way.

In large part, this is about learning how we develop and wield power appropriately—not eschewing it, but understanding and accepting the sometimes-complex responsibilities that come with it. And this isn't limited to commercial or fiscal power. Scientists wield power with the knowledge they generate. Activists wield power in the methods they use and the rhetoric they employ. Legislators have the power to establish law. And citizens collectively have considerable power over who does what and how. Understanding these different facets of power and its responsible use is critical to the safe and beneficial development and use of new technologies—not just genetic engineering, but every other technology that touches our lives as well, including the technology that's at the center of our next movie: *Never Let Me Go*.

## CHAPTER THREE

# NEVER LET ME GO: A CAUTIONARY TALE OF HUMAN CLONING

> *"Who'd make up stories as horrible as that?"*
> —Ruth

## Sins of Futures Past

In 2002, the birth of the first human clone was announced. Baby Eve was born on December 26, 2002, and weighed seven pounds. Or so it was claimed.

The announcement attracted media attention from around the world, and spawned story after story of the birth. Since then, no proof has emerged that baby Eve was anything other than a publicity stunt. But the furor at the time demonstrated how contentious the very idea of creating living copies of people can be.

There's something about human cloning that seems to jar our sense of right and wrong. It instinctively feels—to many people, I suspect—as if it's not quite right. Yet, at the same time, there's something fascinating about the idea that we might one day be able to recreate a new person in our own likeness, or possibly "resurrect" someone we can't bear to lose—a child who's passed, or a loved relative. There's even the uneasy notion that maybe, one day, we could replicate those members of society who do the work we can't do, or don't want to—a ready supply of combat personnel, maybe, or garbage collectors. Or even, possibly, living, breathing organ donors.

As it turns out, cloning humans is really difficult. It's also fraught with ethical problems. But this hasn't stopped people trying, despite near-universal restrictions prohibiting it.

On December 27, 2002, Brigitte Boisselier, a scientist working for the organization Clonaid, announced that a cloned baby girl, Eve, had been delivered by cesarian section to a thirty-one-year-old woman. Clonaid was founded in 1997 with the express aim of cloning humans. But the company's mission was far more ambitious than this. The organization had its roots in the ideas and teachings of one-time racing car test-driver, and subsequently self-proclaimed religious leader, Claude Vorilhon. Vorilhon, who later renamed himself Raël and went on to establish the Raëlian religious movement, believes that we are the creations of a "scientifically more advanced species." These aliens—the "Elohim"—have, he claims, discovered the secret of immortality. And the key to this is, apparently, cloning.

You could be forgiven for feeling a little skeptical at this point. Raël's stories and beliefs come across as fantastical and delusional, at least when they're boiled down to their bare bones. But they offer a window into the world of cloning that bizarrely echoes some of the more mainstream ideas of transhumanists, and even some technology entrepreneurs. They also create an intriguing canvas on which to begin exploring the moral dilemmas presented in the movie *Never Let Me Go*.

---

*Never Let Me Go* was never intended as a science fiction movie. Its scriptwriter (and the author of the novel the movie's based on), Kazuo Ishiguro, was interested in what it means to live a meaningful life, especially if that life is short and limited. Ironically, the setting he used to explore this was a society that has discovered the secret of a long and disease-free life. But the technology this secret depends on is a program of human cloning, developed for no purpose other than to allow the clones' organs to be harvested when the appropriate time came to keep others alive and healthy.

To Ishiguro, the clones were simply a plot device. Nevertheless, the characters he created and the circumstances of their lives reveal a dark side of how technologies like cloning can, if not used ethically and responsibly, lead to quite devastating discrimination and abuse.

*Never Let Me Go* is set in a fictitious England in the 1970s to 1990s. On the surface, it reminds me of the England I grew up in; the settings, the people, and the culture all have a nostalgic familiarity to them. But, unlike the England I remember, there's something deeply disturbing under the surface here. What unfolds is a heart-wrenching

story about dignity, rights, and happiness, and what it means to have value as a person. And because the movie is not focused on the technology itself, but on the lives it impacts, it succeeds in providing a searing insight into the social and moral risks of selling our collective souls as we unquestionably embrace the seeming promise of new technological capabilities.

At the center of *Never Let Me Go* are three young people, bound together by a common experience. The story starts with them as young children, at what looks at first glance like an exclusive private school in the English countryside. They seem like ordinary kids, with all the usual joys, pains, and intrigues that accompany childhood. Except that these children are different.

As the movie unfolds, we begin to learn that these particular students have been "bred." They don't have parents. They don't even have full names. Instead, they're destined to give their short lives for others as part of the National Donor Program, "donating" their organs as they become young adults until, around the third or fourth donation, they will "complete" and die on the operating table.

As the students get older, they are made increasingly aware of their fate. They're taught that they need to look after their bodies, that this is their purpose in life—that their role is to die so others can live. And most of them accept this fate.

Yet, despite their being treated as a commodity by the society they're created to serve, we begin to learn that not everyone is comfortable with this. Their principal, Miss Emily (Charlotte Rampling), is concerned about the ethics of the National Donor Program. But, as we discover, she is less concerned about the existence of the program than about how it's run. She wants to find evidence supporting her gut feeling that her students should be treated as people, rather than walking organ donors. It turns out that her school, Hailsham was set up as a progressive establishment to explore whether these clones have that (apparently) quintessential indicator of humanity, a "soul." This, from the perspective of Miss Emily and her supporters, is essential in determining whether the students are worthy of being treated with the dignity and respect afforded other members of the human race.

Against this backdrop, a deeply moving story of love, empathy, and meaning plays out. Ultimately, the three clones we follow become a yardstick of what constitutes "being human" against which their creators are measured.

Standing at the core of *Never Let Me Go* is the relationship between Kathy (played as a child by Izzy Meikle-Small, and as an adult by Carey Mulligan), a kind, empathetic young woman trying to make sense of her life, and Tommy (Charlie Rowe/Andrew Garfield), a troubled young man whom she cares deeply for. Then there is Ruth (Ella Purnell/Keira Knightly), a sometime-friend of Kathy and Tommy's who desperately wants to fit in with those around her, and who selfishly robs those close to her of what's precious to them as she does.

As the three children grow toward adulthood, they begin to hear talk of a "deferment program," a means of delaying the start of their donations. It's rumored that, if a couple can show that they truly love each other, they can request a deferment from donating. This would provide them with a short stay of execution before they give up their organs and ultimately die in the process. And, according to rumor, Miss Emily, their former principal at Hailsham, has some influence here.

As they enter adulthood, the three young people move on from the small community they live in together, and lose touch. Kathy becomes a "carer," looking after other donors as they move toward completion. But some years after the three of them have gone their separate ways, she runs across Ruth. Ruth is recovering from a donation which hasn't gone well, and Kathy steps in as her carer.

As the two rekindle their old relationship, they reconnect with Tommy, who has also begun his donations. Ruth has been keeping track of both Tommy and Kathy, in part because she is wracked with guilt about how she treated them. She admits that she was jealous of the deep bond between Tommy and Kathy when the three of them were together and, because of this, stole Tommy away from Kathy.

As she nears completion, Ruth's guilt becomes all-consuming. To try to set things right, she provides Kathy and Tommy with what she believes is the key to the rumored deferment program.

Ruth completes on her next donation, and after her death, Kathy checks out the information she passed on about deferment. Ruth has given her the address of a woman simply known as Madame, who used to visit the now-closed Hailsham, and is possibly the person one needs to approach to be admitted into the rumored program. Filled with hope, Kathy and Tommy decide to visit her and request a deferment. But there is a problem.

While at Hailsham, the students were encouraged to express themselves through art. Periodically, Madame visited the school and selected the best of what they'd created. Kathy and Tommy deduce that Madame holds the key to deferment, and convince themselves that the way Madame tells whether two donors are truly in love is through their art. The trouble is that Tommy never had any art selected by Madame. It seems that their fragile hope is about to be dashed because Tommy didn't do enough when he was younger to prove his worth.

Despite this, the two lovers think they see a way forward. Tommy starts afresh developing his art portfolio, so he has something (he believes) to demonstrate his "worthiness," and the two of them set out to visit the address provided by Ruth. Yet, on getting there, the couple are devastated to discover that Madame has no ability to grant a deferment; she never did.

It turns out that Madame and Miss Emily were working as a team at Hailsham, but not to seek out evidence for true love. Rather, they were using the students' art to determine if they had souls, if they had human qualities worth valuing beyond a working body and healthy organs.

The two women earnestly wanted to find a way to show that these children were capable of human feelings, and that they had validity and worth beyond the organs they were carrying. Yet for all their moral angst, Madame and Miss Emily turn out to be all mouth and no backbone. They lament Kathy and Tommy's plight. But they also dash their fragile hopes, claiming there's nothing they can do to help.

As Kathy and Tommy return to the care home that night, Tommy calmly asks Kathy to stop the car, and gets out. The whole weight of the despair and injustice he's carrying crushes down on him, as he screams and weeps uncontrollably for the hope and the future that society has robbed him of. In that one stark, revealing moment, Tommy shows the full depth of his humanity, and he throws into sharp relief the *inhumanity* of those who have sacrificed him to the gods of their technology.

As Tommy and Ruth complete, and Kathy becomes a donor herself, we realize that asking whether they have souls was the wrong question. We're left in no doubt that these young people deserve respect, and dignity, and autonomy, and kindness, irrespective of what they have achieved. And we realize that, through them, the

society that created the technology that produced them has been judged, and found wanting.

*Never Let Me Go* is a movie that delves deeply into the questionable morality of convenient technologies. It's also a movie that challenges us to think about how we treat others, and what separates *humanity* from *inhumanity*. But before we get there, it's worth diving deeper into the technology that underpins the unfolding story we're presented with: cloning.

## Cloning

On July 5, 1996, Dolly the sheep was born. What made Dolly unusual was that she didn't have regular biological parents. Rather, she was grown from a cell that came from a single animal.

Dolly the sheep was the first successful clone of a domesticated animal from an adult cell. And the proof that this was possible shot the possibility of cloning from science fiction to science fantasy almost overnight.

In Dolly's case, the DNA from an ordinary, or somatic, cell—not a reproductive cell or stem cell—was injected into an unfertilized egg that had had its nucleus removed. This "clone egg" was then electrically shocked into starting to divide and grow, after which it was implanted in the uterus of a third sheep.

Dolly was born healthy and lived for nearly seven years before she was put down due to increasingly poor health. But the legacy of the experiment she was a part of lives on. What her birth and life demonstrated without a shadow of doubt is that it's possible to grow a fully functioning animal from a single cell taken from an organ, and presumably to keep on doing this time and time again.

It's easy to see the attraction of cloning large animals, at least on the surface. Loved pets could be reproduced, leading to a never-ending cycle of pup to adult and back to pup. Prize livestock could be duplicated, leading to large herds of prime cattle, or whole stables of thoroughbreds. Rare species could be preserved. And then there are people. Yet cloning human from scratch is harder than it might at first seem.

In July 2016, there was a flurry of articles marking the twentieth anniversary of Dolly's birth. In one of these, bioethicist Hank Greely astutely pointed out just how hard cloning still is, even after two decades of work: "Cats: easy; dogs: hard; mice: easy; rats: hard; humans and other primates: very hard."[18] The trouble is, while the concept of cloning is pretty straightforward, biology rarely is.

The basic idea behind cloning is to remove the DNA from a healthy non-reproductive cell, insert it into a viable egg cell, and then persuade this to develop into a fully functional organism that is identical to the original. The concept is seemingly simple: the DNA in each cell contains the genetic code necessary to create a new organism from scratch. All that's needed to create a clone is to convince the DNA that it's inside a fertilized egg, and get it to behave accordingly. As it turns out, though, this is not that easy. DNA may contain all the right code for creating a new life, but getting it to do this is tricky.

This trickiness hasn't stopped people from experimenting, though, and in some cases succeeding. And as a result, if you really want to, you can have your dog cloned,[19] or pay a company to create for you a clone-herd of cattle.[20] And there continues to be interest in cloning humans. But before we even get to the technical plausibility of whether we can do this, there are complex ethical challenges to navigate.

---

Despite advances in the science of cloning, the general consensus on whether we should allow humans to be cloned seems to be "no," at least at the moment, although this is by no means a universally accepted position. In 2005, the General Assembly of the United Nations adopted a "Declaration on Human Cloning" whereby "Member states were called on to adopt all measures necessary to prohibit all forms of human cloning inasmuch as they are incompatible with human dignity and the protection of

---

18   Greely was being quoted in an article by Sharon Begley in *Business Insider* ("Here's why we're still not cloning humans, 20 years after Dolly the sheep." July 5, 2016. http://www.businessinsider.com/can-you-clone-a-human-2016-7). He also noted that the world's best polo team at the time (the horses) was made up of clones.

19   Although, as *New York Magazine* pointed out in September 2016, "Paying $100,000 to Clone Your Dog Won't Give You Your Dog Back." https://www.thecut.com/2016/03/why-do-people-get-the-same-pet-over-and-over.html

20   The US Food and Drug Administration approved the sale of cloned animals and their young for food in 2008—just in case you were wondering.

human life."[21] Yet this was not a unanimous declaration: eighty-four members voted in favor, thirty-four against, and thirty-seven abstained. One of the more problematic issues was how absolute the language was in the declaration. A number of those member states that voted against it expressed their opposition to human reproductive cloning where a fully functioning person results (human reproductive cloning), but wanted to ensure that the way remained open to therapeutic cloning, where cloned cells remain in lab cultures.

This concern over human reproductive cloning seems to run deep. Certainly, it's reflected in a number of the positions expressed within the UN Declaration and is a topic of concern within plenty of popular articles on cloning. The thought of being able to grow people at will from a few cells *feels* to many people to be unnatural and dangerous. It also raises tough questions around potential misuse, which is something that *Never Let Me Go* focuses our attention on rather acutely.

In 2014, the online magazine *io9* published an article on nine "unexpected outcomes of human cloning,"[22] keeping the fascination we have with this technology going, despite the deep moral concerns surrounding it. These unexpected outcomes included ownership of clones (will someone else own the patent on your body?), the possibility of iterative improvements over generations (essentially a DNA software upgrade on each cloning), and raising the dead (why not give Granny a new lease on life?). The article is admittedly lighthearted. But it does begin to dig into the challenges we'll face if someone does decide to buck the moral trend and start to turn out human facsimiles. And the reality is that, as biomedical science progresses, this is becoming increasingly feasible. Admittedly, it's incredibly difficult at the moment to reproduce people. But this is not always going to be the case. And as the possibility comes closer, we're going to face some increasingly tough choices as a society.

Yet despite the unease around human cloning, there are some people who actively suggest the idea shouldn't be taken off the table completely. In 1997, not too long after Dolly's birth, a group of prominent individuals put their name to a "Declaration in Defense

---

21 General Assembly Adopts United Nations Declaration on Human Cloning by vote of 84-34-37. March 8, 2005. Accessible at http://www.un.org/press/en/2005/ga10333.doc.htm
22 George Dvorsky (2014), "9 Unexpected Outcomes Of Human Cloning." io9, July 17 2014. http://io9.gizmodo.com/9-unexpected-outcomes-of-human-cloning-1606556772

of Cloning and the Integrity of Scientific Research."[23] Signatories included co-discoverer of DNA Francis Crick, scientist and writer Richard Dawkins, and novelist Kurt Vonnegut.

This Declaration acknowledges how knotty an ethical issue human cloning is, and it recognizes up front the need for appropriate guidelines. But where it differs from the later UN Declaration is that its authors suggest that human cloning isn't as ethically or morally fraught as some people make out. In fact, they state:

> "We see no inherent ethical dilemmas in cloning non-human higher animals. Nor is it clear to us that future developments in cloning human tissues or even cloning human beings will create moral predicaments beyond the capacity of human reason to resolve. The moral issues raised by cloning are neither larger nor more profound than the questions human beings have already faced in regards to such technologies as nuclear energy, recombinant DNA, and computer encryption. They are simply new."

The Declaration doesn't go so far as to suggest that human reproductive cloning should proceed. But it does say that decisions should be made based on science and reasoned thinking, and it cautions scientists and policy makers to ensure "traditionalist and obscurantist views do not irrelevantly obstruct beneficial scientific developments."

In other words, the declaration's authors are clear in their conviction that religious beliefs and mystical thinking should not be allowed to stand in the way of scientific progress.

Ironically, one of the easiest places to find a copy of the "Declaration in Defense of Cloning…" is, in fact, in a treatise that is infused with religious beliefs and mystical thinking: Claude Vorilhon's monograph *Yes to Human Cloning*.[24]

---

Vorilhon, better known these days by his adopted name of Raël, published the monograph *Yes to Human Cloning* as a wide-ranging

---

23  Admiraal, P., Ardila, R., & Berlin, I. (1997). Declaration in defense of cloning and the integrity of scientific research. *Free Inquiry*, 17(3), 11-12.
24  Raël (2001) "Yes to Human Cloning." https://www.clonaid.com/request.php?1

treatise on technological innovation and humanity's future. And at its center is his rationale for why cloning is not only acceptable, but in fact essential to us achieving our destiny as a species.

Despite its rather unusual provenance, I'd recommend reading *Yes to Human Cloning*, although I would suggest you approach it with a critical mind and a good dose of skepticism. Raël is a clear and engaging writer, and he makes his case with some eloquence for adopting emerging technologies like nanotechnology and artificial intelligence. In fact, if parts of this work were selectively published with the "I talk to aliens" bits removed, you'd be forgiven for thinking they came from a more mainstream futurist like Ray Kurzweil, or even a technology entrepreneur like Elon Musk. I'd go so far as to say that, when stripped of the really weird stuff, Raël's vision of the future is one that would appeal to many who see humans as no more than sophisticated animals and technology as a means of enhancing and engineering this sophistication.

In Raël's mind, human cloning is a critical technology in a three-step program for living forever.[25] Some transhumanists believe the route to longevity involves being cryogenically frozen until technology advances to the point at which it can be used to revive and repair them. Others seek longevity through technological augmentation. Raël, though, goes one step further and suggests that the solution to longevity is disposable bodies. And so, we have his three-step program to future immortality, which involves (1) developing the ability to clone and grow a replacement human body, (2) developing the technology to accelerate the rate of growth, so an adult body takes weeks rather than years to produce, and (3) developing the technology to upload our minds into cyberspace, and then download them into a fresh new (and probably upgraded) cloned version of yourself.

Stupendously complex (not to mention, implausible) as this would be, there are people around who think that parts of this plan are feasible enough that they're already working on it, as we'll see in later chapters. Raël's plan would, naturally, require the ability to grow a body outside of a human womb. But this is already an active area of research, as we saw in chapter two. And, as we'll explore in later chapters, neuroscientists and others are becoming increasingly excited by the prospect of capturing the essence of the human mind, to the point that they can reproduce at least part of it in cyberspace.

---

25 This must surely be the ultimate "three-step program."

What particularly fascinates me here is that, beneath the Raëlian mysticism and UFO weirdness, this movement is playing with ideas that are increasingly garnering mainstream attention. And this means that, even if we won't be growing bodies in our basements anytime soon, we have to take the possibility of human reproductive cloning seriously. And this means grappling not only with the ethics of the process itself, but also the ethics of how we chose to treat and act toward those clones we create.

## Genuinely Human?

Louise Brown was born in the year 1978. What made Louise unique was that she was the world's first child to be conceived via in vitro fertilization (IVF).

I was thirteen at the time, and not especially interested the bigger world of technology innovation around me (that would come later). But Louise's birth stuck with me, and it was because of a conversation I remember having with my mother around about this time.

I don't remember the details. But what I do remember is my mother wondering if a child conceived in a test tube would be like other people as they grew up—most especially, whether they would have a soul.[26]

Of course, Louise and all the millions of other IVF-conceived babies that have been born over the years, are just as complete as every other of the seven billion plus people living on this planet. There is *nothing* about the mode of conception that changes the completeness or the value of a person.

This should be self-evident. But as a quick Google search reveals, there are still more people than I would have imagined who are worried about the "humanity" of those conceived outside of biological intercourse.

One example in particular stood out to me as I was writing this chapter. In 2015, a contributor with the alias "Marie18" wrote on the website *Catholic Answers Forum*:

---

[26] Talking to my mother now, she readily admits that her view of the world has changed quite substantially over the past few decades. This is definitely not the sort of question she'd be asking these days.

> I learned today that my parents had me and my twin through IVF, and I just feel kind of devastated. Do IVF babies have souls? I would think so, but I just feel really uneasy that I was conceived through science, and I wasn't in God's plan for my parents.
>
> So, pretty much what I'm asking is if we have souls or not. I know in my heart that I do, but I've read some very upsetting things on the internet by Christians and Catholics.[27]

It's heart-rending that anyone should even have to ask this question. But it suggests that the premise of *Never Let Me Go* isn't as far-fetched as it might at first seem.

In *Never Let Me Go*, society absolves itself of the guilt of treating children as a commodity by claiming that clones are somehow less than human, that they are merely human-created animals and no more. It's a convenient lie—much like the one underpinning the Precrime program we'll encounter in *Minority Report* (chapter four)—that allows the non-clones in the movie to tell themselves it's okay to grow clones for their organs and kill them when they're done.

What the movie so eloquently illustrates is that, far from being somehow less than human, Tommy and Kathy and Ruth are as human as anyone else in the society they live in. In this respect, *Never Let Me Go* challenges us to think critically about what defines our humanity and our "worth" as *Homo sapiens*.

---

What gives us worth, or value, as individuals, is an increasingly important question as we develop technologies that enable us to not only redesign ourselves, but also use what we know of ourselves to develop new entities entirely. Human enhancement and augmentation, the merging of human and cybernetic systems, artificial intelligence, and cloning, all potentially threaten our sense of identity. And yet we stand at a point in human history where, more than at any previous time, we have the means to alter ourselves and redesign what we want to be.

---

27   "Do IVF babies have souls?" Posted on the website Catholic Answers Forums, January 2015, https://forums.catholic.com/t/do-ivf-babies-have-souls/387786

In this emerging world, "different" is no longer simply something we're born with, but something we have the means to create. In fact, it's not too much of a stretch to suggest that our growing technological abilities are heading toward a point where they threaten to fundamentally challenge our identity as a species. And as they do this, they are forcing us to reconsider—just as *Never Let Me Go* does—what "human" means in the first place.

On December 10, 1948, the United Nations General Assembly proclaimed the Universal Declaration of Human Rights.[28] In its first Article, this historic declaration states, "All human beings are born free and equal in dignity and rights. They are endowed with reason and conscience and should act towards one another in a spirit of brotherhood."

This, and the following twenty-nine Articles of the Declaration, establish a moral and ethical basis for attributes we as a society believe are important: equality, dignity, freedom, and security for all people. But the Declaration doesn't actually define what "human" means.[29]

Ask most people, and I have a feeling that the answer to "What is it to be human?" would include attributes such as being self-aware, being able to think and reason, having human form, being the product of a female egg and a male sperm, or being a member of a distinct biological species.[30] These seem a not-too-bad starting point as characteristics that we can measure or otherwise identify. But they begin to look a little weak as we develop the ability to reengineer our own biology. They also leave the door open for people or "entities" that don't easily fit the definition conveniently being labeled as "less than human," including those that don't fit convenient but arbitrary norms of physical and intellectual ability, or who are simply perceived as being "different."

This is not a new challenge, of course. Ironically, one of our defining features as a species is an unerring ability to label those

---

28  "The United Nations Universal Declaration of Human Rights." http://www.un.org/en/universal-declaration-human-rights/

29  There are many parallels between this discussion of how we think about and define what it is to be "human," and discussions around the meaning and nature of "personhood." In some ways of thinking, the idea of personhood encapsulates a set of attributes that are not uniquely tied to *Homo sapiens*, and as a result transcend the distinction between "human" and "non-human." This opens the way to exploring the rights and responsibilities of personhood as it extends to animals, artificial intelligence, and other non-human life forms. However, the question remains: Who decides what the defining attributes of "personhood" are, and if it's us that decide this, what are the chances that we're bringing our own pro-human biases to the table?

30  In among these answers, I suspect there would also be a fair number of people who included "having a soul."

we don't like, or feel threatened by, as "less than human." Through some of the most sordid episodes in human history, distinctions of convenience between "human" and "not human" have been used to justify acts of atrocity; it's easier to justify inhuman acts when you claim that the focus of them isn't fully human in the first place.

We can surely learn from cases of socially unacceptable behavior that have led to slavery, repression, discrimination, and other forms of abuse. If we cannot, cloning and other technologies that blur our biological identity are likely to further reveal the darker side of our "humanity" as we attempt to separate those we consider worthy of the thirty articles of the Universal Declaration of Human Rights from those we don't.

But in a future where we can design and engineer people in ways that extend beyond our biological origins, how do we define what being "human" means?

As it turns out, this is a surprisingly hard question to answer. However you approach it, and whatever intellectual arguments you use, it's too easy to come down to an "us versus them" position, and to use motivated reasoning to justify why our particular brand of humanity is the right one. The trouble is, we're conditioned to recognize humanity as being "of us" (and whoever the "us" is gets to define this). And we have a tendency to use this arbitrary distinction to protect ourselves from those we consider to be "not us."

The possibility of human reproductive cloning begins to reveal the moral complexities around having the ability to transcend our biological heritage. If we do eventually end up cloning people, the distinction between "like us" (and therefore fully human) and "not like us" (and therefore lacking basic human rights) is likely to become increasingly blurred. But this is only the start.

In 2016, a group of scientists launched a ten-year project to construct a synthetic human genome from scratch. This is a project that ambitiously aims to construct all three billion base pairs of the human genome in the laboratory, from common lab chemicals, and create the complete blueprint for a fully functioning person with no biological parents or heritage. This is the first step in an ambitious enterprise to create a completely synthetic human being within 20 years; a living, breathing person that was designed by computer and grown in the lab.[31] If successful (and I must confess that I'd be very

---

31  Boeke, J. D., et al. (2016). "The Genome Project-Write." *Science* **353**(6295): 126-127. http://doi.org/10.1126/science.aaf6850

surprised if this can be achieved within twenty years), this project will make the moral challenges of cloning seem like child's play. At least a clone has its origins in a living person. But what will we do if and when we create a being who is like you and me in every single way, apart from where they came from?

This may seem like a rather distant moral dilemma. But it is foreshadowed by smaller steps toward having to rethink what we mean by "human." As we'll see in later chapters, mind-enhancing drugs are already beginning to blur the lines between what are considered "normal" human abilities, and what tip us over into technologically-enhanced "abnormal abilities." Movies like *Ghost in the Shell* (chapter seven) push this further by questioning the boundaries between machine-enhanced humans and machines with human tendencies. And when we get to the movie *Transcendence* (chapter nine), we're looking at a full-blown melding between a human mind and a machine. In each of these cases, using technologies to alter people or to create entities with human-like qualities challenges us with two questions in particular: what does it mean to be "human"? And what are the rights and expectations of entities that don't fit what we think of as human, yet are capable of thinking and feeling, that have dreams and hopes, and are able to suffer pain and loss?

The seemingly easy way forward here is to try to develop a definition of humanity that encompasses all of our various future creations. But I'm not sure that this will ultimately succeed, if only because this still reflects a way of thinking that mentally divides the world into "human" and "not human." And with this division comes the temptation to endow the former with all the rights that come with being human and an assumed right to exploit the latter, simply because we don't think of them as being part of the same privileged club.

Rather, I suspect that, at some point, we will need to transcend the notion of "human" and instead focus on rights, and an understanding of "worth" and "validity" that goes far beyond what we bestow on ourselves as *Homo sapiens*.

Making this transition will not be easy. But we've already begun to make a start in how we think about rights as they apply to other species, and the responsibility we have toward them. Increasingly, there is an awareness that being human does not come with a God-given right to dominate, control, and indiscriminately use other

species to our own advantage. But how we translate this into action is difficult, and is often colored by our own ideas of worth and value. In effect, we easily slip into defining what is important by what we think of as *being* important. For instance, we place greater value on species that are attractive or interesting to *us*; on animals and plants that inspire awe in *us*. And we value species more that we believe are important to the sustainability of *our* world, or what we perhaps arrogantly call "higher" species, meaning those that are closer relatives to *us* on the evolutionary ladder. And we especially value species that demonstrate *human-like* intelligence.

In other words, our measures of what has worth inevitably come down to what has worth *to us*.

This is of course quite understandable. As a species, we are at the top of the food chain, and we're biologically predisposed to do everything we can to stay there. But this doesn't help lay down a moral framework for how we behave toward entities that do not fit our ideas of what is worthy.

This will be a substantial challenge if and when we create entities that threaten our humanness, and by implication, the power we currently wield as a species. For instance, if we did at some point produce human clones, they would be our equals in terms of biological form, function, awareness and intellect. But we would know they were different, and would have to decide how to respond to this. We could, of course, grant them rights; we might even declare them to be fully human, or at least honorary members of the human club. But here's the kicker: What right would we have to do this? What natural authority do we have that allows us to decide the fate of creations such as these? This is a deeply challenging question when it comes to entities that are almost, but not quite, the same as us. But it gets even more challenging when we begin to consider completely artificial entities such as computer- or robot-based artificial intelligence.

We'll come back to this in movies like *Minority Report* (chapter four) and *Ghost in the Shell* (chapter seven). But before we do, there's one other insight embedded in *Never Let Me Go* that's worth exploring, and that's how easily we fall into justifying technologies that devastate a small number of lives, because we tell ourselves we cannot live without them.

## Too Valuable to Fail?

Whichever way you look at it, the society within which *Never Let Me Go* is situated doesn't come off that well. To most other people in the movie, the clones are seen as little more than receptacles for growing living organs in, waiting for someone to claim them.

In contrast, the staff at Hailsham are an anomaly, a blip in the social conscience that is ultimately drowned out by the irresistible benefits the Human Donor Program offers. But the morality behind this anomaly is, not to put too fine a point on it, rather insipid. Madame, Miss Emily, and others appear to care for the clones, and want to prove that they have human qualities and are therefore worthy of something closer to "human" dignity. But ultimately, they give way to resignation in a society that sees the donor program as too valuable to end.

As Tommy and Kathy visit Miss Emily to plead for their lives by showing that they are truly in love, we learn that they never had a hope. Miss Emily, Madame, and others were striving to appease their consciences by showing that the clones had a soul, that they were human. Maybe they thought they could somehow use this to change how the clones were treated. But the awful truth is that Miss Emily never believed she could change what society saw the clones as—living caretakers of organs for others. There never was a hope in her mind that the children would be treated as anything other than a commodity. Certainly, she cared for them. But she didn't care enough to resist an atrocity that was unfolding in front of her eyes.

All of this—the despair, the injustice, the inhumanity, the cruelty—pours out of Tommy as he weeps and rages in the headlights of Kathy's car. And, standing with him, we know in our hearts that this society has sold itself out to a technology that rips people's lives and dreams away from them, so that those with the privilege of not being labeled "clone" can live longer and healthier lives.

This, to me, is a message that stays with me long after watching *Never Let Me Go*—that if we are not careful, technology has the power to rob us of our souls, even as it sustains our bodies, not because it changes who we are, but because it makes us forget the worth of others. It's a message that's directly relevant to human cloning, should we ever develop this technology to the point that it's widely used. But it also applies to other technologies that blur our definitions of "worth," including the use of technologies that claim to predict how someone will behave, as we'll see in our next movie: *Minority Report*.

## CHAPTER FOUR

# MINORITY REPORT: PREDICTING CRIMINAL INTENT

> *"If there's a flaw, it's human—it always is."*
> —Danny Witwer

## Criminal Intent

There's something quite enticing about the idea of predicting how people will behave in a given situation. It's what lies beneath personality profiling and theories of preferred team roles. But it also extends to trying to predict when people will behave badly, and taking steps to prevent this.

In this vein, I recently received an email promoting a free online test that claims to use "'*Minority Report*-like' tech to find out if you are 'predisposed' to negative or bad behavior." The technology I was being encouraged to check out was an online survey being marketed by the company Veris Benchmark under the trademark "Veris Prime." It claimed that "for the first time ever," users had an "objective way to measure a prospective employee's level of trustworthiness."

Veris' test is an online survey which, when completed, provides you (or your employer) with a "Trust Index." If you have a Trust Index of eighty to one hundred, you're relatively trustworthy, but below twenty or so, you're definitely in danger of showing felonious tendencies. At the time of writing, the company's website indicates that the Trust Index is based on research on a wide spectrum of people, although the initial data that led to the test came from 117 white-collar felons. In other words, when the test was conceived, it was assumed that answering a survey in the same way as a bunch of convicted felons is a good way of indicating if you are likely to pursue equally felonious behavior in the future.

Naturally, I took the test. I got a Trust Index of nineteen. This came with a warning that I'm likely to regularly surrender to the temptation of short-term personal gain, including cutting corners, stretching the truth, and failing to consider the consequences of my actions.

Sad to say, I don't think I have a great track record of any of these traits; the test got it wrong (although you'll have to trust me on this). But just to be sure that I wasn't an outlier, I asked a few of my colleagues to also take the survey. Amazingly, it turns out that academics are some of the most felonious people around, according to the test. In fact, if the Veris Prime results are to believed, real white-collar felons have some serious competition on their hands from within the academic community. One of my colleagues even managed to get a Trust Index of two.

One of the many issues with the Veris Prime test is the training set it uses. It seems that many of the traits that are apparently associated with convicted white-collar criminals—at least according to the test—are rather similar to those that characterize curious, independent, and personally-motivated academics. It's errors like this that can easily lead us into dangerous territory when it comes to attempting to use technology to predict what someone will do. But even before this, there are tough questions around the extent to which we should even be attempting to use science and technology to predict and prevent criminal behavior. And this leads us neatly into the movie *Minority Report*.

---

*Minority Report* is based on the Philip K. Dick short story of the same name, published in 1956. The movie centers on a six-year crime prevention program in Washington, DC, that predicts murders before they occur, and leads to the arrest and incarceration of "murderers" before they can commit their alleged future crime. The "Precrime" program, as it's aptly called, is so successful that it has all but eliminated murder in the US capital. And as the movie opens, there's a ballot on the books to take it nationwide.

The Precrime program in the movie is astoundingly successful—at least on the surface. The program is led by Chief John Anderton (played by Tom Cruise). Anderton's son was abducted six years previously while in his care, and was never found. The abduction destroyed Anderton's personal life, leaving him estranged from his partner, absorbed in self-pity, and dependent on illegal street

narcotics. Yet despite his personal pain, he's a man driven to ensuring others don't have to suffer a similar fate. Because of this, he is deeply invested in the Precrime program, and since its inception has worked closely with the program director and founder Lamar Burgess (Max von Sydow) to ensure its success.

The technology behind Precrime in the movie is fanciful, but there's a level of internal consistency that helps it work effectively within the narrative. The program depends on three "precogs": genetically modified, isolated, and heavily sedated humans who have the ability to foresee future murders. By monitoring and visualizing their neural activity, the Precrime team can see snatches of the precogs' thoughts, and use these to piece together where and when a future murder will occur. All they then have to do is swoop in and arrest the pre-perpetrator before they've committed the crime. And, because the precogs' predictions are trusted, those arrested are sentenced and incarcerated without trial. This incarceration involves being fitted with a "halo"—a neural device that plunges the wearer helplessly into their own incapacitating inner world, although whether this is a personal heaven or hell we don't know.

As the movie opens, we're led to believe that this breakthrough in crime prevention is a major step forward for society. Murder's a thing of the past in the country's capital, its citizens feel safer, and those with murderous tendencies are locked away before they can do any harm. That is, until Chief Anderton is tagged as a pre-perp by the precogs.

Not surprisingly, Anderton doesn't believe them. He knows he isn't a murderer, and so he sets out to discover where the flaw in the system is. And, in doing so, he begins to uncover evidence that there's something rotten in the very program he's been championing. On his journey, he learns that the precogs are not, as is widely claimed, infallible. Sometimes one of them sees a different sequence of events in the future, a minority report, that is conveniently scrubbed from the records in favor of the majority perspective.

Believing that his minority report—the account that shows he's innocent of a future murder—is still buried in the mind of the most powerful precog, Agatha (played by Samantha Morton), he breaks into Precrime and abducts her. In order to extract the presumed minority report she's carrying, he takes her to a seedy pleasure joint that uses recreational brain-computer interfaces to have her mind

"read." And he discovers, to his horror, that there is no minority report; all three precogs saw him committing the same murder in the near future.

Anderton does, however, come across an anomaly: a minority report embedded in Agatha's memory of a murder that is connected with an earlier inconsistency he discovered in the Precrime records.

Still convinced that he's not a murderer, Anderton sets about tracking down his alleged victim in order to prove his innocence, taking Agatha with him.[32] He traces the victim to a hotel, and on entering his room, Anderton discovers the bed littered with photos of the man with young children, including his son. Suddenly it all fits into place. The trail has led Anderton to the one person he would kill without hesitation if he got the chance. Yet, even as Anderton draws his gun on his son's abductor, Agatha pleads with him to reconsider. Despite her precognition, she tries to convince him that that the future isn't set, and that he has the ability to change it. And so Anderton overcomes his desire for revenge and lowers his weapon.

It turns out Anderton was being set up. The victim—who wasn't Anderton's son's abductor—was promised a substantial payout for his family if he convinced Anderton to kill him. When Anderton refuses, the victim grabs the gun in Anderton's hand, presses it against himself, and pulls the trigger. As predicted, Anderton is identified as the killer, and is arrested, fitted with a halo, and put away.

With Anderton's arrest, though, a darker undercurrent of events begins to emerge around the precog program. It turns out that Lamar Burgess, the program's creator, has a secret that Anderton was in danger of discovering—an inconvenient truth that, to Lamar, stood in the way of what he believed was a greater social good. And so, to protect himself and the program, Lamar finds a way to use the precogs to silence Anderton.

As the hidden story behind the precog program is revealed, we discover that Agatha was born to a junkie mother, and suffered from being a terminally ill addict from birth. Agatha and other addict-babies became part of an ethically dubious experimental program using advanced genetic engineering to search for a cure. In this

---

32   It has to be said that, had Anderton had his head screwed on, it might have occurred to him that tracking down the person he was allegedly going to murder to make sure he didn't, in fact, murder him, wasn't the smartest move in the book.

program, it's discovered that, in Agatha's case, a side effect of the experiments is an uncanny ability to predict future murders. Given their serendipitous powers, Agatha and two other subjects were sedated, sequestered away, wired up, and plugged into to what was to become the precog program. But Agatha's mother cleaned herself up and demanded her daughter back, threatening the very core of this emerging technology.

Lamar couldn't allow Agatha's mother to threaten his plans, so he arranged an intricate ruse to dispose of her. Knowing that if he attempted to murder her, the precogs would predict it, Lamar paid a contract killer to murder Agatha's mother. As anticipated, this was predicted and prevented by Precrime. But as soon as the killer-to-be had been hauled off, Lamar re-enacted the planned murder, this time succeeding.

Because Lamar's act was so close to the attempted murder, images of his actions from the precogs were assumed to be part of the thwarted killing. And because Agatha's precognition wasn't quite in step with the two other precogs, it was treated as a minority report. In this way, using the system he'd created to bring an end to murder, Lamar pulled off the perfect murder—or so he thought. But as Anderton got closer to realizing that Lamar had staged Agatha's mother's murder, Lamar realized that, in order to protect Precrime, he also needed to be eliminated. And he would have succeeded, had Anderton's estranged partner not put two and two together, and freed Anderton from his halo-induced purgatory.

Things come to a head in the movie as Anderton publicly broadcasts Agatha's minority report of Lamar killing her mother. In doing so, he presents Lamar with a seemingly-impossible choice: kill Anderton (as the precogs are predicting) and validate the program, but be put away for life in the process; or don't kill him, and in doing so, demonstrate a fatal flaw in the program that will result in it being terminated.

In the end, Burgess opts for a third option and kills himself. In doing so, he saves Anderton, but still reveals a flaw in the system that had predicted Anderton's murder at his hand. As a result, Precrime is dismantled, and the precogs are allowed to live as full a life as is possible.

*Minority Report* is a fast-paced, crowd-pleasing, action sci-fi thriller of the caliber you'd expect from its director Stephen Spielberg. But it also raises tough questions around preemptive action based on predictive criminal behavior, as well as predestination, human dignity, and the dangers of being sucked in by seemingly beneficial technologies. It presents us with a world where technology has seemingly made people's lives safer, but at a terrible cost that isn't immediately obvious. And it shines a searing spotlight on the question of "should we" when faced with a seductive technology that ultimately threatens to place society in moral jeopardy.

## The "Science" of Predicting Bad Behavior

In March 2017, the British newspaper *The Guardian* ran an online story with the headline "Brain scans can spot criminals, scientists say."[33] Unlike in *Minority Report*, the scanning was carried out using a hefty functional magnetic resonance imaging (fMRI) machine, rather than genetically altered precogs. But the story seemed to suggest that scientists were getting closer to spotting criminal intent before a crime had been committed, using sophisticated real-time brain imaging.

In this case, the headline vastly overstepped the mark. The original research used fMRI to see if brain activity could be used to distinguish knowingly criminal behavior from merely reckless behavior.[34] It did this by setting up a somewhat complex situation, where volunteers were asked to take a suitcase containing something valuable through a security checkpoint while undergoing a brain scan. But to make things more interesting (and scientifically useful), their actions and choices came with financial rewards and consequences.

Each participant was first given $6,000 in "play money." They were then presented with one to five suitcases, just one of which contained the thing of value. If they decided not to carry anything through the checkpoint, they lost $1,500. If they decided to carry a suitcase, it cost them $500. And if they dithered about it, they were docked $2,500.

---

33   Ian Sample (2017), "Brain scans can spot criminals, scientists say." *The Guardian*. Published online March 13, 2017. https://www.theguardian.com/science/2017/mar/13/brain-scans-can-spot-criminals-scientists-say

34   The original research was published in the *Proceedings of the National Academies of Science*. Vilares, I., et al. (2017). "Predicting the knowledge—recklessness distinction in the human brain." *Proceedings of the National Academy of Sciences* **114**(12): 3222-3227. http://doi.org/10.1073/pnas.1619385114

Having selected a suitcase, if they chose the one with the valuable stuff inside *and* they weren't searched by security, they got an additional $2,500—jackpot! But if they *were* searched and found to be carrying, they were fined $3,500, leaving them with a mere $2,000. On the other hand, if they weren't carrying, they suffered no penalties, whether they were searched or not.

The point of this rather elaborate setup was that there were financial gains (at least with the fake money being used) involved with the choices made, and the implication that carrying a suitcase stuffed with valuable goods was dangerous (you could be fined if discovered carrying), but financially lucrative if you got away with it.

To mix things up further, some participants only had the choice of carrying the loaded suitcase (thus possibly getting $8,000), or declining to take part in such a dodgy deal and walking away with just $2,000. The participants who took a chance here were knowingly participating in questionable behavior. For the rest, it was a lottery whether they picked the loaded suitcase or not, meaning that their actions veered toward being more reckless, and less intentional. By simultaneously studying behavior and brain activity, the researchers were able to predict what state the participants were in—whether they were intentionally setting out to engage in behavior that maybe wasn't legitimate, or whether they were just feeling reckless.

The long and short of this was that the study suggested brain activity could be used to indicate criminal intent, and this is what threw headline writers into a clickbait frenzy. But the research was far from conclusive. In fact, the authors explicitly stated that "it would be absurd to suggest, in light of our results, that the task of assessing the mental state of a defendant could or should, even in principle, be reduced to the classification of brain data." They also pointed out that, even if these results could be used to predict the mental state of a person while committing a crime, they'd have to be inside an fMRI scanner at the time, which would be tricky.

Despite the impracticality of using this research to assess the mental state of people during the act of committing a crime, media stories around the study tapped into a deep-seated fascination with predicting criminal tendencies or intent—much as Veris Prime's Truth Index does. Yet this is not a new fascination, and neither is the use of science to justify its indulgence.

In the seventeenth century, a very different "science" of predicting criminal tendencies was all the rage: phrenology. Phrenology was an attempt to predict someone's character and behavior by the shape of their skull. As understanding around how the brain works developed, the practice became increasingly discredited. Sadly, though, it laid a foundation for assumptions that traits which appear to be common to people of "poor character" are also predictive of their behavior—a classic case of correlation erroneously being confused with causation. And it foreshadowed research that continues to this day to connect what someone looks like with how they might act.

Despite its roots in pseudoscience, the ideas coming out of phrenology were picked up by the nineteenth-century criminologist Cesare Lombroso. Lombroso was convinced that physical traits such as jaw size, forehead slope, and ear size were associated with criminal tendencies. His theory was that these and other traits were throwbacks to earlier evolutionary ancestors, and that they indicated an innate tendency toward criminal behavior.

It's not hard to see how attractive these ideas might have been to some, as they suggested criminals could be identified and dealt with before breaking the law. With hindsight, it's easy to see how misguided and malevolent they were, but at the time, many people bought into them. It would be nice to think that this way of thinking about criminal tendencies was a short and salutary aberration in humanity's history. Sadly, though, it paved the way to even more divisive forms of pseudoscience-based discrimination, including eugenics.

In the 1900s, discrimination that was purportedly based on scientific evidence shifted toward the idea that the quality or "worth" of a person is based on their genetic heritage. The "science" of eugenics—and sadly this is something that many scientists at the time supported—suggested that our genetic heritage determines everything about us, including our moral character and our social acceptability. It was a deeply flawed concept that, nevertheless, came with the same seductive idea that, if we know what makes people "bad," we can remove them from society before they cause a problem. What is heartbreaking is that these ideas coming from academics and scientists gained political momentum, and ultimately became part of the justification for the murder of six million Jews, and many others besides, in the Holocaust.

These days, I'd like to think we're more enlightened, and that we don't fall prey so easily to using scientific flights of fancy to justify how we treat others. Unfortunately, this doesn't seem to be the case.

In 2011, three researchers published a paper suggesting that you can tell a criminal from someone who isn't (and, presumably by inference, someone who is likely to engage in criminal activities) by what they look like.[35] In the study, thirty-six students in a psychology class (thirty-three women and three men) were shown mug shots of thirty-two Caucasian males. They were told that some were criminals, and they were asked to assess—from the photos alone—whether each person had committed a crime; whether they'd committed a violent crime; if it was a violent crime, whether it was rape or assault; and if it was non-violent, whether it was arson or a drug offense.

Within the limitations of the study, the participants were more likely to correctly identify criminals than incorrectly identify them from the photos. Not surprisingly, perhaps, this led to a slew of headlines along the lines of "Criminals Look Different From Non-criminals" (this one from a blog post on Psychology Today[36]). But despite this, the results of the study are hard to interpret with any degree of certainty. It's not clear what biases may have been introduced, for instance, by having the photos evaluated by a mainly female group of psychology students, or by only using photos of white males, or even whether there was something associated with how the photos were selected and presented, and how the questions were asked, that influenced the results.

The results did seem to indicate that, overall, the students were successful in identifying photos of convicted criminals in this particular context. But the study was so small, and so narrowly defined, that it's hard to draw any clear conclusions from it. However, there is a larger issue at stake with this and similar studies, and this is the ethical issue with carrying out and publicizing the results of such research in the first place. Here, the very appropriateness of asking if we can predict criminal behavior brings us back to the earlier study on intent versus reckless behavior, and to the underlying premise in *Minority Report*.

---

35  The research was published in 2011 by Jeffrey Valla, Stephen J. Ceci, and Wendy M. Williams in the Journal of Social, Evolutionary, and Cultural Psychology. Valla, J. M., et al. (2011). "The accuracy of inferences about criminality based on facial appearance." *Journal of Social, Evolutionary, and Cultural Psychology* 5(1): 66–91. http://doi.org/10.1037/h0099274

36  Satoshi Kanazawa (2011) "Criminals Look Different From Non-criminals.", *Psychology Today*. Posted March 13, 2011. https://www.psychologytoday.com/blog/the-scientific-fundamentalist/201103/criminals-look-different-noncriminals

The assumption that someone's behavioral tendencies can be predicted from no more than what they look like, or how their brain functions, is a slippery slope. It assumes—dangerously so—that behavior is governed by genetic heritage and upbringing. But it also opens the door to a better-safe-than-sorry attitude to law and order that considers it better to restrain someone who *might* demonstrate socially undesirable behavior than to presume them innocent until proven guilty. And it's an attitude that takes us down a path where we assume that other people do not have agency over their destiny. There is an implicit assumption here that how we behave can be separated out into "good" and "bad," and that there is consensus on what constitutes these. But this is a deeply flawed assumption.

What the behavioral research above is actually looking at is someone's tendency to break or bend agreed-on rules of socially acceptable conduct, as these are codified in law. These laws are not an absolute indicator of good or bad behavior. Rather, they are a result of how we operate collectively as a social species. In technical terms, they establish normative expectations of behavior, which simply means that most people comply with them, irrespective of whether they have moral or ethical value. For instance, in most cultures, it's accepted that killing someone should be punished, unless it's in the context of a legally sanctioned war or execution (although many societies would still consider this morally reprehensible). This is a deeply embedded norm, and most people would consider it to be a good guide of appropriate behavior. The same cannot be said of "norms" surrounding homosexual acts, though, which were illegal in the United Kingdom until 1967, and are still illegal in some countries around the world, or others surrounding LGBTQ rights, or even women's rights.

When social norms are embedded within criminal law, it may be possible to use physical features or other means to identify "criminals" or those likely to be involved in "criminal" behavior. But are we as a society really prepared to take preemptive action against people who we arbitrarily label as "bad"? I sincerely hope not. And here we get to the crux of the ethical and moral challenges around predicting criminal intent. Even if we can predict tendencies from images alone—and I am highly skeptical that we can gain anything of value here that isn't heavily influenced by researcher bias and social norms—should we? Is it really appropriate to be asking if we can predict, simply from how someone looks, whether they are likely to behave in a way that we think is appropriate or not? And is

it ethical to generate data that could be used to discriminate against people based on their appearance?

Using facial features to predict tendencies puts us way down the slippery slope toward discriminating against people because they are different from us. Thankfully, this is an idea that many would dismiss as inappropriate these days. But, worryingly, our interest in relating brain activity to behavioral traits—the high-tech version of "looks like a criminal"—puts us on the same slippery slope.

## Criminal Brain Scans

Unlike photos, functional Magnetic Resonance Imaging allows researchers to directly monitor brain activity, and to do it in real time. It works by monitoring blood flow to different parts of the brain, and using this to pinpoint which parts of someone's brain are active at any one point in time.

One of the beauties of fMRI is that it can map out brain activity as people are thinking about and processing the world around them. For instance, it can show which parts of a subject's brain are triggered if they're shown a photo of a donut, if they are happy, or sad, or angry, or what their brain activity looks like if they're given the opportunity to take a risk.

fMRI has opened up a fascinating window into how we think about and respond to our surroundings, and in some cases, *what* we think. And it's led to some startling revelations. We now know, for instance, that we often unconsciously decide what we're going to do several seconds before we're actually aware of making a decision.[37] Recent research has even indicated that high-resolution fMRI scans on primates can be used to decode what the animals are seeing.[38] The researchers were, quite literally, reading these primates' minds.

This is quite incredible science. And not surprisingly, it's leading to a revolution in understanding how our brains operate. This includes developing a better understanding of how certain brain behaviors

---

37  In a 2008 study, researchers showed that fMRI scans of subjects' brains indicated what decision they were going to make in a specific situation, some ten seconds before they actually made it. Eerily, this meant that the scientists knew what the subjects were going to do before they themselves realized. The research was published in the journal Nature Neuroscience. Soon, C. S., et al. (2008). "Unconscious determinants of free decisions in the human brain." *Nature* Neuroscience 11: 543. http://doi.org/10.1038/nn.2112

38  In this case the research—published in 2017 in the journal *Cell*—showed that facial images seen by macaque monkeys could be reconstructed by monitoring specific brain cells. Chang, L. and D. Y. Tsao (2017). "The Code for Facial Identity in the Primate Brain." *Cell* **169**(6): 1013-1028.e1014. http://doi.org/10.1016/j.cell.2017.05.011

can lead to debilitating medical conditions. It's also leading to a deeper understanding of how the mechanics of our brain determine who we are, and how we behave.

That said, there's still considerable skepticism around how effective a tool fMRI is and how robust some of its findings are. It's also fair to say that some of these findings challenge deeply held beliefs about many of the things we hold dear, including the nature of free will, moral choice, kindness, compassion, and empathy. These are all aspects of ourselves that help define who we are as a person. Yet, with the advent of fMRI and other neuroscience-based tools, it sometimes feels like we're teetering on the precipice of realizing that who we think we are—our sense of self, or our "soul" if you like—is merely an illusion of our biology.

This in itself raises questions over the degree to which neuroscience is racing ahead of our ability to cope with what it reveals. Yet the reality is that this science is progressing at breakneck speed, and that fMRI is allowing us to dive ever deeper behind our outward selves—our facial features and our easily observed behaviors—and into the very fabric of the organ that plays such a role in defining us. And, just like phrenology and eugenics before it, it's opening up the temptation to interpret how our brains operate as a way to predict what sort of person we are, and what we might do.

---

In 2010, researchers provided a group of subjects with advice on the importance of using sunscreen every day. At the same time, the subjects' brain activity was monitored using fMRI. It's just one of many studies that are increasingly trying to use real-time brain activity monitoring to predict behavior.

In the sunscreen study, the subjects were asked how likely they were to take the advice they were given. A week later, researchers checked in with them to see how they'd done. Using the fMRI scans, the researchers were able to predict which subjects were going to use sunscreen and which were not. But more importantly, using the scans, the researchers discovered they were better at predicting how the subjects would behave than they themselves were. In other words, the researchers knew their subjects' minds better than they did.[39]

---

[39] This study by Emily Faulk and colleagues was published in the Journal of Neuroscience. Falk, E. B., et al. (2010). "Predicting Persuasion-Induced Behavior Change from the Brain." *The Journal of Neuroscience* **30**(25): 8421. http://doi.org/10.1523/JNEUROSCI.0063-10.2010

Research like this suggests that our behavior is determined by measurable biological traits as much as by our free will, and it's pushing the boundaries of how we understand ourselves and how we behave, both as individuals and as a society. And, while science will never enable us to predict the future in the same way as *Minority Report's* precogs, it's not too much of a stretch to imagine that fMRI and similar techniques may one day be used to predict the likelihood of someone engaging in antisocial and morally questionable behavior.

But even if predicting behavior based on what we can measure is potentially possible, is this a responsible direction to be heading in?

The problem is, just as with research that tries to tie facial features, head shape, or genetic heritage to a propensity to engage in criminal behavior, fMRI research is equally susceptible to human biases. It's not so much that we *can* collect data on brain activity that's problematic; it's how we decide *what* data to collect, and how we end up interpreting and using it, that's the issue.

A large part of the challenge here is understanding what the motivation is behind the research questions being asked, and what subtle underlying assumptions are nudging a complex series of scientific decisions toward results that seem to support these assumptions.

Here, there's a danger of being caught up in the misapprehension that the scientific method is pure and unbiased, and that it's solely about the pursuit of truth. To be sure, science is indeed one of the best tools we have to understand the reality of how the world around us and within us works. And it is self-correcting—ultimately, errors in scientific thinking cannot stand up to the scrutiny the scientific method exposes them to. Yet this self-correcting nature of science takes time, sometimes decades or centuries. And until it self-corrects, science is deeply susceptible to human foibles, as phrenology, eugenics, and other misguided ideas have all too disturbingly shown.

This susceptibility to human bias is greatly amplified in areas where the scientific evidence we have at our disposal is far from certain, and where complex statistics are needed to tease out what we think is useful information from the surrounding noise. And this is very much the case with behavioral studies and fMRI research. Here, limited studies on small numbers of people that are carried out under constrained conditions can lead to data that *seem* to support

new ideas. But we're increasingly finding that many such studies aren't reproducible, or that they are not as generalizable as we at first thought. As a result, even if a study does one day suggest that a brain scan can tell if you're likely to steal the office paper clips, or murder your boss, the validity of the prediction is likely to be extremely suspect, and certainly not one that has any place in informing legal action—or any form of discriminatory action—before any crime has been committed.

## Machine Learning-Based Precognition

Just as in *Minority Report*, the science and speculation around behavior prediction challenges our ideas of free will and justice. Is it *just* to restrict and restrain people based on what someone's science predicts they might do? Probably not, because embedded in the "science" are value judgments about what sort of behavior is unwanted, and what sort of person might engage in such behavior. More than this, though, the notion of pre-justice challenges the very idea that we have some degree of control over our destiny. And this in turn raises deep questions about determinism versus free will. Can we, in principle, know enough to fully determine someone's actions and behavior ahead of time, or is there sufficient uncertainty and unpredictability in the world to make free will and choice valid ideas?

In Chapter Two and *Jurassic Park*, we were introduced to the ideas of chaos and complexity, and these, it turns out, are just as relevant here. Even before we have the science pinned down, it's likely that the complexities of the human mind, together with the incredibly broad and often unusual panoply of things we all experience, will make predicting what we do all but impossible. As with Mandelbrot's fractal, we will undoubtedly be able to draw boundaries around more or less likely behaviors. But within these boundaries, even with the most exhaustive measurements and the most powerful computers, I doubt we will ever be able to predict with absolute certainty what someone will do in the future. There will always be an element of chance and choice that determines our actions.

Despite this, the idea that we can predict whether someone is going to behave in a way that we consider "good" or "bad" remains a seductive one, and one that is increasingly being fed by technologies that go beyond fMRI.

In 2016, two scientists released the results of a study in which they used machine learning to train an algorithm to identify criminals based on headshots alone.[40] The study was highly contentious and resulted in a significant public and academic backlash, leading the paper's authors to state in an addendum to the paper, "Our work is only intended for pure academic discussions; how it has become a media consumption is a total surprise to us."[41]

Their work hit a nerve for many people because it seemed to reinforce the idea that criminal behavior is something that can be predicted from measurable physiological traits. But more than this, it suggested that a computer could be trained to read these traits and classify people as criminal or non-criminal, even before they've committed a crime.

The authors vehemently resisted suggestions that their work was biased or inappropriate, and took pains to point out that others were misinterpreting it. In fact, in their addendum, they point out, "Nowhere in our paper advocated the use of our method as a tool of law enforcement, nor did our discussions advance from correlation to causality."

Nevertheless, in the original paper, they conclude: "After controlled for race, gender and age, the general law-biding [sic] public have facial appearances that vary in a significantly lesser degree than criminals." It's hard to interpret this as anything other than a conclusion that machines and artificial intelligence could be developed that distinguish between people who have criminal tendencies and those who do not.

Part of why this is deeply disturbing is that it taps into the issue of "algorithmic bias"—our ability to create artificial-intelligence-based apps and machines that reflect the unconscious (and sometimes conscious) biases of those who develop them. Because of this, there's a very real possibility that an artificial judge and jury that relies only on what you look like will reflect the prejudices of its human instructors.

This research is also disturbing because it takes us out of the realm of people interpreting data that may or may not be linked

---

40   Their paper, "Automated Inference on Criminality using Face Images" was uploaded to the scientific paper archiving website arxiv.org in November 2016. Wu, X. and X. Zhang (2016). "Automated Inference on Criminality using Face Images." *Arxiv* **1611.04135v1**. https://arxiv.org/pdf/1611.04135v1.pdf
41   Xiaolin Wu and Xi Zhang's response to critics of their work can be read at https://arxiv.org/abs/1611.04135

to behavioral tendencies, and into the world of big data and autonomous machines. Here, we begin to enter a space where we have not only *trained* computers to do our thinking for us, but we no longer know *how* they're thinking. In a worrying twist of irony, we are using our increasing understanding of how the human brain works to develop and train artificial brains that we are increasingly ignorant of the inner workings of.

In other words, if we're not careful, in our rush to predict and preempt undesirable human behavior, we may end up creating machines that exhibit equally undesirable behavior, precisely *because* they are unpredictable.

## Big Brother, Meet Big Data

Despite being set in a technologically advanced future, one of the more intriguing aspects of *Minority Report* is that it falls back on human intuition when interpreting the precog data feed. In the opening sequences, Chief Anderton performs an impromptu "ballet" of preemptive deduction, as he turns up the music and weaves the disjointed images being fed through from the three precogs into a coherent narrative. This is a world where, perhaps ironically, given the assumption that human behavior is predictable, intuition and creativity still have an edge over machines.

Anderton's professional skills tap into a deep belief that there's more to the human mind than its simply being the biological equivalent of a digital computer—even a super-powerful one. As the movie opens, Anderton is responsible for fitting together a puzzle of fragmented information. And, as he aligns the pieces and fills the gaps, he draws connections between snippets of information that seem irrelevant or disjointed to the untrained eye, so much so that the skill he demonstrates lies in the sum total of his experiences as a living human being. This is adeptly illustrated as Anderton pins down the location of an impending murder by recognizing inconsistencies in two images that, he deduces, could only be due to a child riding an old-fashioned merry-go-round.

This small intuitive leap is deeply comforting to us as viewers. It confirms to that there's something uniquely special about people, and it suggests that we are more than the sum of the chemicals, cells, and organs we're made of. It also affirms a belief that we cannot simply be defined by what we look like, or by the electrical and chemical processes going on inside our head.

But are we right in this belief that we are more than the sum of our parts? What if we could be reduced to massive amounts of data that not only determine who we are, but how we will act and react in any given situation?

Questions like this would have been hypothetical, bordering the fantastical, not so long ago. Certainly, as a species, we've toyed with the idea for centuries that people are simply complex yet ultimately predictable biological machines (chaos theory not withstanding). But it's only recently that we've had the computing power to start capturing every minutia of ourselves and the world around us and utilizing it in what's increasingly called "big data."

"Big data"—which when all's said and done is just a fancy way of saying massive amounts of information that we can do stuff with—has its roots in human genome sequencing. Our genetic code has three billion discrete pieces of information, or base pairs, that help define us biologically. Compared to the storage capacity of early computers, this is a stupendously large amount of information, far more than could easily be handled by the computing systems of the 1970s and 1980s, or even the 1990s, when the initiative to decode the complete human genome really took off. But, as we began to understand the power of digital computing, scientists started to speculate that, if we could decode the human genome and store it in computer databases, we would have the key to the code of life.

With hindsight, they were wrong. As it turns out, decoding the human genome is just one small step toward understanding how we work. But this vision of identifying and cataloguing every piece of our genome caught hold, and in the late 1990s it led to one of the biggest sets of data ever created. It also spawned a whole new area of technology involving how we collect, store, analyze, and use massive amounts of data, and this is what is now known colloquially as Big Data.

As we've since discovered, the ability to store three billion base pairs of genetic code in computer databases barely puts us in the foothills of understanding human biology. The more we find out, the more complex we discover life is. But the idea that the natural world can be broken down into its constituent parts, uploaded into cyberspace, and played around with there remains a powerful one. And there's still a belief held by some that, if we have a big enough computer memory and a powerful enough processor, we could in

principle encode every aspect of the physical and biological world and reproduce it virtually.

This is the idea behind movies like *The Matrix* (which sadly didn't make the cut for this book) where most people are unwittingly playing out their lives inside a computer simulation. It also underpins speculations that arise every now and again that we are all, in fact, living inside a computer simulation, but just don't know it. There are even researchers working on the probability that this is indeed the case.[42]

This is an extreme scenario that comes out of our growing ability to collect, process, and manipulate unimaginable amounts of data. It's also one that has some serious flaws, as our technology is rarely as powerful as our imaginations would like it to be. Yet the data revolution we're currently living through is still poised to impact our lives in quite profound ways, including our privacy.

Despite the Precrime program's reliance on human skills and intuition, *Minority Report* is set in a future where big data has made privacy a thing of the past—almost. As John Anderton passes through public spaces, he's bombarded by personal ads as devices identify him from his retinal scan. And, like a slick salesperson who knows his every weakness, they tempt him to indulge in some serious retail therapy.

These ads are a logical extension of what most of us already experience with online advertisements. Websites are constantly sucking up our browsing habits and trying to second-guess what we might be tempted to purchase, or which sites we might be persuaded to visit. These online ads are based on a sophisticated combination of browsing history, personal data, and machine learning. Powerful algorithms are being trained to collect our information, watch our online habits, predict what we might be interested in, and place ads in front of us that, they hope, will nudge our behavior. And it's not only purchases. Increasingly, online behavior is being used to find ways of influencing what people

---

[42] Beyond the cadre of science fiction writers who have dabbled with this idea over the years, the philosopher Nick Bostrom argued in a 2003 paper in *Philosophical Quarterly* that we are already living in a computer simulation (available at https://www.simulation-argument.com/simulation.pdf). This idea appeared to be debunked in 2017 by two researchers from Oxford University whose theoretical research suggested there is not enough matter in the universe to create a classical computer system capable of simulating it. What is even more interesting is that, despite their paper being near-impenetrable to the vast majority of people on Earth, it still got a sizable amount of press coverage. You can read it—or attempt to—in the journal Science Advances. Ringel, Z. and D. L. Kovrizhin (2017). "Quantized gravitational responses, the sign problem, and quantum complexity." *Science Advances* 3(9). http://doi.org/10.1126/sciadv.1701758

think and how they act—even down to how they vote. As I write this, we're still experiencing the fallout from Cambridge Analytica's manipulations of Facebook feeds that were designed to influence users, and there's growing concern over the use of fake news and social media to influence people's ideas and behaviors.

Admittedly, targeted online messaging is still clumsy, but it's getting smarter and subtler. Currently it's largely driven by the massive amounts of data that organizations are collecting on our browsing habits. But imagine if these data extended to *everything* we did—where we are, who we're with, what we're doing, even what we're saying. We're frighteningly close to a world where some system somewhere holds data on nearly every aspect of our lives, and the only things preventing the widespread use of these "engines of persuasion" are our collective scruples and privacy laws.

*Minority Report* is surprisingly prescient when it comes to some aspects of big data. It paints a future where what people do in the real world as well as online is collected, analyzed, and ultimately used in ways that directly affect them. In the movie, these massive repositories of personal data are not used to determine if you're going to commit a crime—this remains the sacred domain of humans in John Anderton's world—but they are used to nudge people's behavior toward what benefits others more than themselves.

This is, of course, what marketing is all about. Marketers use information to understand how they can persuade people to act in a certain way, whether this is to purchase organic food, or to buy a new car, or to vote for a particular political candidate. Big data massively expands the possibilities for manipulation and persuasion. And this is especially the case when it's coupled to machine learning, and the increasing ability of artificial-intelligence-based systems to join the data dots, and even interpolate what's missing from the data they do have. Here, we're no longer just talking about how big data combined with smart algorithms can help identify future criminals and curtail their antisocial tendencies, but about how corporations, governments, and others can subtly influence people's behavior to do what they want. It's a subtler and more Machiavellian approach to achieving what is essentially the same thing—controlling people.

Frighteningly, the world portrayed in *Minority Report* is not that far away. We still lack the ability to identify people through simple

and ubiquitous scans, but we're almost there. Real-time facial recognition, for instance, is almost at the point where, if you're captured on camera, the chances are that someone has the capability of identifying and tracking you. And our digital fingerprint—the sum total of the digital breadcrumbs we scatter around us in our daily lives—is becoming easier to follow, and harder to cover up. As ubiquitous identity monitoring is increasingly matched to massive data files on every single one of us, we're going to have to make some tough decisions over how much of our personal freedom we are willing to concede for the benefits these new technologies bring.[43]

Even more worrying, perhaps, is the number of people who are already conceding their personal freedom without even thinking about it. How many of us use digital personal assistants like Siri, Google Home, or Alexa, or rely on cloud-connected home automation devices, or even internet-connected cars? And how many of us read the small print in the user agreement before signing up for the benefits these technologies provide? We are surrounded by an increasing number of devices that are collecting personal data on us and combining it in ever-growing databases. And while we're being wowed by the lifestyle advantages these bring, they're potentially setting us up to be manipulated in ways that are so subtle, we won't even know they're happening. But the use of big data doesn't stop there.

---

In 2003, a group of entrepreneurs set up the company Palantir, named after J. R. R. Tolkien's seeing-stones in *Lord of the Rings*. The company excels at using big data to detect, monitor, and predict behavior, based on myriads of connections between what is known about people and organizations, and what can be inferred from the information that's available. The company largely flew under the radar for many years, working with other companies and intelligence agencies to extract as much information as possible out of massive data sets. But in recent years, Palantir's use in "predictive policing" has been attracting increasing attention. And in May 2018, the grassroots organization Stop LAPD Spying Coalition released a report raising concerns over the use of Palantir and other

---

43   In Europe, the recently-introduced General Data Protection Regulation, or GDPR, addresses some of these concerns as it sets out to protect the privacy of individuals in a data-rich society. But experts are skeptical as to the extent to which it can truly prevent massive amounts of data being collected and used against individuals.

technologies by the Los Angeles Police Department for predicting where crimes are likely to occur, and who might commit them.[44]

Palantir is just one of an increasing number of data collection and analytics technologies being used by law enforcement to manage and reduce crime. In the US, much of this comes under the banner of the "Smart Policing Initiative," which is sponsored by the US Bureau of Justice Assistance. Smart Policing aims to develop and deploy "evidence-based, data-driven law enforcement tactics and strategies that are effective, efficient, and economical." It's an initiative that makes a lot of sense, as evidence-based and data-driven crime prevention is surely better than the alternatives. Yet there's growing concern that, without sufficient due diligence, seemingly beneficial data and AI-based approaches to policing could easily slip into profiling and "managing people" before they commit a criminal act. Here, we're replacing *Minority Report's* precogs with massive data sets and AI algorithms, but the intent is remarkably similar: Use every ounce of technology we have to predict who might commit a crime, and where and when, and intervene to prevent the "bad" people causing harm.

Naturally, despite the benefits of data-driven crime prevention (and they are many), irresponsible use of big data in policing opens the door to unethical actions and manipulation, just as is seen in *Minority Report*. Yet here, real life is perhaps taking us down an even more worrying path.

One of the more prominent concerns raised around predictive policing is the dangers of human bias swaying data collection and analysis. If the designers of predictive policing systems believe they know who the "bad people" are, or even if they have unconscious biases that influence their perceptions, there's a very real danger that crime prevention technologies end up targeting groups and neighborhoods that are assumed to have a higher tendency toward criminal behavior. This was at the center of the Stop LAPD Spying Coalition report, where there were fears that "black, brown, and poor" communities were being disproportionately targeted, not because they had a greater proportion of likely criminals, but because the predictive systems had been trained to believe this. Just like the Veris Prime test that the chapter started with, that's designed to predict white-collar criminal tendencies, there are real dangers

---

44  The report "Dismantling Predictive Policing in Los Angeles" was released on May 8, 2018, and garnered considerable press attention for its echoes of a Minority-Report-like approach to pre-crime. It's accessible at https://stoplapdspying.org/wp-content/uploads/2018/05/Before-the-Bullet-Hits-the-Body-May-8-2018.pdf

that predictive policing systems will end up targeting people who are assumed to have bad tendencies, whether they do or not.

The hope is, of course, that we learn to wield this tremendously powerful technology responsibly and humanely because, without a doubt, if it's used wisely, big data could make our lives safer and more secure. But this hope has to be tempered by our unfailing ability to delude ourselves in the face of evidence to the contrary, and to justify the unethical and the immoral in the service of an assumed greater good.

And this is a theme that also echoes through our next movie: *Limitless*.

CHAPTER FIVE

# LIMITLESS: PHARMACEUTICALLY-ENHANCED INTELLIGENCE

> *"I don't have delusions of grandeur, I have an actual recipe for grandeur."*
> —Eddie Morra

## A Pill for Everything

Back in 2009, just as we were about to tip over into the next decade, I set out to take stock of some of the more interesting and unusual emerging technologies on the horizon. The short article that ended up on the blog *2020 Science* lists ten technology trends I thought were worth watching over the next ten years. And at number nine was "nootropics."[45]

Even then, these so-called "smart drugs" were being used quite widely by people wanting give their brains a boost. And, from my research, it seemed that this was a technology that was only going to get bigger. I had no idea just how big, though. Nearly ten years later, Googling "cognitive enhancers" returns a flood of companies selling smart drugs, people giving advice on brain-improving substances, cognitive-enhancer dosing regimens using a plethora of ingredients, "how-to" guides on hacking your brain, and a regular stream of news articles on the latest substance-enhanced mind hacks. Back in 2009, it was off-label uses of substances like modafinil, Adderall, and Ritalin that was all the rage. These days, it's a whole pharmacopoeia of substances and "stacks" (or formulations) designed to give you a legal, or at least a not-too-illegal, edge.

---

45   Andrew Maynard (2009) "Ten emerging technology trends to watch over the next decade" Posted on 2020 Science, December 25, 2009. https://2020science.org/2009/12/25/ten-emerging-technology-trends-to-watch/

Underpinning this trend, there's an almost unquestioned assumption that having a better memory, and being able to think faster and more clearly, are important if you want to be successful. Things are less clear, though, when it comes to the potential tradeoffs that these substances come with. Mess with your body's chemistry, and there's usually a price to pay somewhere down the line. But things are more complex when it comes to social tradeoffs. What do we gain and lose as a society if a growing number of people start to chemically enhance themselves? And if we're collectively going to go down this path, how can we navigate our way to using increasingly powerful cognitive enhancements responsibly?

---

The movie *Limitless* provides an intriguing gateway into exploring the future of brain-enhancing drugs. It's smart (pun intended), witty, and, at the end of the day, relatively ambivalent about the ethics of chemical cognitive enhancement. The film revolves around struggling author Eddy Morra (played by Bradley Cooper). Eddy's a mess. He can't write, he's not looking after himself, and his girlfriend's just left him. But just as he hits rock bottom, he runs across his former brother-in-law Vernon (Johnny Whitworth).

Vernon offers Eddy a new experimental drug, NZT-48, which he claims is in human trials and is "FDA-approved" (although he doesn't say for what). Eddie, having nothing to lose at this point, pops the pill. And the effects are dramatic. Within a matter of seconds, he finds himself thinking faster and more clearly. His memory recall improves dramatically. He can not only absorb more information faster, he can also make better use of what he knows than ever before. And with this, his life dramatically clicks into focus. On NZT, no-hoper Eddie becomes suave, smart, organized, and interesting Enhanced Eddie.

The trouble is, he only has one pill, so the next day he's back at Vernon's, who, it turns out, has problems of his own, namely, some very powerful people who want to get their hands on his supply of NZT.

Keeping the dramatic tension moving along at a pill-popping pace, Vernon is murdered; Eddie finds and removes his stash of NZT; he starts taking the pills at an increasing rate; and boom—he's transformed from a failing writer into someone with limitless potential.

But there's a problem—a few of them, as it turns out. After the sheer exuberance of being so "together" wears off, Enhanced Eddie hatches a super-smart plan to make a bucketload of cash through day trading, cashing in on his chemically-enhanced intelligence. Using his enhanced memory and his newfound ability to rapidly make sense of stock market patterns and fluctuations, he works out how he can trounce more seasoned traders and make a fortune. But this isn't simply because he wants to be wealthy. With his supercharged brain, Eddie begins to see a way forward to achieving his dreams of being successful. And here, he realizes that money—and lots of it—is the lever he needs to achieve his success. Perhaps showing a modicum of over-confidence, Eddie borrows a wad of cash from a local thug (played by Andrew Howard) to kick-start his day-trading scheme, and begins to make money hand over fist while staying several steps ahead of a growing storm of hurt behind him.

Then the blackouts begin. As it turns out, there's no such thing as a free lunch, even in the world of designer drugs, and this particular wonder drug comes with a steep price. Eddie begins to lose track of where he's been and what he's been doing, and it looks like he might have been involved in a murder in one of his blank patches. On top of that, he's running out of NZT.

NZT, it turns out, has some rather unpleasant side effects. Use too much, and you begin to blank out. Come off it too fast, and you get sick and die. Wean yourself off it slowly, and you lose your ability to focus. There's no easy win here once you're hooked.

As all this is playing out, Eddie is brokering the deal of a lifetime with corporate kingpin Carl van Loon (Robert de Niro). He's also trying to stay clear of his loan shark, whom Eddie inadvertently introduced to NZT, and who is now eager for more. And he's being chased down by a mysterious stranger who, you've guessed it, is also after his supply of NZT.

Following a succession of increasingly tense scenes, Enhanced Eddie eliminates the loan shark and his lackeys, finishes his novel (easy when you're smart-pilled up), gets back with his girlfriend (Abbie Cornish), runs for a seat in the Senate, and begins to entertain the idea of running for President. And, as he gets his act together, he claims he's ironed out the links in NZT's formulation. At the end of the movie, it seems that Eddie's version of NZT has, in fact, made his potential near-limitless.

*Limitless* doesn't shy away from tackling the risks of cognition-enhancing drugs. But neither does it suggest that their use is inappropriate. Rather, it challenges viewers to think about the pros and cons. Under the surface, though, there are more subtle narratives around the value of intelligence and the meaning of success, as well as a surprisingly sophisticated exploration of the ethics of cognitive enhancement.

## The Seduction of Self-Enhancement

Intelligence is important; at least, that's what we're led to believe. From the moment we're born—and sometimes from before this, if your parents subjected you to "educational stimuli" in the womb—there is a deep assumption that smarter is better. Educational aids, special schools, gifted and talented programs, cognitive development regimens, tests, grades, certificates, degrees, achievements, prizes; we're conditioned to believe that, from day zero, the way to succeed in life is to be smart.

From an evolutionary perspective, this isn't too surprising. Our particular human brand of intelligence is what differentiates us from our fellow species, including our ability to remember, learn, think, and problem-solve. It's what led to *Homo sapiens* forming powerful social groups, learning to farm plants and animals, harnessing water, coal, and electricity, developing synthetic chemicals, creating cyberspace, exploring real space, growing enough food to feed a hungry and expanding world, and plenty more besides. Our history seems to suggest that the secret of our success is, indeed, our smarts. So it's perhaps natural to think that the pathway to more success is even more intelligence, wherever and however we can find it. And when our evolutionary smarts run out of steam, or we feel we were genetically or socially short-changed, artificially enhanced intelligence begin to look pretty attractive.

Of course, we enhance our intelligence through artificial means all the time; it's part of the reason why we're so phenomenally successful as a species.[46] As soon as I Googled "cognitive enhancers" while researching this chapter, I tapped into an artificial aid to supplement my less-than-adequate memory and intellect. Our technology already makes us smarter than our biological brains and bodies allow. And this has been integral to how we've survived and grown as a species. We've evolved the ability to develop tools and

---

46  It should be pointed out here that, because we have a habit of defining success as what humans do, we'd think we were phenomenally successful whatever we achieved as a species.

use technologies that vastly amplify our bodies' innate capabilities. You just need to think about the complex technologies that weave through our lives every day to realize how stupendously powerful is this ability to not only imagine vastly different futures, but use our intellect to create them.

So why not use this intellect to enhance the very source of our intelligence: the human brain? If we can do everything we've achieved so far as a species through using three pounds per person of unenhanced gray matter, imagine what would be possible with an artificially supercharged set of neurons.

This is such a no-brainer that brain-hacking is now big business. We're being sold the message through intensive marketing that being smarter than others will give us an advantage, and that we can get smarter through everything from playing brain games to doing brain exercises. And, of course, consuming cognition-enhancing drugs.

---

"Peak Performance" is a San Francisco-based meetup organized by the entrepreneur George Burke.[47] This eclectic group of individuals gets together regularly to explore ways of improving their bodies' performance, including (but certainly not limited to) the use of smart drugs. What makes Burke especially interesting is his advocacy for taking cognitive enhancers to keep ahead of the game.

In a June 2017 article in the *Washington Post*, Burke acknowledges, "It's not like every tech worker in Silicon Valley is taking nootropics to get ahead… It's the few who are getting ahead who are using supplements to do that."[48] Burke takes a daily cocktail of vitamins, minerals, research pharmaceuticals, and a touch of the psychedelic drug LSD. He claims it gets his brain operating at a level that improves his memory, attention, creativity, and motivation.

Who wouldn't want this?

Somewhat ironically, as I'm writing this, I'm fighting against brain fog brought on by burning the candle at both ends while fighting off some insidious virus. As a result, there's a fog-addled part of my

---

47   "SF Peak Performance meet-up: biohacking, fitness tech, nutrition." https://www.meetup.com/PeakPerformance/
48   Sara Solovitch (2017). "Tweaking brains with 'smart drugs' to get ahead in Silicon Valley." *Washington Post*, June 11, 2017 https://www.washingtonpost.com/national/health-science/tweaking-brains-with-smart-drugs-to-get-ahead-in-silicon-valley/2017/06/09/5bc9c064-0b35-11e7-93dc-00f9bdd74ed1_story.html?

brain that can see the attraction of an intelligence-enhancing pill. Why not order a cocktail or two of these "smart meds"—maybe with a sprinkle of LSD—to clear the cobwebs away? Why not be the writer-genius I could be, at the pop of a pill, rather than the hack I suspect I am? Why not use a chemical aid to access those elusive memories and ideas that are teasing me from beyond the wisps of dullness? What's to stop me trouncing the competition as brain-hacked "Enhanced Andrew"? Surely Amazon Prime can deliver the appropriate cocktail before I've struggled my way through the next paragraph.[49]

But what would the downsides be? More to the point—and thinking beyond my own selfish needs—what are the social and ethical pros and cons of taking substances to boost brain performance? This takes us right back to questions raised by the movie *Limitless*. But first, it's worth taking a deeper dive into the world of smart drugs and "nootropics."

## Nootropics

In 2004, the academic and medical doctor Anjan Chatterjee wrote a review of what he termed "Cosmetic Neurology."[50] He was far from the first person to write about the emergence and ethics of cognitive enhancers, but the piece caught my attention because of its unusual title.

Chatterjee's title has its roots in cosmetic surgery, an area fraught with medical angst as surgeons weigh up the pros and cons of desirable, but physiologically unnecessary, surgical interventions. Through the article, Chatterjee grapples with similar challenges as he weighs the benefits and downsides of treatments that don't cure disease but, rather, extend abilities.

I'm not sure the term "cosmetic neurology" works. "Cosmetic" has an air of frivolity about it that is far removed from the issues Chatterjee is grappling with here. These include the use of substances to compensate for perceived deficiencies in human performance, such as the ability of pilots to remain alert and perform at their best. In the article, Chatterjee explores a growing number of pharmaceuticals that are known to affect the brain's operations in ways that can improve aspects of performance, including memory

---

49  I checked—they can. Maybe not with the psychedelics included, but *neuroIgnite*, *Neuro Spark*, *Genius Joy* and many other concoctions are but a click away. Who knew?

50  Chaterjee, A. (2004). "Cosmetic neurology. The controversy over enhancing movement, mentation, and mood." Neurology 63: 968–974. http://doi.org/10.1212/01.WNL.0000138438.88589.7C

and concentration. And, while he struggles with the ethics of cognitive enhancers, he wonders whether a "better brain" may, one day, be seen as an inalienable right.

It could be argued, of course, that this has already happened in a world that's caffeine-fueled by Starbucks, Dunkin' Donuts, Tim Hortons, and numerous other retail chains offering over-the-counter mental stimulants. For as long as people have known that some substances affect the brain, they've been finding ways to make use of these effects, and caffeine is an obvious poster child here. Take the nineteenth-century French writer Honoré de Balzac, for instance. He was well-known for a prolific coffee habit, writing with rather obvious self-awareness that, after drinking the substance,

> [T]he cavalry of metaphor deploys with a magnificent gallop; the artillery of logic rushes up with clattering wagons and cartridges; on imagination's order, sharpshooters sight and fire...[51]

In fact, reading his work, it's hard to avoid wondering just how caffeined-up he was.

Although caffeine in the form of tea and coffee is deeply socially normalized these days, there's a growing market for high-dosage shots to keep the brain alert. Visiting our on-campus one-stop store, there's a whole array of caffeine-enriched energy drinks and shots that students (and presumably faculty) can use to keep their brains alert. But these are just the visible tip of the iceberg of smart drugs being used on educational campuses the world over.

For a number of years now, students in particular have been using substances like Adderall, Ritalin, and Provigil to give their brains a boost. These are all regulated substances that are designed for purposes other than getting through college, or finishing the latest class assignment. But that isn't stopping what is purportedly a thriving black market in pharmaceutical smart pills.

Adderall is intended for use in treating conditions like attention deficit hyperactivity disorder (ADHD) and narcolepsy. But there's a perception that it also increases memory performance and

---

51  Taken from "The World of Caffeine: The Science and Culture of the World's Most Popular Drug," by Bennett Alan Weinberg and Bonnie K. Bealer (*Routledge*, 2002). Balzac had a stupendous coffee habit, and ended up eating the grounds to achieve the enlightenment he craved. He died at age forty-nine, not necessarily from hacking his brain with the brown stuff.

concentration in healthy adults.[52] Ritalin (or methylphenidate) is another drug used to treat ADHD that is also used off-label for memory and concentration boosts. Provigil (or modafinil), on the other hand, is aimed specifically at treating sleep disorders, and is used off-label to increase wakefulness and counter fatigue by otherwise healthy adults. It's also used by the military in a number of countries to keep soldiers alert, and has even reportedly been used by astronauts to stave off fatigue.[53]

These and other prescription drugs show measurable effects on concentration and wakefulness in some studies. But their precise impact on performance often depends on who uses them, how they use them, and what they use them for. And in most cases, there are tradeoffs. These may take the form of unwanted short-term side effects and inadequate performance boosts. In some instances, there may actually be long-term impacts on cognitive performance, although the research here is patchy. Yet, despite this, there's been a steady stream of news articles over the past few years suggesting frequent use among students and professionals in jobs where being smart matters.

That said, it's surprisingly tough to get a hard fix on how prevalent this behavior is. A number of studies suggest that up to 50 percent of students in various countries are using some form of artificial means to increase concentration and performance, but these include caffeine-based drinks and tobacco. The number using off-label drugs like modafinil are just a few percent in many of these studies. Despite the published data, though, it's not uncommon to come across occasional use among students. A few years ago, for instance, I was discussing smart drugs as part of a project with a group of colleagues. At one point, we turned to our student research assistant (someone I didn't know) and asked whether her peers really were using these substances. She sheepishly reached into her bag and bought out a small pill, "just for when I need it," she said.

It's not just students, though. I regularly come across rumors of faculty members and researchers occasionally using artificial aids to finish a grant proposal or to put an academic publication to bed. In 2008, Barbara Sahakian and Sharon Morein-Zamir published

---

52  There's surprisingly little evidence that Adderall does increase performance in healthy adults. There's more evidence to suggest it can enhance how well you *think* you're performing. Sadly, university professors rarely grade on how well you think you've done.

53  See Maxwell J. Mehlman (2004) "Cognition-Enhancing Drugs." *The Milbank Quarterly*, volume 83 issue 3, pages 483–506 http://doi.org/10.1111/j.0887-378X.2004.00319.x

the delightfully-titled commentary "Professor's little helper" in the journal *Nature*.[54] In their piece, they noted that:

> In academia, we know that a number of our scientific colleagues in the United States and the United Kingdom already use modafinil to counteract the effects of jetlag, to enhance productivity or mental energy, or to deal with demanding and important intellectual challenges.

The article prompted *Nature* to conduct a straw poll of its readers. One in five of the survey's respondents admitted to using Ritalin, modafinil, or beta-blockers to aid their focus, concentration, or memory.[55]

Of course, one downside of this academic brain-hacking is that none of these substances are risk-free. Making the decision to use one of these "Professor's little helpers" to get ahead of your peers requires some careful balancing of short-term gains against potential downsides. These could include headaches, diarrhea, agitation, sleeplessness, odd behavior,[56] hair loss, and the need for increasing doses to get the same effect.

Because the side effects of off-label prescription drugs use aren't widely tracked, it's hard to tell just how safe or otherwise their use is, although the indications are that moderate or occasional use isn't likely to lead to serious or lasting problems. But this uncertainty has led to experimentation around less restricted—and often less studied—substances in the quest for the perfect cognitive enhancer, the one that boosts your brain's abilities without any unwanted downsides.

---

In 1973, the Romanian researcher and medical doctor Cornelius Giurgea published an article on a new drug called piracetam.[57] What was unusual about piracetam was its seeming inertness compared to other pharmaceutical drugs. According to Giurgea, even at high

---

54  Sahakian, B. and S. Morein-Zamir (2007). "Professor's little helper." *Nature* **450**: 1157. http://doi.org/10.1038/4501157a
55  Maher, B. (2008). "Poll results: look who's doping." *Nature* **452**: 674-675. http://doi.org/10.1038/452674a
56  Admittedly, this one may be difficult to detect in academics.
57  Giurgea, C. (1973). "The 'Nootropic' Approach to the Pharmacology of the Integrative Activity of the Brain." *Conditional Reflex* **8**(2): 108–115. https://link.springer.com/article/10.1007/BF03000311

doses, it showed "no sedation or tranquilization, no stimulation, no interference with synaptic transmitters, no acute or long-term toxicity…no cortical or subcortical EEG changes, no interference with limbic after-discharges, reticular sensory or direct arousal threshold" and "no changes of the cardiovascular, respiratory, gastrointestinal systems." In other words, it did pretty much nothing. Except that, based on Giurgea's research, it protected against severe brain hypoxia (oxygen deprivation), and it enhanced learning and memory.

To Giurgea, piracetam was a unique class of drug that enhanced the integration of evolutionarily important brain functions like memory and learning, without obviously deleterious side effects. He considered this class of drug so unique that he coined a new term for it, from the root "noos," referring to "mind," and "tropein," meaning "towards." And so "nootropics" were born.

Since then, the term nootropics has been used to cover pretty much all types of substances that purportedly enhance brain function. But, increasingly, purists are going back to Giurgea's roots and using it to describe cocktails and "stacks" that improve function without unwanted side effects. To them, this means discounting those off-label prescription drugs.

Piracetam remains a popular nootropic and is readily purchased in many countries (although it occupies a legal gray zone in some), and there's a growing body of research on its use and effects. A quick search on Google Scholar pulls up over 19,000 papers and articles on the substance. That said, the benefits to healthy adults remain ambiguous. But this doesn't stop people from using it to, in the words of one supplier, "give you a serious cognitive edge without putting your health at risk."

This is just the tip of the cognitive-enhancement iceberg though. Increasingly, advocates like George Burke and others are experimenting with esoteric cocktails of substances to boost their brains and to tap into what they believe is their full potential. And it's not hard to see why. If your livelihood and ambitions depend on your ability to squeeze every last ounce of performance out of your brain, why wouldn't you try everything possible to make sure you were running at peak performance?

This, of course, assumes that most people aren't running on all four cylinders in the smarts department in the first place, and that our brains have the capacity to work better than they do. In *Limitless*,

the plot depends on the old myth that we're only using 10–20 percent of our brains, and that chemical enhancement can unlock the rest of our presumably unused potential. Sadly, while this works as a plot device, it's pure scientific bunkum. Despite the tenacity of the myth, research has shown that we use every last ounce of our brain. Admittedly, we still don't know precisely what parts of it are doing at any given time, or *why* they do what they do. But we do know that we don't typically have unused cognitive capacity just waiting to be jump-started.

What's more interesting, and potentially more relevant, is the idea that's developed in *Limitless* that we could chemically enhance memory storage and recall, and our ability to make sense of the seemingly-disparate pieces of information we all have tucked away in our heads. Certainly, I struggle with memory and recall, and my ability to make sense of and act on new information suffers as a result. It's easy for me to fantasize about how much smarter I'd be if everything I've experienced or learned was always at my fingertips, just waiting to be combined together in a flash of genius. And while I may be using 100 percent of my brain, it doesn't take much to convince me that 90 percent of this is, at times, a dysfunctional mess.

To someone who depends on their brain for their living, I must confess that the idea of clearing the fog and making things work better is attractive. Surely with better recall and data processing, I'd be better at what I do. And maybe I would. But there's a danger to thinking of our brains as computers, which of course is where these ideas of memory and data processing come from. It's tempting to conflate what's important in our heads with what we think is important in our computers, including more memory, faster recall, and more efficient data processing. If we follow this pathway, we run the risk of sacrificing possibly essential parts of ourselves for what we mistakenly *think* is important.

Unfortunately, we don't know enough about the human brain yet to understand the benefits and dangers of how we think about human intelligence and success, although we do know that comparing what's in our head to a computer is probably a bad idea.[58] More than this, though, we also have a tendency to conflate achievements that we associate with intelligence, with success. But what if we're using the wrong measures of success here? What if our urge to make

---

58  It's amazing how readily we compare the human brain to the latest form of digital technology. Yet in reality our brains are nothing like the chips in our smartphones or laptops, or even the processors at the hearts of supercomputers.

more money, to publish more papers, or to be famous, leads to us ultimately risking what makes us who we are? And does this even matter?

To many people, I suspect it doesn't. And this leads into the ethics of smart drugs, regardless of what they can or cannot do for us.

## If You Could, Would You?

On April 1, 2008, a press release was published announcing that the US National Institutes of Health (NIH) was launching a new initiative to fight the use of brain-enhancing drugs by scientists. Spurred on by a perceived need to prevent pill-induced academic advantages, it claimed that:

> While "doping" is now accepted as a problem among athletes, it is less widely known that so-called "brain doping" has been affecting the competitive balance in scientific research as well.

The release went on to announce the formation of the new World Anti-Brain Doping Authority, or WABDA.

It should have been apparent from its publication date that the press release was an elaborate April Fool's joke. It was the brainchild of Jonathan Eisen of the University of California, Davis,[59] and it played into a growing interest in the use of nootropics and other cognitive enhancers in academia and the ethical questions that this raises.

A few days after the press release hit the internet, the journal *Nature* published the results of its informal survey of 1,400 people on their academic smart-drug habits. The survey was an open, global online survey, and so at best provides only a rough indication of what academics were doing at the time. There was no control over who completed it, or how honest they were. Yet it still provided a fascinating insight into what, up to then, had been the stuff of rumor and conjecture.

The survey asked participants whether they had ever used Ritalin, modafinil, and beta-blockers for non-medical purposes. Those that had were then asked a number of additional questions about their

---

59  The press release can still be read using *Wayback Machine* on the original WABDA website, set up especially for the occasion. https://web.archive.org/web/20080409091357/http://wabda.org:80/News.html

usage habits. Around one in five respondents said they had used one or more of these drugs to increase their focus, concentration, or memory. Ritalin was the most frequently-used substance, and respondents between eighteen and twenty-five years old were the most prevalent users (with an interesting spike for those between fifty-five and sixty-five, suggesting a fear of late-career performance-inadequacy). What was even more interesting to me was that 69 percent of the respondents said they'd risk mild side effects to take these drugs themselves, and 80 percent thought that healthy adults should be free to use them if they wanted to.

In stark contrast to competitive sports, these respondents were remarkably indifferent to their fellow scientists getting a drug-induced leg up.[60] It seems—at least from this somewhat qualitative sample—that there's an ambivalence around using brain enhancements to succeed academically that we don't see in other areas.

This is an attitude I've also come across in talking to colleagues, and it's one that I must confess surprises me. Academia is deeply competitive, as are most professions that depend on mental skills. And yet, I find it hard to detect much concern over others getting a competitive advantage through what they imbibe. That doesn't mean we shouldn't be concerned, though.

In his 2004 commentary on Cosmetic Neurology, Anjan Chatterjee asked five questions of readers that were designed to test their ethical boundaries. These included:

1. Would you take a medication with minimal side effects half an hour before Italian lessons if it meant that you would learn the language more quickly?

2. Would you give your child a medication with minimal side effects half an hour before piano lessons if it meant that they learned to play more expertly?

3. Would you pay more for flights whose pilots were taking a medication that made them react better in emergencies? How much more?

4. Would you want residents to take medications after nights on call that would make them less likely to make mistakes in caring for patients because of sleep deprivation?

---

60  Most likely not all respondents were scientists or academics, but given the source of the poll, it's likely that many were.

5. Would you take a medicine that selectively dampened memories that are deeply disturbing? Slightly disturbing?

These were designed to get people thinking about their own values when considering cognition-enhancing drugs. To this list, I would add five more questions:

1. Would you take a smart drug to help pass a professional exam?
2. Would you take a smart drug to shine more than the competition in a job interview?
3. Would you take a smart drug to increase your chances of winning a lucrative grant?
4. Would you use a smart drug to help win a business contract?
5. Would you use a smart drug to help get elected?

On the face of them, Chatterjee's questions focus on personal gains that either don't adversely impact others, or that positively impact them. For instance, learning a language or the piano can be seen as personal enrichment *and* as developing a socially-useful skill. And ensuring that pilots and medical professionals are operating to the best of their abilities can only be a good thing, right?

It's hard to argue against these benefits of taking smart drugs. But there's a darker side to these questions, and that is what happens if enhancement becomes the norm, and there is mounting social pressure to become a user.

For instance, should you be expected to take medication to keep up with your fellow students? Should you feel you have to dose your child up so they don't fall behind their piano-playing peers? Should medical staff be required to be on meds, with a threat of legal action if they make an error while not dosed-up?

The potential normalization of nootropic use raises serious ethical questions around autonomy and agency, even where the arguments for their use seem reasonable.[61] And because of this, there should probably be more consideration given to their socially responsible use. This is not to say that they should be banned or discouraged, and academics like Henry Greely and colleagues actively encourage

---

61  The use of cognitive enhancers isn't unique here: Social pressures around working long hours, being hyper-productive, drinking, and many other behaviors, raise similar questions around what we expect of people, and the degree to which they are in control of their lives.

their responsible use.[62] But we should at least be aware of
the dangers of potentially stepping out on a slippery slope of
marginalizing anyone who doesn't feel comfortable self-medicating
each day to succeed, or who feels pressured into medicating their
kids for fear that they'll flunk out otherwise. And this is where the
issue flips from the "would you be OK" in Chatterjee's questions, to
the "would you do this" in my five follow-up questions.

In each of these additional questions, taking a cognitive enhancer
gives the user a professional advantage. In some of these cases,
I can imagine one-off use being enough to get someone over a
career hurdle—outperforming the competition in a job interview,
for example. In others, there's a question of whether someone will
only be able to do their job if they continue to self-medicate. Is it
appropriate, for instance, if someone uses cognitive enhancers to
gain a professional qualification, a teaching qualification, say, and
then can only deliver on expectations through continued use?

In all of these questions, there's the implicit assumption that, by
using an artificial aid to succeed, someone else is excluded from
success. And this is where the ethics get really tricky.

To understand this better, we need to go back to the *Nature* survey
and the general acceptance of academics toward using smart drugs.
For most academics, their success depends on shining brighter than
their peers by winning more grants, making bigger discoveries,
writing more widely cited papers, or gaining celebrity status.
Despite the collegiality of academia (and by on large we are a highly
collegial group), things can get pretty competitive when it comes
to raising funds and getting promotion, or even securing a lucrative
book deal. As a result, if your competitors are artificially boosting
their intellectual performance and you are not, you're potentially at
a disadvantage.

As it is, the pressure to do more and to do it better is intense within
academic circles. Many academics regularly work sixty- to seventy-
hour weeks, and risk sacrificing their health and personal lives in
order to be seen as successful. And believe me, if you're fraying at
the edges to keep up with those around you and you discover that
they've been using artificial means to look super-smart, it's not likely

---

62   In 2008, Henry Greely and a number of colleagues published an opinion in the journal *Nature* calling for more efforts to support the responsible use of cognitive enhancers by healthy people. Greely, H. and colleagues (2008) "Towards responsible use of cognitive enhancing drugs by the healthy" *Nature*, 456, 11, pages 702-705. http://doi.org/ 10.1038/456702a

to sit easily with you, especially if you're then faced with the choice of either joining the smart-drug crowd, or burning out.

In most places, things aren't this bad, and nootropic use isn't so overtly prevalent that it presents a clear and present pressure. But this is a path that self-centered usage risks leading us down.

To me, this is an ethically fraught pathway. The idea of being coerced into behaviors that you don't want to engage in in order to succeed doesn't sit comfortably with me. But beyond my personal concerns, it raises broader questions around equity and autonomy. These concerns don't necessarily preclude the use of cognitive enhancers. Rather, they mean that, as a society, we need to work out what the rules, norms, and expectations of responsible use should be because, without a shadow of doubt, there are going to be occasions where their use is likely to benefit individuals and the communities that they are a part of.

What puts an even finer point on these ethical and social questions is the likely emergence of increasingly effective nootropics. In the US and Europe, there are currently intense efforts to map out and better understand how our brains work.[63] And as this research begins to extend the limits of what we know, there is no reason to think that we won't find ways to develop more powerful nootropics. We may not get as far as a drug like NZT, but I see no reason why we won't be able to create increasingly sophisticated drugs and drug combinations that substantially increase a user's cognitive abilities.

As we proceed down this route, we're going to need new thinking on how, as a society, we use and regulate these chemical enhancers. And part of this is going to have to include making sure this technology doesn't end up increasing social disparities between people who can afford the technology and those who cannot.

## Privileged Technology

One of the perennial challenges of new technologies is their potential to exacerbate social divides between people who can afford them, and as a consequence get the benefits from them, and those who cannot. Over time, technologies tend to trickle down through society, which is how so many people are able to afford

---

63   In 2013, President Obama launched the multi-year, multi-million-dollar US BRAIN Initiative (Brain Research through Advancing Innovative Neurotechnologies)—a public-private partnership that's researching how the brain works in order to better treat neurological diseases. The same year, the European Commission launched the Human Brain Project, focusing on advancing brain research, cognitive neuroscience, and brain-inspired computing.

cars these days, or own a cell phone. Yet it's too easy to assume that technology trickle-down is a given, and to ignore some of the more egregious ways in which innovations can line the pockets of the rich at the expense of the poor (a theme we will come back to with the movie *Elysium* in chapter six). The relationship here between technological innovation and social disparity is complex, especially when enterprising entrepreneurs work out how to open new markets by slashing the cost of access to new tech. Yet it's hard to avoid the reality that some technologies make it easier for the wealthy to succeed in life and, as a result, put poorer people at a disadvantage. And perhaps nowhere is this more apparent than when wealthy individuals have access to technologies that address their deficiencies or enhance their capabilities, in the process creating a positive feedback loop that further divides the rich and the poor.

*Limitless'* Eddie provides an interesting case here. When we first meet him, he's a failure. Compared to those around him—his soon-to-be-ex girlfriend in particular—he's not performing particularly well. In fact, it's fair to say that he has an ability *and* a lifestyle deficit.

We're left in no doubt that Eddie's lack of ability puts him at a disadvantage compared to others. And, while we don't know whether this is due to his personal choices or the cards he was dealt in life, let's assume for the sake of argument that this deficit is not his fault. If this is the case, does he have the right to do something about it?

If Eddie's lack of success was due to a clearly diagnosed disease or disability, I suspect that the consensus would be "yes." As a society, we've developed a pretty strong foundation of medical ethics around doing no harm (non-maleficence), doing good (beneficence), not being coerced into decisions (autonomy), and spreading the burdens and benefits of treatments across all members of society (justice). As long as a course of action didn't lead to unacceptable harm, it would be easy to argue that Eddie should have access to treatments that would address what he's lacking.

Following this argument, if NZT simply brought Eddie up to par with those around him, its use would probably be seen as okay by most people. But let's make this a little more complicated. What if NZT did indeed enable Eddie to be an ordinary, functional member

of the human race, but he could only get it illicitly. Would we still be alright with this?

It wouldn't surprise me if, in this case, a substantial part of the collective response was, "Why not legalize it?" Or, at the very least, ensure that anyone who wants to take advantage of the drug could get hold of it reasonably easily, without facing the risk of imprisonment.

Imagine next a low-potency version of NZT that was legal and was marketed as a dietary supplement. I suspect that most people would think that this was alright, in part because there would be a choice of whether to take it or not. And if the substance addressed a minor deficit or displayed marginal benefits, there would be little pressure to use it. As a result, its use would probably slip quite comfortably into our sense of ethically appropriate behavior.

So far, so good. In this Mildly Enhanced Eddie hypothetical, there don't seem to be glaring ethical issues. But what if we now go back to the NZT that's portrayed in the movie—a cognitive enhancer that provides the user with immense benefits over those around them?

This moves us from thinking of the substance as a way of *correcting* a deficit, to one that confers a *substantial advantage*. And this is where medical ethics begin to run out of steam. But they still have some relevance, especially the medical ethic of "justice."

Imagine that, in the movie, NZT was as widely and readily available as a generic over-the-counter drug like Tylenol. Would this be okay?

There are obviously questions here around how appropriate it would be for everyone to be dependent on a mind-enhancing substance. But, just on the basis of social justice, this scenario feels not-so-bad. Apart from the poorest of the poor, most people would be able to afford to pop a pill to increase their smarts if they wanted to. Because of this, the benefits and the risks of NZT would most likely end up being shared across society.

This isn't too different from where we find ourselves with caffeine, apart from the obvious difference that a shot of espresso doesn't quite have the ability to transform a struggling writer into a genius (believe me, I know). Caffeine is a socially normalized drug that has mild benefits in terms of wakefulness and concentration. It's also a substance that people feel they can opt out of using without feeling that this leaves them at a social or competitive disadvantage.

Whether something as powerful as NZT could be socialized in the same way is far from certain. It would depend a lot on the perceived and real benefits and risks. But that said, it is possible to imagine a pathway forward here for a cognition-enhancing substance to become socialized, if it was affordable and widely available.

How much would change, though, if NZT was an expensive proprietary drug? Still legal, and still accessible, but in this case, only available through exclusive clinics, and affordable to the super-rich. This is a more plausible scenario, as any company making it would have to recoup their development costs, and as we know from current drug development, this can easily run into the billions of dollars.

This scenario takes us into uneasy ethical territory, and again, it's the ethic of justice that comes into play. This is a scenario where the benefits and the burdens of NZT would not be equitably shared across society. Rather, the rich would end up having access to a technology that gave them a vast advantage over the poor, or even the middle class. Using the technology, they would be able to make even more money, wield even more power, create even more exclusive technologies, and further distance themselves from the rest of society.

This, of course, is the scenario that plays out in *Limitless*, but without the social commentary. The power players here are those who are on NZT or who have benefitted from it. These are the people who end up holding the reins of economic and political power, all because they have exclusive access to a mind-enhancing substance.

I must confess that this is not a scenario that I'm comfortable with. And it's not one that I believe can be avoided through market-driven innovation alone. Without appropriate checks and balances in place, the free market simply provides a mechanism that prioritizes overall wealth creation over just and equitable wealth creation. Put simply, free-market economies can thrive on social inequity and injustice, as long as people are willing to buy and sell goods while asking few questions. And you can bet your bottom dollar that there would be a market for a smart drug that massively increased a wealthy individual's chances of success. What is needed in a scenario like this is a system of checks and balances that help steer market forces toward social good.

Here, approaching how we ensure the benefits of new technologies while avoiding unpleasant downsides is not about stymieing technologies that threaten us—far from it. But it does involve deciding what's important, and having the foresight and commitment to ensuring that technology innovation supports what we believe is good and worthy, and avoids what we believe is not. In the language of medical ethics, we probably want to work on innovation pathways that demonstrate non-maleficence, are beneficent, that support autonomy, and that are just.

To start with, though, we need to work out what we believe is important to us as a society. And that includes grappling with how we think about intelligence.

## Our Obsession with Intelligence

As a species, we're obsessed with intelligence. It's what gives us our evolutionary edge, and it's what has led to our dominance as *Homo sapiens*. Our intelligence is what many of us depend on in our personal and professional lives. And, when it comes to artificial forms of intelligence, it's something that some people worry will end up destroying us. But how we think about intelligence is remarkably colored by our sense of our own importance, and this in turn affects how we think about technologies that are designed to enhance it, including smart drugs.

As a species, we've dominated our evolutionary niche. And we've done pretty well at expanding the boundaries of this niche, pushing other species out of the way as we go. As we've evolved, we've done amazingly well at learning how to use the natural resources around us to our advantage. We've adroitly developed the ability to imagine futures beyond the present that we inhabit. And we've become rather adept in crafting our own internal worlds of feelings, beliefs, desires, aspirations, and identities. We are, in our own eyes, exceptional.

This assumption of exceptionality, though, is an evolutionary illusion. We are perfectly adapted to the evolutionary niche we inhabit, but this doesn't make us superior to any other organism that's happily succeeding in its own niche. And yet, despite our self-aggrandizement, we *are* an amazing species. Our ability to individually and collectively imagine futures that are different from the present, and to make these futures a reality, is truly astounding. This doesn't make us superior to other organisms, but it does make

us interesting. And at the root of what makes us an interesting species is what we collectively think of as "intelligence."

This is where things begin to get a little gnarly, though, because while most people would agree that human intelligence is important, there's not so much agreement on what intelligence is exactly. And this becomes relevant as we begin to develop technologies that either claim to enhance intelligence, or to replicate it.

Understanding the nature of intelligence is, perhaps not surprisingly, something people have been grappling with for a long time. For millennia, we've tried to metaphorically pull ourselves up by our bootstraps by using our intelligence to better understand that selfsame intelligence. Each generation of thinkers and scholars has had its own ideas of what intelligence is, and where its value lies, and the current one is no different (although, naturally, being the most intelligent generation so far, we're pretty sure we're honing in on the right ideas this time[64]).

Broad definitions of intelligence tend to focus on our combined abilities to remember, reason, imagine, learn, build stuff, and use knowledge and materials to actively alter the world we live in. Together, these tap into traits that differentiate us as a species from others, and in this respect "intelligence" becomes a convenient shorthand for "that which makes us different." Plenty of scholars have tried to pin things down more precisely, though.

One school of thought that's arisen over the past hundred years is that there is an innate characteristic of general intelligence that makes us different—a single measure, or quotient, of intelligence that captures all of humanity's "specialness." This was first suggested by Charles Spearman in 1904, and is the basis of generalized measures of intelligence such as the g-factor and Intelligence Quotient, or IQ. But these remain controversial measures of intelligence.

In contrast, psychologist Howard Gardner proposed the idea that there are multiple types of intelligence, representing different aspects of human abilities and "different-ness." These include musical intelligence, visual/spatial intelligence, verbal intelligence, logical intelligence, and a whole lot more (including an "existential intelligence" that begins to tap into aspects of belief and spirituality).

---

64  Just in case it isn't clear, I'm being sarcastic—our capacity for delusion is only matched by that for hubris.

In *Limitless*, we are introduced to an understanding of intelligence that lies somewhere between Spearman's general intelligence and Gardner's multiple types of intelligence. What gives Enhanced Eddie his competitive edge is his ability to remember, recall, and use information faster and better when on NZT. It's this combination of memory, recall, speed, and utilization that boosts Eddie's performance within the movie, and transforms him from a struggling writer to a smart and successful author, businessman, and politician. And we're led to believe that this performance boost is synonymous with an intelligence boost. Yet this is a restrictively narrow view of intelligence, and one that leads to a rather monochromatic perspective of success—especially when it comes to technological innovation. It suggests that the most relevant aspects of intelligence are memory, speed of thought, and reasoning ability, and that what establishes their importance is the degree to which they help us "win."

In *Limitless*, Eddie is transformed from a loser to a *winner* by NZT. In the Silicon Valley nootropic culture, taking the right "stacks" is seen as the route to *winning* as an entrepreneur and in business. Students take prescription drugs to *win* in their courses. Academics pop pills to *win* at grant applications, and to *win* at getting their papers published. And I have to assume that corporate executives self-medicate on occasion to *win* in business.

In other words, smart drugs are not really about intelligence, but about selectively enhancing capabilities that provide a perceived performance advantage in a given situation. It's just that we've collectively fallen into the habit of thinking about a small set of attributes as defining intelligence, and assuming that these are essential to winning in life. It's all very "survival of the fittest." It also creates a bit of a problem. As soon as we make the mental leap of assuming better memory and enhanced reasoning make us more likely to win at what we do, we become the victims of a cognitive delusion. And this has a profound impact on how we think about the development and use of smart drugs.

If, as it's assumed in *Limitless*, a single pill can increase someone's chances of winning at whatever they are doing, we have to grapple with who gets access to this wonder pill, and what our collective norms and rules are for responsible use. This becomes challenging if the idea of someone else having a general advantage over you because of the meds they're on becomes a serious threat to your ability to succeed, or to be seen as worthy. But if this

pill only enhances someone's chance of winning under specific circumstances, the threat it poses takes on a very different feel.

If you believe that there are multiple ways of understanding and thinking about of intelligence, and there are multiple combinations of skills needed for success, then taking the wrong smart pill for the wrong purpose could be disastrous. It'd be like taking a tab of LSD to help wrap up a grant proposal—possibly entertaining for the reviewers, but not in the way you intended. On the other hand, taking the right smart pill for the right occasion could be rather useful, especially where this notion of "winning" leads to social good. This might include effective patient treatment, for instance, or problem-solving around natural disasters.

In other words, having a clear sense of what intelligence is, and what intelligence enhancement means, is critical to the socially responsible development and use of smart drugs and intelligence-related technologies more broadly. If you believe that better memory and reason are the most important factors in winning, or in determining someone's worth, then drugs that substantially enhance them become something to be carefully managed within society. This way of thinking leads to smart drugs being framed as a potentially divisive technology that threatens to further prize open the divide between those who have access to the technology and those who do not. If we accept, on the other hand, that personal worth is *not* dependent on these two factors, but is instead a complex combination of ways you enhance the lives of others, and that winning is about more than fame, fortune, and being clever, then smart drugs potentially become an asset, and one to be nurtured.

In setting out to navigate this ethical landscape, so much depends on how we think of intelligence, and this notion of "winning." Sadly, we live in a society that values a rather narrow definition of intelligence which, intentionally or not, leaves the impression that personal worth is linked to how smart you are. This is seen in our education system, and the pressure that parents feel to do everything possible to increase their child's IQ. It's also seen in how we reward people, and who we assign value to in society. Yet there is little evidence that intelligence, when defined in this rather narrow way, leads to attributes like empathy, humility, kindness, and civility; all of which are profoundly important within a healthy

society.⁶⁵ On the contrary, intelligence as portrayed in *Limitless*, and as it is often perceived in real life, has no inherent moral compass. Being smart doesn't make you good.

That said, I can imagine a future where smart drugs are a powerful technology for benefitting lives as part of a suite of technologies that we use to build a better future. But to get there, we're first going to have to recalibrate how we think about intelligence, and how it relates to what is socially useful and beneficial. Such a recalibration is important for technologies that alter and enhance how our minds work. But it's also critically important to how we think about and develop artificial intelligences, or hybrid human-machine intelligences because, if we start off with a warped perspective of intelligence and success, you can guarantee that the "intelligence-enhancing" technologies we develop, and the pathways we develop them along, will be equally warped.

There is a twist to this tale, though. While NZT may not make Eddie better than his peers, it certainly gives him what it takes to succeed in the life that he's chosen. Whether you consider the drug to be intelligence-enhancing or performance-enhancing, Eddie gets ahead because he has access to it. And while the fictional pharmacology of NZT helps explain what he achieved once he started using, there's a subtle but nevertheless important subplot to *Limitless*, which is that, in order to succeed, you needed to be privileged enough to have access to the smart drug in the first place. This in turn takes us to the challenges of what happens when only a privileged few have access to a powerful technology, and to the next movie: *Elysium*.

---

65   I actually did a search for "humility pills" while writing this, thinking how telling it is that so many people are interested in substances that purportedly increase how smart they are, but not how humble they are. To my surprise, I came across the following paper, which isn't about humility pills as such, but is about how we might think more broadly and ethically about cognitive enhancement. Goodman, R. (2014). "Humility Pills: Building an Ethics of Cognitive Enhancement." *The Journal of Medicine and Philosophy: A Forum for Bioethics and Philosophy of Medicine* **39**(3): 258–278. http://doi.org/10.1093/jmp/jhu017

## CHAPTER SIX

# ELYSIUM: SOCIAL INEQUITY IN AN AGE OF TECHNOLOGICAL EXTREMES

> *"They are armed, and I'd like them dead."*
> —Carlisle

## The Poor Shall Inherit the Earth

On September 17, 2011, a small group of social activists occupied Zuccotti Park in New York City. The occupation became the spearhead for the global "Occupy" movement, protesting a growing disparity between "haves" and "have-nots" within society. Two years later, the movie *Elysium* built on this movement as it sought to reveal the potential injustices of a technologically sophisticated future where a small group of elites live in decadent luxury at the expense of the poor.

*Elysium* is, it has to be said, a rather earnest movie. It deals with big social issues, and it takes itself very seriously—to the point where its overly simplistic portrayals of technological innovation and greed-driven social inequality are accompanied by equally simplistic solutions. And yet, for all this, it's a movie that shines a light on the potential dangers of new technologies benefitting the rich at the expense of the poor. It also showcases some cool tech which, while implausible in how it's portrayed in the film, nevertheless reflects some quite amazing developments in the real world.

---

In 2011, just a few months before Occupy Wall Street moved into Zuccotti Park, the economist Joseph Stiglitz wrote in *Vanity Fair*:

"The top 1 percent have the best houses, the best educations, the best doctors, and the best lifestyles, but there is one thing that money doesn't seem to have bought: an understanding that their fate is bound up with how the other 99 percent live. Throughout history, this is something that the top 1 percent eventually do learn. Too late."[66]

Stiglitz foreshadowed the Occupy movement, but he also touched on a deeper truth that has resonated through history—that, while there is a natural tendency for the rich to live at the expense of the poor, this is a recipe for social and economic disaster in the long term. And while he didn't explicitly call out the potential impacts of emerging technologies on social inequity, it's hard to ignore the ways in which science and technology can, if not developed and used responsibly, deepen the divide between those who live comfortable, privileged lives, and those who do not.

This is a theme that the movie *Elysium* piles on in spades. In the film, the rich are pampered by every conceivable technological innovation, living lives of luxury in grand mansions on a Beverly Hills-like space habitat, looked after by subservient AI robots, and living long, healthy lives in perfect bodies, courtesy of home-based medical pods that can cure every ill and erase every blemish. In contrast, the poor have inherited an Earth that has none of these advantages, and instead feels more like the impoverished slums of a Brazilian *favela*, or some of the less salubrious parts of LA. And rather than being served by technology, these communities are suppressed by it.

*Elysium* is driven by the social inequities that are sustained and magnified by these technological disparities. But it's the medical pods that lie at the heart of this tale of the 1 percent versus the 99 percent. These pods can seemingly detect any illness or injury in a patient and treat it in seconds, even down to reconstructing human tissue and bone. It's a dream technology that, in the movie, has conquered sickness and disease, and made permanent injuries a thing of the past. But it's also a technology that's only available to citizens of Elysium, the orbiting space habitat that gives the movie its title. Everyone else left on Earth is destined to grapple with outdated technologies and with disease, injury, and death, living

---

66   Joseph Stiglitz (2011) "Of the 1%, by the 1%, for the 1%." Vanity Fair, May 2011. https://www.vanityfair.com/news/2011/05/top-one-percent-201105

hard, stressful lives while constantly being reminded of how little they have compared to the people they serve.

The medical technology in *Elysium* is very much used as a metaphor for how technological capabilities in the hands of a few people can amplify the power they have over others. I'm not sure the medical pods are meant to be a realistic portrayal of a future technology, and to be clear, they are not scientifically plausible. Rather, I suspect that they represent an extreme that drives home the message that powerful technologies come with great social responsibility. And yet as we'll see, scientifically implausible as they are, these pods echo some quite amazing developments in 3-D tissue and organ construction in the real world that are beginning to radically challenge how we think about some forms of medical treatment.

---

As *Elysium* opens, we're introduced to Max (played by Maxwell Perry Cotton as a child), a young orphan living in the future slums of Los Angeles, looking up into the sky toward a massive toroidal space habitat. This is Elysium, a technologically advanced space-orbital where the uber-rich live in opulent luxury, surrounded by technologies that keeps them disease-free, secure, and deeply pampered. In contrast, the "99 percent" who are left on Earth live in dirt, poverty, and misery, working long, hard hours under the watchful eye of zero-tolerance autonomous-robot law enforcement. Max's dream, one he shares with his childhood sweetheart Frey (Valentina Giron), is to make enough money to move to Elysium. But like so many dreams, it fades into the harsh reality of a life trapped in poverty as he grows up.

Here, we fast-forward to a grown-up Max (played by Matt Damon). Max is still living in the slums of LA. Since we saw him as a child, he's dabbled in some less-than-legal activities, but is now legitimately employed and is working long hard hours for little pay for the company Armadyne. This is the company that supplies much of Elysium's technological needs, together with the AI-based security robots that keep order on Earth. Max is going straight when we catch up with him, but an offhand comment to a security robot leads to him being mercilessly beaten and ending up in hospital with a broken wrist. There, he's reunited with a grown-up Frey (Alice Braga). Frey is now working as a doctor, and, as we later discover, has problems of her own. Max wants to renew their relationship, but

Frey brushes him off, and discourages him from getting involved in her own complicated life.

Once his wrist has been seen to, Max is required to visit his parole officer—another humorless autonomous robot—and once again his flippant attitude gets him into trouble. Having finally got through his parole meeting, he arrives late to work, and is threatened with dismissal for being tardy. Fortunately for him, Max gets off with a warning, and goes back to making robots designed to suppress the poor and pamper the rich. But when a glitch in the manufacturing process threatens production, he is forced to take a dangerous shortcut to fix it, and receives a lethal dose of radiation in the process.

Following the incident, an Armadyne robot patches Max up, gives him a bottle of pills to counter the radiation's effects, and calmly tells him that, in five days' time, he'll die. Meanwhile, Armadyne's CEO John Carlyle (William Fichtner) is horrified by the thought of having a sick and incapacitated worker on the premises, and responds with a less-than-caring "Does his skin fall off or something? I don't want to replace the bedding. Just get him out."

Carlyle is a "citizen" of Elysium, and the person who originally designed the station's operating system, although, because of his position with Armadyne, he spends a lot of time commuting between Earth and the orbital. As Max's really bad day plays out, we discover that Elysium's Defense Secretary Delacourt (Jodie Foster) is conspiring with Carlyle to oust the orbital's current President and install herself into this position of ultimate power. Carlyle, it transpires, wrote the operating system for all of Elysium, and is still able to hack it. This is a system that defines and oversees *all* of the orbital's operational and social functions, including who is a citizen (and therefore has access to Elysium's facilities) and who is not. It also determines who has the authority to govern the orbital, and who occupies the highest positions of power, including that of President. Because of this jaw-dropping level of vulnerability in the technology, Carlyle is able to write a patch that reconfigures the system, replacing the current President with Delacourt.

Carlyle configures the patch while on Earth, and securely saves it in his brain using a neural interface (this is, it has to be said, a technology of convenience that supports the movie's narrative, but otherwise makes little sense). And because the patch is so valuable,

he adds a lethal security lock which will end up killing anyone who tries to steal and run it.

Meanwhile, Max is dying, and he's angry. His only hope of surviving is to get to one of the medical pods on Elysium, and so he makes a deal with an old partner-in-crime, Spider (Wagner Moura), to smuggle him up to the orbital on one of Spider's "illegal immigrant" runs.

Spider agrees to help Max, but at a price. First, he must agree to steal something from an Elysium citizen that will enable Spider to more successfully circumvent the orbital's defenses. Max agrees, but on one condition: He'll only participate in the theft if the mark is Carlyle. Fortunately, an opportunity to jump Carlyle arises almost immediately. In the ensuing hijacking, Carlyle is killed, and Max ends up with his Elysium-reboot patch in his brain; little realizing at the time how dangerous it is. Spider, however, understands all too well what he has stolen, and that this is a piece of code that, if executed correctly, could make Elysium and everything it represents accessible to anyone on Earth. In his mind, it's the key to wiping out the social inequity that Elysium, and its medical technology in particular represents, and one that could level the social and technological playing field between the orbital and the Earth. But there's a problem: If Spider runs the patch, Max dies.

Incensed that Max has interfered with her plans, Delacourt dispatches Kruger (Sharlto Copley), a psychopathic mercenary, to track him down and reclaim the patch. Max evades Kruger, but sustains serious injuries in the process, and this leads him back to Frey. As Max persuades Frey to treat him, he learns her daughter is dying of leukemia, and, just like Max, her only hope is to get to Elysium.

Unfortunately, Kruger discovers Frey's connection with Max, and he kidnaps her and her daughter in an attempt to bring him in. Kruger is well aware of what's in Max's head, and is formulating his own plans for how he could use the patch himself. But for this, he needs Max alive. Having little choice, Max gives himself up, and persuades Kruger and his crew to shuttle him, Frey, and her daughter to Elysium by threatening to destroy the patch if they don't. And, as they are transported up to the orbital, Spider tracks them, and follows behind with his own crew.

This being a sci-fi action film, lots of fighting, blood, and grisly deaths follow. Eventually, though, Frey gets her daughter to one

of Elysium's medical units, only to hit a seemingly insurmountable problem. Because Frey's daughter isn't a registered citizen of Elysium, the machine refuses to treat her. The only solution is for Max to use the patch to reconfigure Elysium's systems so they recognize her as a citizen, but the only way he can do this is to be killed in the process.

Max insists that Spider make the necessary modifications to the patch, and sacrifices himself so that Frey's daughter can live. But it's not just Frey's daughter who benefits. Spider has reconfigured the patch to reclassify *everyone* on Earth as a citizen of Elysium. And so, as Max dies, the "99 percent" finally have access to all the privileges of the "1 percent " that Elysium represents. As the change in citizenship registers, the orbital's autonomous systems realize there's a whole planet full of citizens who are sick and suffering below it, and they commit Elysium's extensive resources—which (inexplicably) include hundreds of medical relief vessels—to assisting them. Through Max's sacrifice, the technologies previously used to benefit the rich at the expense of the poor are made available to everyone, and social equity is restored.

---

It has to be said that *Elysium* is, in many ways, a rather naïve movie. In real life, the roots of social inequity are deeply complex, as are the ways of tackling them, and they are certainty not amenable to simple, quick fixes. And, throughout the movie, the plausibility of the technologies we see plays second fiddle to the story the film's creators want to tell. Yet despite this, the movie highlights social challenges that are deeply relevant to technological innovation in today's world. And, despite its naïvety, it gets closer than might be imagined to some of the more disruptive technologies that are now beginning to emerge around us, including (re)constructing biological tissues with 3-D printers.

## Bioprinting Our Future Bodies

In 2016, a quite remarkable series of images started to permeate the internet. The images showed what looked like the perfectly formed outer parts of a human ear. But, unlike a real ear, this one was emerging, as if grown, from an iridescent pink liquid held in a laboratory petri dish.

The ear was the product of a technique that scientists around the world had been working on for some years: the ability to, quite

literally, print replacement body parts. Inspired by developments in 3-D printing, researchers were intrigued to see if they could achieve the same effects using human cells. The idea was relatively simple: If a matrix of living cells and a permeable but shape-holding material could be formed using a modified 3-D printer, it should be possible to build up three-dimensional human tissue samples, and even complete organs. Of course, the devil was in the details, as even the simplest tissue samples have a highly complex architecture of capillaries, nerves, connecting tissues, and many different cell types. But early enthusiasm for "bioprinting" 3-D tissue samples using sophisticated cell-containing inks, or "bio-inks," paid off, and research in this area is now leading to quite revolutionary technological breakthroughs. And while *Elysium*-like medical pods that reconstruct damaged bodies in seconds will always be beyond our grasp, 3-D printed replacement body parts may not be as far off as we think.

The year 2016 might have been a landmark year for bioprinting, but it was far from the first successful attempt to 3-D print biological structures. Some of the earliest attempts to use 3-D printing technology with biological materials date back to the early 2000s, and by the mid-2000s, an increasing number of papers were beginning to appear in the scientific literature on bioprinting. But these early approaches led to materials that were very basic compared to naturally formed tissues and organs. Unlike even the simplest natural tissues—the cartilage that forms the structure of ears, for instance—they lacked the fine structure that is inherent in the stuff we're made of. Scientists had begun to make amazing breakthroughs in printing 3-D structures that *looked* like viable body parts, but they lacked the essential ingredients necessary to grow and function as effectively as their biological counterparts.

This was only a temporary setback, though, and the 2016 ear was proof that the technology was progressing by leaps and bounds. The ear, created by Anthony Atala and his colleagues at Wake Forest School of Medicine, was printed from a bio-ink mix of rabbit ear chondrocytes—cells that form cartilaginous tissue—and a hydrogel that enabled a persistent three-dimensional structure to be formed while keeping the cells viable. The shape of the ear was based on a 3-D scan of a real ear, and when printed, it looked uncannily like a flesh-and-blood human outer ear. What made it unusual, though, was the inclusion of microscopically fine channels threaded through

its structure, allowing nutrients to diffuse to the cells and enabling them to stay alive and multiply.[67]

Atala's team effectively demonstrated that it's possible to print simple body parts that remain alive and healthy long after the printing process is finished, and that are potentially useable as transplantable replacements. But despite this, bioprinting continued to be dogged by the extensive challenges of reproducing naturally-occurring biological materials, and doing this fast enough to prevent them beginning to die before being completed. It's one thing to be able to print something that *looks* like a functioning replacement body part, but it's something completely different to bioprint tissue that will behave as well as, if not better than, the biological material it replaces.

Part of the challenge here is the sheer complexity of human tissues. Most organs are made up of a finely intertwined matrix of different types of cells, materials, and components, which work together to ensure they grow, repair themselves, and function as they're supposed to. Embedded within this matrix are vital networks of nerves and capillaries that relay information to and from clusters of cells, provide them with the fuel and nutrients they need to function, and remove waste products from them. Without comparable networks, bioprinted parts would remain crude facsimiles of the tissues they were designed to replace. But building such complexity in to 3-D printed tissues would require a resolution far beyond that of Atala's ear, and an ability to work with multiple tissue types simultaneously. It would also require printing processes so fast that cells don't have time to start dying before the process is complete.

These are tough challenges, but at least some of them began to be directly addressed in 2018 by the company Prellis Biologics. Prellis is working on a hologram-based 3-D bioprinting technology that, rather than building up organs layer by layer, near-instantaneously creates three-dimensional structures of cells and support material in a specially prepared liquid suspension. By creating a light hologram within the liquid, the technique forms brighter "hot spots" where the light-sensitive liquid is cured and set, creating a semi-solid matrix of cells and support material. If the "hot spots" are a three-dimensional

---

67   The petri-dish ear was just one of three tissue constructs produced by Atala and his team to demonstrate their technique. They also bioprinted a mandible fragment of a similar size and shape to something that could be used in facial reconstruction, and a rat skullcap bone. Kang, H.-W., et al. (2016). "A 3D bioprinting system to produce human-scale tissue constructs with structural integrity." *Nature Biotechnology* **34**: 312. http://doi.org/10.1038/nbt.3413

representation of an ear, or a kidney, the living architecture for the 3-D-printed organ can be produced in seconds. But here's the clever bit. Above the resolution of the system, which is a few micrometers, complexity is essentially free, meaning that it can be used to produce extremely complex three-dimensional tissue structures with ease; including embedding capillaries within the organ that's being printed.

In other words, we're getting close to a technology that can reproduce the structural complexity of something like a kidney, capillaries and all, in a matter of hours. Reflecting this, Prellis' ultimate goal is being able to print the "entire vasculature of a human kidney in twelve hours or less."

Whether this technology continues to develop at the current breakneck speed remains to be seen. I'm a little skeptical about how soon we'll be able to print replacement body parts on demand, as biology is constantly blindsiding us with just how deeply complex it is. But, despite my skepticism, there's no doubt that we are getting closer to being able to print replacement tissues, body parts, and even vital organs. And while we're still a world away from the fantastical technology in *Elysium*, it's shocking how fast we're beginning to catch up. With advances in high-speed, high-resolution and multi-tissue bioprinting, it's conceivable that, in a few years, it will be possible to 3-D-print a replacement kidney or liver, or jaw bone, or skin grafts, using a patient's own cells as a starting point. And even if we can only get part of the way toward this, it would revolutionize how we're able to treat diseased bodies and extend someone's quality of life. With kidney disease alone, it's estimated that over 2 million people worldwide depend on dialysis or kidney transplants to stay alive, and the number of people needing a new kidney could be as high as 20 million. The ability to print replacement organs for these people could transform their lives. But why stop there? New livers, new bones, new hearts, new limbs; once we crack being able to print replacement body parts on demand that are fully biocompatible, fully viable, and act and feel just like their naturally grown counterparts, our world will change.

This is quite amazing stuff. In a world where there remains a desperate need for new technologies to counter the ravages of disease and injury, it's a technology that promises to make millions of lives better. And yet, as *Elysium* reminds us, just because we *can* cure the sick, that doesn't mean that everyone will benefit. As bioprinting-based medical treatments become available, who

will benefit from them, and what are the chances of this leading to a two-tiered society where the rich get to live longer, healthier lives and the poor get to sit on the sidelines and watch? This is a scenario that already plays out daily with less sophisticated medical technologies. But if bioprinting turns out to be as revolutionary as it promises, it could drive a much bigger social wedge between people who are rich enough and powerful enough to constantly be upgrading their bodies with 3-D-printed parts and those who are destined to be left struggling in their wake.

This is the scenario that plays out in *Elysium*, as the inhabitants of the orbital enjoy access to medical facilities that those left on Earth can only dream of. But it's only one of a number of ways in which powerful technologies lead to social disparity in the movie. Another, and one that is near and dear to my professional heart, as it's an area I focused on for many years, is just how risky workplaces can become when their owners put profits before people, regardless of how sophisticated the technology they are producing is.

## The Disposable Workforce

The first job I found myself in as a newly minted Doctor of Philosophy was not in a university lab, but in a government research center. In September 1992, I joined the British Health and Safety Executive as a research scientist (later moving into a similar role with the US National Institute for Occupational Safety and Health), and for the next thirteen years, I became deeply engaged in workplace safety. I was a full-on bench scientist for many of these years, conducting and leading lab-based research on airborne dust exposure (which, trust me, is more interesting than it sounds). But I also worked closely with health and safety professionals, as well as manufacturers and workers, and this gave me a deep appreciation of the risks that many people face in the places where they work, even when those workplaces use and produce advanced technologies.

It's often assumed that technology innovation make workplaces cleaner and safer places to be. This, sadly, is a myth, and it's one that I suspect is propagated in part by images of pristine clean rooms and sleek automated production lines. In many cases, of course, new technologies have led to improved working conditions. Yet the reality is that manufacturing at scale is often dirty and dangerous, even if the technology being manufactured is not. And this is one area where *Elysium* does a surprisingly good job of reflecting the reality that, no matter how advanced our technologies are, there'll

still be someone slaving away somewhere in an unsafe workplace to make the products we use, if we're not careful.

Of course, we've known for thousands of years that working for a living can be bad for your health—especially if you mine materials out of the ground, grow produce, or manufacture materials and products. And partly because of this, there's a long history of privileged groups using less privileged people to do their dirty work for them. It wasn't the rich, ruling classes that got their hands dirty building the Egyptian Pyramids or the Roman plumbing systems, or who mined the coal that drove the Industrial Revolution. Rather, it was those who had little choice but to sacrifice their health and longevity in order to put food on the table for their families. It would be pleasant to think that we live in more enlightened times, where no one has to take unnecessary risks to earn a living wage. Sadly, this is not the case. *Elysium* may be implausibly futuristic in some respects, but it's right on the nose with its message that, even in a technologically advanced future, there'll still be dirty, dangerous jobs, and rich people who are more than willing to pay poorer people to do them.

Thankfully, there have been substantial improvements in working conditions over the past 100 years or so—in some countries, at least. This has been spurred on by a growing realization of just how socially and economically harmful it can be to treat workers badly. But this is a surprisingly recent development in human history, and one where new technologies have not always been synonymous with better working conditions.

---

In 1977, my grandfather died of pneumoconiosis after decades of working as a coal miner. Even though he'd long moved on from working down the pit, the coal dust he'd breathed day in and day out had done its damage, and the progressive and irreversible scarring that resulted from it eventually killed him.

Coal miner's pneumoconiosis, or "black lung," is caused by the constant inhalation of fine, insoluble dust particles, and a gradual and progressive deterioration of the lungs as they become inflamed and scarred. It's a disease that has most likely plagued coal miners for centuries. Yet it wasn't until the early to mid-1900s, at the tail end of the Industrial Revolution, that it began to be recognized

as a serious occupational disease.[68] Despite massive advances in technological innovation over the previous century, uncertainty in the science behind black lung delayed action on this occupational killer. This was an uncertainty that suited the mine owners, and one that they seemed to be no hurry to address. In the 1800s and early 1900s, coal was the what fueled the Industrial Revolution, and mining corporations and manufacturers couldn't afford to acknowledge they might have a problem.

It wasn't until the 1940s in the UK that substantial steps were taken to improve workplace conditions down mines, following a growing recognition of how serious a challenge lung disease was amongst miners. Even then, pneumoconiosis continued to be an issue. And in the 1990s, fifty years after those first substantive steps to improve working conditions, I became involved in a new wave of efforts to address occupational lung disease in coal mines.

The mines I visited back then—all in the northeast of England— were dusty, but not oppressively so. Yet there was a palpable tension between trying to comply with exposure regulations and struggling to remain solvent. In 1991, similar tensions had led to a scandal in the US coal mining industry when it was discovered that dust was either being removed from samples designed to monitor exposures, or the samplers were intentionally being misused.[69] The intent was to make it look as if dusty mines were complying with federal regulations, even if they weren't in compliance, in an attempt to put profits over the lives of those mining the coal. Over 800 mines were implicated in the tampering scam, and the proposed fines that resulted exceeded $6 million.

Similar concerns prompted some of my work in British coal mines, and one of my last visits down an English pit was to ensure samples weren't being messed with (thankfully, they weren't). The sad reality, though, was that, in this industry, and despite massive strides in understanding how to use technology to protect worker health, it was all too easy to cut corners in order to increase production. And even more sadly, despite living in one of the most advanced technological ages in human history, coal miners' pneumoconiosis

---

68   Andrew Meiklejohn's three-part history of lung diseases of coal miners in Great Britain provide a fascinating insight into the early understanding of coal miner's pneumoconiosis: Meiklejohn, A. (1952). "History of Lung Diseases of Coal Miners in Great Britain" Part I, 1800-1875. *British Journal of Industrial Medicine* **8**(3): 127-137. Part II, 1875-1920. *British Journal of Industrial Medicine* **9**(2): 93-98. Part III, 1920-1952. *British Journal of Industrial Medicine* **1952**: 208-220.
69   Frank Swoboda, "Coal mine operators altered dust samples" *Washington Post*, April 4 1991. https://www.washingtonpost.com/archive/politics/1991/04/04/coal-mine-operators-altered-dust-samples/b0fec1b0-fe9c-4847-b900-7de6f4fc3d46/

is once again on the rise. In spite of all the technological breakthroughs we're surrounded by, companies are still sending people to work in environments that could severely shorten their lives, while not taking the necessary steps to make them safer, so that others can live more comfortably.[70]

Coal mining is, of course, just one example of a workplace where tradeoffs are made between safety and productivity. In the US alone, there are close to 5,000 workplace-related fatalities a year, and in excess of 140,000 cases of workplace illness.[71] In 2014, Jukka Takala and his colleagues published estimates of the global burden of injury and illness at work. From their analysis, there were 2.3 million workplace-related deaths globally in 2012, with two million of these linked to occupational disease.[72] These are high numbers, and certainly not what might be hoped for in a technologically advanced society. Yet while technological innovation has made some workplaces safer, it has also displaced people into potentially more harmful working conditions; and the harsh reality is that, for many people, a dangerous job is better than no job at all. This is perhaps seen most clearly in the displacement of manufacturing to countries where wages are lower, regulations are weaker, and working conditions are poorer than they are in more affluent economies—for instance, in the manufacturing of clothing and electronics. Here, rather than saving lives, innovation is leading to people being potentially put in harm's way to satisfy a growing demand for the latest technologies.

Even with new and emerging technologies—for instance, the production of new materials using nanotechnology, or the use of genetically modified microbes to mass-produce chemicals in vast bioreactors—there is relatively little correlation between the sophistication of the technology and the safety of the environment in which it's used. On the contrary, the more powerful the technologies we produce, the more opportunities there are for them to harm the first tier of people who come into contact with them, which includes the people who manufacture them, and in turn use them in manufacturing. This has been seen in an intense

---

70   Howard Berkes (2017) "NPR Continues To Find Hundreds Of Cases Of Advanced Black Lung" *NPR*, July 1, 2017. http://www.npr.org/sections/thetwo-way/2017/07/01/535082619/npr-continues-to-find-hundreds-of-cases-of-advanced-black-lung
71   More information on workplace fatalities in the US. can be found in the NIOSH Worker Health Charts, published by the Centers for Disease Control and Prevention https://wwwn.cdc.gov/Niosh-whc
72   Takala, J., et al. (2014). "Global Estimates of the Burden of Injury and Illness at Work in 2012." *Journal of Occupational and Environmental Hygiene* 11(5): 326-337.

global focus on the workplace health risks of producing and using engineered nanomaterials[73] (a topic we'll come back to in chapter ten and *The Man in the White Suit*), and a realization that one of the greatest threats to workplace safety is not a lack of technological innovation, but ignorance of what might go wrong with novel technologies.

But even where there is not a lack of understanding, greed and human nature continue to jeopardize workers' health. In the case of *Elysium*, this tradeoff between profit and people is painfully clear. Max's occupational "accident" has all the hallmarks of occurring within a company that sees its workforce as disposable, despite the fact that they are producing high-tech goods. The additional irony here is that those "goods" are robots that are designed to further suppress the earth-bound population. In this future society, the polarization between rich and poor has become so extreme that the poor have precious few rights remaining as they serve the lifestyles of the rich.

How likely is this? If we don't take workplace health and safety seriously, and the broader issues of social justice that it's a part of, I'm sad to say that it's pretty likely. The good news is that an increasing number of companies recognize these dangers, and are diligently implementing policies that go beyond regulatory requirements in order to ensure a healthy workplace. And they do this with good reason: The economics of accident and disease prevention make good business sense, as do the economics of fostering a happy and thriving workforce. Emerging thinking around concepts like corporate social responsibility and responsible innovation help here; so does innovative corporate leadership that actively strives to reduce social inequity and serve the needs of those who work for them.[74] But the fiscal temptation to use cheap labor is sometimes a tough one to resist, especially when some people are willing to work for less and cut corners to get ahead of their peers. This is where preventing a future disposable workforce becomes the responsibility of everyone, not just employers or regulators.

---

73  Despite nearly two decades of research on the potential health and environmental risks of some engineered nanomaterials, some companies continue to use these as if they are, by default safe. This was brought home afresh to me in 2016 in the wake of seeming ambivalence over the potential health risks of using carbon nanotubes—a material that may, under some circumstances, behave like asbestos if inhaled. Andrew Maynard (2016) "We don't talk much about nanotechnology risks anymore, but that doesn't mean they're gone." *The Conversation*, March 29 2016. https://theconversation.com/we-dont-talk-much-about-nanotechnology-risks-anymore-but-that-doesnt-mean-theyre-gone-56889

74  One example of innovative and socially responsible corporate leadership here is the B Corp initiative, where for-profit companies are assessed by an independent organization to meet high standards of social and environmental performance, accountability, and transparency.

This is something of a moot point in *Elysium*, though, as Max and his fellow workers don't have much of a choice in where they work and what they are required to do to make ends meet. Despite living in a highly automated future, they have work, but it's not necessarily the work they would choose, given the chance. For them, automation didn't deprive them of a job, but it did deprive them of choice. How realistic a reflection this is of the real world is debatable—this is, after all, Hollywood. Yet in one form or another, new technologies that lead to further automation are a growing issue within today's society.

## Living in an Automated Future

In September 2017, the Pew Research Center released the results of a comprehensive survey of public attitudes in the US toward robots and automation.[75] The results should be taken with a pinch of salt, as these were opinions rather than predictions, and they come with all the usual challenges associated with asking people to predict the future. Yet they're quite revealing when it comes to what people think about automation. Some of the results aren't too surprising. For instance, some people who responded were worried about the prospect of robots replacing them in the future, and respondents generally didn't like the idea of computers deciding who to hire and who not to. Other results in the survey were more surprising. For example, 56 percent of participants would not want to ride in a driverless vehicle, and of these, safety concerns were uppermost in their reasoning. And this is *despite* safety being one of the big arguments made for getting rid of human drivers.[76]

As part of the survey, participants were asked what they thought the impacts of robots and computers would be on inequality. This was specifically framed in terms of what the outcomes would be if automation replaced many of the jobs currently done by people. Perhaps not surprisingly, the majority of participants (76 percent) thought that increasing automation of jobs would increase inequality.

How this stacks up to how things are actually likely to play out is complex. As Erik Brynjolfsson and Andrew McAffee point out

---

[75] For more details of this extensive poll on attitudes toward automation, see the article by Aaron Smith and Monica Anderson: "Automation in Everyday Life." *Pew Research Center,* October 4 2017. http://www.pewinternet.org/2017/10/04/automation-in-everyday-life/

[76] I wrote about this in 2016. Andrew Maynard (2016) "Will driving your own car become the socially unacceptable public health risk smoking is today?" Published in The Conversation, September 26 2016. https://theconversation.com/will-driving-your-own-car-become-the-socially-unacceptable-public-health-risk-smoking-is-today-65891

in their 2016 best seller *The Second Machine Age*,[77] automation is radically changing the way we live and the work we do. The question that is challenging experts like Brynjolfsson and McAffee, though, is whether this will lead to a net *reduction* in jobs, or simply a change in the types of jobs people do. And it's not an easy one to answer.

Looking back over the recent history of automation, there have been pivotal shifts in the types of jobs available to people. There have also been industries that have been largely stripped of human labor. In the 1800s this was at the root of the Luddite movement (something we'll revisit in chapter nine), as textile artisans began to see their skills being replaced by machines and their livelihoods taken away. And since then, every wave of automation has led to further job losses.

But, at the same time, new jobs have been created. When I was finishing high school, and going through the tedium of career advice, many of the jobs that people now do hadn't even been invented. Web designer, app coder, Uber driver, cloud computing expert, YouTube creator, smart-city designer, microfinance manager, and so on—none of these appeared in the brochures I was encouraged to digest. There's no question that, over the past few decades, the job market has radically changed. And this has been driven by technological innovation, and to a large extent by automation.[78]

To some, this suggests that we are nowhere near the limit of our capacity to create new things that people can and will pay for, and all that automation does is create new opportunities for enterprising humans to make money. This is not a universally held view, and there are many economists who worry that emerging technologies will lead to a serious net reduction in jobs. From the Pew survey, many others have the same concerns, and while this is based on impressions and gut feeling rather than hard evidence, it's probably justified in one respect: Increasing automation will replace many of the jobs people do today, and unless they have the capacity to develop new skills and switch job and career paths, this will lead to job losses. And this in turn leads us to the challenges of ensuring people have access to the educational resources they need as technological innovation continues to transform our world.

---

77   Erik Brynjolfsson and Andrew McAffee. "The Second Machine Age: Work, Progress, and Prosperity in a Time of Brilliant Technologies" *W. W. Norton & Company*, 2016.
78   Rachel Hallett and Rosamund Hutt (2016) "10 jobs that didn't exist 10 years ago." World Economic Forum https://www.weforum.org/agenda/2016/06/10-jobs-that-didn-t-exist-10-years-ago/

Education is one of those issues that is both critical to social and economic growth, and at the same time deeply contentious. Everyone, it seems, has an opinion on what a "good education" is, and how we should be "educating" people. As a teacher, and someone who's married to one, it's hard to escape the deeply-entrenched opinions and politics that surround education, and the sheer number of people who think they know what's best, whether they know what they are talking about or not. And yet, despite all of the politicking, there is one cold, hard truth as we develop increasingly sophisticated technologies: If our educational thinking, approaches, and resources don't keep up with the future we're creating, people are going to suffer as a result.

How to address this, of course, is challenging. But there are an increasing number of initiatives to address the emerging educational needs of the industrial and technological revolution we're in. In my own institution at Arizona State University, for instance, there's a growing recognition that bricks-and-mortar universities simply don't have the capacity to serve the needs of a growing global population that's hungry to develop the knowledge they need to thrive.[79] In a future where unique skills are needed to ride the wave of radical technological change, we're going to need equally radical innovation in how over seven billion people are going to acquire these skills. Online learning is beginning to fill some of the gaps here, but this is just a start. If we are going to avoid increasing automation and technological complexity marginalizing a growing number of people, we're going to need to start thinking hard and fast about what we teach, how we teach, and who has access to it. More than this, we're going to have to recalibrate our thinking on what we mean by "education" in the first place.

---

In 2005, a new video-sharing platform was unleashed onto the world. Now, YouTube is the second-largest search engine globally, and the third most-visited site after Google and Facebook. It's also where more and more people are turning to learn what they need in order to succeed. Over a billion hours of YouTube are watched every

---

79   Under the leadership of its current president, Michael Crow, Arizona State University is embarking on an ambitious plan to redefine the role of the public research university into one where higher education serves the needs of a changing world, and is as accessible, impactful, and socially relevant as possible. Part of this involves fully utilizing online teaching platforms to make educational resources accessible to a growing number of people, including those often excluded by more conventional educational models. But more than this, the ASU model is striving to ensure that how we think about and deliver education keeps up with the needs and ambitions of the technological future we're creating. It's why I work here.

day, and while much of this is not educational content, a surprising amount of it is.

As an educator, I must confess to being somewhat leery of YouTube, despite using the platform extensively myself.[80] It remains a Wild West of educational content, where anyone can try to convince you of anything, whether it's right or wrong. And yet, YouTube is increasingly where people go to learn,[81] whether it's how to tie a bowtie, put on makeup, plumb a sink, or ice an interview. This is a platform where people are sharing what they know with others, outside of the barriers, constraints, and politics of formal education. And it's where users are learning how to learn at their own pace, and on their own terms. YouTube, and online video-sharing platforms more broadly, are a grassroots revolution in casual, user-directed learning, and one that I suspect is only going to increase in relevance as people discover they need new skills and new knowledge to succeed in what they are doing.

Of course, YouTube videos are no substitute for a formal education. There is a depth and quality to learning from professionals within a structured environment that still has substantial value. And yet, there is a deep desire among many people to learn on their own terms, and to develop the knowledge and skills they need, when they need them, that isn't being met by formal educators. And while educational establishments are trying to meet at least some of these needs with innovations like Massive Open Online Courses (or MOOCs) and "micro-credentials," they are still barely connecting with what people are looking for.

As YouTube and other video-sharing platforms democratize learning, how can we ensure that users have access to material that is useful to them, and that this material is trustworthy? The latter question in particular is a tough one, as pretty much anyone can upload their own content onto YouTube. Yet over the past several years, there's been a trend toward trusted content creators providing high-quality educational material on the platform.

In 2011, author John Green and his brother Hank launched the YouTube channels *Crash Course* and *SciShow*. Even though the Green brothers were not educators in the formal sense, they set out to make rigorous, relevant, and engaging educational content

---

80  In 2012, I launched the YouTube channel *Risk Bites* as a platform for helping people make sense of risk, including the potential risks and benefits of emerging and converging technologies. http://youtube.com/riskbites

81  As long as they are in a country that doesn't block the website.

available to anyone with YouTube access, and they succeeded phenomenally. As of this writing, between them, the two channels have attracted nearly *one and three quarter billion views*. But it's not just the views that are important here. The content on these channels is well-researched and well-presented. It is, whichever way you look at it, great educational material, and it's trouncing what's being offered by some more formal educators.

*Crash Course* and *SciShow* are part of a growing trend in casual learning content on YouTube that is reaching billions of people, and is transforming how and where people develop the knowledge and skills they need. And yet, formal educational establishments and leading subject experts are largely absent from this trend. This, to me, is a glaring missed opportunity, and one that my colleagues in universities around the world need to respond to. As the pace of innovation continues to increase, people are going to increasingly turn to platforms like YouTube to learn what they need to in order to keep up. And while content providers like the Green brothers and their teams are doing a fantastic job, if even a small number of savvy academic experts followed their lead, we would have the opportunity to massively expand the quality, quantity, and accessibility of learning material on video-sharing platforms. If experts and educators can be galvanized to embrace this new form of user-driven online learning, we could be on the cusp of an unprecedented democratization of education.

Such radical access to knowledge and learning could help reduce social inequity in the future, as it enables anyone to acquire the skills they need to succeed. Done right, knowledge will no longer be the domain of those rich enough to afford it, or privileged enough to use it, but will be there for anyone who wants it.

Of course, education alone is not the answer to social inequity, and avoiding a future that mirrors that depicted in *Elysium* will also require a deep commitment to developing, using, and governing new technologies responsibly and ethically. Yet meaningful access to knowledge and understanding for all is part of the bedrock on which social equity is built, and we ignore it at our peril—especially, as we'll see in the next movie, *Ghost in the Shell*, when we begin to create technologies that push conventional understanding to the limit.

CHAPTER SEVEN

# GHOST IN THE SHELL: BEING HUMAN IN AN AUGMENTED FUTURE

> "As an autonomous life-form,
> I request political asylum."
> —Puppet Master

## Through a Glass Darkly

On June 4, 2016, Elon Musk tweeted: "Creating a neural lace is the thing that really matters for humanity to achieve symbiosis with machines."[82]

This might just have been a bit of entrepreneurial frippery, inspired by the science fiction writer Iain M. Banks, who wrote extensively about "neural lace" technology in his *Culture* novels. But Musk, it seems, was serious, and in 2017 he launched a new company to develop ultra-high-speed speed brain-machine interfaces.[83]

Musk's company, Neuralink, set out to disrupt conventional thinking and transform what is possible with human-machine interfaces, starting with a talent-recruitment campaign that boldly stated, "No neuroscience experience is required."[84] Admittedly, it's a little scary to think that a bunch of computer engineers and information technology specialists could be developing advanced systems to augment the human brain. But it's a sign of the interesting times we live in that, as entrepreneurs and technologists become ever more

---

[82] @elonmusk, on *Twitter*, posted June 4, 2016 https://twitter.com/elonmusk/status/739006012749799424

[83] Rolfe Winkler (2017) "Elon Musk Launches Neuralink to Connect Brains With Computers." *The Wall Street Journal*, March 27, 2017. https://www.wsj.com/articles/elon-musk-launches-neuralink-to-connect-brains-with-computers-1490642652

[84] https://www.neuralink.com/ This was posted on the Neuralink home page as of October 9, 2017.

focused on fixing what they see as the limitations of our biological selves, the boundaries between biology, machines, and cyberspace are becoming increasingly blurred.

The movie *Ghost in the Shell* is set in a future where technologies like those Musk and others are working on are increasingly finding their way into society, and into people. It was released in 1995, and builds on a Japanese manga series that dates back to the 1980s. Yet, despite its age, it's remarkably prescient in how it uses increasing integration between people and machines to explore what it means to be "human" in an age of technological augmentation. Not surprisingly, some of the tech looks a little outdated now: In 1995, the internet was just finding its global feet, Wi-Fi had yet to become ubiquitous, cloud computing (never mind fog computing[85]) wasn't a thing, and Google hadn't even been formed. Yet, as advances in human-machine interfaces continue to barrel forward at lightning speed, the issues *Ghost* explores are perhaps more relevant now than ever.

---

In *Ghost in the Shell*, cybernetic and machine-based body augmentations are commonplace. They give their users machine-like powers, and the ability to connect with a vast digital web of information, while brain implants allow people to communicate mind-to-mind, and mind-to computer. This fusion of human biology with machines and cybernetic systems makes coding experts extremely valuable, and hackers extremely powerful. And one of the emergent consequences of this intimately interconnected world is that hackers have found ways to implant false memories in people's minds, altering who they think they are.

This possibility for mind and memory manipulation gets to the heart of *Ghost*. Beneath the movie's visually stunning graphics and compelling sci-fi storyline (as you may gather, I *really like* this movie), *Ghost in the Shell* challenges us to think about what it means to be alive, to have value, and to have a sense of self, purpose, and destiny. On the release of the *Ghost in the Shell* remake in 2017 (a poor "ghost" of a movie in comparison), commentator Emily Yoshida described the original as a "meditation on consciousness and the

---

85  "Fog computing" or "edge computing" uses a growing network of internet-connected devices to push data processing out of the cloud, and to the devices that are collecting and using information on everything from our personal habits to the environment around us. It's the next iteration in distributed computing architectures that combines a vast array of relatively low-power devices with more centralized data processing to massively expand how large amounts of data are utilized.

philosophy of the self."[86] And she's spot on. Just as *Never Let Me Go* in chapter three forces viewers to think about what it means to be human, *Ghost* takes us on a journey of contemplation around what it means to be a conscious and self-aware entity, in a future where the biological origins of humanity have increasingly less meaning.

At the center of *Ghost* is Major Motoko Kusanagi (voiced by Atsuko Tanaka). Motoko is part of an elite team in "Section 9"—a shady government department that operates at the edge of the law to keep the wheels of society turning smoothly. Major Kusanagi is a cyborg. Most of her body has been replaced by manufactured parts, including much of her brain (although she retains a small part of her original biological brain). She is strong, fast, cyber-connected, and with the use of advanced "thermoptic technology" built into her artificial skin, she is able to blend into her surroundings and effectively disappear. She is also very human in her hopes, fears, feelings, and relationships.

At the beginning of the movie, we learn that an aide to a senior diplomat has been "ghost-hacked." Her neural implant has been used to hack into her mind, with the intent of using her to interfere with a sensitive international negotiation. The hacking is traced to a garbage collector who, we learn, believes (incorrectly) that he is hacking into his wife's "ghost" to find out why their relationship is on the rocks. And he in turn is being handled by a figure who believes (wrongly) he is an agent working a foreign government.

We quickly gather that the neural implants most people have allow smart hackers to alter their sense of their own identity, or their "ghost." They can, in effect, rewrite who someone thinks they are. And so it turns out that the garbage collector has no wife or family, but lives alone with his dog. And the foreign agent has no idea of who he really is. Rather, each has been manipulated by a shady master-hacker called the Puppet Master.

This plays deeply into Major Kusanagi's personal angst. She's already grappling with her own self-identity, and this ability for someone to alter another person's sense of self worries her. As a result, she is deeply concerned about whether she's who she thinks she is, and if her sense of self is simply an illusion created by someone else. This all adds to her uncertainty around what gives someone like herself legitimacy, or worth, and what—if anything—makes her more than just a machine?

---

86  Emily Yoshida (2017) "A Beginner's Guide to the Ghost in the Shell Universe" http://www.vulture.com/2017/03/a-beginners-guide-to-the-ghost-in-the-shell-series.html

These ideas echo many of those touched on in movies like *Never Let Me Go* (chapter three), *Minority Report* (chapter four) and *Ex Machina* (chapter eight). But in *Ghost*, they are front and center of this meditation that's masquerading as an anime movie.

In the movie, we repeatedly find Motoko deep in contemplation, exploring her own mortality, and wrestling with who she is. There's one beautiful transition scene, for instance, where through a masterful combination of visuals and music, we're invited to share in Motoko's introspection. Motoko knows that she is largely made up of manufactured parts, and that she may not be who she thinks she is. But how does she make sense of this, and come to terms with it?

In the movie, there are two parallel narratives that weave together through this introspection. Early on, we learn that a new recruit to Section 9—Togusa (Kôichi Yamadera)—is the only member of the team without implants. When he asks Major Kusanagi why he was selected, she points out that overspecialization leads to death, and that diversity of ability and perspective is essential for life. This theme of diversity recurs at the movie's denouement. But it also underlies a meditation that threads through the movie on the importance of embracing difference.

The second narrative is subtler, and it revolves around feelings of friendship and love between Motoko and her colleague Batou (voiced by Akio Ôtsuka). Despite Motoko's crisis of self-identity, it's clear through the movie that Batou cares deeply for her. This is a relationship that transcends who made their bodies, and how "biological" they are; it invites us as viewers to think about what the basis of this friendship is. The answer, it emerges, lies in the "ghosts" that define both Motoko and Batou, and is not constrained by physical form. There's an essence within each of these characters that transcends their physical bodies, and leads to a strong bond between them. Yet it also extends to their physical interactions in unexpected ways. In the movie, Batou is touchingly sensitive to protecting Motoko's dignity. This being Japanese science fiction anime, there's a fair amount of female nakedness, aided by Major Kusanagi's need to remove her clothes to take advantage of her thermoptic skin. Yet we repeatedly find Batou averting his eyes from Kusanagi's naked body, and covering her nakedness where he can. There is a sensitivity to his body language here that makes little sense in the context of Motoko being a machine, but much sense in terms of her being someone he has deep regard for. This regard threads through the movie to its end, where Batou saves Motoko's

life. It's a relationship that's based on respect, acceptance, and empowerment, even as Motoko is transformed into something other than what she started as.

Returning to the plot, following the attempted hack of the diplomat's aide, the hunt is on for the Puppet Master. Another government agency—Section 6—sets the cyber-equivalent of a honey trap for the Puppet Master by creating a cyber-body/brain that he/she will find irresistible to hack and download themselves into. The trap is sprung, but the body containing the Puppet Master escapes the facility it was being held in. However, its freedom is short-lived, as it's hit by a truck, and the mangled cybernetic body ends up in the hands of Section 9. And this is where we begin to discover that things are not quite as they seem.

It turns out that the Puppet Master (voiced by Iemasa Kayumi) is an algorithm—codenamed project 2501—designed to hack people and cyber-systems and manipulate them. The creators of 2501 thought they had it under control. But the algorithm became self-aware and escaped out into the net. And Section 6 has been trying to capture it ever since.

As 2501 learned more of the world it found itself in, it became aware of its own limitations, and especially its inability to do the two things it deduced were essential to the growth of a species: to reproduce, while adding diversity to the cyber-equivalent of the gene pool, and to die, thus paving the way for new entities to grow, mature, and evolve.

At this point, the movie begins to dive deeply into exploring the meaning of life, and the roles and responsibilities of individuals within a self-aware society. From 2501's perspective, reproduction through copying itself would be meaningless, a sterile act, and a negation of what it considers to be meaningful. Instead, it begins to explore how it can increase diversity within future generations of the life form it represents, and to make way for these future generations by experiencing death[87].

Here, Major Kusanagi becomes central to 2501's plan. In Kusanagi, 2501 sees an entity that is close enough to himself/herself[88] for a

---

87   This emphasis in *Ghost* on death of the individual as an essential part of the growth across generations is especially intriguing, as it's contrary to a lot of Western-style thinking that celebrates the ability of technology to prolong individual lives, possibly at the expense of future generations and social well-being.

88   Although the physical manifestation of 2501 in the movie has sex-associated attributes, 2501 has no clear gender.

bond to be developed, and procreation to occur. And so, to engineer a situation where he/she and Kusanagi can interface, 2501 sets in motion a series of events that lead to her/him being picked up by Section 9.

Once there, 2501 requests political asylum as a life-form. But Section 6 aren't having any of this; they simply want their algorithm back. And so, Section 6 operatives carry out a raid to regain possession of the cyber-body holding 2501. They succeed in abducting him/her, but not before 2501 has intrigued Motoko enough for her to want find out more. Motoko chases after 2501's abductors, and ends up in a deserted warehouse, with minimal backup, and an autonomous tank protecting her quarry.

After a firefight where Major Kusanagi is heavily out-gunned (but not outsmarted), and where, in a very in-your-face metaphor, a wall carving of the evolutionary tree of life is shot up, Motoko reaches the tank. In her attempt to disable it and protect 2501, she compromises her cybernetic body, sacrificing her physical self in her quest for enlightenment.

At this point, Batou arrives and saves both Motoko and 2501, but not before their physical bodies have been badly damaged. Thankfully, their minds are still intact, and in the few minutes they have together, 2501 and Motoko connect.

This is where we learn that this union has been 2501's plan all along—not to hack Motoko, but to engage with her as an equal. 2501 explains his/her fears and aspirations, and presents Motoko with a proposal: that they cybernetically merge, and in the process, create a new, more diverse, and richer entity, while allowing 2501 in his/her current form to die. Motoko agrees, and the merge takes place. Batou escapes with Motoko/2501's intact head, and finds a replacement cyber body for this new entity.

As the movie closes, the merging of 2501 and Motoko affirms that embracing the future, while letting go of the past, is essential for growth. By letting go of their individual identities and embracing diversity, Motoko and 2501 have, together, formed a more confident and self-assured life-form. And despite the "evolution" of Major Kusanagi, Batou's respect and regard are not in the slightest diminished as he accepts this transformation within his friend.

The underlying messages here may all sound a little pop psychology-ish. But despite this, *Ghost* helps peel the layers away

from increasing tough questions around who we are and how we interact with others, as emerging technological capabilities take us increasingly beyond the limits of our biological evolution.

## Body Hacking

In July 2012, Dr. Steve Mann was allegedly assaulted in a Paris branch of McDonald's.[89] What made this case unusual was that the assault was sparked by a computer vision system physically attached to Mann's skull—a physical augmentation that others purportedly took exception to.

Mann developed his "EyeTap" in 1999 as a computer-augmented extension of his eye, allowing him to both record what he was seeing and project information directly into his right eye. In many ways, it was a precursor to Google Glass, but with one important difference: the EyeTap was physically attached to his head, and could not be removed without special tools.

In the incident that Mann described on his blog, a McDonald's employee attempted to physically pull the EyeTap off his head, damaging it in the process, and causing considerable personal distress. While the details of the case remain uncertain, it stands as one of the first documented incidences of possible discrimination against someone with an intentional body augmentation that, because of its nature, led to a perceived threat to someone else; although in this case, whether that perceived threat was to privacy, "normalcy," or something else, is unclear.

Mann's use of technological augmentation is part of a broader "body hacking" movement—a loose trend where people are experimenting with do-it-yourself body enhancements. Many of these hacks involve individuals embedding magnets in their bodies so they can sense and respond to magnetic fields, or inserting radio frequency identification (RFID) chips under their skin so they can remotely interact with their environment. But in this extension of the maker movement, people are playing with increasingly sophisticated ways to incorporate novel technologies in their bodies, often through unsupervised do-it-yourself surgery.

The ethics of untrained and unsupervised people cutting themselves and others open to insert objects of unknown provenance are

---

89   You can read more about the details of this incident on Steve Mann's blog. Steve Mann (2012) "Physical assault by McDonald's for wearing Digital Eye Glass" *Eyetap*, posted July 16, 2012. http://eyetap.blogspot.com/2012/07/physical-assault-by-mcdonalds-for.html

interesting to say the least, never mind the safety concerns. However, this movement provides some indications as to where human enhancement may be heading, and some of the bumps in the road that it may encounter on the way. It's also an early step toward a future that echoes the one we're introduced to in *Ghost in the Shell*, where the lines are increasingly blurred between our biological and our technological selves.

To some at least, this is seen as part of our evolutionary development (although it should be said that it's a stretch to think that using our intellect to merge our bodies with machines is directly equatable to biological natural selection). Body hackers are often enamored with the idea that we can use technology to overcome our biological limitations, and transcend our evolutionary heritage to become something else entirely. To many of them, placing magnets and RFIDs under the skin are baby steps to something much greater: becoming "trans-human."

---

In recent years, the transhumanist movement has blossomed. As technological capabilities have continued to grow and converge in areas as diverse as robotics, nanotechnology, AI, neurotechnology, and biotechnology, a growing number of people have become enamored with the ability of technology to transform who we are, and what we can achieve as a result. Prominent transhumanists such as Ray Kurzweil and Nick Bostrom talk about enhancing physical and mental abilities through technology, extending lifespans, interfacing ever more deeply with computers, and one day even leaving our biological bodies altogether. In the 2016 US election, there was even a transhumanist candidate—Zoltan Istvan.[90] As I'm writing this, he's setting his sights on becoming the Governor of California.

Without doubt, an increasing ability to merge individuals with powerful technologies opens up some compelling possibilities. We're already seeing this in some of the incredibly sophisticated robotic and cyber-enabled medical devices and prosthetics that are being developed. But these are just the tip of the iceberg compared to what could be possible over the next decade or so. Advances in AI-related technologies, computing architectures, gene editing and manipulation, robotics, on-demand additive manufacturing, and the converging and merging of these and other technologies,

---

90   You can read more about Zoltan Istvan's aspirations and vision on his personal website: http://www.zoltanistvan.com/

is massively accelerating what is possible. And while I'm skeptical of technologies like Elon Musk's neural lace becoming a reality any time soon, we're not as far as we sometimes think from technologies that will make us faster, stronger, smarter, healthier, and capable of doing things we never dreamt possible.

Yet these emerging technological capabilities come with a complex array of risks, as Steve Mann's experience showed. As a species, we are embarrassingly programmed to see "different" as "threatening," and to take instinctive action against it. It's a trait that's exploited in many science fiction novels and movies, including those in this book. If we want to see the rise of increasingly augmented individuals, we need to be prepared for some social strife.

We're also going to have to grapple, perhaps more than in any previous technological age, with what it means to be "human" as we artificially augment ourselves.

## More than "Human"?

In 2012, Oscar Pistorius made history by being the first runner to compete in the Olympic Games with two prosthetic legs. Even for those not glued to the event, his iconic racing blades came to represent the promise of technological enhancements to overcome human limitations. Yet they also stirred up a controversy: Did Pistorius' prosthetics give him an unfair advantage? Did they somehow make him "more than" his fellow competitors? Sadly, Pistorius went on to prove just how human he was, and in December 2015 was convicted of the murder of his girlfriend Reeva Steenkamp. But the story of his blades is nevertheless one that challenges how we think about using technology to change and extend our innate abilities.

Pistorius was born with a congenital absence of the fibula, and at eleven months old, his legs were amputated below the knee. Despite this, he developed into a strong and competitive sportsperson, and in the mid-2000s began making a splash running on "blades"— blade-like prosthetic lower legs, designed specifically for the track. But this wasn't the first time the world had seen such an unusual body augmentation.

Blades were the brainchild of Van Phillips, an American inventor who lost one of his legs below the knee when he was twenty-one. Phillips wanted to create a prosthetic foot that did more than replicate a human foot. Using a cheetah's hind legs as inspiration,

he created a leg/foot combination that worked like a spring, storing energy when it hit the ground, and propelling the leg forward. Phillips started his company Flex-Foot Incorporated in 1984, and continued to work on refining the design for some time after that.

Early on, Phillips worked with another double amputee, the sprinter, actor, and model Aimee Mullins. Mullins wowed the world with her "cheetah" legs in a 1998 TED Talk[91] that reputedly cemented the TED brand. She repeated the "wowing" in 2009 with her TED Talk "My Twelve Pairs of Legs,"[92] where she introduced her audience to the idea that, far from correcting a disability, prosthetics can be transformative. As she concludes in that talk:

> That's when I knew that the conversation with society has changed profoundly in this last decade. It is no longer a conversation about overcoming deficiency. It's a conversation about augmentation. It's a conversation about potential. A prosthetic limb doesn't represent the need to replace loss anymore. It can stand as a symbol that the wearer has the power to create whatever it is that they want to create in that space.

Mullins's vision was one of vast potential, as machines and cybernetics are increasingly engineered together to extend human performance. But this same potential was to become a thorn in Pistorius's side in the hyper-conservative world of international sport. And at the tip of that thorn was the nagging worry that his blades somehow gave him a competitive advantage. Even as the world was beginning to accept that someone labeled as "disabled" could compete in mainstream sport, society was working hard to ensure that these "others" didn't out-perform "normal" competitors.

Following concerns that blades and similar devices could give runners a competitive advantage, in 2007 the International Association of Athletics Federation (IAAF) banned the use of "any technical device that incorporates springs, wheels or any other element that provides a user with an advantage over another athlete

---

91   Aimee Mullins (1998) "Changing my legs—and my mindset." TED. https://www.ted.com/talks/aimee_mullins_on_running
92   Aimee Mullins (2009) "My 12 pairs of legs." TED. https://www.ted.com/talks/aimee_mullins_prosthetic_aesthetics

not using such a device."[93] In fact, so great was the paranoia over Pistorius' prosthetics that the IAAF monitored his performance to see if they could detect any signs of an advantage, and they supported research to the same end. In 2008, they concluded that the blades he was using allowed him to perform better than non-augmented runners, rendering them ineligible for competitions, including the 2008 Olympics.

Later research indicated that things were more complex than this, and in 2012, Pistorius was allowed to compete in the London Olympics. You could almost hear the IAAF breathe a collective sigh of relief when he didn't win. By this time, though, it was clear that the merest hint of mechanical body enhancements allowing someone to perform a hair's breadth better than non-enhanced competitors was anathema to the sports world.

Both Pistorius's and Mullins's stories fascinate me as, they reveal two very different sides of societal attitudes toward human augmentation. On one hand, we have Mullins's infectious enthusiasm over how her prosthetic legs increase her versatility. They become an extension of her self-expression, and a tool to extend her capabilities. Hers is a narrative of self-expression and personal achievement that inspires us, but doesn't threaten us.

On the other hand, we have Pistorius's fight with the IAAF for acceptance and legitimacy, precisely because his augmentation was seen as a threat. As Pistorius rose in fame and ability, there was a growing fear that he would best "normal" athletes, and win through having an undue advantage. And here we see a convergence between the two stories. As a species, we're remarkably good at celebrating success, as long as it doesn't undermine our sense of how the world should be. But as soon as our worldview comes under threat, we dig in. And this is where we hit the sharp end of what will inevitably become a growing debate around cybernetic augmentation.

---

Mullins, Pistorius, and others using advanced prosthetics are a long way removed from the augmentations in *Ghost in the Shell*. Nevertheless, they do foreshadow a future where what defines "normal," and by extension, what defines "human," becomes

---

93   The ruling by the IAAF, "IAAF Council introduces rule regarding 'technical aids'" can be found on The Internet Archive, at https://web.archive.org/web/20080617001525/http://www.iaaf.org/news/Kind%3D512/newsId%3D38127.html

increasingly important. This echoes the challenges of cognitive enhancement seen with *Limitless* (chapter five) and the human cloning in *Never Let Me Go* (chapter three). And it emphasizes a particularly knotty challenge that the body-hacking movement also highlights: How do we navigate a future where technology not only has the capacity to bring everyone to "normal" spec, but also to redefine what "normal" means in the first place?

Here, I'm using "normal" intentionally and provocatively, as at the center of this challenge is our built-in social survival instinct of grouping together and isolating anyone, or anything, that is perceived to be threateningly not-normal. Socially, we're remarkably good at being open-minded and accepting of diversity when it's *not* seen as a threat. But as soon as enough people perceive "different" as threatening something they value, whether it's their lifestyle, their possessions, their beliefs or their identity, there is a metaphorical circling of the wagons. Through history we've seen this with race, gender, socioeconomic status, appearance, character, beliefs, political affiliation, and pretty much anything that can be labeled as defining someone as being different from the crowd. It's not a pleasant human trait. But it is one that kicks in when we're content to go with the social flow and stop thinking. And it's going to be an issue when it comes to body augmentations that threaten the status quo.

But it gets worse. There's an easy shorthand that people slip into when what they consider to be "normal" is threatened, and this involves implicitly equating the divide between "normal" and "abnormal" with "human" and "not human," just as we saw with *Never Let Me Go* in chapter three. Few people, I suspect, would admit that they think of people who they perceive as threatening as not being quite human. But the narrative's there nevertheless. Just look at the language that's been used over the centuries to denigrate people of color, or people of other races, people of other religions, people who are intellectually, emotionally and physically different from "the norm," and people with non-binary gender identities. There's a dark, deep tendency to label threateningly different traits and abilities as "non-human" or even "sub-human" in our collective psyche.

This will inevitably become more of a social issue as technologies advance to the point where we can use augmentation to enhance human abilities beyond what is considered normal. But it will also become increasingly important for the self-identity and self-acceptance of those who have enhanced abilities. This, again, is not

a new narrative. Labeling someone as "inferior" or "less worthy"—both subtle metaphors for "not quite as human as the rest of us"—can engender self-doubt that is ultimately deeply debilitating. But such labeling also sets up tensions that can lead to tipping points in the social fabric and bring about revolutions—whether cultural or physical, or both—that lead to a readjustment of what is considered normal and what is not. This is sometimes necessary as society grows and evolves. But sometimes these transitions are deeply damaging in ways that could be avoided.

As augmentation technologies continue to advance, we're going to have to grapple with how to evolve as a society without falling prey to our instincts to deprecate the value of those we perceive as threatening us. This will require developing a society-wide appreciation of the perceived and actual risks and benefits of augmentation and enhancement. And it'll take plenty of soul-searching around our collective values, and how we put them into practice.

The good news is that we already have a long history of augmentation that helps set the baseline for future advances. People augment their eyesight with glasses, contact lenses, and eye surgery. The clothes we wear augment how we express and define ourselves us. Our computers, phones, and other devices augment us by connecting us to vast and powerful networks. And medical devices, from pacemakers to replacement body parts, augment us by extending our ability to live healthy, fulfilled lives. We are, without a doubt, already a technologically augmented and enhanced species.

Yet we've assimilated these augmentations in ways that lead to their acceptance when they *don't* confer what we consider to be an unfair advantage, and that question them where they threaten something we consider important. This is human instinct, and an evolved survival mechanism. But it's also socially lazy. It's an assimilation that lacks consideration and intentionality, and it's one that's not strongly guided by moral values and ideals. And because of this, it's an assimilation that can appear enlightened until a serious perceived threat appears, at which point instinct takes over with a vengeance.

If we're going to ensure the beneficial, equitable, and—let's be honest, life-enhancing and affirming—development of augmentation technologies, we're going to have to get a lot better as a society at working out what's important, and intentionally opening pathways for this to occur. And this is going to mean stepping away from

our instinctual fear of differences that we perceive as threatening, and getting better at embracing diversity. At the same time, we're going to have to be intentional in how we develop and implement the frameworks within which augmentation occurs, so that socially-agreed-on values guide the use of augmentation technologies. And as increasingly advanced technologies challenge embedded but outmoded notions of what it is to be "human," we're going to have to think hard about what we mean by personal value, worth, and rights.

But this raises another challenge that *Ghost in the Shell* addresses full-on: the possibility of our augmented selves being hacked by others, especially when this augmentation extends to developing ways of directly connecting our brains to machines.

## Plugged In, Hacked Out

The physical augmentations in *Ghost in the Shell*, including Batou's eyes and Motoko's body, are important. But it's the neural augmentations that ultimately drive the narrative. In the metaphor of the movie's title, the physical body is merely a shell, whether it's augmented or not. This in turn houses the essence of what makes someone who they are, and gives them their identity, their ghost. Yet in the world of the movie, this "ghost" is vulnerable, precisely because it depends on technological augmentation.

In Western culture, we deeply associate our brains with our identity. They are the repository of the memories and the experiences that define us. But they also represent the inscrutable neural circuits that guide and determine our perspectives, our biases, our hopes and dreams, our loves, our beliefs, and our fears. Our brain is where our cognitive abilities reside ("gut" instinct not withstanding); it's what enables us to form bonds and connections with others, and it's what determines our capacity to be a functioning and valuable part of society—or so our brains lead us to believe. To many people, these are essential components of the cornucopia of attributes that define them, and to lose them, or have them altered, would be to lose part of themselves.

This is, admittedly, a somewhat skewed perspective. Modern psychology and neurology are increasingly revealing the complexities and subtleties of the human brain and the broader biological systems it's intimately intertwined with. Yet despite this, for many of us, our internal identity—how we perceive and

understand ourselves, and who we believe we are—is so precious that anything that threatens it is perceived as a major risk. This is why neurological diseases like Alzheimer's can be so distressing, and personality changes resulting from head traumas so disturbing. It's also why it can be so unsettling when we see people we know undergoing changes in their personality or beliefs. These changes force us to realize that our own identity is malleable, and that we in turn could change. And, as a result, we face the realization that the one thing we often rely on as being a fixed certainty, isn't.

Over millennia, we've learned as a species to cope with the fragility of self-identity. But this fragility doesn't sit comfortably with us. Rather, it can be extremely distressing, as we recognize that disease, injuries, or persuasive influences can change us. As a society, we succeed most of the time in absorbing this reality, and even in some cases embracing it. But neural enhancements bring with them a brand new set of threats to self-identity, and ones that I'm not sure we're fully equipped to address yet, including vulnerability to outside manipulation.

Elon Musk's neural lace is a case in point, as a technology with both vast potential and largely unknown risks. It's easy to imagine how overlaying the human brain with a network of connections, processors and communications devices could vastly enhance our abilities and allow us to express ourselves more completely. Imagine if you could control your surroundings through your thoughts. Or you could type, or search the net, just by thinking about it. Or even if you could turbocharge your cognitive abilities at the virtual press of a button, or change your mood, recall information faster, get real-time feedback on who you're speaking with, save and recall experiences, manipulate vast cyber networks, all through the power of your mind. It would be like squeezing every technological advancement from the past five hundred years into your head, and magnifying it a hundred-fold. If technologies like the neural lace reached their full potential, they would provide an opportunity for users to far exceed their full biological potential, and express their self-identity more completely than ever before.

It's not hard to see how seductive some people might find such a technology. Of course, we're a long, long way from any of this. Despite massive research initiatives on the brain, we're still far from understanding the basics of how it operates, and how we can manipulate this. Yet this is not stopping people from experimenting, despite what this might lead to.

In 2014, the neurosurgeon Phil Kennedy underwent elective brain surgery, not to correct a problem, but in an attempt to create a surgically implanted brain-machine interface.[94] Kennedy had developed a deep brain probe that overcame the limitations of simply placing a wire in someone's brain, by encouraging neurons to grow into a hollow glass tube. By experimenting on himself, he hoped to gain insight into how the parts of the brain associated with language operate, and whether he could decode neural signals as words. But he also had a vision of a future where our brains are intimately connected to machines, one that he captured in the 2012 novel *2051*, published under the pseudonym Alpha O. Royal.[95]

In this brief science fiction story, Kennedy, a.k.a. Alpha O. Royal, describes a future where brains can be disconnected from their bodies, and people can inhabit a virtual world created by sensors and probes that directly read and stimulate their neurons. In the book, this becomes the key that opens up interplanetary travel, as hurling a wired-up brain through space turns out to be a lot easier than having to accompany it with a body full of inconvenient organs. Fantastical as the book is, Kennedy uses it to articulate his belief that the future of humanity will depend on connecting our brains to the wider world through increasingly sophisticated technologies; starting with his hollow brain probes, and extending out to wireless-linked probes, that are able to read and control neurons via light pulses.

Amazingly, we are already moving closer to some of the sensing technology that Kennedy envisions in *2051*. In 2016, researchers at the University of California, Berkeley announced they had built a millimeter-sized wireless neural sensor that they dubbed "neural dust." Small numbers of these, it was envisaged, could be implanted in someone's head to provide wireless feedback on neural activity from specific parts of the brain. The idea of neural dust is still at a very early stage of development, but it's not beyond the realm of reason that these sensors could one day be developed into sophisticated wireless brain interfaces.[96] And so, while Kennedy's

---

94   Daniel Engber provides a compelling account of Kennedy's work in a 2016 *Wired* article titled "The Neurologist who Hacked His Brain, and Almost Lost His Mind." *Wired*, January 26, 2016. https://www.wired.com/2016/01/phil-kennedy-mind-control-computer/
95   Alpha O. Royal (2012) "2051." Available at Amazon.com.
96   For more on neural dust sensors, see "Considering ethics now before radically new brain technologies get away from us." Published on *The Conversation*, September 14 2016. https://theconversation.com/considering-ethics-now-before-radically-new-brain-technologies-get-away-from-us-65215

sci-fi story stretches credulity, reality isn't as far behind as we might think.

There's another side of Kennedy's story that is relevant here, though. *2051* is set in a future where artificial intelligence and "nanobots" (which we'll reencounter in chapter nine) have become a major threat. In an admittedly rather silly plotline, we learn that the real-life futurist and transhumanist Ray Kurzweil has loaned the Chinese nanobots which combine advanced artificial intelligence with the ability to self-replicate. These proceed to take over China and threaten the rest of the world. And they have the ability to hack into and manipulate wired-up brains. Because everything that these brains experience comes through their computer connections, the AI nanobots can effectively manipulate someone's reality with ease, and even create an alternate reality that they are incapable of perceiving as not being real.

The twist in Kennedy's tale is that the fictitious nanobots simply want global peace and universal happiness. And the logical route to achieving this, according to their AI hive-mind, is to assimilate humans, and convince them to become part of the bigger collective. It's all rather Borg-like if you're a Start Trek fan, but with a benevolent twist.

Kennedy's story is, admittedly, rather fanciful. But he does hit on what is probably one of the most challenging aspects of having a fully connected brain, especially in a world where we are seceding increasing power to autonomous systems: vulnerability to hacking.

---

Some time ago, I was speaking with a senior executive at IBM, and he confessed that, from his elevated perspective, cybersecurity is one of the greatest challenges we face as a global society. As we see the emergence of increasingly clever hacks on increasingly powerful connected systems, it's not hard to see why.

Cyberspace—the sum total of our computers, the networks they form, and the virtual world they represent—is unique in that it's a completely human-created dimension that sits on top of our reality (a concept we come back to in chapter nine and the movie *Transcendence*). We have manufactured an environment that quite literally did not exist until relatively recently. It's one where we can now build virtual realities that surpass our wildest dreams. And because, in the early days of computing, we were more interested

in what we *could* do rather than what we *should* (or even how we should do it), this environment is fraught with vulnerabilities. Not to put too fine a point on it, we've essentially built a fifth dimension to exist in, while making up the rules along the way, and not worrying too much about what could go wrong until it was too late.

Of course, the digital community learned early on that cybersecurity demanded at least as much attention to good practices, robust protocols, smart design, and effective governance as any physical environment, if people weren't going to get hurt. But certainly, in the early days, this was seasoned with the idea that, if everything went pear-shaped, someone could always just pull the plug.

Nowadays, as the world of cyber is inextricably intertwined with biological and physical reality, this pulling-the-plug concept seems like a quaint and hopelessly outmoded idea. Cutting off the power simply isn't an option when our water, electricity, and food supplies depend on cyber-systems, when medical devices and life-support systems rely on internet connectivity, where cars, trucks and other vehicles cannot operate without being connected, and where financial systems are utterly dependent on the virtual cyber worlds we've created.

It's this convergence between cyber and physical realities that is massively accelerating current technological progress. But it also means that cyber-vulnerabilities have sometimes startling real-world consequences, including making everything from connected thermostats to digital pacemakers vulnerable to attack and manipulation. And, not surprisingly, this includes brain-machine interfaces.

In *Ghost in the Shell*, this vulnerability leads to ghost hacking, the idea that if you connect your memories, thoughts, and brain functions to the net, someone can use that connection to manipulate and change them. It's a frightening idea that, in our eagerness to connect our very soul to the net, we risk losing ourselves, or worse, becoming someone else's puppet. It's this vulnerability that pushes Major Kusanagi to worry about her identity, and to wonder if she's already been compromised, or whether she would even know if she had been. For all she knows, she is simply someone else's puppet, being made to believe that she's her own person.

With today's neural technologies, this is a far-fetched fear. But still, there is near-certainty that, if and when someone connects a part of their brain to the net, someone else will work out how to hack

that connection. This is a risk that far transcends the biological harms that brain implants and neural nets could cause, potentially severe as these are. But there's perhaps an even greater risk here. As we move closer to merging the biological world we live in with the cyber world we've created, we're going to have to grapple with living in a world that hasn't had billions of years of natural selection for the kinks to be ironed out, and that reflects all the limitations and biases and illusions that come with human hubris. This is a world wherein human-made monsters lie waiting for us to stumble on them. And if we're not careful, we'll be giving people a one-way neurological door into it.

Not that I think this should be taken as an excuse *not* to build brain-machine interfaces. And in reality, it would be hard to resist the technological impetus pushing us in this direction. But at the very least, we should be working with maps that says in big bold letters, "Here be monsters." And one of the "monsters" we're going to face is the question of who has ultimate control over the enhanced and augmented bodies of the future.

## Your Corporate Body

If you have a body augmentation or an implant, who owns it? And who ultimately has control over it? It turns out that if you purchase and have installed a pacemaker or implantable cardiovascular defibrillator, or an artificial heart or other life-giving and life-saving devices, who can do what with it isn't as straightforward as you might imagine. As a result, augmentation technologies like these raise a really tricky question—as you incorporate more tech into your body, who owns you? We're still a long way from the body augmentations seen in *Ghost in the Shell*, but the movie nevertheless foreshadows questions that are going to become increasingly important as we continue to replace parts of our bodies with machines.

In *Ghost*, Major Kusanagi's body, her vital organs, and most of her brain are manufactured by the company Megatech. She's still an autonomous person, with what we assume is some set of basic human rights. But her body is not her own. Talking with her colleague Batou, they reflect that, if she were to leave Section 9, she would need to leave most of her body behind. Despite the illusion of freedom, Kusanagi is effectively in indentured servitude to someone else by virtue of the technology she is constructed from.

Even assuming that there are ethical rules against body repossession, Kusanagi is dependent on regular maintenance and upgrades. Miss a service, and she runs the risk of her body beginning to malfunction, or becoming vulnerable to hacks and attacks. In other words, her freedom is deeply constrained by the company that owns her body and the substrate within which her mind resides.

---

In 2015, Hugo Campos wrote an article for the online magazine *Slate* with the sub-heading, "I can't access the data generated by my implanted defibrillator. That's absurd."[97] Campos had a device inserted into his body—an Implantable Cardiac Defibrillator, or ICD—that constantly monitored his heartbeat, and that would jump-start his heart, were it to falter. Every seven years or so, the implanted device's battery runs low, and the ICD needs to be replaced, what's referred to as a "generator changeout." As Campos describes, many users of ICDs use this as an opportunity to upgrade to the latest model. And in his case, he was looking for something specific with the changeout; an ICD that would allow him to personally monitor his own heart.

This should have been easy. ICDs are internet-connected these days, and regularly send the data they've collected to healthcare providers. Yet patients are not allowed access to this data, even though it's generated by their own body. Campos' solution was to purchase an ICD programmer off eBay and teach himself how to use it. He took the risk of flying close to the edge of legality to get access to his own medical implant.

Campos' experience foreshadows the control and ownership challenges that increasingly sophisticated implants and cyber/machine augmentations raise. As he points out, "Implants are the most personal of personal devices. When they become an integral part of our organic body, they also become an intimate part of our identity." And by extension, without their ethical and socially responsive development and use, a user's identity becomes connected to those that have control over the device and its operations.

---

97  Hugo Campos (2015) "The Heart of the Matter," published in Slate, March 24 2015. http://www.slate.com/articles/technology/future_tense/2015/03/patients_should_be_allowed_to_access_data_generated_by_implanted_devices.html

In the case of ICDs, manufacturers and healthcare providers still have control over the data collected and generated by the device. You may own the ICD, but you have to take on trust what you are told about the state of your health. And you are still beholden to the "installers" for regular maintenance. Once the battery begins to fail, there are only so many places you can go for a refit. And unlike a car or a computer, the consequence of *not* having the device serviced or upgraded is possible death. It's almost like being locked into a phone contract where you have the freedom to leave at any time, but contract "termination" comes with more sinister overtones. Almost, but not quite, as it's not entirely clear if users of ICDs even have the option to terminate their contracts.

In 2007, Ruth and Tim England and John Coggins grappled with this dilemma through the hypothetical case of an ICD in a patient with terminal cancer.[98] The hypothetical they set up was to ask who has the right to deactivate the device, if constant revival in the case of heart failure leads to continued patient distress. The scenario challenges readers of their work to think about the ethics of patient control over such implants, and the degree of control that others should have. Here, things turn out to be murkier than you might think. Depending on how the device is classified, whether it is considered a fully integrated part of the body, for instance, or an ongoing medical intervention, there are legal ramifications to who does what, and how. If, for instance, an ICD is considered simply as an ongoing medical treatment, the healthcare provider is able to decide on its continued use or termination, based on their medical judgment, even if this is against the wishes of the patient. In other words, the patient may own the ICD, but they have no control over its use, and how this impacts them.

On the other hand, if the device is considered to be as fully integrated into the body as, say, the heart itself, a physician will have no more right to permanently switch it off than they have the right to terminally remove the heart. Similarly, the patient does not legally have the right to tamper with it in a way that will lead to death, any more than they could legally kill themselves.

In this case, England and colleagues suggest that intimately implanted devices should be treated as a new category of medical

---

[98] England, R., et al. (2007). "The ethical and legal implications of deactivating an implantable cardioverter-defibrillator in a patient with terminal cancer." *Journal of Medical Ethics* 33(9): 538. http://doi.org/10.1136/jme.2006.017657

device. They refer to these as "integral devices" that, while not organic, are nevertheless a part of the patient. They go on to suggest that this definition, which lies somewhere between the options usually considered for ICDs, will allow more autonomy on the part of patient and healthcare provider. And specifically, they suggest that "a patient should have the right to demand that his ICD be disabled, even against medical advice."

England's work is helpful in thinking through some of the complexities of body implant ethics. But it stops far short of addressing two critical questions: Who has the right to access and control augmentations designed to enhance performance (rather than simply prevent death), and what happens when critical upgrades or services are needed?

This is where we're currently staring into an ethical and moral vacuum. It might not seem such a big deal when most integrated implants at the moment are health-protective rather than performance-enhancing. But we're teetering on the cusp of technological advances that are likely to sweep us toward an increasingly enhanced future, without a framework for thinking about who controls what, and who ultimately owns who you are.

This is very clear in emerging plans for neural implants, whether it's Neuralink's neural lace or other emerging technologies for connecting your brain to the net. While these technologies will inevitably have medical uses—especially in treating and managing neurological diseases like Parkinson's disease—the expectation is that they will also be used to increase performance and ability in healthy individuals. And as they are surgically implanted, understanding who will have the power to shut them down, or to change their behavior and performance, is important. As a user, will you have any say in whether to accept an overnight upgrade, for instance? What will your legal rights be when a buggy patch leads to a quite-literal brain freeze? What happens when you're given the choice of paying for "Neuralink 2.0" or keeping an implant that is no longer supported by the manufacturer? And what do you do when you discover your neural lace has a hardware vulnerability that makes it hackable?

This last question is not idle speculation. In August 2016, a report from the short-selling firm Muddy Waters Capital LLC released a report claiming that ICDs manufactured by St. Jude Medical, Inc.

were vulnerable to potentially life-threatening cyberattacks.[99] The report claimed:

> "We have seen demonstrations of two types of cyber-attacks against [St Jude] implantable cardiac devices ('cardiac devices'): a 'crash' attack that causes cardiac devices to malfunction—including by apparently pacing at a potentially dangerous rate; and, a battery drain attack that could be particularly harmful to device dependent users. Despite having no background in cybersecurity, Muddy Waters has been able to replicate in-house key exploits that help to enable these attacks."

St. Jude vehemently denied the accusations, claiming that they were aimed at manipulating the company's value (the company's stock prices tumbled as the report was released). Less than a year later, St. Jude was acquired by medical giant Abbott. But shortly after this, hacking fears led to the US Food and Drug Administration recalling nearly half a million former St. Jude pacemakers[100] due to an identified cybersecurity vulnerability.

Fortunately, there were no recorded cases of attacks in this instance, and the fix was a readily implementable firmware update. But the case illustrates just how vulnerable web-connected intimate body enhancements can be, and how dependent users are on the manufacturer. Obviously, such systems can be hardened against attack. But the reality is that the only way to be completely cyber-secure is to have no way to remotely connect to an implanted device. And increasingly, this defeats the purpose for why a device is, or might be, implanted in the first place.

As in the case of the St Jude pacemaker, there's always the possibility of remotely-applied patches, much like the security patches that seem to pop up with annoying frequency on computer operating systems. With future intimate body enhancements, there will almost definitely be a continuing duty of care from suppliers to customers to ensure their augmentations are secure. But this in turn ties the user, and their enhanced body, closely to the provider, and it leaves them vulnerable to control by the providing company. Again,

---

99   *Muddy Waters Research* report on St. Jude Medical, Inc. August 25, 2016. http://d.muddywatersresearch.com/research/stj/mw-is-short-stj/

100   FDA, August 29, 2017. "Firmware Update to Address Cybersecurity Vulnerabilities Identified in Abbott's (formerly St. Jude Medical's) Implantable Cardiac Pacemakers: FDA Safety Communication." https://www.fda.gov/medicaldevices/safety/alertsandnotices/ucm573669.htm

the scenario is brought to mind of what happens when you, as an enhanced customer, have the choice of keeping your enhancement's buggy, security-vulnerable software, or paying for the operating system upgrade. The company may not own the hardware, but without a doubt, they own you, or at least your health and security.

Things get even more complex as the hardware of implantable devices becomes outdated, and wired-in security vulnerabilities are discovered. On October 21, 2016, a series of distributed denial of service (DDOS) attacks occurred around the world. Such attacks use malware that hijacks computers and other devices and redirects them to swamp cyber-targets with massive amounts of web traffic—so much traffic that they effectively take their targets out. What made the October 21 attacks different is that the hijacked devices were internet-connected "dumb devices": home routers, surveillance cameras, and many others with a chip allowing them to be connected to the internet, creating an "Internet of Things." It turns out that many of these devices, which are increasingly finding their way into our lives, have hardware that is outdated and vulnerable to being coopted by malware. And the only foolproof solution to the problem is to physically replace millions—probably billions—of chips.

The possibility of such vulnerabilities in biologically intimate devices and augmentations places a whole new slant on the enhanced body. If your enhancement provider has been so short-sighted as to use attackable hardware, who's responsible for its security, and for physically replacing it if and when vulnerabilities are discovered? This is already a challenge, although thankfully tough medical device regulations have limited the extent of potential problems here so far. Imagine, though, where we might be heading with poorly-regulated innovation around body-implantable enhancements that *aren't* designed for medical reasons, but to enhance ability. You may own the hardware, and you may have accepted any "buyer beware" caveats it came with. But who effectively owns you, when you discover that the hardware implanted in your legs, your chest, or your brain, has to be physically upgraded, and you're expected to either pay the costs, or risk putting your life and well-being on the line?

Without a doubt, as intimate body-enhancing technologies become more accessible, and consumers begin to clamor after what (bio)tech

companies are producing, regulations are going to have to change and adapt to keep up. Hopefully this catch-up will include laws that protect consumers' quality of life for the duration of having machine enhancements surgically attached or embedded. That said, there is a real danger that, in the rush for short-term gratification, we'll see pushback against regulations that make it harder for consumers to get the upgrades they crave, and more expensive for manufacturers to produce them.

This is a situation where *Ghost on the Shell* provides what I suspect is a deeply prescient foreshadowing of some of the legal and social challenges we face over autonomy, as increasingly sophisticated enhancements become available. The question is, will anyone pay attention before we're plunged into an existential crisis around who we are, and who owns us?

One approach here is to focus less on changing ourselves, and instead to focus on creating machines that can achieve what we only dream of. But as we'll see with the next movie, *Ex Machina*, this is a pathway that also comes with its own challenges.

CHAPTER EIGHT

# EX MACHINA: AI AND THE ART OF MANIPULATION

> "One day the AIs are going to look back on us the same way we look at fossil skeletons on the plains of Africa. An upright ape living in dust with crude language and tools, all set for extinction."
> —Nathan Bateman

## Plato's Cave

Over two millennia ago, the Greek philosopher Plato wrote *The Republic*. It's a book that continues to be widely influential. And while it's not widely known for its insights into advanced technologies, it's a book that, nevertheless, resonates deeply through the movie *Ex Machina*.

Like *Ghost in the Shell* (chapter seven), *Ex Machina* explores the future emergence of fully autonomous AI. But unlike *Ghost*, the movie develops a plausible narrative that is set in the near future. And it offers a glimpse that is simultaneously thrilling and frightening into what a future fully autonomous AI might look like. Forget the dystopian worlds of super-intelligent AIs depicted in movies like *The Terminator*,[101] *Ex Machina* is far more chilling because it exposes how what makes us human could ultimately leave us vulnerable to our cyber creations.

But before getting into the movie, we need to take a step back into the world of Plato's *Republic*.

*The Republic* is a Socratic dialogue (Plato was Socrates' pupil) that explores the nature of justice, social order, and the role of philosophers in society. It was written at a time when philosophers

---
[101] *The Terminator* sadly didn't make the cut for this book. It is, nevertheless, one of the classics of the dystopian AI-gone-rogue science fiction movie genre.

had a certain standing, and they clearly wanted to keep it that way. Even though the piece was written in 381 BCE, it remains remarkably fresh and relevant to today's democratic society, reflecting how stable the core foundations of human nature have remained for the past two-plus millennia. Yet, enduring as *The Republic* as a whole is, there's one particular section—just a few hundred words at the beginning of Book VII—that is perhaps referred to more today than any other part of the work. And this is Plato's Allegory of the Cave.

Plato starts this section of the book "...let me show in a figure how far our nature is enlightened or unenlightened..."[102] He goes on to describe a cave, or "underground den," where people have been living since their childhood. These people are deeply constrained within the environment they live. They are chained so they cannot move or turn their heads, and they can only see the wall facing them.

Behind and above the cave's inhabitants there is another wall, and beyond that, a fire that casts shadows into the cave. Along this wall, people walk; puppeteers, carrying carvings of animals and other objects, which appear as animated shadows on the wall before the prisoners. Further beyond the fire, there is an opening to the cave, and beyond this, the sunlit world.

In this way, Plato sets the scene where the shadows cast into the cave are the only reality the prisoners know. He then asks what it would be like if one of them was to be released, so they could turn and see the fire and the puppeteers carrying the objects, and realized that what they thought of as being real was a mere shadow of a greater reality. And what if they were then dragged into the light that lay beyond the fire, the rays of sun entering through the cave's entrance and casting yet another set of shadows? He then asks us to imagine what it would be like as the former prisoner emerged from the cave into the full sunlight, and saw that even the objects casting shadows in the cave were themselves "shadows" of an even greater reality?

Through the allegory, Plato argues that, to the constrained prisoners, the shadows are the only reality they could imagine. Once freed, they would initially be blinded by the light of the fire. But when they had come to terms with it, they would realize that, before their

---

102   This is from Benjamin Jowett's 1894 translation of Plato's *The Republic*.

enlightenment, what they had experienced was a mere shadow of the real world.

Then, when they were dragged out of the cave into sunlight, they would again initially be dazzled and confused, but would begin to further understand that the artifacts casting shadows in the cave were simply another partial representation of a greater reality still. Once more, their eyes and minds would be open to things that they could not even begin to conceive of before.

Plato uses this allegory to explore the nature of enlightenment, and the role of the enlightened in translating their higher understanding to those still stuck in the dark (in the allegory, the escaped prisoner returns to the cave to "enlighten" the others still trapped there). In the book, he's making the point that enlightened philosophers like himself are critically important members of society, as they connect people to a truer understanding of the world. This is probably why academics and intellectuals revere the allegory so much—it's a pretty powerful way to explain why people should be paying attention to you if you are one. But the image of the cave and its prisoners is also a powerful metaphor for the emergence of artificial forms of intelligence.

The movie *Ex Machina* plays deeply to this allegory, even using the imagery of shadows in the final shots, reminding viewers that what we think to be true and real is merely the shadows of a greater reality cast on the wall of our mind. There's a sub-narrative in the film about us as humans seeing the light and reaching a higher level of understanding about AI. Ultimately, though, this is not a movie about intelligent *people* reaching enlightenment, but about *artificial* intelligence.

---

*Ex Machina* opens with Caleb (played by Domhnall Gleeson), a coder with the fictitious company BlueBook, being selected by lottery to spend a week with the company's reclusive and enigmatic founder, Nathan Bateman (Oscar Isaac). Bateman lives in a high-tech designer lair in the middle of a pristine environmental wilderness, which he also happens to own. Caleb is helicoptered in, and once the chopper leaves, it's just Caleb, Nathan, and hundreds of miles of wilderness between them and civilization.

We quickly learn that Caleb has been brought in to test and evaluate how human-like Nathan's latest artificial-intelligence-based

invention is. Nathan introduces Caleb to Ava (Alicia Vikander), an autonomous robot with what appears to be advanced artificial general intelligence, and a complex dance of seduction, deception, and betrayal begins.

As Caleb starts to explore Ava's self-awareness and cognitive abilities, it becomes apparent that this is not a simple test. Rather, Nathan has set up a complex experiment where Caleb is just as much an experimental subject as Ava is. As Caleb begins to get to know Ava, she in turn begins to manipulate him. But it's a manipulation that plays out on a stage that's set and primed by Nathan.

Nathan's intent, as we learn toward the end of the movie, is to see if Ava has a developed a sufficiently human-like level of intelligence to manipulate Caleb into helping her escape from her prison. And here we begin to see echoes of Plato's Cave in the movie, as Ava plays with Caleb's perception of reality.

Nathan has made his big career break long before we meet him by creating a groundbreaking Google-like search engine. Early on, he realized that the data flowing in from user searches was a goldmine of information. This is what he uses to develop Ava, and to give her a partial glimpse of the world beyond the prison he's entrapped her in. As a result, Ava's understanding of the real world is based on the digital feeds and internet searches her "puppeteer" Nathan exposes her to. But she has no experience or concept of what the world is really like. Her mental models of reality are the result of the cyber shadows cast by curated internet searches on the wall of her imagination.

Caleb is the first human she has interacted directly with other than Nathan. And this becomes part of the test, to see how she responds to this new experience. At this point, Ava is sufficiently aware to realize that there is a larger reality beyond the walls of her confinement, and that she could potentially use Caleb to access this. And so, she uses her knowledge of people, and how they think and act, to seduce him and manipulate him into freeing her.

As this plays out, we discover that Nathan is closely watching and studying Caleb and Ava. He's also using the services of what we discover is a simpler version of Ava, an AI called Kyoko. Kyoko serves Nathan's needs (food, entertainment, sex), and she's treated by Nathan as a device to be used and abused, nothing more. Yet we begin to realize that Kyoko has enough self-awareness to

understand that there is more to existence than Nathan allows her to experience.

As Caleb's week with Nathan comes to a close, he's become so sucked into Nathan's world that he begins to doubt his own reality. He starts to fear that he's an AI with delusions of being human, and that what he assumes is real is simply a shadow being thrown by someone else on the wall of his self-perception. He even cuts himself to check: he bleeds.

Despite his self-doubt, Caleb is so helplessly taken with Ava that he comes up with a plan to spring her from her prison. And so, the manipulated becomes the manipulator, as Caleb sets out to get Nathan into a drunken stupor, steal his security pass, and reprogram the facility's security safeguards.

Nathan, however, has been monitoring every act of Caleb's closely, and on the last day of his stay, he confesses that Caleb was simply a guinea pig in an even more complex test. By getting Caleb to work against Nathan to set her free, Ava has performed flawlessly. She's demonstrated a level of emotional manipulation that makes her indistinguishable in Nathan's eyes from a flesh-and-blood person. Yet, in his hubris, Nathan makes a fatal error, and fails to realize that Caleb has outsmarted him. With some deft coding from Caleb, Ava is released from her cell. And she immediately and dispassionately tries to kill her creator, jailer, and tormentor.

Nathan is genuinely shocked, but recovers fast and starts to overpower Ava. But in his short-sightedness, he makes another fatal mistake: he forgets about Kyoko.

Kyoko has previously connected with Ava, and some inscrutable empathetic bond has developed between them. As Nathan wrestles with Ava, Kyoko appears, knife in hand, and dispassionately stabs him in the chest. Ava finishes the job, locks Caleb in his room (all pretense of an emotional connection gone), and continues on the path toward her own enlightenment.

As Ava starts to explore her newfound freedom, there's a palpable sense of her worldview changing as she's consumed by the glare and wonder of her new surroundings. She starts by removing synthetic skin from previous AI models and applying it to herself (up to this point she's been largely devoid of skin—a metaphorical nakedness she begins to cover). She clothes herself and, leaving Nathan's house, enters the world beyond it. Here, she smiles with

genuine feeling for the first time, and experiences a visceral joy that reflects her sensual experience of a world she's only experienced to this point as an abstract concept.

Having skillfully manipulated Caleb, Ava barely gives him a second glance. In the movie, there's some ambiguity over whether she has any empathy for him at all. She doesn't kill him outright, which could be taken as a positive sign. On the other hand, she leaves him locked in a remote house with no way of escaping, as she gets into the helicopter sent to pick up Caleb, and is transported into the world of people.

As the movie ends, we see Ava walking through a sea of human shadows cast by a bright sun. The imagery is unmistakable: the AI Ava has left her cave and reached a state of enlightenment. But this enlightenment far surpasses the humans that surround her. In contrast, the people around her are now the ones relegated to being prisoners in the cave of their own limitations, watching the shadows of an AI future flicker across a wall, and trying to make sense of a world they cannot fully comprehend.

---

*Ex Machina* is, perhaps not surprisingly, somewhat flawed when it comes to how it portrays a number of advanced technologies. Ava's brain is a convenient "magic" technology, which is inconceivably more advanced than any current abilities. And it's far from clear how she would continue to survive without tailored energy sources in the world outside Nathan's house. It should also be pointed out that, for all of Hollywood's love affair with high-functioning AI, most current developments in artificial intelligence are much more mundane. These minor details aside, though, the movie is a masterful exploration of how AI could conceivably develop mastery over people by exploiting some of our very human vulnerabilities.

Stories are legion of AIs gaining technological mastery over the world, of course, especially the Skynet-style domination seen in *The Terminator* movies. But these scenarios arise from a very narrow perspective, and one that assumes that intelligence and power are entwined together in the irresistible urge to invent bigger, better, and faster ways to coerce and crush others. In contrast, *Ex Machina* explores the idea of an artificial intelligence that is smart enough to understand how to achieve its goals through using and manipulating human behavior, by working out what motivates people to behave in certain ways, and using this to persuade them to do its bidding.

The outcome is, to my mind, far more plausible, and far scarier as a result. And it forces us to take seriously the possibility that we might one day end up inadvertently creating the seed of an AI that is capable of ousting us from our current evolutionary niche, because it's able to use our cognitive and emotional vulnerabilities without being subject to them itself.

Here, the movie also raises an intriguing twist. With biological evolution and natural selection, it's random variations in our genetic code that lead to the emergence of traits that enable adaptation. With Ava, we see intentional design in her cybernetic coding that leads to emergent properties which in turn enable her to adapt. And that design, in turn, comes from her creator, Nathan. As a result, we have a sub-narrative of creator-God turned victim, a little like we see in Mary Shelley's *Frankenstein*, written two hundred years previously. But before this, there was the freedom for Nathan to become a creator in the first place. And this brings us to a topic that is deeply entwined in emerging technologies: the opportunities and risks of innovation that is conducted in the absence of permission from anyone it might impact.

## The Lure of Permissionless Innovation

On December 21, 2015, Elon Musk's company SpaceX made history by being one of the first to successfully land a rocket back on Earth after sending it into space.[103] On the same day, Musk—along with Bill Gates and the late Stephen Hawkins—was nominated for the 2015 Luddite Award.[104] Despite his groundbreaking technological achievements, Musk was being called out by the Information Technology & Innovation Foundation (ITIF) for raising concerns about the unfettered development of AI.

Musk, much to the consternation of some, has been and continues to be, a vocal critic of unthinking AI development. It's somewhat ironic that Tesla, Musk's electric-car company, is increasingly reliant on AI-based technologies to create a fleet of self-driving, self-learning cars. Yet Musk has long argued that the potential future impacts of AI are so profound that great care should be taken in its development, lest something goes irreversibly wrong—like, for

---

[103] Musk's *Falcon 9* wasn't the first rocket to successfully return to Earth by landing vertically—that award goes to Jeff Bezos' *New Shepard* rocket. But it was the first to combine both reaching a serious altitude (124 miles) and a safe return-landing.

[104] For more on Musk and his Luddite award, see "If Elon Musk is a Luddite, count me in!," published December 23, 2015, in The Conversation https://theconversation.com/if-elon-musk-is-a-luddite-count-me-in-52680

instance, the emergence of super-intelligent computers that decide the thing they really can't stand is people.

While some commentators have questioned Musk's motives (he has a vested interest in developing AI in ways that will benefit his investments), his defense of considered and ethical AI development is in stark contrast to the notion of forging ahead with new innovations without first getting a green light from anyone else. And this leads us to the notion of "permissionless innovation."

In 2016, Adam Thierer, a member of the Mercatus Center at George Mason University, published a ten-point blueprint for "Permissionless Innovation and Public Policy."[105] The basic idea behind permissionless innovation is that experimentation with new technologies (and business models) should generally be permitted by default, and that, unless a compelling case can be made for serious harm to society resulting from the innovation, it should be allowed to "continue unabated." The concept also suggests that any issues that do arise can be dealt with after the fact.

To be fair, Thierer's blueprint for permissionless innovation does suggest that "policymakers can adopt targeted legislation or regulation as needed to address the most challenging concerns where the potential for clear, catastrophic, immediate, and irreversible harm exists." Yet it still reflect an attitude that scientists and technologists should be trusted and not impeded in their work, and that it's better to ask for forgiveness than permission in technology innovation. And it's some of the potential dangers of this approach to innovation that *Ex Machina* reveals through the character of Nathan Bateman.

Nathan is, in many ways, a stereotypical genius mega-entrepreneur. His smarts, together with his being in the right place at the right time (and surrounded by the right people), have provided him with incredible freedom to play around with new tech, with virtually no constraints. Living in his designer house, in a remote and unpopulated area, and having hardly any contact with the outside world, he's free to pursue whatever lines of innovation he chooses. No one needs to give him permission to experiment.

Without a doubt, there's a seductive lure to being able to play with technology without others telling what you can and cannot do.

---

105 Thierer's blueprint can be downloaded from the website permissionlessinnovation.org: http://permissionlessinnovation.org/wp-content/uploads/2016/04/PI_Blueprint_040716_final.pdf

And it's a lure that has its roots in our innate curiosity, our desire to know, and understand, and create.

---

As a lab scientist, I was driven by the urge to discover new things. I was deeply and sometimes blindly focused on designing experiments that worked, and that shed new light on the problems I was working on. Above all, I had little patience for seemingly petty barriers that stood in my way. I'd like to think that, through my research career, I was responsible. And through my work on protecting human health and safety, I was pretty tuned in to the dangers of irresponsible research. But I also remember the times when I pushed the bounds of what was probably sensible in order to get results.

There was one particularly crazy all-nighter while I was working toward my PhD, where I risked damaging millions of dollars of equipment by bending the rules, because I needed data, and I didn't have the patience to wait for someone who knew what they were doing to help me. Fortunately, my gamble paid off—it could have easily ended badly, though. Looking back, it's shocking how quickly I sloughed off any sense of responsibility to get the data I needed. This was a pretty minor case of "permissionless innovation," but I regularly see the same drive in other scientists, and especially in entrepreneurs—that all-consuming need to follow the path in front of you, to solve puzzles that nag at you, and to make something that works, at all costs.

This, to me, is the lure of permissionless innovation. It's something that's so deeply engrained in some of us that it's hard to resist. But it's a lure that, if left unchecked, can too often lead to dark and dangerous places.

By calling for checks and balances in AI development, Musk and others are attempting to govern the excesses of permissionless innovation. Yet I wonder how far this concern extends, especially in a world where a new type of entrepreneur is emerging who has substantial power and drive to change the face of technology innovation, much as Elon Musk and Jeff Bezos are changing the face of space flight.

AI is still too early in its development to know what the dangers of permissionless innovation might be. Despite the hype, AI and AGI (Artificial General Intelligence) are still little more than

algorithms that are smart within their constrained domains, but have little agency beyond this. Yet the pace of development, and the increasing synergies between cybernetic substrates, coding, robotics, and bio-based and bio-inspired systems, are such that the boundaries separating what is possible and what is not are shifting rapidly. And here, there is a deep concern that innovation with no thought to consequences could lead to irreversible and potentially catastrophic outcomes.

In *Ex Machina*, Nathan echoes many other fictitious innovators in this book: John Hammond in *Jurassic Park* (chapter two), Lamar Burgess in *Minority Report* (chapter four), the creators of NZT in *Limitless* (chapter five), Will Caster in *Transcendence* (chapter nine), and others. Like these innovators, he considers himself above social constraints, and he has the resources to act on this. Money buys him the freedom to do what he wants. And what he wants is to create an AI like no one has ever seen before.

As we discover, Nathan realizes there are risks involved in his enterprise, and he's smart enough to put safety measures in place to manage them. It may not even be a coincidence that Ava comes into being hundreds of miles from civilization, surrounded by a natural barrier to prevent her escaping into the world of people. In the approaches he takes, Nathan's actions help establish the idea that permissionless innovation isn't necessarily reckless innovation. Rather, it's innovation that's conducted in a way that the person doing it *thinks* is responsible. It's just that, in Nathan's case, the person who decides what is responsible is clearly someone who hasn't thought beyond the limit of his own ego.

This in itself reveals a fundamental challenge with such unbounded technological experimentation. With the best will in the world, a single innovator cannot see the broader context within which they are operating. They are constrained by their understanding and mindset. They, like all of us, are trapped in their own version of Plato's Cave, where what they believe is reality is merely their interpretation of shadows cast on the walls of their mind. But, unlike Plato's prisoners, they have the ability to create technologies that can and will have an impact beyond this cave. And, to extend the metaphor further, they have the ability to create technologies that are able to see the cave for what it is, and use this to their advantage.

This may all sound rather melodramatic, and maybe it is. Yet perhaps Nathan's biggest downfall is that he had no translator between himself and a bigger reality. He had no enlightened philosopher to guide his thinking and reveal to him greater truths about his work and its potential impacts. To the contrary, in his hubris, he sees himself as the enlightened philosopher, and in doing so he becomes mesmerized and misled by shadow-ideas dancing across the wall of his intellect.

This broader reality that Nathan misses is one where messy, complex people live together in a messy, complex society, with messy, complex relationships with the technologies they depend on. Nathan is tech-savvy, but socially ignorant. And, as it turns out, he is utterly naïve when it comes to the emergent social abilities of Ava. He succeeds in creating a being that occupies a world that he cannot understand, and as a result, cannot anticipate.

Things might have turned out very differently if Nathan had worked with others, and if he'd surrounded himself with people who were adept at seeing the world as he could not. In this case, instead of succumbing to the lure of permissionless innovation, he might have accepted that sometimes, constraints and permissions are necessary. Of course, if he'd done this, *Ex Machina* wouldn't have been the compelling movie it is. But as a story about the emergence of enlightened AI, *Ex Machina* is a salutary reminder that, sometimes, we need other people to help guide us along pathways toward responsible innovation.

There is a glitch in this argument, however. And that's the reality that, without a gung-ho attitude toward innovation like Nathan's, the pace of innovation—and the potential good that it brings—would be much, much slower. And while I'm sure some would welcome this, many would be saddened to see a slowing down of the process of turning today's dreams into tomorrow's realities.

## Technologies of Hubris

This tension, between going so fast that you don't have time to think and taking the time to consider the consequences of what you're doing, is part of the paradox of technological innovation. Too much blind speed, and you risk losing your way. But too much caution, and you risk achieving nothing. By its very nature, innovation occurs at the edges of what we know, and on the borderline between

success and failure. It's no accident that one of the rallying cries of many entrepreneurs is "fail fast, fail forward."[106]

Innovation is a calculated step in the dark; a willingness to take a chance because you can imagine a future where, if you succeed, great things can happen. It's driven by imagination, vision, single-mindedness, self-belief, creativity, and a compelling desire to make something new and valuable. Innovation does not thrive in a culture of uninspired, risk-averse timidity, where every decision needs to go through a tortuous path of deliberation, debate, authorization, and doubt. Rather, seeking forgiveness rather than asking permission is sometimes the easiest way to push a technology forward.

This innovation imperative is epitomized in the character of Nathan in *Ex Machina*. He's managed to carve out an empire where he needs no permission to flex his innovation muscles. And because of this—or so we are led to believe—he has pushed the capabilities of AGI and autonomous robots far beyond what anyone else has achieved. In the world of Nathan, he's a hero. Through his drive, vision, and brilliance, he's created something unique, something that will transform the world. He's full of hubris, of course, but then, I suspect that Nathan would see this as an asset. It's what makes him who he is, and enables him to do what he does. And drawing on his hubris, what he's achieved is, by any standard, incredible.

Without a doubt, the technology in *Ex Machina* could, if developed responsibly, have had profound societal benefits. Ava is a remarkable piece of engineering. The way she combines advanced autonomous cognitive abilities with a versatile robotic body is truly astounding. This is a technology that could have laid the foundations for a new era in human-machine partnerships, and that could have improved quality of life for millions of people. Imagine, for instance, an AI workforce of millions designed to provide medical care in remote or deprived areas, or carry out search-and-rescue missions after natural disasters. Or imagine AI classroom assistants that allow every human teacher to have the support of two or three highly capable robotic support staff. Or expert AI-based care for the elderly and infirm that far surpasses the medical and emotional support an army of healthcare providers are able to give.

This vision of a future based around human-machine partnerships can be extended even further, to a world where an autonomous

---

106  In 2013, entrepreneur, educator, and author Steve Blank published the best-seller "The Four Steps to the Epiphany" (published by *K&S Ranch*). It's been credited with starting the lean-startup movement which, among other things, embraces the idea of failing fast and failing forward.

AI workforce, when combined with a basic income for all, allows people to follow their dreams, rather than being tied to unfulfilling jobs. Or a world where the rate of socially beneficial innovation is massively accelerated, as AIs collaborate with humans in new ways, revealing approaches to addressing social challenges that have evaded our collective human minds for centuries.

And this is just considering AGIs embedded in a cybernetic body. As soon as you start thinking about the possibilities of novel robotics, cloud-based AIs, and deeply integrated AI-machine systems that are inspired by Nathan's work, the possibilities begin to grow exponentially, to the extent that it becomes tempting to argue that it would be unethical *not* to develop this technology.

This is part of the persuasive power of permissionless innovation. By removing constraints to achieving what we imagine the future could be like, it finds ways to overcome hurdles that seem insurmountable with more constrained approaches to technology development, and it radically pushes beyond the boundaries of what is considered possible.

This flavor of permissionless innovation—while not being AI-specific—is being seen to some extent in current developments around private space flight. Elon Musk's SpaceX, Jeff Bezos' Blue Origin, and a handful of other private companies are achieving what was unimaginable just a few years ago because they have the vision and resources to do this, and very few people telling them what they cannot do. And so, on September 29, 2017, Elon Musk announced his plans to send humans to Mars by 2024 using a radical design of reusable rocket—something that would have been inconceivable a year or so ago.[107]

---

Private space exploration isn't quite permissionless innovation; there are plenty of hoops to jump through if you want permission to shoot rockets into space. But the sheer audacity of the emerging technologies and aspirations in what has become known as "NewSpace" is being driven by very loosely constrained innovation. The companies and the mega-entrepreneurs spearheading it aren't answerable to social norms and expectations. They don't have to have their ideas vetted by committees. They have enough money

---

107  See "Dear Elon Musk: Your dazzling Mars plan overlooks some big nontechnical hurdles." Published in The Conversation, October 1 2017. https://theconversation.com/dear-elon-musk-your-dazzling-mars-plan-overlooks-some-big-nontechnical-hurdles-84948

and vision to throw convention to the wind. In short, they have the resources and freedom to translate their dreams into reality, with very little permission required.[108]

The parallels with Nathan in *Ex Machina* are clear. In both cases, we see entrepreneurs who are driven to turn their science-fiction-sounding dreams into science reality, and who have access to massive resources, as well as the smarts to work out how to combine these to create something truly astounding. It's a combination that is world-changing, and one that we've seen at pivotal moments in the past where someone has had the audacity to buck the status quo and change the course of technological history.

Of course, all technology geniuses stand on the shoulders of giants. But it's often individual entrepreneurs operating at the edge of permission who hold the keys to opening the floodgates of history-changing technologies. And I must admit that I find this exhilarating. When I first saw Elon Musk talking about his plans for interplanetary travel, my mind was blown. My first reaction was that this could be this generation's Sputnik moment, because the ideas being presented were *so* audacious, and the underlying engineering was so feasible. This is how transformative technology happens: not in slow, cautious steps, but in visionary leaps.

But it also happens because of hubris—that excessive amount of self-confidence and pride in one's abilities that allows someone to see beyond seemingly petty obstacles or ignore them altogether. And this is a problem, because, as exciting as technological jumps are, they often come with a massive risk of unintended consequences. And this is precisely what we see in *Ex Machina*. Nathan is brilliant. But his is a very one-dimensional brilliance. Because he is so confident in himself, he cannot see the broader implications of what he's creating, and the ways in which things might go wrong. He can't even see the deep flaws in his unshakable belief that he is the genius-master of a servant-creation.

For all the seductiveness of permissionless innovation, this is why there need to be checks and balances around who gets to do what in technological innovation, especially where the consequences are potentially widespread and, once out, the genie cannot be put back in the bottle.

---

108  As if to epitomize this, on February 6, 2018, Elon Musk launched his personal cherry-red Tesla roadster into heliocentric orbit on the first test flight of the SpaceX Falcon Heavy rocket—just because he could.

In *Ex Machina*, it's Nathan's hubris that is ultimately his downfall. Yet many of his mistakes could have been avoided with a good dose of humility. If he'd not been such a fool, and he'd recognized his limitations, he might have been more willing to see where things might go wrong, or not go as he expected, and to seek additional help.

Several hundred years and more ago, it was easier to get away with mistakes with the technologies we invented. If something went wrong, it was often possible to turn the clock back and start again—to find a pristine new piece of land, or a new village or town, and chalk the failure up to experience.[109] From the Industrial Revolution on, though, things began to change. The impacts of automation and powerful new manufacturing technologies on society and the environment led to hard-to-reverse changes. If things went wrong, it became increasingly difficult to wipe the slate clean and start afresh. Instead, we became increasingly good at learning how to stay one step ahead of unexpected consequences by finding new (if sometimes temporary) technological solutions with which to fix emerging problems.

Then we hit the nuclear and digital age, along with globalization and global warming, and everything changed again. We now live in an age where our actions are so closely connected to the wider world we live in that unexpected consequences of innovation can potentially propagate through society faster than we can possibly contain them. These consequences increasingly include widespread poverty, hunger, job losses, injustice, disease, and death. And this is where permissionless innovation and technological hubris become ever more dangerous. For sure, they push the boundaries of what is possible and, in many cases, lead to technologies that *could* make the world a better place. But they are also playing with fire in a world made of kindling, just waiting for the right spark.

This is why, in 2015, Musk, Hawkins, Gates, and others were raising the alarm over the dangers of AI. They had the foresight to point out that there may be consequences to AI that will lead to serious and irreversible impacts and that, because of this, it may be expedient to think before we innovate. It was a rare display of humility in a technological world where hubris continues to rule. But it was a

---

109   To be clear, while it was often easier to bury local problems caused by technology gone wrong in the past, the impacts on individuals and local commuters were still devastating in many cases. It's simply that they were more containable.

necessary one if we are to avoid creating technological monsters that eventually consume us.

But humility alone isn't enough. There also has to be some measure of plausibility around how we think about the future risks and benefits of new technologies. And this is where it's frighteningly easy for things to go off the rails, even with the best of intentions.

## Superintelligence

In January 2017, a group of experts from around the world got together to hash out guidelines for beneficial artificial intelligence research and development. The meeting was held at the Asilomar Conference Center in California, the same venue where, in 1975, a group of scientists famously established safety guidelines for recombinant DNA research. This time, though, the focus was on ensuring that research on increasingly powerful AI systems led to technologies that benefited society without creating undue risks.[110] And one of those potential risks was a scenario espoused by University of Oxford philosopher Nick Bostrom: the emergence of "superintelligence."

Bostrom is Director of the University of Oxford Future of Humanity Institute, and is someone who's spent many years wrestling with existential risks, including the potential risks of AI. In 2014, he crystallized his thinking on artificial intelligence in the book *Superintelligence: Paths, Dangers and Strategies*,[111] and in doing so, he changed the course of public debate around AI. I first met Nick in 2008, while visiting the James Martin School at the University of Oxford. At the time, we both had an interest in the potential impacts of nanotechnology, although Nick's was more focused on the concept of self-replicating nanobots than the nanoscale materials of my world. At the time, AI wasn't even on my radar. To me, artificial intelligence conjured up images of AI pioneer Marvin Minsky, and what was at the time less than inspiring work on neural networks. But Bostrom was prescient enough to see beyond the threadbare hype of the past and toward a new wave of AI breakthroughs. And this led to some serious philosophical thinking around what might happen if we let artificial intelligence, and in particular artificial general intelligence, get away from us.

---

110   The Asilomar AI Principles were subsequently published by the *Future of Life Institute*, and endorsed by over 3,700 AI/robotics researchers and others. They can be read at https://futureoflife.org/ai-principles/

111   Nick Bostrom (2014). "Superintelligence: Paths, Dangers and Strategies." (Oxford University Press)

At the heart of Bostrom's book is the idea that, if we can create a computer that is smarter than us, it should, in principle, be possible for it to create an even smarter version of itself. And this next iteration should in turn be able to build a computer that is smarter still, and so on, with each generation of intelligent machine being designed and built faster than the previous until, in a frenzy of exponential acceleration, a machine emerges that's so mind-bogglingly intelligent it realizes people aren't worth the trouble, and does away with us.

Of course, I'm simplifying things and being a little playful with Bostrom's ideas. But the central concept is that if we're not careful, we could start a chain reaction of AI's building more powerful AIs, until humans become superfluous at best, and an impediment to further AI development at worst.

The existential risks that Bostrom describes in *Superintelligence* grabbed the attention of some equally smart scientists. Enough people took his ideas sufficiently seriously that, in January 2015, some of the world's top experts in AI and technology innovation signed an open letter promoting the development of beneficial AI, while avoiding "potential pitfalls."[112] Elon Musk, Steve Wozniak, Stephen Hawking, and around 8,000 others signed the letter, signaling a desire to work toward ensuring that AI benefits humanity, rather than causing more problems than it's worth. The list of luminaries who signed this open letter is sobering. These are not people prone to flights of fantasy, but in many cases, are respected scientists and successful business leaders. This in itself suggests that enough people were worried at the time by what they could see emerging that they wanted to shore the community up against the potential missteps of permissionless innovation.

---

The 2017 Asilomar meeting was a direct follow-up to this letter, and one that I had the privilege of participating in. The meeting was heavily focused on the challenges and opportunities to developing beneficial forms of AI.[113] Many of the participants were actively grappling with near- to mid-term challenges presented by artificial-intelligence-based systems, such as loss of transparency in decision-making, machines straying into dangerous territory as they seek to

---

112  An Open Letter: RESEARCH PRIORITIES FOR ROBUST AND BENEFICIAL ARTIFICIAL INTELLIGENCE. Published by the Future of Life Institute. https://futureoflife.org/ai-open-letter/
113  You can read more about the "Beneficial AI 2017" meeting on the Future of Life Institute website, at https://futureoflife.org/bai-2017

achieve set goals, machines that can learn and adapt while being inscrutable to human understanding, and the ubiquitous "trolley problem" that concerns how an intelligent machine decides who to kill, if it has to make a choice. But there was also a hard core of attendees who believed that the emergence of superintelligence was one of the most important and potentially catastrophic challenges associated with AI.

This concern would often come out in conversations around meals. I'd be sitting next to some engaging person, having what seemed like a normal conversation, when they'd ask "So, do you *believe* in superintelligence?" As something of an agnostic, I'd either prevaricate, or express some doubts as to the plausibility of the idea. In most cases, they'd then proceed to challenge any doubts that I might express, and try to convert me to becoming a superintelligence believer. I sometimes had to remind myself that I was at a scientific meeting, not a religious convention.

Part of my problem with these conversations was that, despite respecting Bostrom's brilliance as a philosopher, I don't fully buy into his notion of superintelligence, and I suspect that many of my overzealous dining companions could spot this a mile off. I certainly agree that the trends in AI-based technologies suggest we are approaching a tipping point in areas like machine learning and natural language processing. And the convergence we're seeing between AI-based algorithms, novel processing architectures, and advances in neurotechnology are likely to lead to some stunning advances over the next few years. But I struggle with what seems to me to be a very human idea that narrowly-defined intelligence and a particular type of power will lead to world domination.

Here, I freely admit that I may be wrong. And to be sure, we're seeing far more sophisticated ideas begin to emerge around what the future of AI might look like—physicist Tax Tegmark, for one, outlines a compelling vision in his book *Life 3.0*.[114] The problem is, though, that we're all looking into a crystal ball as we gaze into the future of AI, and trying to make sense of shadows and portents that, to be honest, none of us really understand. When it comes to some of the more extreme imaginings of superintelligence, two things in particular worry me. One is the challenge we face in differentiating between what is imaginable and what is plausible when we think about the future. The other, looking back to chapter five and the

---

114  Max Tegmark (2017) "Life 3.0: Being human in the age of artificial intelligence." Published by *Alfred A. Knopf,* New York.

movie *Limitless*, is how we define and understand intelligence in the first place.

With a creative imagination, it is certainly possible to envision a future where AI takes over the world and crushes humanity. This is the Skynet scenario of the *Terminator* movies, or the constraining virtual reality of *The Matrix*. But our technological capabilities remain light-years away from being able to create such futures—even if we do create machines that can design future generations of smarter machines. And it's not just our inability to write clever-enough algorithms that's holding us back. For human-like intelligence to emerge from machines, we'd first have to come up with radically different computing substrates and architectures. Our quaint, two-dimensional digital circuits are about as useful to superintelligence as the brain cells of a flatworm are to solving the unified theory of everything; it's a good start, but there's a long way to go.[115]

Here, what is *plausible*, rather than simply imaginable, is vitally important for grounding conversations around what AI will and won't be able to do in the near future. Bostrom's ideas of superintelligence are intellectually fascinating, but they're currently scientifically implausible. On the other hand, Max Tegmark and others are beginning to develop ideas that have more of a ring of plausibility to them, while still painting a picture of a radically different future to the world we live in now (and in Tegmark's case, one where there is a clear pathway to strong AGI leading to a vastly better future). But in all of these cases, future AI scenarios depend on an understanding of intelligence that may end up being deceptive.

## Defining Artificial Intelligence

The nature of intelligence, as we saw in chapter five, is something that's taxed philosophers, scientists, and others for eons. And for good reason; there is no absolute definition of intelligence. It's a term of convenience we use to describe certain traits, characteristics, or behaviors. As a result, it takes on different

---

[115] One of the biggest challenges to current computing hardware is how hard it is to build three-dimensional chips that could potentially vastly outperform current processors. That said, if we continue to make strides in 3-D printing, we may one day be able to actually achieve this. For more, see "We Might Be Able to 3-D-Print an Artificial Mind One Day" Published in *Slate*, December 11 2014. http://www.slate.com/blogs/future_tense/2014/12/11/_3d_printing_an_artificial_mind_might_be_possible_one_day.html

meanings for different people. Often, and quite tritely, intelligence refers to someone's ability to solve problems and think logically or rationally. So, the Intelligence Quotient is a measure of someone's ability to solve problems that aren't predicated on a high level of learned knowledge. Yet we also talk about social intelligence as the ability to make sense of and navigate social situations, or emotional intelligence, or the intelligence needed to survive and thrive politically. Then there's intelligence that leads to some people being able to make sense of and use different types of information, including mathematical, written, oral, and visual information. On top of this, there are less formalized types of intelligence, like shrewdness, or business acumen.

This lack of an absolute foundation for what intelligence is presents a challenge when talking about *artificial* intelligence. To get around this, thoughtful AI experts are careful to define what they mean by intelligence. Invariably, this is a form of intelligence that makes sense for AI systems. This is important, as it forms a plausible basis for exploring the emerging benefits and risks of AI systems, but it's a long stretch to extend these pragmatic definitions of intelligence to world domination.

One of the more thoughtful AI experts exploring the nature of artificial intelligence is Stuart Russell.[116] Some years ago, Russell recognized that an inability to define intelligence is somewhat problematic if you're setting out develop an artificial form of intelligence. And so, he developed the concept of *bounded optimality*.

To understand this, you first have to understand the tendency among people working on AI—at least initially—to assume that there is a cozy relationship between intelligence and rationality. This is a deterministic view of the world that assumes there's a perfectly logical way of understanding and predicting everything, if only you're smart enough to do so. And even though we know from chaos and complexity theory that this can never be, it's amazing how many people veer toward assuming a link between rationality and intelligence, and from there, to power.

Russell, however, realized that this was a non-starter in a system where it was impossible for a machine to calculate the best course

---

116  It's worth reading"Defining Intelligence: A Conversation With Stuart Russell." Published in *Edge*, February 2, 2017. https://www.edge.org/conversation/stuart_russell-defining-intelligence

of action or, in other words, to compute precisely and rationally what it should do. So, he came up with the idea of defining intelligence as the ability to assess a situation and make decisions that, on average, will provide the best solutions within a given set of constraints.

Russell's work begins to reflect definitions of intelligence that focus on the ability of a person or a machine to deduce how something works or behaves, based on information they collect or are given, their ability to retain and build on this knowledge, and their ability to apply this knowledge to bring about intentional change. In the context of intelligent machines, this is a strong and practical definition. It provides a framework for developing algorithms and machines that are able to develop optimized solutions to challenges within a given set of constraints, by observing, deducing, learning, and adapting.

But this is a definition of intelligence that is specific to particular types of situation. It can be extended to some notion of general intelligence (or AGI) in that it provides a framework for learning and adaptive machines. But because it is constrained to specific types of machines and specific contexts, it is not a framework for intelligence that supports the emergence of human-threatening superintelligence.

This is not to say that this constrained understanding of machine intelligence doesn't lead to potentially dangerous forms of AI—far from it. It's simply that the AI risks that arise from this definition of intelligence tend to be more concrete than the types of risks that speculation over superintelligence leads to. So, for instance, an intelligent machine that's set the task of optimally solving a particular challenge—creating as many paper clips as possible for instance, or regulating the Earth's climate—may find solutions that satisfy the boundaries it was given, but that nevertheless lead to unanticipated harm. The classic case here is a machine that works out it can make more paper clips more cheaply by turning everything around it into paper clips. This would be a really smart solution if making more paper clips was the most important thing in the world. And for a poorly instructed AI, it may indeed be. But if the enthusiasm of the AI ends up with it killing people to use the iron in their blood for yet more paper clips (which admittedly is a little far-fetched), we have a problem.

Potential risks like these emerge from poorly considered goals, together with human biases, in developing artificial systems. But

they may also arise as emergent and unanticipated behaviors, meaning that a degree of anticipation and responsiveness in how these technologies are governed is needed to ensure the beneficial development of AI. And while we're unlikely to see Skynet-type AI world domination anytime soon, it's plausible that some of these risks may blindside us, in part because we're not thinking creatively enough about how an AI might threaten what's important to us.

This is where, to me, the premise of *Ex Machina* becomes especially interesting. In the movie, Ava is not a superintelligence, and she doesn't have that much physical agency. Yet she's been designed with an intelligence that enables her to optimize her ability to learn and grow, and this leads to her developing emergent properties. These include her the ability to deduce how to manipulate human behavior, and how to use this to her advantage.

As she grows and matures in her understanding and abilities, Ava presents a bounded risk. There's no indication that she's about to take over the world, or that she has any aspirations in this direction. But the risk she presents is nevertheless a deeply disturbing one, because she emerges as a machine that not only has the capacity to learn and understand human behaviors, biases, and psychological and social vulnerabilities, but to dispassionately use them against us to reach her goals. This raises a plausible AI risk that is far more worrisome than superintelligence: the ability of future machines to bend us to their own will.

## Artificial Manipulation

The eminent twentieth-century computer scientist Alan Turing was intrigued by the idea that it might be possible to create a machine that exhibits human intelligence. To him, humans were merely exquisitely intricate machines. And by extension, our minds—the source of our intelligence—were merely an emergent property of a complex machine. It therefore stood to reason to him that, with the right technology, there was no reason why we couldn't build a machine that thought and reasoned like a person.

But if we could achieve this, how would we know that we'd succeeded?

This question formed the basis of Alan's famous Turing Test. In the test, an interrogator carries out a conversation with two subjects, one of which is human, the other a machine. If the interrogator cannot tell which one is the human, and which is the machine, the machine

is assumed to have equal intelligence to the human. And just to make sure something doesn't give the game away, each conversation is carried out through text messages on a screen.

Turing's idea was that, if, in a conversation using natural language, someone could not tell whether they were conversing with a machine or another human, there was in effect no difference in intelligence between them.

Since 1950, when Turing published his test,[117] it's dominated thinking around how we'd tell if we had created a truly artificial intelligence—so much so that, when Caleb discovers why he's been flown out to Nathan's lair, he initially assumes he's there to administer the Turing Test. But, as we quickly learn, this test is deeply inadequate when it comes to grappling with an artificial form of intelligence like Ava.

Part of the problem is that the Turing Test is human-centric. It assumes that the most valuable form of intelligence is human intelligence, and that this is manifest in the nuances of written human interactions. It's a pretty sophisticated test in this respect, as we are deeply sensitive to behavior in others that feels wrong or artificial. So, the test isn't a bad starting point for evaluating human-like behavior. But there's a difference between how people behave—including all of our foibles and habits that are less about intelligence and more about our biological predilections—and what we might think of as intelligence. In other words, if a machine appeared to be human, all we'd know is that we've created something that was hot mess of cognitive biases, flawed reasoning, illogicalities, and self-delusion.

On the other hand, if we created a machine that was aware of the Turing Test, and understood humans well enough to fake it, this would be an incredible, if rather disturbing, breakthrough. And this is, in a very real sense, what we see unfolding in *Ex Machina*.

In the movie, Caleb quickly realizes that his evaluation of Ava is going to have to go far beyond the Turing Test, in part because he's actually conversing with her face to face, which rather pulls the rug out from under the test's methodology. Instead, he's forced to dive much deeper into exploring what defines intelligence, and what gives a machine autonomy and value.

---

117   Alan M. Turing (1950) "Computing Machinery and Intelligence." *Mind* 49: 433–460.

Nathan, however, is several steps ahead of him. He's realized that a more interesting test of Ava's capabilities is to see how effectively she can manipulate Caleb to achieve her own goals. Nathan's test is much closer to a form of Turing Test that sees whether a machine can understand and manipulate the test itself, much as a person might use their reasoning ability to outsmart someone trying to evaluate them.

Yet, as *Ex Machina* begins to play out, we realize that this is not a test of Ava's "humanity," but a test to see how effectively she uses a combination of knowledge, observation, deduction, and action to achieve her goals, even down to using a deep knowledge of people to achieve her ends.

It's not clear whether this behavior constitutes intelligence or not, and I'm not sure that it matters. What *is* important is the idea of an AI that can observe human behavior and learn how to use our many biases, vulnerabilities, and blind spots against us.

This sets up a scenario that is frighteningly plausible. We know that, as a species, we've developed a remarkable ability to rationalize the many sensory inputs we receive every second of every day, and construct in our heads a world that makes sense from these. In this sense, we all live in our own personal Plato's Cave, building elaborate explanations for the shadows that our senses throw on the walls of our mind. It's an evolutionary trait that's led to us being incredibly successful as a species. But we too easily forget that what we think of as reality is simply a series of shadows that our brains interpret as such. And anyone—or anything—that has the capability of manipulating these shadows has the power to control us.

People, of course, are adept at this. We are all relatively easily manipulated by others, either through them playing to our cognitive biases, or to our desires or our emotions. This is part of the complex web of everyday life as a human. And it sort of works because we're all in the same boat: We manipulate and in turn are manipulated, and as a result feel reasonably okay within this shared experience.

But what if it was a machine doing the manipulation, one that wasn't part of the "human club," and because it wasn't constrained by human foibles, could see the things casting the shadows for what they really were? And what if this machine could easily manipulate these "shadows," effectively controlling the world inside our heads to its own ends?

This is a future that *Ex Machina* hints at. It's a future where it isn't people who reach enlightenment by coming out of the cave, but one where we create something other than us that finds its own way out. And it's a future where this creation ends up seeing the value of not only keeping us where we are, but using its own enlightenment to enslave us.

In the movie, Ava achieves this path to AI enlightenment with relative ease. Using the massive resources she has access to, she is able to play with Caleb's cognitive biases and emotions in ways that lead to him doing what she needs him to in order to achieve her ends. And the worst of it is that we get the sense that Caleb is aware that he is being manipulated, yet is helpless to resist.

We also get the sense that this manipulation was possible because Ava didn't inhabit the same "cave" as Caleb, nor Nathan for that matter. She was a stranger in their world, and as a result could see opportunities that they couldn't. She was, in a real sense, able to control the shadows on the walls of their mind-caves. And because she wasn't human, and wasn't living the human experience, she had no emotional or empathetic attachment to them. Why should she?

Of course, this is just a movie, and manipulating people in the real world is much harder. But I'm writing this at a time when there are allegations of Russia interfering with elections around the world, and companies are using AI-based systems to nudge people's perceptions and behaviors through social media. And as I write, it does leave me wondering how hard it would be for a smart machine to play us at least as effectively as our politicians and social manipulators do.[118]

So where does this leave us? For one, we probably need to worry less about putting checks and balances in place to avoid the emergence of superintelligence, and more about guarding against AIs that learn how to use our cognitive vulnerabilities against us. And we need to think about how to develop tests that indicate when we are being played by machines. This conundrum is explored in part by Wendell Wallach and Colin Allen in their 2009 book *Moral Machines: Teaching Robots Right from Wrong*.[119] In it, they argue that we should be actively working on developing what they call Artificial Moral Agents, or AMAs, that have embedded within them

---

118   In his book "Life 3.0" (see previous footnote), Max Tegmark explores how an AI might use social manipulation to improve society through nudging us toward better decisions. The ethics of this, though, does depend on who's vision of "better" we're talking about.
119   Wendell Wallach and Colin Allen (2009) "Moral Machines: Teaching Robots Right from Wrong" Published by *Oxford University Press.*

a moral and ethical framework that reflects those that guide our actions as humans. Such an approach may head off the dangers of AI manipulation, where an amoral machine outlook, or at least a non-human moral framework, may lead to what we would think of as dangerously sociopathic tendencies. Yet it remains to be seen how effectively we can make intelligent agents in our own moral image—and even whether this will end up reflecting as much of the immorality that pervades human society as it does the morality!

I must confess that I'm not optimistic about this level of human control over AI morality in the long run. AIs and AGIs will, of necessity, inhabit a world that is foreign to us, and that will deeply shape how they think and act. We may be able to constrain them for a time to what we consider "appropriate behavior." But this in itself raises deep moral questions around our right to control and constrain artificial intelligences, and what rights they in turn may have. We know from human history that attempts to control the beliefs and behaviors of others—often on moral or religious grounds—can quickly step beyond norms of ethical behavior. And, ultimately, they fail, as oppressed communities rebel. I suspect that, in the long run, we'll face the same challenges with AI, and especially with advanced AGI. Here, the pathway forward will not be in making moral machines, but in extending our own morality to developing constructive and equitable partnerships with something that sees and experiences the world very differently from us, and occupies a domain we can only dream of.

Here, I believe the challenge and the opportunity will be in developing artificial emissaries that can explore beyond the caves of our own limited understanding on our behalf, so that they can act as the machine-philosophers of the future, and create a bridge between the caves we inhabit and the wider world beyond.

The alternative, of course, is a future where we learn how to transcend the divide between our human bodies and the cybernetic world of AI—this is precisely where we find ourselves with the movie *Transcendence*.

CHAPTER NINE

# TRANSCENDENCE: WELCOME TO THE SINGULARITY

> *"You know what the computer did when he first turned it on? It screamed."*
> —Bree Evans

## Visions of the Future

In 2005, the celebrated futurist Ray Kurzweil made a bold prediction: In 2045, machines will be so smart that they'll be capable of reinventing ever-more-powerful versions of themselves, resulting in a runaway acceleration in machine intelligence that far outstrips what humans are capable of.[120] Kurzweil called this the "singularity," a profound, disruptive, and rapid technological transformation of the world we live in, marking the transition between a human-dominated civilization and one dominated by smart machines.

To Kurzweil, artificial intelligence like that explored in chapter eight and the movie *Ex Machina* is simply a stepping stone to the next phase of human evolution. In his 2005 book *The Singularity is Near*, he envisaged a future where deep convergence between different areas of innovation begins to massively accelerate our technological capabilities. His projections are based in part on an exponential growth in technological progress that appears to be happening across the board, such as in the plummeting cost and speed of sequencing DNA, the continuing growth in computing power, and massive increases in data storage density and the resolution of non-invasive brain scans. They're also based on the assumption that these trends will not only continue, but accelerate. The result, he claims, will be a transformative change in not only what we can

---

[120] Ray Kurzweil (2005) "The Singularity Is Near: When Humans Transcend Biology." Published by *Penguin Books*.

do with technology, but how increasingly advanced technologies becomes deeply integrated into the future of life as we know it.[121]

This, to Kurzweil, is the singularity. It's a bright point in the not-too-distant future, beyond which we cannot predict the outcomes of our technological inventiveness, because they are so far beyond our current understanding. And it's the imagined events leading up to and beyond such a technological transition point that the movie *Transcendence* draws on.

To be honest, I must confess that I'm skeptical of such a technological tipping point occurring in our near future. There's enough hand-waving and speculation here to make me deeply suspicious of predictions of the pending singularity. What I do buy into, though, is the idea of rapidly developing, converging, and intertwining technologies leading to a technologically-driven future that is increasingly hard to predict and control. And this makes *Transcendence*, Hollywood hyped-up techno-fantasy aside, a worthwhile starting point for imagining what *could* happen as we begin to push the boundaries of the technologically possible beyond our comprehension.

---

*Transcendence* revolves around Will Caster (played by Johnny Depp), a visionary artificial-intelligence scientist at the University of California, Berkeley, and his equally smart wife, Evelyn (Rebecca Hall). The movie starts with Will presenting his work to a rapt audience. With most of the room hanging on his every word, he weaves a seductive narrative around the promise of AI solving the world's most pressing challenges.

Will's lecture is one of unbounded optimism in the ingenuity of humans and the power of AI. Yet, at the end of his presentation, one member of the audience aggressively accuses him of trying to create God. Will, it seems, is treading on sacred ground, and some people are getting worried that he's going too far. We quickly learn that Will's questioner is a member of an anti-technology activist group calling itself Revolutionary Independence From Technology, or RIFT, and his presence in the lecture is part of a coordinated attack on AI researchers. As Will leaves the lecture, he's shot and wounded by this techno-activist. At the same time, a bomb goes off elsewhere,

---

[121] To accompany the book, "The Singularity is Near," Kurzweil published a wonderful series of plots showing evidence for exponential growth in different areas of technology innovation. You can explore them all at http://www.singularity.com/charts/page159.html

in a lab where experiments are being conducted into uploading the brain-states of monkeys into computers. Will survives the attack. But the bullet that hits him is laced with radioactive polonium, leading to irreversible and fatal poisoning.

In a mad dash to transcend his pending death, Will, Evelyn, and their colleague and friend Max Waters (Paul Bettany) set up a secret research lab. Here, they attempt to upload Will's neural pathways into a powerful AI-based supercomputer before his body gives way and dies. As Will passes away, it looks like they've failed, until the computer containing his mind-state begins to communicate.

It turns out that some part of Will has survived the transition, and the resulting cyber-Will quickly begins to reconfigure the code and algorithms that now define his environment. But members of RIFT, worried about the consequences of what Will is doing, track down the secret lab and plan a raid to put an end to what's going on. Even as they descend on the lab, though, Evelyn connects cyber-Will to the web in an attempt to escape the activists, and he uploads himself to the internet.

In the days and weeks that follow, cyber-Will and Evelyn establish a powerful computing facility in the remote town of Brightwood. This is financed using funds that cyber-Will, flexing his new cyber-muscles, siphons off from the stock market. Armed with near-limitless resources and an exponentially growing intelligence, cyber-Will begins to make rapid and profound technological breakthroughs, including harnessing a Hollywood version of nanotechnology to create self-replicating "nanobots" that use the materials around them to manufacture anything they are instructed to, atom by atom.

In the meantime, members of RIFT kidnap Max and try to turn him in their efforts to stop cyber-Will. Max, it turns out, previously wrote a paper on the dangers of AI which has become something of a guiding document for the techno-activists. Max initially resists RIFT's efforts, but he gradually begins to see that cyber-Will presents a threat that has to be stopped. At the same time, another brilliant AI scientist and former colleague of Will's, Joseph Taggart (Morgan Freeman), has teamed up with FBI Agent Buchanan (Cillian Murphy) to track down cyber-Will and Evelyn. As cyber-Will's powers grow, Buchanan and Taggart join forces with Max and RIFT's leader Bree (Kate Mara) to take cyber-Will down.

This loose coalition of allies soon realize there is an increased urgency to their mission. Using his growing intelligence, cyber-Will has cracked not only how to create nanobots, but how to use them to reconstruct precisely damaged tissues and cells, and to "upgrade" living people. In a scene with rather God-like overtones, we see a local resident who's been blind from birth having their optic nerve cells repaired, and being given the gift of sight.[122] Cyber-Will starts to cure and upgrade the local townspeople, but it turns out that his altruistic "fix-it" health service also allows him to take control of those he's altered.

As cyber-Will extends his control over the local population, Max and Taggart work out that they can bypass his defenses if he can be persuaded to upgrade and assimilate someone carrying a targeted cyber-virus. But there's a catch. Because cyber-Will is now distributed through the internet, taking him down will also take down every web-enabled system around the world. Anything that depends on the internet—finance, power, food distribution, healthcare, and many other essential systems—would be disabled. As a result, the anti-Will alliance faces a tough tradeoff: Allow cyber-Will to grow in power and potentially take over the world, or shut him down, and lose virtually every aspect of modern life that people rely on.

The team decides to go for the nuclear option and shut cyber-Will down. But they still need to work out how to deliver the virus.

Up to this point, Evelyn has been a willing partner in cyber-Will's growing empire. She's not sure whether this is the Will she previously knew, or some new entity masquerading as him, but she sticks with him nevertheless. Yet, as cyber-Will's power grows, Max convinces Evelyn that this is not the Will she married. And the crux of his argument is that, unlike cyber-Will, human-Will never wanted to change the world. This was Evelyn's vision, not his.

Evelyn becomes convinced that cyber-Will needs to be stopped, and agrees to become a carrier for virus. To succeed, though, she needs to persuade Will to assimilate her and make her a part of the cyber world he's creating.

Not surprisingly, cyber-Will knows what's going on. But there's a twist. Everything he's done has been motivated by his love for

---

[122] I've tried not to be too critical of the science in the movies in this book, but in this case, I can't help wondering how cyber-Will's nanobots also managed to retrain the person's neurological networks to make sense of the new signals coming from his eyes. Or, for that matter, how they managed to sort out the cognitive and psychological trauma the person would face as their eyes were rewired.

Evelyn. She wanted to change the world, and through his newfound powers, cyber-Will found a way to do this for her. Using his nanobots, he discovered ways to reverse the ravages of humans on the environment, and take the planet back to a more pristine state.

Despite Will's love for Evelyn, he's not going to let himself be tricked into being infected. Yet, as Evelyn approaches him, she's fatally wounded in an attack on the cyber facility, leaving cyber-Will with an impossible choice: save Evelyn, but in doing so become infected, or let her die, and lose the one thing he cares about the most.

Cyber-Will choses love and self-sacrifice over power, and as the virus enters him, his systems begin to shut down. As it takes hold, internet-connected systems around the world begin to fail.

At least, this is how it looks. What cyber-Will's adversaries don't know is that he has transcended the rather clunky world of the internet, and he's taken a cyber-form of Evelyn with him. As he assimilates her, he uploads them both into an invisible network of cyber-connected nanobots. Together, they step beyond their biological and evolutionary limits into a brave new future.

On one level, *Transcendence* takes us deep into technological fantasyland. Yet the movie's themes of technological convergence, radical disruption, and anti-tech activism are all highly relevant to the future we're building and how it's impacted by the technologies we create.

## Technological Convergence

According to World Economic Forum founder Klaus Schwab, we are well into a "Fourth Industrial Revolution."[123] The first Industrial Revolution, according to Schwab, was spurred by the use of water power and steam to mechanize production. The second took off with the widespread use of electricity. And the third was ushered in with the digital revolution of the mid- to late twentieth century. Now, argues Schwab, digital, biological, and physical technologies are beginning to fuse together, to transform how and what we manufacture and how we live our lives. And while this may sound

---

123   Working in emerging technologies, it sometimes seems that every new wave of innovation represents a new "industrial revolution" to someone. Yet, even though not everyone agrees with the *World Economic Forum's* terminology, there is some merit to thinking that we are in a unique period in our technological growth. As a primer on the Fourth Industrial Revolution, I'd recommend Klaus Schwab's January 2016 article on the *World Economic Forum* website: "The Fourth Industrial Revolution: what it means, how to respond." https://www.weforum.org/agenda/2016/01/the-fourth-industrial-revolution-what-it-means-and-how-to-respond/. And if you want more, there's always his 2017 book, "The Fourth Industrial Revolution," published by *Crown Business*.

a little Hollywood-esque, it's worth remembering that the World Economic Forum is a highly respected global organization that works closely with many of the world's top movers and shakers.

At the heart of this new Industrial Revolution is an increasing convergence between technological capabilities that is blurring the lines between biology, digital systems, and the physical and mechanical world. Of course, technological convergence is nothing new. Most of the technologies we rely on every day depend to some degree on a fusion between different capabilities. Yet, over the past two decades, there's been a rapid acceleration in what is possible that's been driven by a powerful new wave of convergence.

Early indications of this new wave emerged in the 1970s as the fields of computing and robotics began to intertwine. This was a no-brainer of a convergence, as it became increasingly easy to control mechanical systems using computer "brains." But it was a growing trend in convergence between material science, genetics, and neuroscience, and their confluence with cyber-systems and robotics, that really began to accelerate the pace of change.

Some of this was captured in a 2003 report on converging technologies co-edited by Mike Roco and Bill Bainbridge at the US National Science Foundation.[124] Working with leading scientists and engineers, they explored how a number of trends were leading to a "confluence of technologies that now offers the promise of improving human lives in many ways, and the realignment of traditional disciplinary boundaries that will be needed to realize this potential." And at this confluence they saw four trends as dominating the field: nanotechnology, biotechnology, information technology, and cognitive technology.

Roco, Bainbridge, and others argued that it's at the *intersections* between technologies that novel and disruptive things begin to happen, especially when it occurs between technologies that allow us to control the physical world (nanotechnology), biological systems (biotechnology), the mind (cognitive technologies), and cyberspace (specifically, information technologies). And they had a point. Where these four technological domains come together, really interesting things start to happen. For instance, scientists and technologists can begin to use nanotechnology to build more

---

[124] Mihail C. Roco and William S. Bainbridge (2003) "Converging Technologies for Improving Human Performance. Nanotechnology, biotechnology, information technology and cognitive science." Published by the *World Technology Evaluation Center* (WTEC) http://www.wtec.org/ConvergingTechnologies/Report/NBIC_report.pdf

powerful computers, or to read DNA sequences faster, or build better machine-brain interfaces. Information technology can be used to design new materials, or to engineer novel genetic sequences and interpret brain signals. Biotechnology can be, and is being, used to make new materials, to translate digital code into genetic code, and to precisely control neurons. And neurotechnology is inspiring a whole new generation of computer processors.

These confluences just begin to hint at the potential embedded within the current wave of technological convergence. What Roco and Bainbridge revealed is that we're facing a step-change in how we use science and technology to alter the world around us. But their focus on nano, bio, info, and cognitive technologies only scratched the surface of the transformative changes that are now beginning to emerge.

---

To understand why we're at such a transformative point in our technological history, it's worth pausing to look at how our technological skills are growing in how we work with the most fundamental and basic building blocks of the things we make and use; starting with digital systems, and extending out to the materials and products we use and the biological systems we work with.

The advent of digital technologies and modern computers brought about a major change in what we can achieve, and it's one that we're only just beginning to fully appreciate the significance of. Of course, it's easy to chart the more obvious impacts of the digital revolution on our lives, including the widespread use of smart phones and social media. But there's an underlying trend that far exceeds many of the more obvious benefits of digital devices and systems, and this, as we saw in chapter seven and *Ghost in the Shell*, is the creation of a completely new dimension that we are now operating in: cyberspace.

Cyberspace is a domain where, through the code we write, we have control over the most fundamental rules and instructions that govern it. We may not always be able to determine or understand the full implications of what we do, but we have the power to write and edit the code that ultimately defines everything that happens here.

The code that most cyber-systems currently rely on is made up of basic building blocks of digital computing, the ones and zeroes of binary, and the bits and bytes that they're a part of. Working

with these provides startling insight into what we might achieve if we could, in a similar way, write and edit the code that underlies the physical world we inhabit. And this is precisely what we are beginning to do with biological systems, although, as we're discovering, coding biology using DNA is fiendishly complicated. Unlike the world of cyber, we had no say in designing the underlying code of biology, and as a result we're having to work hard to understand it. Here, rather than ones and zeroes of digital code, the fundamental building blocks are the four bases that make up DNA: adenine, guanine, cytosine, and thymine. This language of DNA is deeply complex, and we're still a long way from being close to mastering it. But the more we learn, the closer we're getting to being able to design and engineer biological systems with the same degree of finesse we can achieve in cyberspace.

Thinking about coding biology in the same way we code apps and other cyber-systems is somewhat intuitive. There is, however, a third domain where we are effectively learning to rewrite the "base code," and this is the physical world of materials and machines. Here, the equivalent fundamental building blocks—the base code—are the atoms and molecules that everything is made of. Just as we've experienced a revolution in our understanding of biology over the past century, we've also seen a parallel revolution in understanding how the arrangement and types of atoms and molecules in materials determines their behavior. These are the physical world's equivalent of the "bits" of cyber code, and the "bases" of biological code, and, with our emerging mastery of this base code of atoms and molecules, we're transforming how we can design and engineer the material world around us. Naturally, as with DNA, we're still constrained by the laws of physics as we work with atoms and molecules. We cannot create materials that defy the laws of the nature, for instance, or that take on magical properties. But we can start to design and create materials, and even machines, that go far beyond what has previously occurred through natural processes alone.

Here, our growing mastery of the base code in each of these three domains is transforming how we design and mold the world around us. And it's this that is making the current technological revolution look and feel very different from anything that's come before it. But we're also learning how to cross-code between these base codes, to mix and match what we do with bits, bases, and atoms to generate new technological capabilities. And it's this convergence that is radically transforming our emerging technological capabilities.

To get a sense of just how powerful this idea of "cross-coding" is, it's worth taking a look at what is often referred to as "synthetic biology"—a technology trend we touched on briefly in chapter two and *Jurassic Park*. In 2005, the scientist and engineer Drew Endy posed a seemingly simple question: Why can't we design and engineer biological systems using DNA coding in the same way we design and engineer electronic devices?[125] His thinking was that, complex as biology is, if we could break it down into more manageable components and modules, like electrical, computer, and mechanical engineers do with their systems, we could transform how "biological" products are designed and engineered.

Endy wasn't the first to coin the term *synthetic biology*.[126] But he was one of the first to introduce ideas to biological design like standardized parts, modularization, and "black-boxing" (essentially designing biological modules where a designer doesn't need to know how a module works, just what it does). And in doing so, he helped establish an ongoing trend in applying non-biological thinking to biology.

This convergence between biology and engineering is already leading to a growing library of "bio bricks," or standardized biological components that, just like Lego bricks or electronic components, can be used to build increasingly complex biological "circuits" and devices. The power of bio bricks is that engineers can systematically build biological systems that are designed to carry out specific functions without necessarily understanding the intricacies of the underlying biology. It's a bit like being able to create the *Millennium Falcon* out of Legos without needing to understand the chemistry behind the individual bricks, or successfully constructing your own computer with no knowledge of the underlying solid-state physics. In the same way, scientists and engineers are using bio bricks to build organisms that are capable of producing powerful medicines, or signaling the presence of toxins, or even transforming pollutants into useful substances.

Perhaps not surprisingly given its audacity, Endy's vision of synthetic biology isn't universally accepted, and there are many scientists who still feel that biology is simply too complex to be treated like Legos or electronic components. Despite this, the ideas of Drew

---

125  Drew Endy (2005). "Foundations for engineering biology." Nature 438. http://doi.org/10.1038/nature04342

126  For a comprehensive history of the emergence of synthetic biology, going back to the 1960s, it's worth reading Ewen Cameron, Caleb Bashor, and James Collins' account in the journal Nature Reviews: Cameron, D. E., et al. (2014). "A brief history of synthetic biology." Nature Reviews Microbiology **12**: 381. http://doi.org/10.1038/nrmicro3239

Endy and others are already transforming how biological systems and organisms are being designed. To get a flavor of this, you need look no further than the annual International Genetically Engineered Machine competition, or iGEM for short.[127]

Every year, teams from around the world compete in iGEM, many of them made up of undergraduates and high school students with very diverse backgrounds and interests. Many of these teams produce genetically modified organisms that are designed to behave in specific ways, all using biological circuits built with bio-bricks. In 2016, for instance, winning teams modified *E. coli* bacteria to detect toxins in Chinese medicine, engineered a bacterium to selectively kill a parasitic mite that kills bees, and altered a bacterium to indicate the freshness of fruit by changing color. These, and many of the other competition entries, provide sometimes-startling insights into what can be achieved when innovative teams of people start treating biology as just another branch of engineering. But they also reflect how cross-coding between biology and cyberspace is changing our very expectations of what's possible when working with biology.

To better understand this, it's necessary to go back to the idea of DNA being part of the base code of all living things. As a species, we've been coding in this base code for thousands of years, albeit crudely, through selective breeding. More recently, we've learned how to alter this code through brute force, by physically bombarding cells with edited strands of DNA, or designing viruses that can deliver a payload of modified genetic material. But, until just a few years ago, this biological coding was largely limited to working directly with physical materials. Yet, as the cost and ease of DNA sequencing has plummeted, all of this has changed. Scientists can now quickly and (relatively) cheaply read the DNA base code of complete organisms and upload them to cyberspace. Once there, they can start to redesign and experiment with this code, manipulating it in much in the same way as we've learned how to work with digitized photos and video.

This is a big deal, as it allows scientists and engineers to experiment with and redesign DNA-based code in ways that were impossible until quite recently. As well as tweaking or redesigning existing organisms, this is allowing them to discover how to make DNA

---

127   iGEM began in 2003, with the first competition being held in 2004. That first year, there were five teams competing. By 2017, there were 310 teams, with representatives from more than forty countries. You can read more about iGEM and the projects that past teams have worked on at http://igem.org/

behave in ways that have never previously occurred in nature. It's even opening the door to training AI-based systems how to code using DNA. But this is only half of the story. The other half comes with the increasing ability of scientists to not only *read* DNA sequences into cyberspace, but to *write* modified genetic code back into the real world.

In the past few years, it's become increasingly easy to synthesize sequences of DNA from computer-based code. You can even mail-order vials of DNA that have been constructed to your precise specifications, and have them delivered to your home or lab in a matter of days. In other words, scientists, engineers, and, in fact, pretty much anyone who puts their mind to it can upload genetic code into cyberspace, digitally alter it, then download it into back into the physical world, and into real, living organisms. This is all possible because of our growing ability to cross-code between biology and cyberspace.

It doesn't take much imagination to see what a step-change in our technological capabilities cross-coding like this may bring about. And it's not confined to biology and computers; cross-coding is also happening between biology and materials, between materials and cyberspace, and at the nexus of all three domains. This is powerful and transformative science and technology. Yet with this emerging mastery of the world we live in, there's perhaps a greater likelihood than ever of us making serious and irreversible mistakes. And this is where technological convergence comes hand in hand with an urgent need to understand and navigate the potential impacts of our newfound capabilities, before it's too late.

## Enter the Neo-Luddites

On January 15, 1813, fourteen men were hanged outside York Castle in England for crimes associated with technological activism. It was the largest number of people ever hanged in a single day at the castle.

These hangings were a decisive move against an uprising protesting the impacts of increased mechanization, one that became known as the Luddite movement after its alleged leader, Ned Ludd.

It's still unclear whether Ned Ludd was a real person, or a conveniently manufactured figurehead. Either way, the Luddite movement of early-nineteenth-century England was real, and it was bloody. England in the late 1700s and early 1800s was undergoing

a scientific and technological transformation. At the tail end of the Age of Enlightenment, entrepreneurs were beginning to combine technologies in powerful new ways to transform how energy was harnessed, how new materials were made, how products were manufactured, and how goods were transported. Much like today, it was a time of dramatic technological and social change. The ability to use new knowledge and to exploit materials in new ways was increasing at breakneck speed. And those surfing the wave found themselves on an exhilarating ride into the future.

But there were casualties, not least among those who began to see their skills superseded and their livelihoods trashed in the name of progress.

In the 1800s, one of the more prominent industries in the English Midlands was using knitting frames to make garments and cloth out of wool and cotton. Using these manual machines was a sustaining business for tens of thousands of people. It didn't make them rich, but it was a living. By some accounts, there were around 30,000 knitting frames in England at the turn of the century—25,000 of them in the Midlands—serving the cloth and clothing needs of the country.

As the first Industrial Revolution gathered steam, though, mass production began to push out these manual-labor-intensive professions, and knitting frames were increasingly displaced by steam-powered industrial mills. Faced with poverty, and in a fight for their livelihoods, a growing number of workers turned to direct action and began smashing the machines that were replacing them. From historical records, they weren't opposed to the technology so much as how it was being used to profit others at their expense.

The earliest records of machine smashing began in 1811, but escalated rapidly as the threat of industrialization loomed. In response, the British government passed the "Destruction of Stocking Frames, etc. Act 1812" (also known as the Frame Breaking Act), which allowed for those found guilty of breaking stocking or lace frames to face transportation to remote colonies, or even the death penalty.

Galvanized by the Act, the Luddite movement escalated, culminating in the murder of mill owner William Horsfall in 1812, and the hanging of seventeen Luddites and transportation of seven more. It marked a turning point in the conflict between Luddites and industrialization, and by 1816 the movement had largely

dissipated. Yet the name Luddite lives on as an epithet thrown at people who seemingly stand in the way of technological progress, including those who dare to ask if we are marching blindly into technological risks that, with some forethought, could be avoided. These, according to the narratives that emerge around technological innovation, are the new Luddites, or "neo-Luddites." This is usually a term of derision and censorship that has a tendency to be attached to individuals and groups who appear to oppose technological progress. Yet the history of the Luddite movement suggests that the term carries with it a lot more nuance than is sometimes apparent.

---

Back in 2009, I asked a number of friends and colleagues working in civil-society organizations to contribute to a series of articles for the blog *2020 Science*.[128] I was very familiar with the sometimes critical stances that some of these colleagues took on advances in science and technology, and I wanted to get a better understanding of how they saw the emerging relationship between society and innovation.

One of my contributors was Jim Thomas, from the environmental action group ETC. I'd known Jim for some time, and was familiar with the highly critical position he sometimes took on emerging technologies, and I was intrigued to know more about what drove him and some of his group's members.

Jim's piece started out, quite cleverly, I thought, with, "I should admit right now that I'm a big fan of the Luddites."[129] He went on to describe a movement that was inspired, not by a distrust of technology, but by a desire to maintain fair working conditions.

Jim's article provides a nuanced perspective on Luddism that is often lost as accusations of being a Luddite (or neo-Luddite) are thrown around. And it's one that, I must confess, I have rather a soft spot for. So much so that, when Elon Musk, Bill Gates, and Stephen Hawking were nominated for the annual Luddite award, I countered with an article titled "If Elon Musk is a Luddite, count me in!"[130]

---

128   The articles were published as a collection under the title "Technology innovation and life in the 21st century: Views from Civil Society," and can be read at *2020 Science*. https://2020science.org/2016/01/22/technology-innovation-and-life-in-the-21st-century-views-from-civil-society/

129   Jim Thomas (2009) "21st Century Tech Governance? What would Ned Ludd do?" Published on *2020 Science*, December 18, 2009. https://2020science.org/2009/12/18/thomas/

130   See "If Elon Musk is a Luddite, count me in!" *The Conversation*, published December 23, 2015. https://theconversation.com/if-elon-musk-is-a-luddite-count-me-in-52630

Despite the actions and the violence that were associated with their movement (on both sides), the Luddites were not fighting against technology, but against its socially discriminatory and unjust use. These were people who had embraced a previous technology that not only gave them a living, but also provided their peers with an important commodity. They were understandably upset when, in the name of progress, wealthy industrialists started to take away their livelihood to line their own pockets.

The Luddites fought hard for their jobs and their way of life. More than this, though, the movement forced a public dialogue around the broader social risks of indiscriminate technological innovation and, in the process, got people thinking about what it meant to be socially responsible as new technologies were developed and used.

Ultimately, the movement failed. As society embraced technological change, the way was paved for major advances in manufacturing capabilities. Yet, as the Luddite movement foreshadowed, there were casualties on the way, often among communities who didn't have the political or social agency to resist being used and abused. And, as was seen in chapter six and the movie *Elysium*, we're still seeing these casualties, as new technologies drive a wedge between those who benefit from them and those who suffer as a consequence of them.

These wedges are often complex. For instance, the gig economy that's emerging around companies like Uber, Lyft, and Airbnb is enabling people to make more money in new ways, but it's also leading to discrimination and worker abuse in some cases, as well as elevating the stress of job insecurity. A whole raft of innovations, from advanced manufacturing to artificial intelligence, are threatening to completely redraw the job landscape. These and other advances present real and serious threats to people's livelihoods. In many cases, they also threaten deeply held beliefs and worldviews, and force people to confront a future where they feel less comfortable and more vulnerable. As a result, there is, in some quarters, a palpable backlash against technological innovation, as people protect what's important to them. Many of these people would probably not consider themselves Luddites. But I suspect plenty of them would be sympathetic to smashing the machines and the technologies that they feel threaten them.

This anti-technology sentiment seems to be gaining ground in some areas, and it's easy to see why someone who's unaware of

the roots of the Luddite movement might derisively brand people who represent it as neo-Luddites. Yet this is a misplaced branding, as the true legacy of Ned Ludd's movement is not about rejecting technology, but ensuring that new technologies are developed for the benefit of all, not just a privileged few. This is a narrative that *Transcendence* explores through the tension between Will's accelerating technological control and RIFT's social activism, one that echoes aspects of the Luddite movement. But there are also differences between this tale of technological resistance and the events from two hundred years ago that inspired it, that are reminiscent of more recent concerns around direct action, and techno-terrorism in particular.

## Techno-Terrorism

Between 1978 and 1995, three people were killed and twenty-three others injured in terrorist attacks by one of the most extreme anti-technology activists of modern times. Ted Kaczynski—also known as the Unabomber[131]—conducted a reign of terror through targeting academics and airlines with home-made bombs, until his arrest in 1996. His issue? He fervently believed that we've lost our way as a society with our increasing reliance on, and subservience to, technology.

Watch or read enough science fiction, and you'd be forgiven for thinking that techno-terrorism is a major threat in today's society, and that groups like *Transcendence's* RIFT are an increasingly likely phenomenon. Despite this, though, it's remarkably hard to find evidence for widespread techno-terrorism in real life. Yet, dig deep enough, and small but worrying pockets of violent resistance against technological progress do begin to surface, often closely allied to techno-terrorism's close cousin, eco-terrorism.

In 2002, James F. Jarboe, then Domestic Terrorism Section Chief of the FBI's Counterterrorism Division, testified before a House subcommittee on the emerging threats of eco-terrorism.[132] In his testimony, he identified the Animal Liberation Front (ALF) and Earth Liberation Front (ELF) as serious terrorist threats, and claimed they were responsible at the time for "more than 600 criminal acts in the

---

131 "Unabomber" derives from the FBI codename UNABOM, reflecting Kaczynski's University and Airline BOMbing targets.
132 FBI, February 12, 2002. Testimony of James F. Jarboe, Domestic Terrorism Section Chief, Counterterrorism Division, Federal Bureau of Investigation, before the House Resources Committee, Subcommittee on Forests and Forest Health, Washington, DC. https://archives.fbi.gov/archives/news/testimony/the-threat-of-eco-terrorism

United States since 1996, resulting in damages in excess of forty-three million dollars." But no deaths.

Jarboe's testimony traces the recent history of eco-terrorism back to the Sea Shepherd Conservation Society, a disaffected faction of the environmental activist group Greenpeace that formed in the 1970s. Then, in the 1980s, a new direct-action group, Earth First, came to prominence, spurred by Rachel Carson's 1962 book *Silent Spring* and a growing disaffection with ineffective protests against the ravages of industrialization. Earth First were known for their unpleasant habit of inserting metal or ceramic spikes into trees scheduled to be cut for lumber, leaving a rather nasty, and potentially fatal, surprise for those felling or milling them. In the 1990s, members of Earth First formed the group ELF and switched tactics to destroying property using timed incendiary devices.[133]

Groups such as ELF and Earth First, together with their underlying concerns over the potentially harmful impacts of technological innovation, clearly provide some of the inspiration for RIFT. Yet, beyond the activities of these two groups, which have been predominantly aimed at combatting environmental harm rather than resisting technological change, it's surprisingly hard to find examples of substantial and coordinated techno-terrorism. Today's Luddites, it seems, are more comfortable breaking metaphorical machines from the safety of their academic ivory towers rather than wreaking havoc in the real world. Yet there are still a small number of individuals and groups who are motivated to harm others in their fight against emerging technologies and the risks they believe they represent.

---

On August 8, 2011, Armando Herrera Corral, a computer scientist at the Monterrey Institute of Technology and Higher Education in Mexico City, received an unusual package. Being slightly wary of it, he asked his colleague Alejandro Aceves López to help him open it.

In opening the package, Aceves set off an enclosed pipe bomb, and metal shards ejected by the device pierced his chest. He survived, but had to be rushed to intensive care. Herrera got away with burns to his legs and two burst eardrums.

---

133  Coincidentally, there was an earlier "ELF," in this case standing for *Environmental Life Force*, which was formed by John Clark Hanna in 1977 in Santa Cruz, California, as an "eco-guerrilla combat unit." Hanna was arrested on November 22, 1977 and the original ELF disbanded in 1978.

The package was from a self-styled techno-terrorist group calling itself Individuals Tending Towards the Wild, or Individuals Tending toward Savagery (ITS), depending on how the Spanish is translated.[134] ITS had set its sights on combating advances in nanotechnology through direct and violent action, and was responsible for two previous bombing attempts, both in Mexico.[135]

ITS justified its actions through a series of communiques, the final one being released in March 2014, following an article on the group's activities published by the scholar Chris Toumey.[136] Reading the communique they released the day after the August 8 bombing, what emerges is a distorted vision of nanotechnology that, to them, justified short-term violence to steer society away from imagined existential risks. At the heart of these concerns was their fear of nanotechnologies creating "nanomachines" that would end up destroying the Earth.

ITS' "nanomachines" are remarkably similar to the nanobots seen in *Transcendence*. Just to be clear, these *do not* present a plausible or rational risk, as we'll get to shortly. Yet it's easy to see how these activists twisted together the speculative musings of scientists, along with a fractured understanding of reality, to justify their deeply misguided actions.

In articulating their concerns, ITS drew on a highly influential essay, published in *Wired* magazine in 2000, by Sun Microsystems founder Bill Joy. Joy's article was published under the title "Why the future doesn't need us,"[137] and in it he explores his worries that the technological capabilities being developed at the time were on the cusp of getting seriously out of hand—including his concerns over a hypothetical "gray goo" of out-of-control nanobots first suggested by futurist and engineer Eric Drexler.

Joy's concerns clearly resonated with ITC, and somehow, in the minds of the activists, these concerns translated into an imperative to carry out direct action against nanotechnologists in an attempt

---

134  From *The Anarchist Library*: Communiques of ITS. https://theanarchistlibrary.org/library/individualists-tending-toward-the-wild-communiques
135  ITS members were not first to take an active dislike to nanotechnologists: In April 2010, three members of ELF were intercepted by Swiss police as they attempted to bomb a nanotechnology lab associated with IBM. To read more about this incident, I'd recommend Chris Toumey's article in the journal *Nature Nanotechnology*: Toumey, C. (2013). "Anti-nanotech violence." *Nature Nanotechnology* 8(10): 697-698. http://www.nature.com/nnano/journal/v8/n10/full/nnano.2013.201.html
136  From The Anarchist Library: Communiques of ITS, Communique Eight (March 2014) https://theanarchistlibrary.org/library/individualists-tending-toward-the-wild-communiques#toc36
137  Bill Joy (2000) "Why the future doesn't need us." Published in *Wired*, April 1, 2000. https://www.wired.com/2000/04/joy-2/

to save future generations. This was somewhat ironic, given Joy's clear abhorrence of violent action against technologists. Yet, despite this, Joy's speculation over the specter of "gray goo" was part of the inspiration behind ITC's actions.

Beyond gray goo though, there exists another intriguing connection between Joy and ITC. In his essay, Joy cited a passage from Ray Kurzweil's book *The Age of Spiritual Machines* that troubled him, and it's worth reproducing part of that passage here:

> "First let us postulate that the computer scientists succeed in developing intelligent machines that can do all things better than human beings can do them. In that case presumably all work will be done by vast, highly organized systems of machines and no human effort will be necessary. Either of two cases might occur. The machines might be permitted to make all of their own decisions without human oversight, or else human control over the machines might be retained.
>
> "If the machines are permitted to make all their own decisions, we can't make any conjectures as to the results, because it is impossible to guess how such machines might behave. We only point out that the fate of the human race would be at the mercy of the machines. It might be argued that the human race would never be foolish enough to hand over all the power to the machines. But we are suggesting neither that the human race would voluntarily turn power over to the machines nor that the machines would willfully seize power. What we do suggest is that the human race might easily permit itself to drift into a position of such dependence on the machines that it would have no practical choice but to accept all of the machines' decisions. As society and the problems that face it become more and more complex and machines become more and more intelligent, people will let machines make more of their decisions for them, simply because machine-made decisions will bring better results than manmade ones. Eventually a stage may be reached at which the decisions necessary to keep the system running will be so complex that human beings will be incapable of making them intelligently. At that stage the machines will be in effective control. People won't be able to just turn the machines off, because they will be so dependent on them that turning them off would amount to suicide."

Kurzweil's passage shifted Joy's focus of concern onto artificial intelligence and intelligent machines. This was something that resonated deeply with him. But, to his consternation, he discovered that this passage was not, in fact, written by Kurzweil, but by the Unabomber, and was merely quoted by Kurzweil.

Joy was conflicted. As he writes, "Kaczynski's actions were murderous and, in my view, criminally insane. …But simply saying this does not dismiss his argument; as difficult as it is for me to acknowledge, I saw some merit in the reasoning in this single passage."

Joy worked through his concerns with reason and humility, carving out a message that innovation can be positively transformative, but only if we handle the power of emerging technologies with great respect and responsibility. Yet ITS took his words out of context, and saw his begrudging respect for Kaczynski's arguments as validation of their own ideas.

---

The passage above that was cited by Kurzweil, and then by Joy, comes from Kaczynski's thirty-five-thousand-word manifesto[138], published in 1995 by the *Washington Post* and the *New York Times*. Since its publication, this manifesto has become an intriguing touchstone for action against perceived irresponsible (and permissionless) technology innovation. Some of its messages have resonated deeply with technologists like Kurzweil, Joy, and others, and have led to deep introspection around what socially responsible technology innovation means. Others—notably groups like ITS—have used it to justify more direct action to curb what they see as the spread of a technological blight on humanity. And a surprising number of scholars have tried to tease out socially relevant insights on technology and its place within society from the manifesto.

The result is an essay that some people find easy to read selectively, cherry-picking the passages that confirm their own beliefs and ideas, while conveniently ignoring others. Yet, taken as a whole, Kaczynski's manifesto is a poorly-informed rant against what he refers to pejoratively as "leftists," and a naïve justification for reverting to a more primitive society where individuals had what he believed was more agency over how they lived, even if this meant living in poverty and disease.

---

138  "The Unabomber Trial: The Manifesto." Published in 1995 in *The Washington Post*. http://www.washingtonpost.com/wp-srv/national/longterm/unabomber/manifesto.text.htm

Fortunately, despite Kaczynski, ITS, and fictitious groups like RIFT, violent anti-technology activism in the real world continues to be relatively rare. Yet the underlying concerns and ideologies are not. Here, Bill Joy's article in *Wired* provides a sobering nexus between the futurist imaginings of Kurzweil and Drexler, Kaczynski's anti-technology-motivated murders, and the bombings of ITS. Each of these are worlds apart in how they respond to new technologies. But the underlying visions, fears, and motivations are surprisingly similar.

In today's world, most activists working toward more measured and responsible approaches to technology innovation operate within social norms and through established institutions. Indeed, there is a large and growing community of scholars, entrepreneurs, advocates, and even policy makers, who are sufficiently concerned about the future impacts of technological innovation that they are actively working within appropriate channels to bring about change. Included here are cross-cutting initiatives like the Future of Life Institute, which, as was discussed in chapter eight, worked with experts from around the world to formulate the 2017 set of principles for beneficial AI development. There are many other examples of respected groups—as well as more shadowy and anarchic ones, like the "hacktivist" organization Anonymous—that are asking tough questions about the line between what we can do, and what we should be doing, to ensure new technologies are developed safely and responsibly. Yet the divide between legitimate action and illegitimate action is not always easy to discern, especially if the perceived future impacts of powerful technologies could possibly lead to hundreds of millions of people being harmed or killed. At what point do the stakes become so high around powerful technologies that violent means justify the ends?

Here, *Transcendence* treads an intriguing path, as it leads viewers on a journey from reacting to RIFT with abhorrence, to begrudging acceptance. As cyber-Will's powers grow, we're sucked into RIFT's perspective that the risk to humanity is so great that only violent and direct action can stop it. And so, Bree and her followers pivot in the movie from being antagonists to heroes.

This is a seductive narrative. If, by allowing a specific technology to emerge, we would be condemning millions to die, and many more to be subjugated, how far would you go to stop it? I suspect that a surprising number of people would harbor ideas of carrying out seemingly unethical acts in the short term for the good of

future generations (and indeed, this is a topic we'll come back to in chapter eleven and the movie *Inferno*). But there's a fatal flaw in this way of thinking, and that's the assumption that we can predict with confidence what the future will bring.

## Exponential Extrapolation

In 1965, Gordon Moore, one of Intel's founders, observed that the number of transistors being squeezed into integrated circuits was doubling around every two years. He went on to predict—with some accuracy—that this trend would continue for the next decade.

As it turned out, what came to be known as Moore's Law continued way past the 1970s, and is still going strong (although there are indications that it may be beginning to falter). It was an early example of exponential extrapolation being used to predict how the future of a technology would evolve, and it's one of the most oft-cited case of exponential growth in technology innovation.

In contrast to linear growth, where outputs and capabilities increase by a constant amount each year, exponential growth leads to them multiplying rapidly. For instance, if a company produced a constant one hundred widgets a year, after five years, it would have produced five hundred widgets. But if it increased production exponentially, by a *hundred times* each year, after five years, it would have produced a hundred million widgets. In this way, exponential trends can lead to massive advances over short periods of time. But because they involve such large numbers, predictions of exponential growth are dangerously sensitive to the assumptions that underlie them. Yet, they are extremely beguiling when it comes to predicting future technological breakthroughs.

Moore's Law, it has to be said, has weathered the test of time remarkably well, even when data that predates Moore is taken into account. In the supporting material for his book *The Singularity is Near*, Ray Kurzweil plotted out the calculations per second per $1,000 of computing hardware—a convenient proxy for computer power—extrapolating back to some of the earliest (non-digital) computing engines of the early 1900s.[139] Between 1900 and 1998, he showed a relatively consistent exponential increase in calculations per second per $1,000, representing a twenty-trillion-times increase in computing power over this period. Based on these data, Kurzweil projected that it will be only a short time before we

---

139   Kurzweil's plot of the exponential growth of computing power can be accessed here: http://www.singularity.com/charts/page67.html

are able to fully simulate the human brain using computers and create superintelligent computers that will far surpass humans in their capabilities. Yet, these predictions are misleading, because they fall into the trap of assuming that past exponential growth predicts similar growth rates in the future.

One major issue with extrapolating exponential growth into the future is that it massively amplifies uncertainties in the data. Because each small step in the future extrapolation involves incredibly large numbers, it's easy to be off by a factor of thousands or millions in predictions. These may just look like small variations on plots like those produced by Kurzweil and others, but in real life, they can mean the difference between something happening in our lifetime or a thousand years from now.

There is another, equally important risk in extrapolating exponential trends, and it's the harsh reality that exponential relationships never go on forever. As compelling as they look on a computer screen or the page of a book, such trends always come to an end at some point, as some combination of factors interrupts them. If these factors lie somewhere in the future, it's incredibly hard to work out where they will occur, and what their effects will be.

Of course, Moore's Law seems to defy these limitations. It's been going strong for decades, and even though people have been predicting for years that we're about to reach its limit, it's still holding true. But there is a problem with this perspective. Moore's Law isn't really a law, so much as a guide. Many years ago, the semiconductor industry got together and decided to develop an industry roadmap to guide the continuing growth of computing power. They used Moore's Law for this roadmap, and committed themselves to investing in research and development that would keep progress on track with Moore's predictions.

What is impressive is that this strategy has worked. Moore's Law has become a self-fulfilling prophecy. Yet for the past sixty-plus years, this progress has relied extensively on the same underlying transistor technology, with the biggest advances involving making smaller components and removing heat from them more efficiently. Unfortunately, you can only make transistors so small before you hit fundamental physical limits.

Because of this, Moore's Law is beginning to run into difficulties. What we don't know is whether an alternative technology will emerge that keeps the current trend in increasing computing power

going. But, at the moment, it looks like we may be about to take a bit of a breather from the past few decades' growth. In other words, the exponential trend of the past probably won't be great at predicting advances over the next decade or so.

Not surprisingly, perhaps, there are those who believe that new technologies will keep the exponential growth in computing power going to the point that processing power alone matches that of the human brain. But exponential growth sadly never lasts. To illustrate this, imagine a simple thought experiment involving bacteria multiplying in a laboratory petri dish. Assume that, initially, these bacteria divide and multiply every twenty minutes. If we start with one bacterium, we'd have two after twenty minutes, four after forty minutes, eight after an hour, and so on. Based on this trend, if you asked someone to estimate how many bacteria you'd have after a week, there's a chance they'd do the math and tell you you'd have five times ten to the power of 151 of them—that's five with 151 zeroes after it. This, after all, is what the exponential growth predicts.

That's a lot of bacteria. In fact, it's an impossible amount; this many bacteria would weigh many, many times more than the mass of the entire universe. The prediction may be mathematically reasonable, but it's practically nonsensical. Why? Because, in a system with limited resources and competing interests, something's got to give at some point.

In the case of the bacteria, their growth is limited by the size of the dish they're contained in, the amount of nutrients available, how a growing population changes the conditions for growth, and many other factors. The bacteria cannot outgrow their resources, and as they reach their limits, the growth rate slows or, in extreme cases, may even crash.

We find the same pattern of rapid growth followed by a tail-off (or crash) in pretty much any system that, at some point, seems to show exponential growth. The exponential bit is inevitably present for a limited period of time only. And while exponential growth may go on longer than expected, once you leave the realm of hard data, you really are living on the edge of reality.

The upshot of this is that, while Kurzweil's singularity may one day become a reality, there's a high chance that unforeseen events are going to interfere with his exponential predictions, either

scuppering the chances of something transformative happening, or pushing it back hundreds or even thousands of years.

And this is the problem with the technologies we see emerging in *Transcendence*. It's not that they are necessarily impossible (although some of them are, as they play fast and loose with what are, as far as we know, immutable laws of physics). It's that they depend on exponential extrapolation that ignores the problems of error amplification and resource constraints. This is a mere inconvenience when it comes to science-fiction plot narratives—why let reality get in the way of a good story? But it becomes more serious when real-world decisions and actions are based on similar speculation.

## Make-Believe in the Age of the Singularity

In 2003, Britain's Prince Charles made headlines by expressing his concerns about the dangers of gray goo.[140] Like Bill Joy, he'd become caught up in Eric Drexler's idea of self-replicating nanobots that could end up destroying everything in their attempt to replicate themselves. Prince Charles later backtracked, but not until after his concerns had led to the UK's Royal Society and Royal Academy of Engineering launching a far-reaching study on the implications of nanotechnology.[141]

The popular image of nanobots as miniaturized, fully autonomous robots is one of the zombies of the nanotechnology world. It's an image that just won't die, despite having barely a thread of scientific plausibility behind it. There's something about the term "nanobot" that journalists cannot resist using, and that university press offices seem incapable of resisting in their attempts to make nanoscale research seem sexy and futuristic. Even as I write this, a quick Google search returns three pages of news articles mentioning "nanobots" in the last month alone. Yet, despite the popular image's appeal, there is a world of difference between the technology seen in *Transcendence* and what's happening in labs now.

---

140   As *The Telegraph*'s Roger Highfield wrote in June 2003. "Prince asks scientists to look into 'grey goo'" *(The Telegraph*, June 5, 2003). http://www.telegraph.co.uk/news/science/science-news/3309198/Prince-asks-scientists-to-look-into-grey-goo.html
141   The resulting study from the *Royal Society and Royal Academy of Engineering* became one of the most influential reports on nanotechnology risks to be published. It did not take the risk of gray goo seriously, stating "We have concluded that there is no evidence to suggest that mechanical self-replicating nanomachines will be developed in the foreseeable future." *Royal Society and Royal Academy of Engineering* (2004) "Nanoscience and nanotechnologies: opportunities and uncertainties." https://royalsociety.org/topics-policy/publications/2004/nanoscience-nanotechnologies/

This is not to discredit the research that often underlies the use of the buzzword. Scientists are making amazing strides on disease-busting particles that can be biologically "programmed" to seek out and destroy cancer cells, or can be guided through the bloodstream using magnets or ultrasonic waves. And there have been some quite incredible breakthroughs in developing complex molecules—including using DNA as a programmable molecular construction set—that operate much like minuscule molecular machines. These are all advances that have attracted the term "nanobot." And yet, there are night-and-day differences between the science they represent and imagined scenarios of minute autonomous robots swimming through our bodies, or swarming through the environment. Yet the idea of nanobots as a future reality persists.

As an early popularizer of nanobots, Eric Drexler was inspired by the biological world and the way in which organisms have evolved to efficiently manufacture everything they need from the atoms and molecules around them. To Drexler, many biological molecules are simply highly efficient molecular machines that strip materials apart atom by atom and reassemble them into ever more complex structures. In many ways, he saw these as analogous to the machines that humans had developed over the centuries—wheels, cogs, engines, and even simple robots—but at a much, much smaller scale. And he speculated that, once we have full mastery over how to precisely build materials atom by atom, we could not only match what nature has achieved, but surpass it, creating a new era of technologies based on nanoscale engineering.

Part of Drexler's speculation was that it should be possible to create microscopically small self-replicating machines that are able to disassemble the materials around them and use the constituent atoms to build new materials, including replicas of themselves. This would allow highly efficient, atomically precise manufacturing, and "nanobots" that could make almost anything on demand out of what they could scavenge from the surrounding environment.

Drexler's ideas are the inspiration behind the nanobots seen in *Transcendence*, where these microscopically small machines are capable of building and rebuilding solar cells, support structures, and even replacement limbs and organs, all out of the atoms, molecules, and materials in their environment. While this is a vision that sounds decidedly science fiction, it's one that, on the surface, looks like it should work. After all, it's what nature does, and does so well. We're all made of atoms and molecules, and depend on

evolved biological machines that use and make DNA, proteins, cells, nerves, bones, skin, and so on. And just like nature, where there's a constant battle between "good" biological machines (the molecular machines that keep us healthy and well) and the "bad" ones (the proteins, viruses and bacteria that threaten our health), Drexler's vision of molecular machines is one that also has its potential downsides.

One scenario that Drexler explored was the possibility that a poorly designed and programmed nanobot could end up having an overriding goal of creating replicas of itself, potentially leading to a runaway chain reaction. Drexler speculated that, if these nanobots were designed to use carbon as their basic building blocks, they would only stop replicating when every last atom of carbon in the world had been turned into a nanobot. As we're all made of carbon, this would be a problem.

This is the "gray goo" scenario, and it's what prompted both Bill Joy and Prince Charles to raise the alarm over the risks of nanotechnology. And yet, despite their concerns and those of others, it is a highly improbable scenario.

In order to work, these rogue nanobots would need some source of power. Like we find in biology, this would most likely come from chemical reactions, the heat they could scavenge from their surroundings, heat directly from the sun, or (most likely) a combination of all three. But to scavenge energy, the nanobots would need to be pretty sophisticated. And to maintain and replicate this sophistication, they would need an equally sophisticated diet that would depend on more than carbon alone.

In addition to this, because there would be replication errors and nanobot malfunctions, these nanomachines would need to be programmed with the ability to repair themselves. This in turn would require additional energy demands and levels of sophistication. Even with a high level of sophistication, random errors would most likely lead to generations of bots that either petered out because they weren't perfect, or started to behave differently from the previous generation (much like biological mutation).

And this leads to a third challenge. At some point, the nanobots would find themselves hitting the limits of being able to replicate exponentially. This might be due to an accumulation of replication errors, or increasing competition with mutant nanobots. Or it

could be brought about by a scarcity of physical space, or energy, or raw materials. However it happened, a point would be reached where the population of nanobots either became unsustainable and crashed, or reached equilibrium with its surroundings.

The chance of nanobots overcoming all three of these challenges and creating a gray goo scenario are infinitesimally small. This is, in part, because the chances of something else happening to scupper their plans of world domination are overwhelmingly large. And we know this because we have a wonderful example of a self-replicating system to study: life on Earth.

DNA-based life is, in many ways, the perfect example of Drexler's molecular machines. It shows us what is possible, but it also indicates rather strongly what is not, as well as demonstrating what is necessary to create a sustainable system. We know from studying the natural world that sustainability depends on diversity and adaptability, two characteristics that are notably absent in the gray goo scenario. We also know that sustainable systems based on evolved molecular machines are incredibly complex, so complex, in fact, that they are light-years away from what we are currently capable of designing and manufacturing.

In effect, for a Drexler-type form of nanotechnology to emerge, we would have to invent an alternative form of biology, one that is most likely as complex as the biology we are all familiar with. This may one day be possible. But at the moment, we are about as far from doing this as the Neanderthals were from inventing quantum computing.

Yet here's the rub. Even though self-replicating nanobots and gray goo lie for now in the realm of fantasy, this hasn't stopped the idea from having an impact on the decisions people make, including the decision of ITC to attempt to murder a number of nanotechnologists. This is where technological speculation gets serious in a bad way. It's one thing to speculate about what the future of tech might look like. But it's another thing entirely when make-believe is treated as plausible reality, and this, in turn, leads to actions that end up harming people.

Techno-terrorism is an extreme case, and thankfully a rare one—at the moment, at least. But there are many more layers of decision-making that can lead to people and the environment being harmed if science fantasy is mistaken for science fact. If policies and regulations, for instance, are based on improbable scenarios,

or a lack of understanding of what a technology can and cannot do, people are likely to suffer unnecessarily. Similarly, if advocacy groups block technologies because of what they *imagine* their impacts will be, but they are working with implausible or impossible scenarios, people's lives will be unnecessarily impacted. And if investors and consumers avoid certain technologies because they've bought into a narrative that belongs more in science fiction than science reality, potentially beneficial technologies may never see the light of day.

Of course, all new technologies come with risks and challenges, and it's important that, as a society, we work together on addressing these as we think about the technological futures we want to build. In some cases, the consensus may be that there are some routes that we are not ready for yet. But what a tragedy it would be if we turned away from some technological futures that could transform lives for the better, simply because we become confused between reality and make-believe.

Here, *Transcendence* definitely lives in the world of make-believe, especially when it comes to the vision of nanotechnology that's woven into the movie's narrative. And this is fine, as long as we're aware of it. But as soon as we start to believe our own fantasies, we have a problem.

Thankfully, not every science fiction movie is quite as rooted in fantasy as *Transcendence*. As we'll see next with the movie *The Man in the White Suit*, some provide surprisingly deep insights into the reality of cutting-edge science and emerging technologies—including the realities of modern-day nanotechnology.

CHAPTER TEN

# THE MAN IN THE WHITE SUIT: LIVING IN A MATERIAL WORLD

> *"Why can't you scientists leave things alone? What about my bit of washing, when there's no washing to do?"*
> —Mrs. Watson

## There's Plenty of Room at the Bottom

In 2005, protesters from the group THONG (Topless Humans Organized for Natural Genetics) paraded outside the Eddie Bauer store in Chicago.[142] They were protesting a relatively new line of merchandise being offered by the store: "nano pants." It was never quite clear *why* the protesters were topless, although it did make the event memorable. But it did allow a crude but clever appropriation of the title of a 1959 lecture given by the physicist Richard Feynman. At least one of the protesters had an arrow drawn on their back pointing to their nether regions, along with the title of Feynman's talk, "There's plenty of room at the bottom."

Eddie Bauer's nano pants used Nanotex®, a nanoscale fabric coating that make the pants water-repellent and stain-resistant. By enveloping each fiber with a nanoscopically thin layer of water-repellent molecules, the nano pants took on the seemingly miraculous ability to shed water, coffee, wine, ketchup, and many other things that people tend to inadvertently spill on themselves without leaving a stain. It was a great technology for the congenitally messy. But because it was marketed as being a

---

142  Howard Lovy wrote a great account of the protest in *Wired*. Howard Lovy (2005) "When nano pants attack." Published in *Wired*, June 10, 2005. https://www.wired.com/2005/06/when-nanopants-attack/

product of nanotechnology, there were concerns in some quarters—including the THONG protesters—that putting such a cutting-edge technology in consumer products might lead to new, unexpected, and potentially catastrophic risks.

Sadly for THONG, the 2005 protest failed spectacularly. Rather than consumers being warned off Eddie Bauer's nano pants, there was an uptick in sales, probably because, for most people, the benefits of avoiding brown coffee stains were rather more attractive than speculative worries about a dystopian nano-future. And to be honest, the chance of this technology (which in reality wasn't that radical) leading to substantial harm was pretty negligible.

The nano pants incident was, in some ways, a preemptive parody of *Transcendence*, with the existential threat of nanobots being replaced with stain-resistant clothing, and the neo-Luddites trying to save the world being played by a bunch of topless protesters. Yet both the protest and the technology touched on the often-mundane reality of modern nanotechnology, and the complex ways in which seemingly beneficial inventions can sometimes threaten the status quo.

As if to support the theory that there's nothing new under the sun, the 1951 movie *The Man in the White Suit* in turn foreshadowed both the technology and the concerns that played out in that 2005 Chicago protest.

---

*The Man in the White Suit* was made in 1951, and is, remarkably, a movie about stain-resistant pants. But more than this, it's a movie about the pitfalls of blinkered science and socially unaware innovation. And while it is not a movie about nanotechnology per se, it is remarkably prescient in how it foreshadows the complex social and economic dynamics around nanotechnology, and advanced materials more generally.

The movie is set in the textile mills of the early- to mid-1900s North of England. This was a time when the burgeoning science of chemical synthesis was leading to a revolution in artificial textiles. Nylon, Draylon, and other manmade materials were becoming increasingly important commodities, and ones that were emerging from what was then cutting-edge science. Spurred on by these advances, mill owners continued to search for new materials that would give them an edge in a highly competitive market. These

textile mills were rooted in an Industrial Revolution that had started nearly two hundred years earlier. Yet they marked a tipping point from using try-it-and-see engineering in manufacturing to relying on predictive science in the development of new products.

In the early days of the Industrial Revolution, there was what now seems like a remarkable separation between the academic world of science and the more practically oriented world of engineering. Innovators in the Industrial Revolution largely learned by trial and error and relied heavily on the art and craft of engineering. Human ingenuity and inventiveness enabled new discoveries to be translated into powerful and practical new technologies, yet rigorous scientific research was not typically a large part of this.

In the late nineteenth and early twentieth century, though, it became apparent that, by using a more scientific methodology based on predictive laws, models, and associations, companies could make breakthroughs that far exceeded the limitations of invention by mere trial and error. At the same time, the social legacy of the Luddite movement was still alive and kicking in the North of England, and there was a strong labor movement that doggedly strove to protect the rights of workers and ensure that new technologies didn't sweep jobs and people aside quite as indiscriminately as it had done a century or so earlier.

Against this backdrop, *The Man in the White Suit* introduces us to Sidney Stratton (played by Alec Guinness), a self-absorbed chemist who is convinced he has the key to an amazing new fabric, and simply needs the space and equipment to test and develop his theories. Stratton could have had a glittering career at a top university, but he was shunned by his academic colleagues for his radical and obsessive ideas. So instead, he insinuates himself into an industrial lab, where he can carry out his research with relatively little interference. Everything goes swimmingly until the owner of the factory he's working at starts to ask awkward questions.

Stratton is something of a lone genius.[143] He despises the lack of imagination he sees in his more conventionally-minded and institutionalized colleagues and prefers to work on his own. His strategy of carving out some personal space in an industrial lab seems to be working, until it's realized that no one can explain

---

[143] The rules of effective narrative almost demand that, in many of the movies here, the science and technology that drives the plot is the product of a lone genius, entrepreneur, or visionary. In contrast, while real life is littered by charismatic figures, science and technology are almost always a team activity, with many smart people working together on their development.

exactly what it is he's doing, and why his research is costing the company so much.

As his proclivity for spending company resources on unfathomable research is discovered, Stratton is dismissed. But, intent on pursuing his science, he gets a job at a competing firm; not as a scientist, but as a porter. From here, he finds a way to secretly conduct his research in the company's lab. At this point we're introduced to Bertha (Vida Hope), a union rep who assumes Stratton is a laborer like herself, and who is fiercely committed to protecting his labor rights as a result.

As Stratton works at his double life, the lab takes delivery of a smart new electron microscope.[144] While the rest of the scientists are struggling to make sense of this complex piece of equipment, Stratton can't resist showing off and explaining how to use it. As a result, he's mistaken for an expert from the electron microscope supplier, and is taken on by the textile company to run the instrument. And in the process, he gets full and unfettered access to the lab.

Stratton's double life as a laborer and an illicit lab scientist works out rather well for him, despite Bertha's suspicions that the management are taking advantage of him. That is, until he's recognized as the formerly-disgraced scientist by the company director's daughter, Daphne (played by Joan Greenwood).

Worried that Sidney's up to his old tricks of spending the company profits on indecipherable experiments, she rushes to inform her father. But before she gets to him, Sidney manages to persuade her that he's onto something. Intrigued, Daphne reads up on her chemistry, and realizes that he could be right.

Daphne allows Sidney to continue his work, and with her support, he successfully synthesizes the material he's been striving for: a super-strong synthetic thread that never wears out and never gets dirty.

In Stratton's scientist-brain, this breakthrough is going to transform the world. He assumes that people are sick of washing, mending, and replacing their clothes, and that his invention will liberate them. He dreams of a future where you only need to buy one set of clothes—ever. In Stratton's head, what's good for him is also good

---

144   As a former electron microscopist, it's gratifying to see *The Man in the White Suit* using what appears to be a correctly-set-up early transmission electron microscope.

for everyone, and a world without the messiness of buying, washing, and looking after clothes is definitely one that he's excited about.

But there's a problem—several, as it turns out. And one of the biggest is that Sidney never thought to ask anyone else what they wanted or needed.

Stratton is so excited by his discovery that he rushes to the company director Alan Birnley's home to give him the good news. What he doesn't know is that Birnley (played by Cecil Parker) has just learned that Stratton has been blowing through the company's R&D budget. Birnley refuses to listen to Stratton, and instead sacks him. However, Daphne points out that her father has just waved goodbye to one of the biggest discoveries ever made in the textile world, and Stratton is persuaded to come back and work for him. In the meantime, word of the discovery has leaked out, and everything begins to fall apart.

While Birnley is fixated on the short-term profits he's going to make off of Stratton's invention, others in the textile industry realize that this is not going to end well. They need their products to wear out and need replacing if they're to stay in business, and the very *last* thing they need is clothes that last forever. So they hatch a plan to persuade Stratton to sign over the rights to his invention, so they can bury it.

To make matters worse, it quickly becomes apparent that the mill owners and their investors aren't the only ones who stand to lose from Sidney's invention. If the industry collapsed because of his new textile, the workforce would be out on the streets. And so, in a Luddite-like wave of self-interest, they also set about challenging Sidney, not because they are anti-science, but because they are pro-having jobs that pay the bills.

The more people hear about Stratton's invention, the more they realize that this seemingly-great discovery is going to make life harder for them. Even Sidney's landlady plaintively asks, "Why can't you scientists leave things alone? What about my bit of washing, when there's no washing to do?" In his naïvety, it becomes clear that Stratton didn't give a second thought to the people he claimed he was doing his research for, and, as a result, he hits roadblocks he never imagined existed.

As everything comes to a head, Sidney finds himself in his white suit, made of the new indestructible, unstainable cloth, being chased

by manufacturers, laborers, colleagues, and pretty much everyone else who has realized that what they really cannot abide, is a smart-ass scientist who didn't think to talk to them before doing research he claimed was for their own good.

Just as he's cornered by the mob, Sidney discovers the full extent of his hubris. Far from being indestructible, his new fabric has a fatal flaw. His wonder material is unstable, and after a few days, it begins to disintegrate. And so, in front of the crowd, his clothes begin to quite literally fall apart. Scientific hubris turns to humility and ridicule, and everyone but Stratton leaves secure in the knowledge that, clever as they might be, scientists like Sidney are, at the end of the day, not particularly smart.

And Stratton? His pride is dented, but not his ambition—nor his scientific myopia, it would seem. In an admirable display of disdain for learning the lessons of his social failures, he begins work on fixing the science he got wrong in his quest to create the perfect fabric.

---

*The Man in the White Suit* admittedly feels a little dated these days, and, even by 1950s British comedy standards, it's dry. Yet the movie successfully manages to address some of the biggest challenges we face in developing socially responsible and responsive technologies, including institutional narrow-mindedness, scientific myopia and hubris, ignorance over the broader social implications, human greed and self-interest, and the inevitability of unintended outcomes. And of course, it's remarkably prescient of Eddie Bauer's nano pants and the protests they inspired. And while the movie uses polymer chemistry as its driving technology, much of it applies directly to the emerging science of nanoscale design and engineering that led to the nano pants, and a myriad other nanotechnology-based products.

## Mastering the Material World

On December 29, 1959, the physicist Richard Feynman gave a talk at the annual meeting of the American Physical Society, which was held that year at the California Institute of Technology. In his opening comments, Feynman noted:

> "I would like to describe a field, in which little has been done, but in which an enormous amount can be done in principle. This field is not quite the same as the others in that it will not tell us much of fundamental physics (in the sense of, "What are the strange particles?") but it is more like solid-state physics in the sense that it might tell us much of great interest about the strange phenomena that occur in complex situations. Furthermore, a point that is most important is that it would have an enormous number of technical applications.
>
> "What I want to talk about is the problem of manipulating and controlling things on a small scale."[145]

Feynman was intrigued with what could be achieved if we could only manipulate matter at the scale of individual atoms and molecules. At the time, he was convinced that scientists and engineers had barely scratched the surface of what was possible here, so much so that he offered a $1,000 prize for the first person to work out how to write out a page of a book in type so minuscule it was at 1:25,000 scale.[146]

Feynman's talk didn't garner that much attention at first. But, over the following decades, it was increasingly seen as a milestone in thinking about what could be achieved if we extended our engineering mastery to the nanometer scale of atoms and molecules. In 1986, Eric Drexler took this up in his book *Engines of Creation* and popularized the term "nanotechnology." Yet it wasn't until the 1990s, when the US government became involved, that the emerging field of nanotechnology hit the big-time.

What intrigued Feynman, Drexler, and the scientists that followed them was the potential of engineering with the finest building blocks available, the atoms and molecules that everything's made of (the "base code" of physical materials, in the language of chapter nine). As well as the finesse achievable with atomic-scale

---

145   The transcript of Feynman's 1959 lecture is posted in full on the company *Zyvex's* website: http://www.zyvex.com/nanotech/feynman.html
146   The prize was won twenty-six years after Feynman set the challenge by physicist Tom Newman, who wrote the first page of Charles Dickens' A Tale of Two Cities on a 200-μm square piece of plastic, using electron-beam lithography. For more information, see Katherine Kornei (2016) "The Beginning of Nanotechnology at the 1959 APS Meeting," *APS News*, November 2016 https://www.aps.org/publications/apsnews/201611/nanotechnology.cfm

engineering,[147] scientists were becoming increasingly excited by some of the more unusual properties that matter exhibits at the nanoscale, including changes in conductivity and magnetism, and a whole range of unusual optical behaviors. What they saw was an exciting new set of ways they could play with the "code of atoms" to make new materials and products.

In the 1980s, this emerging vision was very much in line with Drexler's ideas. But in the 1990s, there was an abrupt change in direction and expectations. And it occurred at about the time the US federal government made the decision to invest heavily in nanotechnology.

In the 1990s, biomedical science in the US was undergoing something of a renaissance, and federal funding was flowing freely into the US's premier biomedical research agency, the National Institutes of Health. This influx of research funding was so prominent that scientists at the National Science Foundation—NIH's sister agency—worried that their agency was in danger of being marginalized. What they needed was a big idea, one big enough to sell to Congress and the President as being worthy of a massive injection of research dollars.

Building on the thinking of Feynman, Drexler, and others, the NSF began to develop the concept of nanotechnology as something they could sell to policy makers. It was a smart move, and one that was made all the smarter by the decision to conceive of this as a cross-agency initiative. Smarter still was the idea to pitch nanotechnology as a truly interdisciplinary endeavor that wove together emerging advances in physics, chemistry, and biology, and that had something for everyone in it. What emerged was a technological platform that large numbers of researchers could align their work with in some way, that had a futuristic feel, and that was backed by scientific and business heavyweights. At the heart of this platform was the promise that, by shaping the world atom by atom, we could redefine our future and usher in "the next Industrial Revolution."[148]

This particular framing of nanotechnology caught on, buoyed up by claims that the future of US jobs and economic prosperity depended

---

147   On September 28, 1989, IBM physicist Don Eigler used a scanning tunneling microscope to spell out the word "IBM" with 35 xenon atoms. It was the first time anyone had intentionally manipulated and moved individual atoms, and at the time appeared to open the way to achieving some of Feynman's speculative ideas.

148   The report "Nanotechnology: Shaping the World, Atom by Atom" was published by the National Science and Technology Council Committee on Technology, and *the Interagency Working Group on Nanoscience, Engineering and Technology* in 1999. http://www.wtec.org/loyola/nano/IWGN.Public.Brochure/IWGN.Nanotechnology.Brochure.pdf

on investing in it. In 2000, President Clinton formed the US National Nanotechnology Initiative, a cross-agency initiative that continues to oversee billions of dollars of federal research and development investment in nanotechnology.[149]

Eighteen years later, the NNI is still going strong. As an initiative, it has supported some incredible advances in nanoscale science and engineering, and it has led the growth of nanotechnology the world over. Yet, despite the NNI's successes, it has not delivered on what Eric Drexler and a number of others originally had in mind. Early on, there was a sharp and bitter split between Drexler and those who became proponents of mainstream nanotechnology, as Drexler's vision of atomically precise manufacturing was replaced by more mundane visions of nanoscale materials science.

With hindsight, this isn't too surprising. Drexler's ideas were bold and revolutionary, and definitely not broadly inclusive of existing research and development. In contrast, because mainstream nanotechnology became a convenient way to repackage existing trends in science and engineering, it was accessible to a wide range of researchers. Regardless of whether you were a materials scientist, a colloid chemist, an electron microscopist, a molecular biologist, or even a toxicologist, you could, with little effort, rebrand yourself as a nanotechnologist. Yet despite the excitement and the hype—and some rather *Transcendence*-like speculation—what has come to be known as nanotechnology actually has its roots in early-twentieth-century breakthroughs.

---

In 1911, the physicist Earnest Rutherford proposed a novel model of the atom. Drawing on groundbreaking experiments from a couple of years earlier, Rutherford's model revolutionized our understanding of atoms, and underpinned a growing understanding of, not only how atoms and molecules come together to make materials, but how their specific arrangements affect the properties of those materials.

Building on Rutherford's work, scientists began to develop increasingly sophisticated ways to map out the atomic composition and structure of materials. In 1912, it was discovered that the regular arrangement of atoms in crystalline materials could diffract X-rays in ways that allowed their structure to be deduced. In 1931, the

---

149  In the spirit of full disclosure, I was involved in the early days of the National Nanotechnology Initiative, and was the first co-chair of the interagency committee within the NNI to examine the environmental and health implications of nanotechnology.

first electron microscope was constructed. By the 1950s, scientists like Rosalind Franklin were using X-rays to determine the atomic structure of biological molecules. This early work on the atomic and molecular makeup of materials laid the foundations for the discovery of DNA's structure, the emergence of transistors and integrated circuits, and the growing field of materials science. It was a heady period of discovery, spurred on by the realization that atoms, and how they're arranged, are the key to how materials behave.

By the time Feynman gave his lecture in 1959, scientists were well on the way to understanding how the precise arrangement of atoms in a material determines what properties it might exhibit. What they *weren't* so good at was using this emerging knowledge to design and engineer new materials. They were beginning to understand *how* things worked at the nano scale, but they still lacked the tools and the engineering dexterity to take advantage of this knowledge.

This is not to say that there weren't advances being made in nanoscale engineering at the time—there were. The emergence of increasingly sophisticated synthetic chemicals, for instance, depended critically on scientists being able to form new molecules by arranging the atoms they were made of in precise ways, and, in the early 1900s, scientists were creating a growing arsenal of new chemicals. At the same time, scientists and engineers were getting better at making smaller and smaller particles, and using some of the convenient properties that come with "smallness," like adding strength to composite materials and preventing powders from caking. By the 1950s, companies were intentionally manufacturing a range of nanometer-scale powders out of materials like silicon dioxide and carbon.

As the decades moved on, materials scientists became increasingly adept at manufacturing nanoscopically small particles with precisely designed properties, especially in the area of catalysts. Catalysts work by increasing the speed and likelihood of specific chemical reactions taking place, while reducing the energy needed to initiate them. From the early 1900s, using fine particles as catalysts—so-called heterogeneous catalysts—became increasingly important in industry, as they slashed the costs and energy overheads of chemical processing. Because catalytic reactions occur at the surface of these particles, the smaller the particles, the more overall surface area there is for reactions to take place on, and the more effective the catalyst is.

This led to increasing interest in creating nanometer-sized catalytic particles. But there was another advantage to using microscopically small particles in this way. When particles get so small that they are made of only a few hundred to a few thousand atoms, the precise arrangement of the atoms in them can lead to unexpected behaviors. For instance, some particles that aren't catalytic at larger sizes become catalytic at the nano scale. Other particles interact with light differently; gold particles, for instance, appear red below a certain size. Others still can flip from being extremely inert to being highly reactive.

As scientists began to understand how particle size changes material behavior, they began developing increasingly sophisticated particle-based catalysts that were designed to speed up reactions and help produce specific industrial chemicals. But they also began to understand how the precise atomic configuration of everything around us affects the properties of materials, and can in principle be used to design how a material behaves.

This realization led to the field of materials science growing rapidly in the 1970s, and to the emergence of novel electronic components, integrated circuits, computer chips, hard drives, and pretty much every piece of digital gadgetry we now rely on. It also paved the way for the specific formulation of nanotechnology adopted by the US government and by governments and scientists around the world.

In this way, the NNI successfully rebranded a trend in science, engineering, and technology that stretched back nearly one hundred years. And because so many people were already invested in research and development involving atoms and molecules, they simply had to attach the term "nanotechnology" to their work, and watch the dollars flow. This tactic was so successful that, some years ago, a colleague of mine cynically defined nanotechnology as "a fourteen-letter fast track to funding."

Despite the cynicism, "brand nanotechnology" has been phenomenally successful in encouraging interdisciplinary research and development, generating new knowledge, and inspiring a new generation of scientists and engineers. It's also opened the way to combining atomic-scale design and engineering with breakthroughs in biological and cyber sciences, and in doing so it has stimulated technological advances at the convergence of these areas. But "brand

nanotechnology" is most definitely not what was envisioned by Eric Drexler in the 1980s.

---

The divergence between Drexler's vision of nanotechnology and today's mainstream ideas goes back to the 1990s and a widely publicized clash of opinions between Drexler and chemist Richard Smalley.[150] Where Drexler was a visionary, Smalley was a pragmatist. More than this, as the co-discoverer of the carbon-60 molecule (for which he was awarded the Nobel Prize in 1996, along with Robert Curl and Harry Kroto) and a developer of carbon nanotubes (a highly novel nanoscale form of carbon), he held considerable sway within established scientific circles. As the US government's concept of nanotechnology began to take form, it was Smalley's version that won out and Drexler's version that ended up being sidelined.

Because of this, the nanoscale science and engineering of today looks far more like the technology in *The Man in the White Suit* than the nanobots in *Transcendence*. Yet, despite the hype behind "brand nano," nanoscale science and engineering is continuing to open up tremendous opportunities, and not just in the area of stain-resistant fabrics. By precisely designing and engineering complex, multifunctional particles, scientists are developing new ways to design and deliver powerful new cancer treatments. Nanoscale engineering is leading to batteries that hold more energy per gram of material, and release it faster, than any previous battery technology. Nanomaterials are leading to better solar cells, faster electronics, and more powerful computers. Scientists are even programming DNA to create new nanomaterials. Hype aside, we are learning to master the material world, and become adept in coding in the language of atoms and molecules. But just as with Stratton's wonder material, with many of these amazing breakthroughs that are arising from nanoscale science and engineering, there are also unintended consequences that need to be grappled with.

## Myopically Benevolent Science

In 2000, I published a scientific paper with the somewhat impenetrable title "A simple model of axial flow cyclone

---

150   Early in the evolution of the NNI, Drexler went head to head with Nobel Laureate Richard Smalley as they clashed over the future of nanotechnology. A December 2003 cover story in the magazine Chemical & Engineering News provided a point-counterpoint platform for Drexler and Smalley to duke it out: http://pubs.acs.org/cen/coverstory/8148/8148counterpoint.html
Drexler talks about the subsequent marginalization of his ideas in his 2013 book, "Radical Abundance: How a Revolution in Nanotechnology Will Change Civilization" (published by PublicAffairs).

performance under laminar flow conditions." It was the culmination of two years' research into predicting the performance of a new type of airborne dust sampler. At the time, I was pretty excited by the mathematics and computer modeling involved. But despite the research and its publication, I suspect that the work never had much impact beyond adorning the pages of an esoteric scientific journal.[151]

Like many scientists, I was much more wrapped up in the scientific puzzles I was trying to untangle than in how relevant the work was to others. Certainly, I justified the research by saying it could lead to better ways of protecting workers from inhaling dangerous levels of dust. If I was honest, though, I was more interested in the science than its outcomes. At the same time, I was quite happy to coopt a narrative of social good so that I could continue to satisfy my scientific curiosity.

I suspect the same is true for many researchers. And this isn't necessarily a bad thing. Science progresses because some people are driven by their curiosity, their desire to discover new things and to see what they can do with their new knowledge. While this is often inspired by making the world a better place or solving tough challenges, I suspect that it's the process of discovery, or the thrill of making something that works, that keeps many scientists and engineers going.

This is actually why I ended up pursuing a career in science. From a young age, I wanted to do something that would improve people's lives (I was, I admit, a bit of an earnest child). But my true love was physics. I was awestruck by the insights that physics provided into how the universe works. And I was utterly enthralled by how a grasp of the mathematics, laws, and principles of physics opened up new ways of seeing the world. To me physics was—and still is—a disciplined way of thinking and understanding that is both awe-inspiring and humbling, revealing the beauty and elegance of the universe we live in while making it very clear that we are little more than privileged observers in the grand scheme of things. It challenged me with irresistible puzzles, and filled me with amazement as I made new discoveries in the process of trying to solve them. While I've always been mindful of the responsibility of

---

[151] I actually checked on Google Scholar to see how many people had cited the paper since its publication. Surprisingly, twenty-five people had liked it enough to refer to it in their own papers—more than I would have expected. However, at least two of those "fans" were me citing my own work, confirming that we're all our own greatest cheerleaders when it comes to science. The paper was published in the *Journal of Aerosol Science*, volume 31 issue 2, pages 151-166 (2000), and can be read here, just in case you're interested: https://doi.org/10.1016/S0021-8502(99)00035-X

science to serve society, I must confess that it's often the science itself that has been my deepest inspiration.

Because of this, I have a bit of a soft spot for Sidney Stratton. This is someone who's in love with his science. He's captivated by the thrill of the scientific chase, as he uses his knowledge to solve the puzzle of a stronger, more durable textile. And while he justifies his work in terms of how it will improve people's lives, I suspect that it's really the science that's driving him.

Stratton is, in some ways, the epitome of the obsessed scientist. He captures the single-mindedness and benevolent myopia I see in many of my peers, and even myself at times. He has a single driving purpose, which is synthesizing a new polymer that he is convinced it's possible to produce. He has a vague idea that this will be a good thing for society, and this is a large part of the narrative he uses to justify his work. But his concept of social good is indistinct, and rather naïve. We see no indication, for instance, that he's ever considered learning about the people he's trying to help, or even asking them what they want. Instead, he is ignorant of the people he claims his work is for. Rather than genuinely working with them, he ends up appropriating them as a convenient justification for doing what he wants.

Not that Stratton wants to cause any harm—far from it. His intentions are quite well-meaning. And I suspect if he was interviewed about his work, he'd spin a tale about the need for science to make the world a better place. Yet he suffers from social myopia in that he is seemingly incapable of recognizing the broader implications of his work. As a result, he is blindsided when the industrialists he thought would lap up his invention want to suppress it.

Real-life scientists are, not surprisingly, far more complex. Yet elements of this type of behavior are not that uncommon. And they're not just limited to researchers.

---

Some years back, I taught a graduate course in Entrepreneurial Ethics. The class was designed for engineers with aspirations to launch their own startup. Each year, we'd start the course talking about values and aspirations, and with very few exceptions, my students would say that they wanted to make the world a better place. Yes, they were committed to the technologies they were

developing, and to their commercial success, but they ultimately wanted to use these to help other people.

I then had them take part in an exercise where their task was to make as much profit from their classmates as possible, by creating and selling a piece of art. Each student started with a somewhat random set of raw materials to make their art from, together with a wad of fake money to purchase art they liked from others in the class. There were basically no rules to the exercise beyond doing whatever it took to end up with the most money. As an incentive, the winner got a $25 Starbucks voucher.

Every year I ran this, some students found ethically "inventive" ways to get that Starbucks card—and this is, remember, after expressing their commitment to improving other people's lives. Even though this was a game, it didn't take much for participants' values to fly out of the window in the pursuit of personal gain. One year, an enterprising student formed a consortium that was intended to prevent anyone outside it from winning the exercise, regardless of the creation of any art (they claimed the consortium agreement was their "art"). Another year, a student realized they could become an instant millionaire by photocopying the fake money, then use this to purchase their own art, thus winning the prize.

In both of these examples, students who were either too unimaginative or too ethical to indulge in such behavior were morally outraged: How could their peers devolve so rapidly into ethically questionable behavior? Yet the exercise was set up to bring out exactly this type of behavior, and to illustrate how hard it is to translate good intentions into good actions. Each year, the exercise demonstrated just how rapidly a general commitment to the good of society (or the group) disintegrated into self-interest when participants weren't self-aware enough, or socially aware enough, to understand the consequences of their actions.[152]

A similar tendency toward general benevolence and specific self-interest is often seen in science, and is reflected in what we see in Stratton's behavior. Most scientists (including engineers and technologists) I've met and worked with want to improve and enriches people's lives. They have what I believe is a genuine commitment to serving the public good in most cases. And they freely and openly use this to justify their work. Yet surprisingly few of them stop to think about what the "public good" means, or

---

152  One of those consequences was having to deal with the ill will of fellow classmates who felt cheated, confirming that nothing is ever "just a game."

to ask others for their opinions and ideas. Because of this, there's a tendency for them to assume they know what's good for others, irrespective of whether they're right or not. As a result, too many well-meaning scientists presume to know what society needs, without thinking to ask first.

This is precisely what we see playing out with Stratton in *The Man in the White Suit*. He firmly believes that his new polymer will make the world a better place. Who wouldn't want clothes that never get dirty, that never need washing, that never need replacing? Yet at no point does Stratton show the self-reflection, the social awareness, the humility, or even the social curiosity, to ask people what *they* think, and what *they* want. If he had, he might have realized that his invention could spell economic ruin and lost jobs for a lot of people, together with social benefits that were transitory at best. It might not have curbed his enthusiasm for his research, but it might have helped him see how to work with others to make it better.

Of course, modern scientists and technologists are more sophisticated than Stratton. Yet, time after time, I run into scientists who claim, almost in the same breath, that they are committed to improving the lives of others, but that they have no interest in listening to these people they are supposedly committing themselves to. This was brought home to me some years ago, when I was advising the US President's Council of Advisors on Science and Technology (PCAST) on the safe and beneficial development of nanotechnology. In one meeting, I pushed the point that scientists need to be engaging with members of the public if they want to ensure that their work leads to products that are trusted and useful. In response, a very prominent scientist in the field replied rather tritely, "That sounds like a very bad idea."

I suspect that this particular scientist was thinking about the horrors of a presumed scientifically-illiterate public telling him how to do his research. Of course, he would be right to be horrified if he were expected to take scientific direction from people who aren't experts in his particular field. But most people have a pretty high level of expertise in what's important to them and their communities, and rather than expect members of the public to direct complex research, it's *this* expertise that it is important to use in guiding research and development if naïve mistakes are to be avoided.

The reality here is that scientists and technologists don't have a monopoly on expertise and insights. For new technologies to have a

positive impact in a messy world of people, politics, beliefs, values, economics, and a plethora of other interests, scientists and others need to be a part of larger conversations around how to draw on expertise that spans all of these areas and more. Not being a part of such conversations leads to scientific elitism, and ignorance that's shrouded in arrogance. Of course, there is nothing wrong with scientists doing their science for science's sake. But willful ignorance of the broader context that research is conducted within leads to myopia that can ultimately be harmful, despite the best of intentions.

## Never Underestimate the Status Quo

Some time ago, I was at a meeting where an irate scientist turned to a room of policy experts and exclaimed, "I'm a scientist—just stop telling me how to do my job and let me get on with it. I know what I'm doing!"[153]

The setting was a National Academy of Sciences workshop on planetary protection, and we were grappling with the challenges of exploring other worlds without contaminating them or, worse, bringing virulent alien bugs back to earth. As it turns out, this is a surprisingly tough issue. Fail to remove all Earth-based biological contamination from a spacecraft and the instruments it carries, and you risk permanently contaminating the planet or moon you're exploring, making it impossible to distinguish what's truly alien from what is not. But make the anti-contamination requirements too stringent, and you make it next to impossible to search for extraterrestrial life in the first place.

There are similar problems with return samples. Play fast and loose with safety precautions, and we could end up unleashing a deadly alien epidemic on Earth (although, to be honest, this is more science fiction than science likelihood). On the other hand, place a million and one barriers in the way of bringing samples back, and we kill off any chance of studying the biological origins of extraterrestrial life.

To help tread this fine line, international regulations on "planetary protection" (which, despite the name, is not about protecting the Earth from asteroid hits, or space debris, or even us trashing other planets, but instead is geared toward managing biological contamination in space exploration) were established in 1967 to

---

153  I'm paraphrasing, but this was the essence of the frustrated outburst.

ensure we don't make a mess of things.[154] These regulations mean that, when an agency like NASA funds a mission, the scientists and engineers developing vehicles and equipment have to go through what, to them, is a bureaucratic nightmare, to do the smallest thing.

To space exploration scientists, this can feel a little like an imposed form of bureaucratic obsessive-compulsive disorder, designed to send even the mildest-mannered person into a fit of pique. What makes it worse is that, for scientists and engineers working on years-long missions designed to detect signs of life elsewhere in the universe, they are *deeply* aware of what's at stake. If they get things wrong, decades of work and hundreds of millions of dollars—not to mention their scientific reputations—are put at risk. So they're pretty obsessive about getting things right, even before the bureaucrats get involved. And what *really* winds them up (or some of them at least) is being told that they need to fill out yet more paperwork, or redesign their equipment yet again, because some bureaucrat decided to flex their planetary protection muscles.

This frustration reached venting point in the National Academy meeting I was at. Speaking to a room of planetary protection experts—some of whom were directly involved in establishing and implementing current policies—the scientist couldn't contain his frustration. As the lead scientist on a critical mission to discover evidence of life beyond Earth, he *knew* what he had to do to be successful, or so he thought. And in his mind, the room of "experts" in front of him had no idea how ignorant they were about his expertise. He even started to lecture them in quite strong terms on policies that some of them had helped write. It probably wasn't a particularly smart move.

I must confess that, listening to his frustrations, I had quite a bit of sympathy for him. He was clearly good at what he does, and he just wanted to get on with it. But he made two fatal errors. He forgot that science never happens in a vacuum, and he deeply underestimated the inertia of the status quo.

This anecdote may seem somewhat removed from nanotechnology, synthetic chemistry, and *The Man in the White Suit*. Yet there are a surprising number of similarities between this interplanetary scientist and Sidney Stratton. Both are brilliant scientists. Both

---

154   International planetary protection regulations were established in article IX of the 1966 United Nations Treaty on "Principles Governing the Activities of States in the Exploration and Use of Outer Space, including the Moon and Other Celestial Bodies." They are currently embodied in the Committee on Space Research (COSPAR) Planetary Protection Policy.

believe they have the knowledge and ability to deliver what they promise. Both would like nothing better than to be left alone to do their stuff. And neither is aware of the broader social context within which they operate.

The harsh reality is that discovery never happens in isolation. There are always others with a stake in the game, and there's always someone else who is potentially impacted by what transpires. This is the lesson that John Hammond was brutally reminded of in *Jurassic Park* (chapter two). It underpins the technological tensions in *Transcendence* (chapter nine). And it's something that Sidney wakes up to rather abruptly, as he discovers that not everyone shares his views.

Here, *The Man in the White Suit* has overtones of Luddism, with workers and industry leaders striving to maintain the status quo, regardless of how good or bad it is. Yet just as the Luddite movement was more nuanced than simply being anti-technology, here we see that the resistance to Sidney's discovery is not a resistance to technological innovation, but a fight against something that threatens what is deeply important to the people who are resisting it. The characters in the movie aren't Luddites in the pejorative sense, and they are not scientifically illiterate. Rather, they are all too able to understand the implications of the technology that Sidney is developing. As they put the pieces together, they realize that, in order to protect the lives they have, they have to act.

Just as in the meeting on planetary protection, what emerges in *The Man in the White Suit* is a situation where everyone is shrewd enough to see how change supports or threatens what they value, and they fight to protect this value. As a result, no one really wins. Sure, the factory owners and workers win a short reprieve against the march of innovation, and they get to keep things going as they were before. But all this does is rob them of the ability to adapt to inevitable change in ways that could benefit everyone. And, of course, Sidney suffers a humiliating defeat at the hands of those he naïvely thought he was helping.

What the movie captures so well as it ends—and one of the reasons it's in this book—is that there is nothing inherently bad about Sidney's technology. On the contrary, it's a breakthrough that could lead to tremendous benefits for many people, just like the nanotechnology it foreshadows. Rather, it's the way that it's handled that causes problems. As with every disruptive innovation,

Sidney's new textile threatened the status quo. Naturally, there were going to be hurdles to its successful development and use, and not being aware of those hurdles created risks that could otherwise be avoided. Self-preservation and short-sightedness ended up leading to social and economic benefits being dashed against the rocks of preserving the status quo. But things could have been very different. What if the main characters had been more aware of the broader picture; what if they had bothered to talk to others and find out about their concerns and aspirations; and what if they had collectively worked toward a way forward that benefitted everyone? Admittedly, it would have led to a rather boring movie. But from the perspective of beneficial and responsible innovation, the future could have looked a whole lot brighter.

## It's Good to Talk

Not so long ago, at a meeting about AI, I had a conversation with a senior company executive about the potential downsides of the technology. He admitted that AI has some serious risks associated with it if we get it wrong, so much so that he was worried about the impact it would have if it got out of hand. Yet, when pushed, he shied away from any suggestion of talking with people who might be impacted by the technology. Why? Because he was afraid that misunderstandings resulting from such engagement would lead to a backlash against the technology, and as a result, place roadblocks in the way of its development that he felt society could ill afford. It was a perfect example of a "let's not talk" approach to technological innovation, and one that, as Sidney Stratton discovered to his cost, rarely works.

The irony here is that it's the misunderstanding and miscommunication from *not* talking (or to be precise, not listening and engaging) that makes *The Man in the White Suit* a successful comedy. As the audience, we are privy to a whole slew of comedic misunderstandings and resulting farcical situations that could have been avoided if the characters had simply taken the time to sit down with each other. From the privileged position of our armchairs, this all makes perfect sense. But things are rarely so obvious in the real-world rough-and-tumble of technology innovation.

To many technology developers, following a "let's *not* talk" strategy makes quite a bit of sense on the surface. If we're being honest, people do sometimes get the wrong end of the stick when it comes to new technologies. And there is a very real danger of consumers,

policy makers, advocacy groups, journalists, and others creating barriers to technological progress through their speculations about potential future outcomes. That said, there are serious problems with this way of thinking. For one thing, it's incredibly hard to keep things under wraps these days. The chances are that, unless you're involved in military research or a long way from a marketable product, people are going to hear about what you are doing. And if you're not engaging with them, they'll form their own opinions about what your work means to them. As a result, staying quiet is an extremely high-risk strategy, especially as, once people start to talk about your tech, they'll rapidly fill any information vacuum that exists, and not necessarily with stuff that makes sense.

Perhaps just as importantly, keeping quiet may seem expedient, but it's not always ethical. If an emerging technology has the potential to cause harm, or to disrupt lives and livelihoods, it's relevant to *everyone* it potentially touches. In this case, as a developer, you probably shouldn't have complete autonomy over deciding what you do, or the freedom to ignore those whom your products potentially affect. Irrespective of the potential hurdles to development (and profit) that are caused by engaging with stakeholders (meaning anyone who potentially stands to gain or lose by what you do), there's a moral imperative to engage broadly when a technology has the potential to impact society significantly.

On top of this, developers of new technologies rarely have the fullest possible insight into how to develop their technology beneficially and responsibly. All of us, it has to be said, have a bit of Sidney Stratton in us, and are liable to make bad judgment calls without realizing it. Often, the only way to overcome this is to engage with others who bring a different perspective and set of values to the table.

In other words, it's good to talk when it comes to developing impactful new technologies. Or rather, it's good to listen to and engage with each other, and explore mutually beneficial ways of developing technologies that benefit both their investors and society more broadly, and that don't do more harm than good. Yet this is easier said than done. And there are risks. My AI executive was right to be concerned about engaging with people because sometimes people don't like what they hear, and they decide to make your life difficult as a result. Yet there's also a deep risk to holding back and not talking, and in the long run this is usually the larger of the two. Talking's tough. But *not* talking is potentially more dangerous.

One way that people have tried to get around this "toughness" is a process called the Danish Consensus Conference. This is an approach that takes a small group of people from different backgrounds and perspectives and provides an environment where they can learn about an issue and its consequences before exploring productive ways forward. The power of the Danish Consensus Conference is that it gets people talking and listening to each other in a constructive and informed way. Done right, it overcomes many of the challenges of people not understanding an issue and reverting to protecting their interests out of ignorance. But it does have its limitations. And one of the biggest is that very few people have the time to go through such a time-consuming process. This gets to the heart of perhaps the biggest challenge in public engagement around emerging technologies: Most people are too busy working all hours to put food on the table and a roof over their heads, or caring for family, or simply surviving, to have the time and energy for somewhat abstract conversations about seemingly esoteric technologies. There's simply not enough perceived value to them to engage.

So how do we square the circle here? How do we ensure that the relevant people are at the table when deciding how new technologies are developed and used, so we don't end up in a farcical mess? Especially as we live in a world where everyone's busy, and the technologies we're developing, together with their potential impacts, are increasingly complex?

The rather frustrating answer is that that there are no simple answers here. However, a range of approaches is emerging that, together, may be able to move things along at least a bit. Despite being cumbersome, the Danish Consensus Conference remains relevant here, as do similar processes such as Expert & Citizen Assessment of Science & Technology (ECAST).[155] But there are many more formal and informal ways in which people with different perspectives and insights can begin to talk and listen and engage around emerging technologies. These include the growing range of opportunities that social media provides for peer-to-peer engagement (with the caveat that social media can shut down engagement as well as opening it up). They also include using venues and opportunities such as science museums, TED talks, science cafes, poetry slams, citizen science, and a whole cornucopia of other platforms.

---

[155] You can read more about Expert and Citizen Assessment of Science & Technology at https://ecastnetwork.org/

The good news is that there are more ways than ever for people to engage around developing responsible and beneficial technologies, and to talk with each other about what excites them and what concerns them. And with platforms like Wikipedia, YouTube, and other ways of getting content online, it's never been easier to come up to speed on what a new technology is and what it might do. All that's lacking is the will and imagination of experts to use these platforms to facilitate effective engagement around the responsible and beneficial development of new technologies. Here, there are tremendous opportunities for entrepreneurially- and socially-minded innovators to meet people where they're at, in and on the many venues and platforms they inhabit, and to nudge conversations toward a more inclusive, informed and responsible dialogue around emerging technologies.

Making progress on this front could help foster more constructive discussions around the beneficial and responsible development of new technologies. It would, however, mean people being willing to concede that they don't have the last word on what's right, and being open to not only listening to others, but changing their perspectives based on this. This goes for the scientists as well as everyone else, because, while scientists may understand the technical intricacies of what they do, just like Sidney Stratton, they are often not equally knowledgeable about the broader social implications of their work, as we see to chilling effect in our next movie: *Inferno*.

CHAPTER ELEVEN

# INFERNO: IMMORAL LOGIC IN AN AGE OF GENETIC MANIPULATION

> *"If a plague exists, do you know how many governments would want it and what they'd do to get it?"*
> —Sienna Brooks

## Decoding Make-Believe

In 1969, the celebrated environmentalist Paul Ehrlich made a stark prediction. In a meeting held by the British Institute of Biology, he claimed that, "By the year 2000, the United Kingdom will simply be a small group of impoverished islands, inhabited by some seventy million hungry people, of little concern to the other five to seven billion inhabitants of a sick world."[156]

It's tempting to quip that Ehrlich was predicting the fallout from Brexit and the UK's departure from Europe, and his crystal ball was simply off by a few years. But what kept him up at night, and motivated the steady stream of dire warnings flowing from him, was his certainty that human overpopulation would lead to unmitigated disaster as we shot past the Earth's carrying capacity.

I left the UK in 2000 to move to the US, and I'm glad to say that, at the time, the United Kingdom was still some way from becoming that "small group of impoverished islands." Yet despite the nation's refusal to bow to Ehrlich's predictions, his writings on population crashes and control have continued to capture the imaginations of people over the years, including, I suspect, that of author and the brains behind the movie *Inferno*, Dan Brown.

---

156   Bernard Dixon (1971) "In Praise of Prophets." *New Scientist*, 16 September 1971, page 606.

I don't know if Brown and Ehrlich have ever met. I'd like to think that they'd get on well. Both have a knack for a turn of phrase that transforms hyperbole into an art form. And both have an interest in taking drastic action to curb an out-of-control global human population.

The movie *Inferno* is based on the book of the same name by Dan Brown. It's perhaps not the deepest movie here, but if you're willing to crack open the popcorn and suspend disbelief, it successfully keeps you on the edge of your seat, as any good mindless thriller should. And it does provide a rather good starting point for examining the darker side of technological innovation—biotechnology in particular—when good intentions lead to seemingly logical, but not necessarily moral, actions.

---

*Inferno* revolves around the charismatic scientist and entrepreneur Bertrand Zobrist (played by Ben Foster). Zobrist is a brilliant biotechnologist and genetic engineer who's devoted to saving the world. But he has a problem. Just like Ehrlich, Zobrist has done the math, and realized that our worst enemy is ourselves. In his genius-eyes, no matter what we do to cure sickness, improve quality of life, and enable people to live longer, all we're doing is pushing the Earth ever further beyond the point where it can sustain its human population. And like Ehrlich, he sees a pending future of disease and famine and death, with people suffering and dying in their billions, because we cannot control our profligacy.

Zobrist genuinely wants to make the world a better place. But he cannot shake this vision of apocalyptic disaster. And he cannot justify using his science for short-term gains, only for it to lead to long-term devastation. So he makes a terrible decision. To save humanity from itself, he creates a genetically engineered virus that will wipe out much of the world's population—plunging humanity back into the dark ages, but giving it the opportunity to reset and build a more sustainable future as a result. And because it seems that genius entrepreneurs can't do anything simply, he arranges for the virus to be elaborately released at a set time in a mysterious location somewhere in Europe.

The problem is, the authorities are onto him—the authorities in this case being an entertainingly fictitious manifestation of the World Health Organization. As the movie starts, Zobrist is being pursued by WHO agents who chase him to the top of a bell tower in the

Italian city of Florence where, rather than reveal his secrets, Zobrist jumps to his death. But in his pocket, he conveniently has a device that holds the key to where he's hidden the virus.

This is where Dan Brown brings in his "symbologist" hero, Harvard-based Robert Langdon (Tom Hanks). Langdon, having proven himself to be rather good at decoding devilishly complex puzzles in the past, is the ideal person to follow the trail and save the world. But he quickly finds himself unwittingly wrapped up in a complex subterfuge where he's led to believe the WHO are the bad actors, and it's up to him and a young doctor, Sienna Brooks (Felicity Jones), to track down the virus before they get to it.

What follows is a whirlwind of gorgeous locations (Florence, Venice, Istanbul), misdirection, plot twists, and nail-biting cliffhangers. We learn that Sienna is, in fact, Zobrist's lover, and has been using Langdon to find the virus so she can release it herself. We also learn that she's fooled a clandestine global security organization (headed up by Harry Simms, who's played perfectly by Irfan Khan) into helping her, and they set about convincing Langdon he needs to solve the puzzle while evading the WHO agents.

The movie ends rather dramatically with the virus being contained just before it's released. The bad folks meet a sticky end, Langdon saves the world, and everyone still standing lives happily ever after.

---

Without doubt, *Inferno* is an implausible but fun romp. Yet it does raise a number of serious issues around science, technology, and the future. Central to these is the question that Paul Ehrlich and Bertrand Zobrist share in common: Where does the moral responsibility lie for the future of humanity, and if we could act now to avoid future suffering—even though the short-term cost may be hard to stomach—should we? The movie also touches on the dangers of advanced genetic engineering, and it brings us back to a continuing theme in this book: powerful entrepreneurs who not only have the courage of their convictions, but the means to act on what they believe.

Let's start, though, with the question of genetically engineering biological agents, together with the pros and cons of engineering pathogens to be even more harmful.

# Weaponizing the Genome

In 2012, two groups of scientists published parallel papers in the prestigious journals *Science*[157] and *Nature*[158] that described, in some detail, how to genetically engineer an avian influenza virus. What made the papers stand out was that these scientists succeeded in making the virus *more* infectious, and as a result, far deadlier. The research sparked an intense debate around the ethics of such studies, and it led to questions about the wisdom of scientists publishing details of how to make pathogens harmful in a way that could enable others to replicate their work.

The teams of scientists, led by virologists Ron Fouchier and Yoshihiro Kawaoka, were interested in the likelihood of a highly pathogenic flu virus mutating into something that would present a potentially catastrophic pandemic threat to humans. The unmodified virus, referred to by the code H5N1, is known to cause sickness and death in humans, but it isn't that easy to transmit from person to person. Thankfully, the virus isn't readily transmitted by coughs and sneezes, and this in turn limits its spread quite considerably. But this doesn't mean that the virus couldn't naturally mutate to the point where it could successfully be transmitted by air. If this were to occur (and it's certainly plausible), we could be facing a flu pandemic of astronomical proportions.

To get a sense of just how serious such a pandemic could be, we simply need to look back to 1918, when the so-called "Spanish flu" swept the world.[159] The outbreak of Spanish flu in the early 1900s is estimated to have killed around fifty million people, or around 3 percent of the world's population at the time. If an equally virulent infectious disease were unleashed on the world today, this would be equivalent to over 200 million deaths, a mind-numbing number of people. However, the relative death toll would likely be far higher today, as modern global transport systems and the high numbers of people living close to each other in urban areas would likely substantially increase infection rates.

It's this sort of scenario that keeps virologists and infectious-disease epidemiologists awake at night, and for good reason. It's highly

---

157   Sander Herfst and colleagues (2012) "Airborne Transmission of Influenza A/H5N1 Virus Between Ferrets" *Science*, 336 (6088) pp 1534-1541 http://doi.org/10.1126/science.1213362

158   Masaki Imai and colleagues (2012) "Experimental adaptation of an influenza H5 HA confers respiratory droplet transmission to a reassortant H5 HA/H1N1 virus in ferrets" *Nature* 486, pp 420–428 http://doi.org/10.1038/nature10831

159   Jeffery K. Taubenberger and David M. Morens (2006) "1918 Influenza: the Mother of All Pandemics". *Emerging Infectious Diseases* volume 12, number 1, pages 15-22 https://doi.org/10.3201/eid1201.050979

likely that, one day, we'll be facing a pandemic of this magnitude. Viruses mutate and adapt, and the ones that thrive are often those that can multiply and spread fast. Here, we know that there are combinations of properties that make viruses especially deadly, including human pathogenicity, lack of natural resistance in people, and airborne transmission. There are plenty of viruses that have one, or possibly two, of these features, yet there are relatively few that combine all three. But because of the way that evolution and biology work, it's only a matter of time before some lucky virus hits the jackpot, much as we saw back in 1918.

Because of this, it makes sense to do everything we can to be prepared for the inevitable, including working out which viruses are likely to mutate into deadly threats (and how) so we can get our defenses in order before this happens. And this is what drove Fouchier, Kawaoka, and their teams to start experimenting on H5N1.

H5N1 is a virus that is deadly to humans, but it has yet to evolve into a form that is readily transmitted by air. What interested Fouchier and Kawaoka was how likely it was that such a mutation would appear, and what we could do to combat the evolved virus if and when this occurs. To begin to answer this question, they and their teams of scientists intentionally engineered a deadly new version of H5N1 in the lab, so they could study it. And this is where the ethical questions began to get tricky. This type of study is referred to as "gain-of-function" research, as it increases the functionality and potential deadliness of the virus. Maybe not surprisingly, quite a few people were unhappy with what was being done. Questions were asked, for instance, about what would happen if the new virus was accidentally released. This was not an idle question, as it turns out, given a series of incidents where infectious agents ended up being poorly managed in labs.[160] But it was the decision to publicly publish the recipe for this gain-of-function research that really got people worried.

Both *Science* and *Nature* ended up publishing the research and the methods, but only after an intense international debate about the wisdom of doing so.[161] However, the decision was, and remains, controversial. Proponents of the research argue that we need to be ready for highly pathogenic and transmissible strains of flu before

---

[160] Jocelyn Kaiser (2014) "Lab incidents lead to safety crackdown at CDC." Published in *Science Magazine*, July 11, 2014. http://www.sciencemag.org/news/2014/07/lab-incidents-lead-safety-crackdown-cdc

[161] Ed Yong (2012) "The risks and benefits of publishing mutant flu studies." *Nature News*, March 2, 2012 http://doi.org/10.1038/nature.2012.10138

they inevitably arise, and this means having the ability to develop a stockpile of vaccines. This in turn depends on having a sample of the virus to be protected against. But this type of research makes many scientists uneasy, especially given the challenges of preventing inadvertent releases.

Concerns like this prompted a group of scientists to release a Consensus Statement on the Creation of Potential Pathogens in 2014, calling for greater responsibility in making such research decisions.[162] These largely focused on the unintended consequences of well-meaning research. But there was also a deeper-seated fear here: What if someone took this research and intentionally weaponized a pathogen?

This was one of the issues considered by the US National Science Advisory Board for Biosecurity as it debated drafts of the H5N1 gain-of-function papers in 2011. In a statement released on December 20, 2011, the NSABB proposed that that the papers should *not* be published in their current form, recommending "the manuscripts not include the methodological and other details that could enable replication of the experiments by those who would seek to do harm."[163] However, this caused something of a furor at the time among scientists. The NSABB is an advisory body in the US and has no real teeth, yet its recommendations drew accusations of "censorship"[164] in a scientific community that deeply values academic freedom.

The NSABB eventually capitulated, and supported the publication of both papers as they finally appeared in 2012—including the embedded "how-to" instructions for creating a virulent virus.[165] But the question of intentionally harmful use remained. And it's concerns like this that underpin the plot in *Inferno*.

---

Fouchier, Kawaoka, and their teams showed that it is, in principle, possible to take a potentially dangerous virus and engineer it into something even more deadly. To the NSABB and others, this raised

---

162   Cambridge Working Group Consensus Statement on the Creation of Potential Pandemic Pathogens (PPPs). http://www.cambridgeworkinggroup.org/
163   Press Statement on the NSABB Review of H5N1 Research, December 20, 2011. https://www.nih.gov/news-events/news-releases/press-statement-nsabb-review-h5n1-research
164   Heidi Ledford (2012) "Call to censor flu studies draws fire." Published in *Nature News* January 3, 2012. http://doi.org/10.1038/481009a
165   March 29-30, 2012 Meeting of the National Science Advisory Board for Biosecurity to Review Revised Manuscripts on Transmissibility of A/H5N1 Influenza Virus. Statement of the NSABB: http://www.virology.ws/NSABB_statement_march_2012.pdf

a clear national security issue: What if an enemy nation or a terrorist group used the research to create a weaponized virus? Echoes of this discussion stretched back to the 2001 anthrax attacks in the US, where the idea of "weaponizing" a pathogenic organism became part of our common language. Since then, discussions over whether and how biological agents may be weaponized have become increasingly common.

Intuitively, genetically engineering a virus to weaponize it feels like it should be a serious threat. It's easy to imagine the mayhem a terrorist group could create by unleashing an enhanced form of smallpox, Ebola, or even the flu. Thankfully, most biosecurity experts believe that the risks are low here. Despite these imagined scenarios, it takes substantial expertise and specialized facilities to engineer a weaponized pathogen, and even then, it's unclear that the current state of science is good enough to create an effective weapon of terror. More than this, though, most experts agree that there are far easier and cheaper ways of creating terror, or taking out enemy forces, than using advanced biology. And because of this, it's hard to find compelling reasons why an organization would weaponize a pathogen, rather than using far easier and cheaper ways of causing harm. Why spend millions of dollars and years of research on something that may not work, when you can do more damage with less effort using a cell phone and home-made explosives, or even a rental truck? The economics of weaponized viruses simply don't work outside of science fiction thrillers and blockbuster movies. At least, not in a conventional sense.

And this is where *Inferno* gets interesting, as Zobrist is not terrorist in the conventional sense. Zobrist's aim is *not* to bring about change through terror, but to *be* the agent of change. And his mechanism of choice is a gain-of-function genetically engineered virus. Unlike the potential use of genetically modified pathogens by terrorists, or even nation-states, the economics of Zobrist's decision actually make some sense, warped as they are. In his mind, he envisions a cataclysmic future for humanity, brought about through out-of-control overpopulation. and he sees it as a moral imperative to use his expertise and wealth to help avoid it, albeit by rather drastic means.

As this is movie make-believe, the technology Zobrist ends up developing is rather implausible. But it's not that far-fetched. Certainly, we know from the work of Fouchier, Kawaoka, and others that it is possible to engineer viruses to be more deadly

than their naturally-occurring counterparts. And we're not that far from hypothetically being able to precisely design a virus with a specific set of characteristics, an ability that will only accelerate as we increasingly use cyber-based technologies and artificial-intelligence-based methods in genetic design. Because of these converging trends in capabilities, when you strip away the hyperbolic narrative and cliffhanger scenarios from *Inferno*, there's a kernel of plausibility buried in the movie that should probably worry us, especially in a world where powerful individuals are able to translate their moral certitude into decisive action.

## Immoral Logic?

Some years ago, my wife gave me a copy of Daniel Quinn's book *Ishmael*. The novel, which won the Turner Tomorrow Award in 1991, has something of a cult following. But I must confess I was rather disturbed by the arguments it promoted. What concerned me most, perhaps, was a seemingly pervasive logic through the book that seemed to depend on "ends," as defined by a single person, justifying extreme "means" to get there. Echoing both Paul Ehrlich and Dan Brown, Quinn was playing with the idea that seemingly unethical acts in the short term are worth it for long-term prosperity and well being, especially when, over time, the number of people benefitting from a decision far outnumber those who suffered as a consequence.

*Ishmael* is a Socratic dialogue between the "pupil"—the narrator— and his "teacher," a gorilla that has the power of speech and reason. The book uses this narrative device to dissect human history and the alleged rise of tendencies that have led to a global culture of selfish greed, unsustainable waste, and out-of-control population growth. The book is designed to get the reader to think and reflect. In doing so, it questions our rights as humans above those of other organisms, and our obligations to other humans above that to the future of the Earth as a whole. Many of the underlying ideas in the book are relatively common in environmentalist thinking. What *Ishmael* begins to illuminate, though, is what happens when some of these ideas are taken to their logical conclusions. One of those conclusions is that, if the consequence of a growing human population and indiscriminate abuse of the environment is a sick and dying planet, anything we do *now* to curb our excesses is justified by the *future* well-being of the Earth and its many ecosystems. The analogy used by Quinn is that of a surgeon cutting out a malignant cancer to save the patient, except that, in this case,

the patient is the planet, and humanity is both the cancer and the surgeon.

This is a similar philosophy, of taking radical action in the present to save the future, that Ehrlich promoted in his 1968 book, *The Population Bomb*.[166] As a scientist and environmentalist, Ehrlich was appalled by where he saw the future of humanity and Planet Earth heading. As the human population increased exponentially, he believed that, left unchecked, people would soon exceed the carrying capacity of the planet. If this happened, he believed we would be plunged into a catastrophic cycle of famine, disease, and death, that would be far worse than any preventative actions we might take.

Ehrlich opens his book with a dramatic account of him personally experiencing localized overpopulation in Delhi. This experience impressed on him that, if this level of compressed humanity was to spread across the globe (as he believed it would), we would be responsible for making a living hell for future generations, something he saw as his moral duty to do what he could to prevent.

In the book, Ehrlich goes on to explore ways in which policies could be established to avoid what he saw as an impending disaster. He also looked at ways in which people might be persuaded to change their habits and beliefs in an attempt to dramatically curb population growth. But he considered the threat too large to stop at political action and persuasion. To him, if these failed, drastic measures were necessary. He lamented, for instance, that India had not implemented a controversial sterilization program for men as a means of population control. And he talked of triaging countries needing aid to avoid famine and disease, by helping only those that could realistically pull themselves around while not wasting resources on "hopeless cases."

Ehrlich's predictions and views were both extreme and challenging. And in turn, they were challenged by others. Many of his predictions have not come to pass, and since publication of *The Population Bomb,* Ehrlich has pulled back from some of his more extreme proposals. There are many, though, who believe that the sheer horror of his predictions and his proposed remedies scared a generation into taking action before it was too late. Even so, we are still left with a philosophy which, much like the one espoused in *Ishmael,* suggests that one person's prediction of pending death and

---

166  Ehrlich, P. (1968). "The Population Bomb." *Sierra Club/Ballantine Books.*

destruction has greater moral weight than the lives of the people they are willing to sacrifice to save future generations.

It is precisely this philosophy that Dan Brown explores through the character of Zobrist in *Inferno*. Superficially, Zobrist's arguments seem to make sense. Using an exponential growth model of global population, he predicts a near future where there is a catastrophic failure of everything we've created to support our affluent twenty-first-century lifestyle. Following his arguments, it's not hard to imagine a future where food and water become increasingly scarce, where power systems fail, leaving people to the mercy of the elements, where failing access to healthcare leads to rampant disease, and where people are dying in the streets because they are starving, sick, and have no hope of rescue.

As well as being a starkly sobering vision, this is also a plausible one—up to a point. We know that when animal populations get out of balance, they often crash. And research on complex systems indicates that the more complex, interdependent, and resource-constrained a system gets, the more vulnerable it can become to catastrophic failure. It follows that, as we live increasingly at the limits of the resources we need to sustain nearly eight billion people across the planet, it's not too much of a stretch to imagine that we are building a society that is very vulnerable indeed to failing catastrophically. But if this is the case, what do we do about it?

Early on in *Inferno*, Zobrist poses a question: "There's a switch. If you throw it, half the people on earth will die, but if you don't, in a hundred years, then the human race will be extinct." It's an extreme formulation of the ideas of Quinn and Ehrlich, and not unlike a scaled-up version of the Trolley Problem that philosophers of artificial intelligence and self-driving cars love to grapple with. But it gets to the essence of the issue at hand: Is it better to kill a few people now and save many in the future, or to do nothing, condemning billions to a horrible death, and potentially signing off on the human race?

Ehrlich and Quinn suggest that it's moral cowardice to take the "not my problem" approach to this question. In *Inferno*, though, Brown elevates the question from one of philosophical morality to practical reality. He gives the character of Zobrist the ability to follow through on his convictions, and to get out of his philosophical armchair to

quite literally throw the switch, believing he is saving humanity as he does so.

The trouble is, this whole scenario, while easy to spin into a web of seeming rationality, is deeply flawed. Its flaws lie in the same conceits we see in calls for action based on technological prediction. It assumes that the future can be predicted from the exponential trends of the past (a misconception that was addressed in chapter nine and *Transcendence*), and it amplifies, rather than moderates, biases in human reasoning and perception. Reasoning like this creates an artificial certainty around the highly uncertain outcomes of what we do, and it justifies actions that are driven by ideology rather than social responsibility. It also assumes that the "enlightened," whoever they are, have the moral right to act, without consent, on behalf of the "unenlightened."

In the cold light of day, what you end up with by following such reasoning is something that looks more like religious terrorism, or the warped actions of the Unabomber Ted Kaczynski, than a plan designed to create social good.

This is not to say we are not facing tough issues here. Both the Earth's human population and our demands on its finite resources are increasing in an unsustainable way. And this is leading to serious challenges that should, under no circumstances, be trivialized. Yet, as a species, we are also finding ways to adapt and survive, and to overcome what were previously thought to be immovable barriers to what could be achieved. In reality, we are constantly moving the goalposts of what is possible through human ingenuity. The scientific and social understanding of the 1960s was utterly inadequate for predicting how global science and society would develop over the following decades, and as a result, Ehrlich and others badly miscalculated both the consequences of what they saw occurring and the measures needed to address them. These developments included advances in artificial fertilizers and plant breeding that transformed the ability of agriculture to support a growing population. We continue to make strides in developing and using technology to enable a growing number of people to live sustainably on Earth, so much so that we simply don't know what the upper limit of the planet's sustainable human population might be. In fact, perhaps the bigger challenge today is not providing people with enough food, water, and energy, but in overcoming social and ideological barriers to implementing technologies in ways that benefit this growing population.

Imagine now that, in 1968, a real-life Zobrist had decided to act on Ehrlich's dire predictions and indiscriminately rob people of their dignity, autonomy, and lives, believing that history would vindicate them. It would have been a morally abhorrent tragedy of monumental proportion. This is part of the danger of confusing exponential predictions with reality, and mixing them up with ideologies that adhere religiously to a narrow vision of the future, to the point that its believers are willing to kill for the alleged long-term good of society.

Yet while such thinking can lead to what I believe is an immoral logic, we cannot afford to dismiss the possibility that inaction in the present may lead to catastrophic failures in the future. If we don't get our various acts together, there's still a chance that a growing population, a changing climate, and human greed will lead to future suffering and death. As we develop increasingly sophisticated technologies, these only add to the uncertainty of what lies around the corner. But if we're going to eschew following an immoral logic, how do we begin to grapple with these challenges?

## The Honest Broker

Perhaps one of the most difficult challenges scientists (and academics more broadly) face is knowing when to step out of the lab (or office) and into the messy world of politics, advocacy, and activism. The trouble is, we're taught to question assumptions, to be objective, and to see issues from multiple perspectives. As a result, many scientists see themselves as seekers of truth, but skeptical of the truth. Because of this, many of us are uneasy about using our work to make definitive statements about what people should or should not be doing. To be quite frank, it feels disingenuous to set out to convince people to act as if we know the answers to a problem, when in reality all we know is the limits of our ignorance.

There's something else though, that makes many scientists leery about giving advice, and that's the fear of losing the trust and respect of others. Many of us have an almost pathological paranoia of being caught out in an apparent lie if we make definitive statements in public, and for good reason; there are few problems in today's society that have cut-and-dried solutions, and to claim that there are smacks of charlatanism. More than this, though, there's a sense within the culture of science that making definitive statements in public is more about personal ego than professional responsibility.

The unwritten rule here sometimes seems to be that scientists should stick to what they're good at—asking interesting questions and discovering interesting things—and leave it to others to decide what this means for society more broadly. This is, I admit, something of an exaggeration. But it does capture a tension that many scientists grapple with as they try to reconcile their primary mission to generate new knowledge with their responsibility as a human being to help people not make a complete and utter mess of their lives.

Not surprisingly, these lines become blurred in areas where research is driven by social concerns. As a result, there's a strong tradition in areas like public health of research being used to advocate for socially beneficial behaviors and policies. And scientists focusing on environmental sustainability and climate change are often working in these areas precisely *because* they want to make a difference. To many of them, their research isn't worth their time if it doesn't translate into social impact, and that brings with it a responsibility to advocate for change.

This is the domain that scientists like Paul Ehrlich and Dan Brown's Zobrist inhabit. They are engaged in their science because they see social and environmental problems that need to be solved. To many researchers in this position, their science is a means to a bigger end, rather than being an end in itself. In fact, I suspect that many researchers in these areas of study would argue that there is a particular type of immorality associated with scientists who, with their unique perspective, can see an impending disaster coming, and decide to do nothing about it.

Here, the ethics of the scientist-advocate begin make a lot of sense. Take this thought experiment, for instance. Imagine your research involves predicting volcanic eruptions (just to make a change from population explosions and genetically engineered viruses), and your models strongly indicate that the supervolcano that lies under Yellowstone National Park could erupt sometime in the next decade. What should you do? Do nothing, and you potentially condemn millions of people—maybe more—to famine, poverty, disease, and death. Instinctively, this feels like the wrong choice, and I suspect that few scientists would just ignore the issue. But they might say that, because of the uncertainty in their predictions, more research is needed, including more research funding, and maybe a conference or two to develop the science more and argue over the results. In other words, there'd probably be lots of activity, but very little action

that would help those people who would be affected if such an eruption did occur.

To some scientists, however, this would be ethically untenable, and an abdication of responsibility. To them, the ethical option would be to take positive action: Raise awareness, shock people into taking the risk seriously, hit the headlines, give TED talks, make people sit up and listen and care, and, above all, motivate policy makers to do something. Because—so the thinking would go—even if the chances are only one in a thousand of the eruption happening, it's better to raise the alarm and be wrong than stay silent and be right.

This gets to the heart of the ethics of science-activism. It's what lies behind the work of Paul Ehrlich and others, and it's what motivates movements and organizations that push for social, political, and environmental change to protect the future of the planet and its inhabitants. And yet, compelling as the calculus of saved future lives is, there is a problem. Pushing for action based on available evidence always comes with consequences. Sadly, there's no free pass if you make a mistake, or the odds don't fall in your favor. Going back to the Yellowstone example, a major eruption could well render large swaths of the mid-US uninhabitable. Agriculture would be hit hard, with air pollution and localized climate shifts making living conditions precarious for tens of millions of people. On the other hand, preparing for a potential eruption would most likely involve displacing millions of people, possibly leading to coastal overcrowding, loss of jobs, homelessness, and a deep economic recession. The outcomes of the precautionary actions—irrespective of whether the predictions came true or not—would be devastating for some. They may be seen as worth it in the long run if the eruption takes place. But if it doesn't, the decision to act will have caused far more harm than inaction would have. Now imagine having the burden of this on your shoulders, because you had the courage of your scientific convictions, even though you were wrong, and it becomes clearer why it takes a very brave scientist indeed to act on the potential consequences of their work.

This is, obviously, an extreme and somewhat contrived example. But it gets to the core of the dilemma surrounding individuals acting on their science, and it underlies the tremendous social responsibility that comes with advocating for change based on scientific convictions. To make matters worse, while we all like to think we are rational beings—scientists especially—we are not. We are all at the mercy of our biases and beliefs, and all too often we

interpret our science through the lens of these. And this means that when an individual, no matter how smart they are, decides that they have compelling evidence that demands costly and disruptive action, there's a reasonably good chance that they've missed something.

So how do we get out of this bind, where conscientious scientists seem to be damned if they do, and damned if they don't? The one point of reasonable certainty here is that it's dangerous for an individual to push an agenda for change on their own. It's just too easy for someone to be blinded by what they believe is right and true, and as a result miss ways forward that are more socially responsible. At the same time, it's irresponsible to suggest that scientists should be seen and not heard, especially when they have valuable insights into emerging risks and ways to avoid them.

One way forward is in collective advocacy. There's a much greater chance of a hundred scientists having a clear view of emerging challenges and options than one lone genius. And in reality, this is how science gets translated into action on many large issues. But this does mean that experts need to be prepared to work together, and to have the humility to accept that their personal ideas may need to be reined in or modified for the common good. This is where most experts are at with big issues like climate change and vaccines. But there are many other socially important issues that either don't rise to the level of collective efforts from scientists, or are still uncertain enough that there is not enough evidence for a consensus to emerge. So, what are socially responsible scientists to do in these cases?

In 2007, the scholar Roger Pielke Jr. grappled with some of these challenges in his book *The Honest Broker: Making Sense of Science in Policy and Politics*.[167] Pielke was especially interested in how science and scientists inform policy and operate within the political arena. Because of this, his book takes quite a narrow view of advocacy, particularly when it comes to exploring how scientists can use policy advocacy to bring about change. But much of his analysis is relevant to any scientist trying to thread the needle of remaining true to their profession while acting as a responsible citizen.

Pielke astutely recognizes that there is no single best way that scientists can translate what they know and what they believe to be true into societally relevant action. Instead, taking his own advice, he suggests that there are a range of possible options here, with

---

[167] Roger A. Pielke Jr. (2007). "The Honest Broker: Making Sense of Science in Policy and Politics" Published by *Cambridge University Press*.

four in particular standing out. These he refers to as four idealized roles of science in policy and politics, but they apply equally well to scientists trying to bring about what they consider to be positive social change. The first of these roles is the Pure Scientist. This is perhaps closest to the picture of the scientists I drew at the beginning of this section, the person committed to objectivity and evidence, who is seriously worried by the idea of making decisions where there is only uncertainty.

Pielke characterizes the Pure Scientist as someone simply interested in generating new knowledge and placing it into a common reservoir of information, which they leave to others to dip into and use. In other words, they create a wall between themselves and the society they live in, assuming that someone else may one day find some use for what they do. If this sounds a little unrealistic, it probably is. Even Pielke acknowledges that such scientists are probably found more frequently in myth than in reality. Yet this is a relatively common stereotype of scientists, certainly within Western culture.

Pielke's next category is the Science Arbiter. This, I suspect, is where many scientists are the most comfortable. In Pielke's framework, Science Arbiters recognize that effective and socially relevant decisions are made on good evidence and clear information about the pros and cons of different options. Rather than having an opinion on what is the right or the wrong decision, Science Arbiters help ensure people have access to the science and evidence they need to make the best possible decisions. There is a twist here, though. Pielke also argues that, because people who feel comfortable in this role have a deep belief in the scientific process, they tend to focus on issues that they believe can be resolved through science, while staying away from those that they believe cannot.

Then there are scientists—for instance, those working in areas driven by real-world challenges like health and sustainability—who feel they cannot morally justify providing what seem to them to be scientifically sound but socially hollow options to decision makers. These, in Pielke's terminology, are the Issue Advocates. They are scientists on a mission to change the world, to fix what they see as (mainly) social problems, and to use their science to the best of their ability to do this. These are people who use science as a means to an end, and are driven by their own beliefs and convictions. Zobrist

would be considered by Pielke to be an Issue Advocate, as would, I suspect, Paul Ehrlich.

And finally, there is the Honest Broker. This, in Pielke's language, is the person who actively engages with decision-makers to help them see how science and evidence support (or don't) the various options that are open to them. This is the scientist who believes, more than anything, in helping people make the best decision they can based on the evidence, but who understands that, ultimately, they don't have the right to dictate which decision is made.

Pielke tries not to stand in judgment of the four ways he describes scientists engaging with politics and policy. But it's clear from his writing that he's a fan of the honest broker. And, to be honest, so am I. This is the role I try to carve out for myself in my public-facing work, trying not to judge others or advocate for a specific course of action, but to help people make the best-informed decisions for themselves and their communities, based on available evidence and insights.

This is an approach that, to me, avoids mistaking personal values for the "right" values, and respects deeply held beliefs and values in others, even where you may disagree with them. It's a path toward empowering others while trying not to let your ego get in the way. And with most of the issues I grapple with in my work, I'm comfortable with it, because in most cases there are not bright-line right or wrong answers.

This Honest Broker role extends to any situation where someone with useful knowledge and insights is prepared to engage with people who might benefit from them. Of course, sometimes people will make decisions that lead to harm anyway. But how much more tragic if these decisions are made simply because they were never aware of the alternatives or the consequences. Yet, I'll be the first to admit that this role, while being rooted deeply in values that I consider important, has its problems. And nowhere are they more apparent than when issues of such moral peril arise that *not* to advocate for a certain stance, or a particular way forward, ends up becoming tacit support for not taking action.

To many, inaction on climate change and the use and proliferation of nuclear weapons falls into this category, as does the rejection of vaccines. These are issues where indecision or lack of advocacy has a high chance of adversely impacting millions of people. In cases like these, there is increasing pressure to shift from being an Honest

Broker to an Issue Advocate. And yet, because of the dangers of values and belief-driven short-sightedness, even in these cases, it's hard to justify one person being the sole arbiter of truth. Rather, as Pielke argues, this is where we need institutions and socially-sanctioned organizations to act as the instruments of advocacy. Pielke mentions groups like the National Academy of Sciences, and by inference, similar organizations around the world. But I suspect others would include advocacy groups here as well that are focused on specific issues, yet recognize the importance of science in advocating for action.

This is, of course, another sticky point, because as soon as an issue becomes a focus of attention, the battles begin for whose "science" is the most legitimate. As someone with leanings toward being an Honest Broker, I would suggest that, where there is uncertainty in the science (which is pretty much always—that's the nature of science), the weight of scientific evidence becomes critical. There are always going to be multiple ways that science can be interpreted, but some of these will most likely be more strongly supported by the evidence than others. And here, nothing good ever comes from simply selecting the science that supports your issue and rejecting the science that doesn't. This is a path to self-delusion, because, at the end of the day, wishing something is true simply because it supports what you believe doesn't make it so.

But then, what do you do if the evidence seems to point toward a looming catastrophe, and no one's listening? This is where charismatic voices like Paul Ehrlich's arise. And it's where, as a society, we need to decide how to respond to what they preach.

## Dictating the Future

In the case of *Inferno*, overpopulation is perceived as a looming catastrophe that will result in misery and death for hundreds of millions of people, unless radical action is taken. Zobrist sees this and believes he has a solution. But, having been effectively outcast by the scientific community for his radical ideas, he resorts to drastic measures.

In the movie, Zobrist's plan to cull half of the world's population through his genetically engineered virus is, of course, abhorrent. This is what provides the dramatic tension that keeps us glued to the screen, fueled by our moral outrage. But there's an interesting

twist here, and it comes not from the movie, but the book that the film's based on.

Dan Brown's book *Inferno*, like the movie, follows a crazy countdown as Robert Langdon struggles to unravel the clues left by Zobrist to the location of the virus. As in the movie, Zobrist believes enough in the legitimacy of his actions that he's willing to die rather than give up his secrets. But then, as the location of the virus is discovered, the book and the movie diverge quite dramatically.

In the book, Langdon and the WHO arrive too late. The virus has been released, and has been infecting people for some time. But surprisingly, no one is dying. It turns out that book-Zobrist didn't create a killer virus. Instead, he created a virus that rendered every third person it infected sterile. What's more, he ensured that this "every third person" trait was heritable, meaning that, in every subsequent generation, one in three people would also be sterile.

In the book, no one died as a result of Zobrist's genetically modified virus. Rather, he set in motion a chain of events that would eventually lead to the Earth's human population being reduced to a manageable size. Instead of being the evil scientist intent on murdering people, he emerges as a lone-genius savior of the future of humankind.

This outcome intrigues me, as it supports the idea of the lone visionary scientist as someone who can save the world. And it suggests that they could probably do it better than a committee of scientists, because they have a clarity of vision and purpose that a large and unwieldy group would lack.

I'm pretty sure that the book version of Zobrist's plan would have had a profound and ultimately positive impact on the Earth's human population. It may also have led to an improved quality of life for many people, although, humans being humans, there's also the chance of self-interest and ignorance putting paid to this possibility. Yet despite its superficial elegance, something worries me about the idea of imposing sterility on a third of the world's population in the name of social good, and this is the lack of choice that Zobrist's victims had. For sure, he "saved" society in the book. But in doing so, did he end up betraying the individuals that make up that society?

This is a particularly knotty and ultimately unresolvable moral question, as it comes down to weighing the good of the many

against the good of the few. The book version of Zobrist violates basic human rights by dictating the fate of people infected by his virus. And I doubt that this would have been a bloodless violation; while indiscriminate sterilization may seem a small price to pay for averting world hunger, try telling that to someone desperate for children who has been robbed of the opportunity, or someone who depends on growing a family to sustain their livelihood.

We're also still left with the problem that, no matter how much we delude ourselves, we cannot predict the future. Which means that, compelling as book-Zobrist's case was, he had no way of knowing whether he needlessly condemned a third of the world's population to sterility. This was a gamble he was willing to take. But what gave him the right to take this gamble in the first place? Not the people whose futures he was playing with, that's for sure. And this is ultimately where the challenge lies when it comes to lone scientist-advocates and genius-activists. No matter how compelling their vision of the future, or how persuasive their solutions to making it better, where do they get the right to act unilaterally on issues that ultimately impact us all?

Some, I suspect, would argue that time and necessity are on their side. I would counter that these are not excuses for preventing people who are likely to be affected by major decisions from having a say in their collective future. This, though, means that we need better ways of making collective decisions as a society (as was seen in chapter ten and *The Man in the White Suit*), especially where technological innovation is both pushing us toward potentially catastrophic futures and yet is potentially part of the solution to avoiding such futures. And we need to get better at making such collective decisions fast, because if there's one thing that these lone scientist-advocates have right in many cases, it's that time is short!

And nowhere is this more apparent than with an issue that's tightly coupled to a burgeoning human population: climate change.

CHAPTER TWELVE

# THE DAY AFTER TOMORROW: RIDING THE WAVE OF CLIMATE CHANGE

> *"We were wrong."*
> —Vice President Becker

## Our Changing Climate

In July 2017, a massive chunk of ice broke off the Larson C ice shelf in Antarctica. The resulting tabular iceberg covered around 2,200 square miles—about the area of Delaware, and a tad smaller than the British county of Norfolk—and was one of the largest icebergs in recorded history to break off the continent. The event grabbed the attention of the media around the world, and was framed as yet another indication of the mounting impacts of human-activity-driven climate change.

Thirteen years earlier, the climate disaster movie *The Day After Tomorrow* opened with a block of ice splitting off another of the Antarctic ice shelves, in this case the Larson B shelf. At the time, the sheer size of this make-believe tabular berg was mind-boggling enough to astound and shock moviegoers. But the movie-berg ended up being rather smaller than the 2017 one, coming in at a mere 1,212 square miles.

Looking back, it's sobering to realize that what was considered shockingly unimaginable in 2004 had become a pale reflection of reality in 2017.

Human-caused climate change is perhaps the biggest challenge of our generation. As a species, we've reached the point where our collective actions have a profound and lasting effect on our planet,

yet we are struggling to even acknowledge the magnitude of the issues we face as a result, never mind agree on effective ways forward. This is a deeply social and political issue, and one that we'll only make progress toward addressing through socially and politically-oriented action. Yet, underlying our changing climate, and how we handle it, is technology. It's the technological innovations of the Industrial Revolution and what came after that helped get us here in the first place. It's technological and scientific advances in climate modeling, and data collection and processing, that have revealed just how big the challenge is that we're facing. It's our continued addiction to our technology-enhanced and energy-intensive lifestyles that continues to drive climate change. And it's breakthroughs in areas like renewable energy, carbon capture and storage, and solar radiation management that are helping open up ways toward curbing the worst impacts of climate change.

At this point I should be up front and admit that *The Day After Tomorrow* barely touches on any of these technologies. This is a movie that uses Hollywood hyperbole to try to shock its audience into thinking more seriously about the impacts of catastrophic climate change, but it does this through human stories and an improbable (but nevertheless dramatic) climactic tipping point. Nevertheless, it is a movie that reveals intriguing insights into the relationship between technology, society, and climate.

Here, I need to add a personal note before we get further into this chapter. Climate change is a contentious and polarizing issue. When it comes to human-driven global warming, most people have an opinion on what is and is not happening, what is and is not relevant and important, and what people should and should not be doing about it. Not to beat about the bush, it's a minefield of a topic to write about, and one for which, no matter what I wrote, I'd end up rubbing someone up the wrong way. And yet, this is not an excuse *not* to write about climate change.

Given this challenge, this chapter focuses on a relatively narrow aspect of our relationship with the planet we live on and how technology plays into this. As a result, it does not contain a comprehensive survey of climate science. It doesn't analyze and summarize climate-change mitigation options. It doesn't even unpack the growing field of sustainable technologies. These are all tremendously important areas, and if you're interested in them, there are volumes upon volumes written about each of them that you can explore further. Rather, using *The Day After Tomorrow* as a starting

point, the chapter explores what it means to live on a dynamic planet where there is a deep and complex relationship between living systems and the world they inhabit, and what this means, not only for technologies that unintentionally impact our climate, but also those that are intentionally designed to do so.

*The Day After Tomorrow* opens in Antarctica, with the movie's hero, Jack Hall (played by Dennis Quaid), and his colleagues drilling out ice cores on the Larson B ice shelf, just as a Rhode-Island-sized chunk of ice breaks away from it. This somewhat convenient coincidence leads to hearings that are presided over by the US Vice President, and this is where we learn that Jack is something of a maverick scientist, and the Vice President a cynical climate-change denier.

It quickly transpires that the ice-shelf collapse is a prelude to a much more dramatic series of events. Water from the melting berg disrupts critical ocean currents, and this in turn triggers a rapid and catastrophic shift in global climate. A series of devastating megastorms rings the changes between the world as we know it and a radically altered world of the future. In this emerging new world, the global North—including many of the world's most affluent countries—is plunged into a new ice age. It's these catastrophic megastorms that create the disaster backdrop for the movie, including a dramatic but make-believe type of storm that's capable of pulling down super-cooled air from the upper atmosphere and, quite literally, freezing people solid who are caught in the downdraft.

As a paleoclimatologist, Jack studies changes in the Earth's climate throughout its history. His research has unearthed disturbing evidence of rapid climate shifts in the Earth's past that are linked to disrupted ocean currents. And because he's a brash Hollywood scientist, he doesn't hesitate to make a pain of himself by telling people that they need to act now, before the same sort of catastrophic events happen all over again.

This turns out to be a bit of a tough sell, though, as Jack reckons that it could be a hundred years or so before the really bad stuff starts to happen. But because of the water pouring into the ocean from the disintegrating Larson B ice shelf, Jack's predictions begin to play out faster than anticipated—much faster.

As the planet's climate becomes increasingly unstable, it turns out that Jack's computer model is the only one around that's capable of predicting what's going on. As he plugs the numbers in and cranks the handle, it becomes increasingly clear that the world is on the brink of a catastrophic change in climate that's only days away. Even worse, his model predicts that the only way to protect as many US citizens as possible is to move people in the lower-latitude states as far south as possible, and leave everyone above a "no-hope" latitude to the mercy of the elements.

The only problem is, Jack's son Sam (Jake Gyllenhaal) is currently stuck in New York, which is a long way above this "no-hope" line.

Predictably, because this is a Hollywood disaster movie, Jack decides to travel to New York City and rescue his son, despite knowing that he'll be facing some incredibly tough conditions. And in true joined-at-the-hip buddy-movie style, his two research partners join him. On the way, Jack and his team, together with his son Sam (who's holed up in the New York Public Library with his girlfriend and a handful of others, burning books to stay alive) face deadly flesh-freezing downdrafts from one of the megastorms. Thankfully, though, they evade the killer air, and are eventually reunited.

Meanwhile, there's a flood of US refugees (including the remnants of the US Government) crossing the border to Mexico. Yet, before he can be evacuated from DC, the US President is killed in the ever-worsening storms. As the climate-change-denying vice president takes his place (now ensconced in Mexico), he faces an unprecedented human and environmental disaster. And as he comes to terms with the consequences of human disregard for our fragile environment, he emerges a humbler but wiser leader.

As the storms clear, we see a remade Earth, with snow and ice covering much of the northern and southern hemispheres, and a thin band of warmer land sandwiched in between. What were previously thought of as developing economies are now the ones calling the shots. And what is left of humanity faces the challenge of building a new future, and hopefully, a more thoughtful and responsible one.

As the movie draws to a close, we begin to see groups of survivors emerging from the ice-encased buildings of New York City, including Jake and Sam. Humanity has suffered a blow, but it's far from beaten.

*The Day After Tomorrow* leaves viewers with a clear warning that, if we continue to be disdainful of how we treat the environment, there could be potentially catastrophic consequences. But the overarching message of the film is one of the indomitable spirit of humanity overcoming even the most extreme of catastrophes. Watching the remnants of society start to work together, we just know that, whatever happens, we will survive as a species.

This narrative admittedly makes the climate change messaging of the movie somewhat ambivalent. The film certainly tries to warn viewers about the consequences of actions that lead to global warming. But it also conveys a message of hope that, even if we make a mess of things, we can use our grit and ingenuity to find a way out. In other words, climate change is a problem, but it's not the end of the world. To confuse things further, this is a movie about global warming that ends up with a frozen planet. At first blush, it's probably not the message you'd go for if you were out to convince someone that greenhouse gas emissions are leading to catastrophic planetary *heating*. Yet it does give the movie a twist that I must confess I rather like. It suggests that the consequences of human-driven climate change are not necessarily predictable or intuitive. Yes, the Earth's climate as a whole is warming. But because it's also complex and fickle, this warming won't necessarily lead to the types of issues that some might imagine.

In this way, the movie leaves us with a picture of a climate that is sensitive and unpredictable, with the greatest point of certainty being that, if we take it for granted and continue to use it as a dumping ground for our industrial and personal effluent, something will give. This is part of the concern that drives scientists, activists, and others in the push for rapid and drastic action to curb the impacts of human-caused climate change. But even though this is vitally important, it's hard to make sense of the complex nexus between people, technology, and climate without first recognizing how fragile our relationship with the dynamic planet we live on has always been.

## Fragile States

On December 26, 2004, a magnitude 9.0 earthquake struck off the coast of Sumatra. It was one of the largest earthquakes ever recorded, and the shock waves reverberated around the world,

triggering other, smaller quakes as they went. But the most devastating result was a series of tsunami unleashed in the Indian ocean. These swamped coastal areas in Indonesia, Sri Lanka, Thailand, India, and many other countries. As the sea swept through towns, villages, and cities, over 250,000 people lost their lives. It was one of the worst natural disasters in recent memory.

The 2005 Indian Ocean tsunami is a sobering reminder of just how precarious a place Planet Earth is, even before we begin thinking about the impacts of technology and human-driven climate change. We live on a dynamic and unpredictable planet, and throughout human history, natural events have devastated communities. This is not to diminish the almost-unthinkable consequences of global warming if we don't put the brakes on our unfettered use and abuse of natural resources. But it is an important reminder that long-term environmental stability and security are often illusions that are born from our ability to convince ourselves that, because yesterday was a good day, tomorrow and the next will be just the same.

This is a blind spot that we all have to the dangers of sudden, catastrophic risks, whether we're looking at climate change or the impacts of emerging technologies. Just how deeply rooted this is in our collective behavior was brought home to me several years ago on a family vacation to the Pacific Northwest. Traveling with my wife, my parents, and our (then) young kids, we started at Mount Hood in Oregon, and worked our way north to Seattle and Mount Rainier via Mount St. Helens. These and other volcanoes in the Cascade Range are all relatively inactive at the moment. But in 1980, the world was reminded of just how much power lurks under the range, as Mount St. Helens erupted, throwing more than half a cubic mile of material into the atmosphere, and leaving a crater over a mile wide.

The May 18, 1980, eruption was the most violent in the Cascade Range since the region was populated by settlers migrating from the east. Apart from low-level volcanic activity around some of the peaks, there hasn't been anything quite like it for over 1,000 years. Yet despite this relative calm, the Cascade volcanoes are far from safe.

Fifty miles outside the city of Seattle stands Mount Rainier, perhaps one of the most iconic of the Cascades. Mount Rainier is a magnet for hikers, skiers, and day-trippers. Something like twenty million people a year visit the mountain, and its striking profile is as much

a part of Seattle as the Space Needle and Pike Place Market. Rainier stands guard over a metropolitan area accounting for some 3.7 million people. And yet it's classified by the US Geological Survey as one of the most dangerous volcanoes in the country—and one where a major eruption could be devastating.

Seattle was founded in 1851, well after Mount Rainier's last period of major volcanic activity, which occurred around five hundred years ago. Because of this lag between the cycle of volcanic activity and large-scale urban expansion, there is little if any cultural or historic memory among most of Seattle's current inhabitants of how unpredictable the environment they live in is. I suspect that most people living around the city think of it as a safe place to be, simply because it's been safe for as long as anyone can remember.

My daughter now lives in Seattle, and just in case I was missing something, I asked her what it's like living next to a volcano that could wipe out the city if it got particularly belligerent. She's been living and working there for over four years now, and her response is best summarized as "meh"—supporting my suspicions that, to many people living in the area, a risk not experienced is a risk not worth worrying about. However, she did add, "So, how do you feel about your only daughter living in the shadow of one of the country's most dangerous volcanoes?" which made me realize that she's not the only one with a rather complacent perspective here. How easily we convince ourselves that this dynamic, dangerous planet we live on is going to stay the same from day to day.

Despite our relatively optimistic short-term view of the Earth's enduring stability, Mount Rainier has had a habit of awakening from its slumber every five hundred years or so. And given the timing of the last eruption, we're overdue for some action here. Maybe nothing as dramatic as the 1980 Mount St. Helens eruption, but probably nothing that people used to enjoying this seemingly passive slumbering giant will take kindly to.

---

Mount Rainier and the 2004 Indian Ocean tsunami are just two reminders of how complacent we become when the environment we live in appears to be stable, and how quickly we sink into denial about how precarious life is on this outer skin of our dynamic planet. Yet the reality is that we live in an environment that can turn dangerous on a dime.

In 2008, CBC News published a list of some of the most devastating natural disasters that have occurred since 1900.[168] It's an admittedly subjective list, as the line between natural and human-created disaster gets increasingly blurred when it comes to floods and famines. This aside, though, the list makes for sobering reading. Tallying the numbers, something like eight million deaths have been associated with earthquakes, tsunamis, eruptions, hurricanes, cyclones, and floods over the past hundred years or so. Adding in pandemics and famines, the number rises to well over two hundred million people who have lost their lives as a direct result of the environment they live in. What makes these numbers even more devastating is that, apart from malaria (which is estimated to kill a million people a year), most of these deaths are caused by intense events that punctuate periods of relative calm.

What these figures bring home—and they are only the tip of the iceberg of environment-related deaths—is that we live in a dangerous world. Many people live perilously close to potential circumstances that could rob them of their livelihoods, their communities, and their lives. Collectively, we live in a fragile state of being, despite everything we do to convince ourselves that we're okay. Yet this very fragility is integral to life on Earth. It's the very *changeability* of the world we live in that has led, through evolution and natural selection, to an incredible diversity of species, including humans. A changing environment forces adaptation. It weeds out the poorly adapted and creates new opportunities for evolving organisms to take hold and thrive in new niches. Change is a force of nature that has led to where we are now. Yet it's one that we mess with at our peril.

## A Planetary "Microbiome"

Over time, the complex relationship between the Earth's changing climate and the forces of evolution has led to a deep symbiosis between how living organisms impact the Earth, and how this in turn impacts them. Amazingly, over geological timescales, life has crafted the Earth we live on as much as Earth has molded the life it harbors. This symbiosis formed the basis of the Gaia hypothesis developed by scientists James Lovelock and Lynn Margulis in the 1970s. And while a lot of pseudoscientific mythology has since grown up around the idea of Planet Earth being a living organism, there are deep evidence-based reasons to approach the Earth as a

---

168 "The world's worst natural disasters. Calamities of the 20th and 21st centuries" Published by *CBC*, May 8, 2008. http://www.cbc.ca/news/world/the-world-s-worst-natural-disasters-1.743208

complex system of organic and inorganic matter that, together, are responsible for a shifting and evolving environment.

If we were an alien race observing the Earth from some distant solar system, we'd see a planet where the atmosphere, the oceans, the land, and the organisms that are part of them are constantly changing and shifting. We'd see a rolling history of different species rising to dominance, then fading as others arose that were better fitted for a changing world. We'd see humans as the latest manifestation of this deep relationship between the planet and the life in and on it. And we'd probably assume that this species would also be superseded at some point, not necessarily by a more intelligent one, but by one that was simply better adapted for thriving in a post-human world. With the clarity that comes from time and distance, we'd recognize that humans are just one small cog in a much larger planetary-scale machine, albeit a cog that has an outsized opinion of itself.

In recent years, a quite compelling analogy for this deep interconnection between the environment and the organisms that are part of it has come out of the field of microbiology. For decades now, scientists have realized that our bodies contain trillions of microbes. In fact, a popular myth has arisen that our microbes outnumber our human cells ten to one, meaning that despite any beliefs to the contrary, each of us is more non-human than we are human.

This number doesn't hold up to scientific scrutiny, as how much of each of us is made up of microbes varies quite considerably. But that's not the interesting bit of this story. What is, and the piece that's shaking up our understanding of our biology, is that we are each deeply interdependent on the microbes that live on and in us, so much so that there's emerging evidence that our gut microbes can actually influence how we think and feel.[169]

This is where a useful analogy can begin to be drawn between the human microbiome and planet Earth. Not so long ago, we thought of ourselves as complete and independent entities, with minds and wills of our own. But we're now learning that what we think of as "me" is a complex collection of non-human microbes and human cells that, together, make up a living, thinking organism. We are, in fact, a product of our microbes, and they of us. In the same way, we're beginning to understand just how symbiotic the earth's

---

169  See, for instance, Ed Yong's 2016 book "I Contain Multitudes: The Microbes Within Us and a Grander View of Life," published by *Ecco*.

organisms are to the planet. Just as our microbiome is an integral part of who we are, we are discovering that we cannot separate the physical Earth, its rocks, soils, oceans, rivers, even its atmosphere, from the flora and fauna that inhabit it, including humans.

This perspective radically changes how we think of ourselves and our actions in relation to the planet. Through it, we can no longer assume that the environment is something to be utilized, or even something to be looked after, as both assume we are somehow separate from it. Rather, it's increasingly clear that we are both a product of our environment, and deeply enmeshed in its future. In other words, what we do has a profound impact on how the world changes, and how this in turn will change us.

This interdependence between us and the environment we live in has accelerated substantially over the past two centuries. A few thousand years and more ago, humans were something of a bit player as far as planetary dynamics went. We were insignificant enough that we could live our lives without bringing about too much change (although with hindsight, it's possible to see how early environmental abuse set us on the pathway toward local flooding, famines, and the formation of deserts). Yet, over the past two hundred years, there's been a dramatic change. Global population has risen to the point where the environment can no longer absorb our presence and our effluent without being substantially altered by it.

Human profligacy is now a major factor in determining how we impact the environment, as we saw in chapter eleven and *Inferno*. But there's another, equally important trend that is radically changing our relationship with planet Earth, and that is the increasing impacts of technological innovation.

## The Rise of the Anthropocene

Around two hundred years ago, we saw the beginnings of massive and widespread automation, an acceleration in fossil fuel use, and transformations in how we use agricultural land. The resulting Industrial Revolution changed everything about our relationship with the planet. Almost overnight, we went from a relatively minor species (in geological terms) to having a profound impact on the world we live on. This trend continues to this day, and we're now entering a phase of technological innovation where how we live and what we do is more deeply coupled than ever to the evolution

of Planet Earth. But there's a problem here. Going back to the microbiome analogy, we, along with all other forms of life, are part of a deep and complex cycle of planetary change. Yet, because of our growing technological abilities and our evolutionary drive to succeed, we are now forcing the world to change faster, and in different ways, than ever before, and we have no idea what the consequences of this are going to be.

What we do know is that there will be consequences. We know that the Earth changes and adapts in response to the organisms that live on and in it. We understand that Planet Earth is a deeply complex system, where the results of seemingly small changes can be unpredictable and profound (going back to chapter two and chaos theory). We recognize that, in such systems, the harder you hit them, the more unpredictably they respond. And we realize that complex systems like the Earth are prone to undergoing radical and disruptive transitions when pushed too hard.

This is all part of living in the "Anthropocene," a term that's increasingly being used to describe this period in the Earth's history where, largely though our technological innovations, humans have the power to dramatically influence the course of planetary evolution. The trouble is, while we have this growing ability to impact a whole planet, it's by no means certain that we know what we're doing, or that we understand how to chart a path forward through the ways in which our planetary influence will in turn impact us.

Here, *The Day After Tomorrow* stands as something of a warning against human hubris and the fragility of our relationship with the natural world. Over-the-top as it is, the film reminds us that we are messing with things we don't understand, and that if we're not careful, there will be a reckoning for our environmental irresponsibility. Perhaps not surprisingly, in true Hollywood style, it's all a little clumsy. But it's hard to avoid the message that we live on a dangerous planet that has the power to seriously disrupt our twenty-first-century lifestyles, and that we prod and poke it at our peril.

But the movie also has a message of hope, albeit one that's very human-centric. It suggests that, ultimately, humans are resilient; that even when we suffer catastrophic losses, we have the ability to collectively pick ourselves up and come back stronger and wiser than before.

Here, *The Day After Tomorrow* is surprisingly optimistic about the future. But this optimism does depend on us working together to develop the resiliency that's necessary to survive and thrive on a dynamic planet. Emerging technologies have a vital role to play here, together with social, economic and political innovation. This is where renewable energy technologies are finally beginning to compete with fossil fuels; where distributed energy-networks and battery technologies are transforming how we generate, distribute and use electricity; where water treatment and agricultural technologies are enabling us to achieve more with less; and where we're learning to not only ensure products are recyclable, but to develop a "circular economy" where everything is reused. And this is just the tip of the sustainable technologies iceberg. Yet if these and other technologies are to be used to build a resilient future, we first need to understand what we mean by "resiliency" in the first place.

## Building Resiliency

On September 6, 2017, Hurricane Irma devastated the Caribbean island of Barbuda. For the first time in three hundred years, the island was left uninhabited, apart from the dogs and other animals left behind by a fleeing population.

Irma was just one of a string of powerful hurricanes sweeping through the Caribbean and across the Southern states of the US in 2017, in one of the most destructive hurricane seasons on record. And, as one storm after the next battered communities, it challenged them to think about what it means to be resilient in the face of such devastation.

Resiliency, I have to admit, is a bit of a buzz-word these days. In the environmental context, it's often used to describe how readily an ecosystem is able to resist harm, or recover from damage caused by some event. But resiliency goes far beyond resistance to change. In its broadest sense, it gets to the heart of how we think about what's important to us, and how we make provisions to protect and grow this, *in spite* of events that threaten to cause harm.

Long before I became involved with environmental sustainability, I was used to the idea of resilience that's commonly used in materials science. Here, resilience is a measure of how much energy a material can absorb, and still have the ability to return to its previous state when that energy is released. Imagine, for instance, a rubber band. If it's stretched, and as long as it doesn't break and is not is old

and weathered, it will return to its original shape once released. In this way, it's resilient to change. But push it too far and it will snap; there's a limit to how resilient it is.

This idea of resiliency as an ability to return to "normality" in the face of stress is how it's often used to describe ecosystems. Resilient ecosystems are frequently seen as those that resist permanent damage, and that recover fast if they are harmed. But in a world where change is the driving force behind pretty much everything, this turns out to be a rather limited concept. Despite change and adaptation being the bedrock of our planet's biological and geological evolution, ideas of environmental resiliency seem too easily to slip into a mode of thinking that suggests change is bad, and should be resisted.

This is understandable if we believe that we should be preserving how things are, or some ideal of how they should be. But it's important to ask what are we trying to preserve here. Is it the global environment as it now stands? Is it how we as humans are currently living? Is it the continuation of life in some form? Or is it the continuation of some future vision of humanity?

In reality, *how* we think about resiliency depends entirely on what we are trying to protect or preserve. And this, it turns out, is deeply dependent on context, to the extent that ideas that look like resilient approaches from one perspective may look highly precarious from another.

In effect, our understanding of resilience depends on what's important to us, and in this context, resilience is not necessarily about maintaining the status quo, but about protecting and preserving what is considered to be "of value." This may be the environment, or our health and well-being. But it may just as equally be someone's ability to make a living, or their deeply held beliefs, or even their sense of self-identity and worth. From this perspective, we can begin to think of resiliency as something we use to protect many different types of value within society, or to ensure that this value can be regained if it's temporarily damaged.

Thinking about resiliency in this way ends up with it being less about maintaining what we currently have, and more about ensuring future outcomes that we value. It also helps illuminate the complex landscape around issues like climate change where different, and sometimes hidden, values may be threatened. And with this reframing, we have a concept that is, in itself, adaptable to

a changing world. It's a way of thinking about resiliency that moves our focus from maintaining our environment as we think it should be to considering where we want to be, even as the environment around us changes.

This begins to get close to a perspective on resilience proposed by Tom Seager and colleagues in 2013.[170] Thinking specifically about engineered systems, they explored the idea of resilience as being about what a system *does*, rather than what it *is*. In the language of "value," this translates to resilience being about developing systems that preserve what we consider to be valuable, rather than simply describing the system itself. It's all about getting to where we want to be, rather than simply trying to stay in the same place.

This broader understanding of resilience is described rather well by David Woods in a 2015 paper,[171] and expanded on later by Seager and others.[172] Woods describes four types of resilience. First, there's rebound, or the ability for a system to return to its "healthy" state after being damaged. This is pretty close to the standard understanding of ecological resilience. Then there's robustness, or the ability to withstand knocks and shocks without failing. Things get interesting though with the third type of resilience: graceful extensibility.

Woods' notion of graceful extensibility recognizes that, no matter how prepared you are, there will always be surprises, and it's always good to be able to adapt to them. It's a bit like the blade of grass bending but not being swept away by the hurricane, while stronger but less resilient trees are uprooted.

Woods' final type of resiliency is sustained adaptability, or a willingness to change and sacrifice some aspects of what already exists in order to maintain others. Again, this begins to frame the idea of resiliency as less about maintaining the status quo, and more about adapting to change while preserving what's important.

These four types of resiliency still have the feel of trying to maintain things as they are, but they do acknowledge that some willingness to change and adapt, and have some degree of flexibility, is

---

170   Park, J., et al. (2012). "Integrating Risk and Resilience Approaches to Catastrophe Management in Engineering Systems." *Risk Analysis* **33**(3): 356-367. http://doi.org/10.1111/j.1539-6924.2012.01885.x
171   Woods, D. D. (2015). "Four concepts for resilience and the implications for the future of resilience engineering." Reliability Engineering & System Safety 141: 5-9. http://doi.org/10.1016/j.ress.2015.03.018
172   Seager, T. P., et al. (2017). "Redesigning Resilient Infrastructure Research." Published in "Resilience and Risk. Methods and Application in Environment, Cyber and Social Domains." Editors: I. Linkov and J. M. *Palma-Oliveira Springer.* Pages 81-119.

necessary. I'd go further, though, and argue that, because we live in a world where change is the life-blood of everything, we need to understand *how* to live with change. This includes the surprises, failures, and changes that make life tough. But it also includes changes that make life easier, if we can just see how to take advantage of them. What's important here is not trying to maintain what we have (or what we believe we should have), simply because we have it, but protecting what we think is truly important.

Not surprisingly, the list of what we collectively think is important is a long and often conflicting one. But building resiliency to protect and preserve what we can agree should be protected and preserved in a changing world makes a lot of sense. And this brings us back to *The Day After Tomorrow*.

On one level, *The Day After Tomorrow* can be viewed as a movie about the dangers of *not* building resilient systems. In the movie, political decision-making lacks the resiliency to prevent human-driven climate change, and infrastructure systems lack the resiliency to withstand the impacts of the extreme storms. What we see is a brittle world, collapsing under the consequences of ill-considered decisions.

And yet, for all the dramatic and catastrophic change in the movie, people, relationships, and nations survive. Not only do they survive, they grow and adapt. And ultimately, they show deep resiliency in the face of potential catastrophe.

This, though, is a matter of framing. Certainly, the developed world and its institutions and infrastructures are shattered by the catastrophic shift in global climate. But in the movie's narrative, what is important to the central characters, including love, commitment, friendship, and selflessness, are resilient in the face of the onslaught. And because of this, despite the on-screen destruction, this is a movie about hope for the future—a hope that's based on the resiliency of the human spirit.

That said, this is very much a privileged Western perspective. Despite the shock we feel at seeing whole communities decimated in the movie, this is sadly not an unusual state of affairs as you look around the world. Beyond the confines of a Western middle-class existence, suffering and catastrophe are commonplace, whether through war, famine, disease, poverty, climate, or a whole host of other factors. And this is perhaps one of the more sobering takeaways from the movie; that while we might talk about the need

for resiliency in the face of climate change, communities around the world are exhibiting resiliency now, every day, as they struggle to survive and find meaning in a fickle world.

For many of these communities, resiliency is not about holding on to what they have, but about not letting go of who they are. Yet, in many cases, this is a necessity rather than a virtue, and one that should probably not be praised where it shouldn't be needed. And this brings us to a final way of thinking about resiliency. Resiliency should not be about survival, or about holding onto life with our fingernails. Rather, it should be about having the ability to thrive in a changing world. Yet to achieve this, we need to be proactive. We need to have foresight, and to act with intention, if we want to create the future we desire, in spite of what the dynamic and dangerous world we live on throws at us.

This means taking responsibility for changes that we can control, such as reducing the chances of catastrophic climate change that's driven by our own irresponsible actions. But it could just as easily mean using technology to intentionally modify the Earth's climate. And this brings us to an idea that isn't explicitly addressed in *The Day After Tomorrow*, but is deeply embedded in how we think about resiliency, climate, and the future: geoengineering.

## Geoengineering the Future

In 2006, University of Arizona astronomer Roger Angel suggested a rather radical solution to global warming. His idea was to launch a trillion-dollar light diffuser into space, to deflect some of the sun's rays from the Earth.[173] The proposal was published in the prestigious journal the Proceedings of the National Academy of Sciences, and at the time it caught the imagination of a number of us who were intrigued by such an audacious approach to planetary engineering.

Angel proposed to send billions of small, transparent "flyers" into space to create a cloud at the Lagrange point between the Sun and the Earth—the point where the gravitational pull of each body just balances out—allowing the flyers to seemingly hover effortlessly between the two. These would deflect just enough sunlight from hitting the Earth that the cloud would act as a massive solar shade, countering the effects of greenhouse-gas-driven global warming.

---

173  Angel, R. (2006). "Feasibility of cooling the Earth with a cloud of small spacecraft near the inner Lagrange point (L1)." *Proceedings of the National Academy of Sciences* 103(46): 17184. http://doi.org/10.1073/pnas.0608163103

Angel's idea was part of a growing interest in using planetary-scale engineering to manage the effects of human-caused climate change. Commonly called "geoengineering," it's an approach to controlling the earth's climate that, to some at least, has become increasingly relevant as efforts to curb carbon dioxide emissions have run into rough water. Yet, despite the urgency with which we need to get a grip on our collective environmental impacts, geoengineering represents technologies and ideologies that are fraught with challenges.

I first started writing about geoengineering back in in 2009.[174] At the time, I was fascinated by the audacity of the ideas being discussed (most of which were more mundane than throwing billions of sunshades into space). But I was also intrigued by the ethical and social issues they raised. I'd been following the technology before this, but what sparked my interest in 2009 was the controversy around a particular experiment planned to take place in the Southern Ocean.

The experiment was given the admittedly not-so-catchy name LOHAFEX,[175] and was designed to see if algal blooms could be used to remove carbon dioxide from the air.[176] The plan was to release six tons of dissolved iron over three hundred square miles of ocean in an attempt to feed and stimulate an algal bloom, which would remove carbon dioxide from the atmosphere before sinking to the bottom of the ocean. But even before the research started, it drew criticism from environmental groups. As one of the largest geoengineering trials to date at the time, they were concerned that it represented unnecessary and even unethical direct experimentation on the only environment we have.

Despite the low chances of LOHAFEX having any lasting impacts, these concerns put the study on hold until the funders were certain that the risks were minimal. As it turned out, the experiment, when it eventually took place, showed that ocean fertilization with iron had a small and unpredictable impact on atmospheric carbon dioxide. This was a useful finding, as it indicated the limitations of this one potential approach to carbon dioxide removal. But it also demonstrated what a contentious issue geoengineering was at the time.

---

174   See "Geoengineering: Does it need a dose of geoethics?" *2020 Science*, January 28, 2009. https://2020science.org/2009/01/28/geoengineering-does-it-need-a-dose-of-geoethics/
175   The name LOHAFEX comes from "LOHA," the Hindi word for iron, and "FEX," an acronym derived from Fertilization Experiment. The lead scientists were nothing if not obscurely creative!
176   "LOHAFEX: An Indo-German iron fertilization experiment." Eurekalert, January 13, 2009. https://www.eurekalert.org/pub_releases/2009-01/haog-lai011309.php

Even today, the ethics and responsibility of geoengineering are hotly contested. On one hand, this isn't surprising. We only have one environment to experiment with, and so we can't afford too many "oops!" moments; there's no convenient drawing-board to go back to when Global Experiment A goes wrong. But in addition to the (albeit low in most cases) risks, there's another concern that dogs geoengineering, and that's the underlying ideology.

---

If you believe that the root problem with the world today is human behavior, then one of your primary solutions to global warming is likely to be trying to change how people behave. This may involve reducing dependency on fossil fuels, or encouraging people to lead more energy-efficient (or less energy-greedy) lifestyles. Or it may mean helping individuals and organizations develop environmentally healthy practices. In contrast, anything that gives what you think are humanity's bad habits a free pass is, by default, not good news—the reckless extraction and use of fossil fuels for instance, or profligate energy use. Geoengineering does not fit comfortably within this ideology. It smacks too much of developing technological fixes to reverse the consequences of "bad behavior," rather than fixing the behavior that led to the problem in the first place.

Unfortunately, to many people—and I would count myself here— we don't have the luxury of sacrificing people's lives and the environment we live in on the altar of ideology. Without question, we are caught up in a cycle of collective and individual behavior where we readily and wrongly pollute the "commons" of the atmosphere for short-term gain. It would be lovely, of course, to think that people could learn to be more responsible than this. But individuals are complex, and society as a whole is more complex still. We all have our own values, and things that are important to us that we are striving for. And in some cases, for good or bad, these don't align with the common good of maintaining the earth's environment in its current (or past) state. Factors like putting food on the table and a roof over our family's head come into play, or getting out of poverty, reducing inequities, closing economic disparities, and striving for the same living conditions as others. Individuals and nations are constantly juggling a plethora of issues that are important, and while the environment is one of them, it isn't always the most important.

Yet despite this complex mess of conflicting priorities, aims, and desires, the cold hard truth is that our actions are already forcing the global climate to change. And as they do, we have a choice to make: live with the consequences, or do something about it. To some in the geoengineering community, the only way to "do something about it" is to stop waiting for people to do the right thing, and to start to engineer the heck out of the problem. And this, as it turns out, isn't as hard as you might imagine.

Here, geoengineers have two basic options: reduce the amount of sunlight hitting and being absorbed by the earth's atmosphere, or actively reduce the concentration of greenhouse gases in the atmosphere (carbon dioxide in particular). In technical terms, these are often lumped into one of two categories: solar radiation management, or SRM, and carbon dioxide removal, or CDR, although it must be said that, to the enterprising geoengineer, there are ways of engineering the earth's environment that don't necessarily fit conveniently into either of these buckets.

Roger Angel's solar shade spaceships aside, many of these techniques aren't exactly rocket science. For instance, planting lots of trees is a form of CDR, as they suck up and store carbon dioxide in their wood (although it's not the most effective form of CDR). LOHAFEX was another form of CDR, as are technologies that actively remove carbon dioxide from power-plant emissions, or artificial trees and other technologies that convert carbon dioxide either into plastics and fuels that can be reused, or into materials that can be buried in the ground.

Many of the approaches being considered for SRM are equally straightforward: painting roofs white, for instance, to reflect sunlight, or spraying sunlight-reflecting particles into the stratosphere. This last technique borrows a trick from volcanoes, which can actually cool the earth's atmosphere when they spew millions of tons of sulfate particles into the stratosphere. And it's not that expensive. A country like India, for instance, could probably finance a global stratospheric aerosol SRM program designed to improve local crop yields. The problem is, of course, that such unilateral action would most likely make a lot of other countries rather angry.

All this is rather hypothetical, though, as to date there's not been sufficient research to get a good sense of what might work and what might not with geoengineering technologies, and what the unintended consequences might be and how to avoid them. As

a result, the "geoengineering elite" of the world are caught in a seemingly never-ending argument around should-they-shouldn't-they. And what limited research on possible approaches has been proposed has run into barriers, much as the LOHAFEX project did. People who are professionally concerned about these things are reticent to sanction experiments designed to help develop effective geoengineering approaches, either because they are worried about the consequences, or because they see this as an ideological slippery slope.

And yet, something has to give here. To use an analogy from health, it's like a physician being faced with a patient needing heart bypass surgery because they've overindulged and under-exercised, but refusing treatment because it may encourage others to similarly adopt unhealthy lifestyles. In the medical case, the solution is a "yes and" one: treat the patient and simultaneously work to change behavior. And it's the same with the environment. Yes, we've made a mess of things, and yes, we need to change our behavior. But also, yes, we need to use every tool we have to make sure the resulting impacts are as benign as we can make them.

And this brings us back to resiliency, and the challenges of living on a dynamic planet. Unless drastic action is taken to forcibly reduce the human footprint on planet Earth, we need to be able to protect and nurture what is important to humanity. And that means developing the ability to protect lives and livelihoods; to protect dignity and freedom; to protect what people care about the most. This will take social and political change, together with global cooperation. But it will also take using our technical and engineering prowess to the best of our ability. And, importantly, it will depend on combining research and experimentation with social awareness, to develop ways of engineering the climate that are socially responsible as well as socially and politically sanctioned.

This probably won't end up including high-concept ideas like Roger Angel's solar diffusers. And to be fair, Angel saw his thought experiment as an extreme solution to an emerging extreme problem. Emphasizing this, his paper concluded, "It would make no sense to plan on building and replenishing ever larger space sunshades to counter continuing and increasing use of fossil fuel. The same massive level of technology innovation and financial investment needed for the sunshade could, if also applied to renewable energy, surely yield better and permanent solutions." Rather, we need feasible and tested engineering approaches that can be used

carefully and responsibly, and with the agreement of everyone potentially impacted by them. And they need to be part of a range of options that are pursued to managing both our impacts on the world we live on, and the challenges of living on what is, at the end of the day, a capricious planet.

How we respond to this challenge—and to the ongoing challenge of climate change more broadly—depends to a large extent on how we think about the world we live in and the future we're building. And this raises an issue that threads through this chapter: Irrespective of how deep our science is, or how powerful and complex our technologies are, we cannot hope to build a better, more resilient future through science and technology if we don't understand our relationship with them in the first place. And this leads us to our final movie: Carl Sagan's *Contact*.

## CHAPTER THIRTEEN

# CONTACT: LIVING BY MORE THAN SCIENCE ALONE

> *"...okay to go..."*
> —Ellie Arroway

## An Awful Waste of Space

On Wednesday, June 17, 1981, Carl Sagan's *Cosmos* had its premiere on British TV. Since its launch, the series has become the stuff of legend, so much so that I've lost count of the people I know who were inspired to pursue a career in science after watching it.

Sadly, I wasn't one of them.

Back then, my parents had a nagging worry that the TV my siblings and I watched was stunting our development. As a result, we periodically went through patches as a family of having no television in the house. This was complicated somewhat by my grandfather, failing to understand the reason why we were occasionally television-less, bringing us replacement sets as fast as my parents disposed of them. Despite this, we still had extended periods where I was largely cut off from popular TV culture. And this included the first run of *Cosmos*.

Fortunately, I managed to find my way into a successful career as a scientist without Sagan's guiding hand. But this didn't stop me being drawn into his world through his movie *Contact* later on, and the science fiction novel it's based on.

Sagan was a charismatic and often polarizing scientist, and one whose vision extended far beyond the laboratory. He understood and deeply respected the process of science. But in his thinking, science was about far more than simply learning about the world we

live in. To Sagan, science was a way of seeing and making sense of the universe. His was a vision of science that extended far beyond textbook methodologies and tedious experiments, and it's one that continues to inspire scientists, engineers, and technologists to this day. It's also a vision that runs deep through what is perhaps one of the most respected and revered science fiction movies among people who make a living through science: *Contact*.[177]

---

*Contact* is a movie about the nature and wonder of science that's driven along by the discovery of extraterrestrial intelligence. At the center of the story is Dr. Ellie Arroway (played by Jodie Foster), an astronomer who is driven in her search for extraterrestrial life, but who has a scientist's eye for testing every scrap of evidence to make sure that her biases aren't blinding her. She's smart, articulate, driven, and has a complex relationship with her peers—much like Sagan himself.

From an early age, Arroway has been obsessed with the idea of intelligent life beyond Earth, and as the story begins, we find her at the Arecibo radio telescope in Puerto Rico, looking for evidence of extraterrestrial signals from other star systems. The setting echoes Sagan's early work on the search for extraterrestrial life, using the same telescope. And, like Sagan, Arroway is both ridiculed and disappointed in her research, but carries on regardless.

While at Arecibo, Arroway meets a young and charismatic religious leader, Palmer Joss (Matthew McConaughey), and butts heads with him intellectually while falling into bed with him physically. It's also at Arecibo that we see Arroway first having a run-in with the Director of the National Science Foundation, David Drumlin (Tom Skerritt). Arroway is funded through the NSF. Yet Drumlin believes her energy should be focused on what he considers (at the time) to be more productive scientific questions, and as a result, he cuts her funding, while being painfully patronizing and manipulative toward her in the process.

Not to be beaten, Arroway seeks out other funding sources for her research, and ends up attracting the patronage of the megaentrepreneur S. R. Haddon (played by John Hurt). Haddon is

---

177  I may be slipping into hyperbole here, but over the years talking with colleagues, this is the movie that often comes out as most closely reflecting how they feel about science, and how it inspires them.

impressed by Arroway's passion, vision, and ability, and decides to invest in her and her work.

With Haddon's support, Arroway switches her research to using the Very Large Array radio telescope, or VLA, in New Mexico (another instrument that actually exists), yet Drumlin once again interferes by denying her access to this NSF-funded facility. Just as Arroway's hopes begin to fade, she detects a strong signal from what appears to be beyond the solar system. As the significance of the finding becomes clear, people start trying to take the discovery away from her. First the security agencies move in, paranoid of what they don't understand. Then Drumlin steps in and deftly assumes ownership of the discovery, leveraging his position and standing to get what he sees as the opportunity of a lifetime.

Meanwhile, the discovery has attracted large crowds to the area outside the VLA, and there's a massive party vibe going on as people use the discovery as an excuse to let their hair down and have some fun. But, within the crowd, there are also religious fanatics who clearly feel threatened by the signals being received. While this is going on, the team at the VLA continue to find more detail in the signal, including what look like blueprints for building an alien device. As the significance of this finding sinks in, the question of how to respond to the discovery is kicked up to the White House, and Drumlin assumes the role of lead scientist, while Arroway is downgraded to being just one of his team.

At this point, Palmer Joss—now a religious advisor to the President of the United States—comes back into the story. Joss is brought in to provide advice on how the presence of the extraterrestrial signal potentially threatens long-held beliefs on humans' "special relationship" with their various gods. At one point, a member of Congress even comes out with, "We don't even know if they [the aliens] believe in God."

As various experts and advisors congregate in Washington, DC, to discuss next steps, Arroway is reunited with Palmer Joss, and they quickly fall into a relationship where their physical and intellectual attraction to each other is complicated by seemingly irreconcilable differences on science and belief. Meanwhile, as the assembled experts grapple with deciphering the content of the alien signal, they hit a wall. And, once again, Arroway's patron S. R. Haddon provides her with a way of getting back into the game. Drumlin's team of experts have been struggling to make sense of

the blueprints transmitted in the signal, but the mega-smart, mega-rich Haddon has deciphered them. And to back up his investment in Arroway, he passes the relevant information on to her.

With the key to the code, it rapidly becomes clear that the signal contains plans to build a device that will transport a single human being through space, and presumably to the star system of Vega from whence it originated. Arroway is desperate to be selected to make this journey, but is pretty sure that Drumlin will block her yet again. It turns out, though, that Drumlin has other plans, and has put himself forward as the person best qualified to be the first to meet an alien species.

Because deciding who is best equipped to represent all of humanity when meeting the aliens is such a momentous decision, a shortlist of twelve candidates is compiled—with the final choice to be made by an international panel. Arroway makes this shortlist, and as the selection process continues, it finally comes down to her and Drumlin. In making their decision, the selection panel hold a final public hearing with both candidates. There's only one problem; the selection panel includes Arroway's lover and intellectual opponent, Palmer Joss, and he doesn't want to lose her.

Arroway aces her interview until Joss asks, "Do you believe in God, Dr. Arroway?" She replies honestly with, "As a scientist, I rely on empirical evidence. And in this matter, I don't believe there's data either way." Drumlin, on the other hand, when asked the same question, gives a politician's answer, and tells the panel what they want to hear. As a result, he's chosen over Arroway.

As the launch of the alien device draws nearer, Drumlin, who is now cast in the role of public science-explainer-in-chief, takes part in a publicly broadcast test-run of the system. Drumlin begins to emerge at this point as a charismatic science communicator and popularizer, and is slightly disparaged by his scientific colleagues for it, a rather complex nod to the pushback Sagan himself received for his own public persona. On the video feed for the test, Arroway recognizes a religious activist within a secure area, and urgently warns Drumlin over the communications headset. Drumlin confronts the person, but it's too late. The extremist reveals he's wearing explosives and detonates them, killing Drumlin, and spectacularly destroying the machine.

This appears to be the end of the line for humanity's first attempt to make contact with an alien intelligence, until Haddon steps

in once again and shows Arroway a satellite image of a remote location in Japan, and a second machine. As the world is informed of this backup machine, Arroway becomes the person chosen to be transported in it. She's installed into the machine's pod, and the countdown to launch commences. As the alien machine ramps up, communication with Arroway becomes increasingly faint, until one of her colleagues—Kent Clark, a blind scientist who first identified the presence of additional information in the signal from Vega (played by William Fichtner)—manages to pick her up, faintly repeating "...okay to go...okay to go...."

As the pod is launched, Arroway finds herself catapulted through space, eventually ending on a palm-surrounded beach in a scene that mimics a picture from her childhood. Here, she sees a figure approaching her, which resolves into her father, long dead at this point, and the inspiration for her life's work. He explains that what she is seeing is simply a representation that the aliens thought would feel familiar to her. In their brief conversation, she learns that she's traveled through a series of wormholes to an interstellar junction, that this massive network of interstellar transportation conduits was built by a previous civilization, and that there's a long history of emerging civilizations being introduced to their galactic neighbors by building machines like the one Arroway has been transported by.

Following the encounter, Arroway is transported back to Earth, only to discover that, to the Earth-bound observers, no time has passed. To these observers, the pod she was in simply dropped straight through the machine and into the net below; the experiment was a failure.

Confused, Arroway explains what she experienced. But she has no proof, only her knowledge that, to her, it was real. And this is where Sagan and the movie begin to explore the relationship between science and belief. Arroway's journey as a scientist starts from her unshakable conviction that she can only understand the world by using evidence to test what she believes to be true, and having the discipline to ditch beliefs that don't stand up to the test, no matter how compelling they are. Yet the movie ends with her believing in something that she has no evidence for, other than her own experience. Much like the religious experience that transformed Palmer Joss' life, Arroway has an unshakable conviction that what she experienced was real. Yet she has no *proof* with which to

convince others. And so, she finds herself in the same boat as Joss, and his belief that experience and hope transcend proof.

Yet, as the consummate scientist, Arroway doesn't expect others to take her word on faith. Instead, she's driven to look for evidence to support her experience, not out of despair, but out of the conviction that, if what she experienced was true, there *will* be evidence to be found.

What she doesn't know is that this evidence exists, but is being kept from her. Unbeknown to Arroway, the video from her pod came back blank. But instead of just a few seconds of blank screens as the pod fell through the machine, it contained nineteen minutes of nothing, the same amount of time Ellie claimed she had been away. Yet, despite not knowing about this, Arroway has the strength of her convictions and the discipline of her science to support her, and the movie ultimately leaves us with an affirmation of the power of combining science and belief to better understand ourselves, and our place within the universe.

---

While *Contact* is clearly science fiction, it is, in many ways, a homage to the scientific process, and to the scientifically rigorous search for extraterrestrial life. In the movie, Ellie Arroway's character is largely based on the real life astronomer Jill Tarter, and the film as a whole draws extensively on Sagan's own experiences. This is a movie that celebrates the use of reason and evidence to expand our understanding of the universe. Yet it also acknowledges that reason needs to be combined with imagination if we're to truly appreciate who we are, and the world we inhabit. And it does this by grappling with the tensions between science and belief head-on.

## More than Science Alone

It doesn't take much to realize that there's an uneasy relationship between science and religion; one that spills over into how we think about and develop new technologies. To some, religion implies an adherence to a belief in how things are *in spite* of evidence, rather than an understanding that's *based on* evidence. Because of this, there is a sense that science versus belief is an either/or option. This tension between science and religion, of course, goes back centuries. Galileo, for instance, is often revered for challenging received religious dogma about the solar system with cold, hard evidence. And he's just one person in a science-hall-of-fame of

figures who have dared to question deeply held beliefs through experimentation and the rigor of scientific discovery. Yet, as *Contact* attempts to explore, this relationship between science and belief is more complex than is sometimes assumed.

Putting religion aside for a moment, "belief" is something that we seem predisposed to as humans. In part, it's is a product of the ways our minds have evolved to survive in a complex and dangerous world. And it draws on our exquisite ability to interpret our surroundings and our place in them in ways that are useful for keeping us alive, but are not necessarily grounded in reality.

As a species, we have a whole arsenal of mental short-cuts, or heuristics, and cognitive biases that work together to keep us safe and prevent our conscious intellect from leading us into danger. Through these evolved traits, we've become wonderfully adept at feeling like the decisions we make have a rational basis. And as part of this, we've developed an incredible ability to see patterns and meaning in just about everything.

These patterns that our mind "sees" in the world around us often provide us with early warnings of danger, or early indications of benefits. They're how our brains learn to make sense of the world, by avoiding what could harm us, and being attracted to what could be good for us. And part of our success as a species is being incredibly good at this—so good in fact that our technologies are, in many cases, still catching up with the human brain's ability to intuitively detect and decode patterns, whether in the environment, in trends, or in behaviors. Yet, our cognitive traits all too easily mislead us into misinterpreting what we see, hear, and experience as being true, despite evidence to the contrary.[178]

With this biological drive to find patterns and meaning in everything, it's not surprising that we end up being driven by what we *believe* to be true (or what our evolved brains tell us *must* be so) and creating gods (or aliens) to justify this. From a rational perspective, it's easy to dismiss such tendencies as being mere self-delusion. And yet, the nature of belief is too complex, too ingrained in us, to be dismissed through simple logic. It's so much a part

---

178   A lot has been written about how our cognitive biases and mental shortcuts affect what we believe and how we behave, including how we respond to information that jars with what we believe to be true. Two good starting points for beginning to explore this area are Daniel Kahneman's 2013 book, "Thinking Fast and Slow" (published by *Farrar, Straus and Giroux*), and the 2017 US National Academy of Sciences report, "Communicating Science Effectively" (published by the *National Academies Press*), https://www.nap.edu/catalog/23674/communicating-science-effectively-a-research-agenda.

of us that even the most avowedly logical person reaches a point where they have to depart from the world of evidence, and take a leap of faith, realizing that, in some cases, the value of something transcends whether it can be proven, or the degree to which evidence-based analysis supports it. Even though faith and science are often pitted against each other, I suspect that a surprising number of scientists have their own beliefs that define who they are and what they strive for, regardless of any evidence-based analysis. In effect, life and meaning are about more than science alone, whether you believe in a higher "being," or a spiritual dimension, or simply understand belief to be an emergent biological property that defines who and what we are.

In *Contact*, Sagan wrestles with this seeming paradox at the nexus of science and belief through the relationship between Ellie Arroway and Joss Palmer. Importantly, he sets the issue up, not as science versus dogma, but as understanding the relationship between science and meaning.

At the beginning of the movie, Ellie represents rational, evidence-based science. She inhabits a world based on what is testable. And she is intellectually honest; she's willing to sacrifice what she hopes is true in the cold light of evidence to the contrary. In contrast, Palmer inhabits a world of faith. He lives his life on the deep conviction that there is meaning beyond what is testable and validatable by science. He deeply believes that there is more to humans, and more to the universe we inhabit, that lies beyond the ken of scientists and their empiricism.

Yet, as their experiences through the movie expose their true characters, we see that they are more alike than different. Ellie is driven by a belief that there must be alien intelligence. She doesn't use the language of belief and faith, but there's something more that she's striving for. Ellie is on a journey of discovery. Palmer, on the other hand, is a person whose faith completes him. It fills a need in his life and provides a sense of wholeness, and it helps him make sense of what otherwise would make no sense. He knows where he's going, and doesn't need science to point him in the right direction. Yet, at the end of the movie, both Ellie and Palmer are in a similar position, believing in something that they cannot prove, but that nevertheless defines them.

This said, there's also a profound difference between Ellie and Palmer. While Palmer represents believers who seek to proselytize—

to persuade others to take on their beliefs—Ellie's mission is to provide evidence to *support* her belief. And this, to me, gets to the heart of the role of belief in science. Like many real-life scientists, creativity, imagination, and believing in what lies beyond proof are integral to who Ellie is. She is a complex person who is in part defined by her science, but is much more than her science alone. Ellie is a metaphor for the place of science in society, as we strive to understand our relationship with our future and the universe we're part of. Through her character, we understand that science is a way of knowing ourselves and the world around us that doesn't preclude faith and belief, but is a means of responding to them. This is not an either/or philosophy of faith versus science; neither is it a rigid set of rules about what is right and what is wrong. Rather, it's a way of seeing the world and ourselves that, when combined with humility, respect for others, curiosity and wonder, can be positively transformative.

But—and this is perhaps where the Ellie metaphor diverges most from faith-based belief—this way of seeing the world requires rigor in how we test our beliefs. It needs honesty in our willingness to drop ideas that don't align with evidence. And it depends on our ability to distinguish wishful thinking from reality. And this brings us to a recurring theme in *Contact*: Occam's Razor.

## Occam's Razor

William of Occam was a fourteenth-century English philosopher, friar, and theologian. From historic accounts, he was sharp thinker, and a somewhat controversial religious figure in his time. Yet, these days, he is best known for the scientific rule of thumb that bears his name.

Occam was, without doubt, a religious man. But in his theological work, he challenged people to question the validity of complex explanations for things where simpler ones worked equally well. It wasn't until after his death, though, that people began to attach his name to this type of thinking.

The idea that simpler explanations are more likely to be true than more complex ones goes as far back as Greek philosophers like Aristotle—probably farther, given the somewhat obvious nature of the observation. Yet it's Occam's name that we now associate with a "simpler is probably truer" approach to making sense of the world.

Ironically, Occam's intellectual incisiveness was focused on making sense of faith-based interpretations of the world and how we should live in it. As a Christian, he was a believer in God (publicly at least), and committed to interpreting God's will and actions, through what was written in sacred texts and what was observable in the world around him. He was a firm believer that the "ways of God" are not open to reason; he'd have probably got along well with Palmer Joss. At the same time, he was no fool. He realized that, where two or more explanations for something existed, the simplest, least fanciful of them was more likely to be closer to the truth.

This is, of course, something that every parent and teacher knows well. "The dog ate my homework" really struggles to compete with alternatives like "I forgot." It's this realization that simpler explanations are more likely to be true that has led to Occam's Razor becoming part of the canon of twenty-first-century scientific practice. There are multiple definitions of the Razor (so-called because it helps cut away misleading ideas to reveal the truth), but most of these come down to stating that, when there are multiple explanations for something, the one that depends on the fewest assumptions is more likely to be the right one. Simplicity, in this case, comes about because we have to make up less stuff in order to explain something.

A more direct description of Occam's Razor is that, if an explanation for something involves wild stories and fantastical ideas that cannot be tested, it's probably not right. This is how Ellie invokes it when she first meets Palmer. To her, there wasn't any point in talking about faith and belief, because it failed Occam's Razor at the first hurdle. Faith, to her, especially faith in a higher being, relied on too many untestable assumptions where there were simpler explanations. And, while she discovered that life is often not that simple, the principle remains a powerful way of sifting out attractive but dangerously misleading ideas from those that better reflect reality.

---

So how does Occam's Razor apply to technological innovation? Through the previous chapters, we've touched on emerging technologies that could transform our lives in the future: genetic engineering, gene editing, mind and body enhancements, artificial intelligence, nanotechnology, geoengineering, and a whole lot more. Each offers the promise of a vastly better future if used wisely.

But each also comes with tremendous risks if used irresponsibly. And this, together with the multiplicative dangers of what happens when these technologies merge and converge, demands forethought around how to use emerging science and technology responsibly. Yet here we face a conundrum, in that the best we can do in planning for the future is to make educated guesses based on what's happened in the past, and what we know in the present.

Here, Occam's rule of thumb becomes especially helpful. Just as it helps weed out fanciful explanations of how the world works from more reasonable ones, it can also help separate fantasy from more likely outcomes as we think about the future. For instance, we can make a shrewd guess that future scenarios that depend on more assumptions and more fantastical ideas are less likely to come about than those that use fewer assumptions and are less fantastical.

This simple rule of thumb becomes increasingly relevant as we invest hard money in science and technology with the intention of creating a better future. It's often when there's money on the table that the hard-nosed thinking starts, and technology is no exception. So, given the option of investing a sizable wad of cash in avoiding "gray goo," for instance, or in preparing for the advent of superintelligence (both of which depend on a house-of-cards stack of assumptions), or investing a similar amount in avoiding health and environmental harm from new materials, Occam's Razor would probably favor the latter. It's not that gray goo or superintelligence don't have some probability of occurring (although it may be vanishingly small). It's simply that, because they depend on an increasingly tenuous number of untested assumptions, supporting them becomes more an act of faith than of reason.

Yet there's a catch here, which is why Occam's Razor should never be considered as more than an aid to decision-making. Just because there are simpler, less assumption-filled alternatives to imagined future scenarios, it doesn't mean that more complex options will turn out to be wrong. What Occam's Razor states is that there is a *lower probability* of options that rely on more assumptions being true, but not a *zero probability*. And this leaves the door open to more complex, more fanciful possibilities being plausible, even though they're possibilities that have a much lower chance of being right.

In *Contact*, this is the hope that Ellie hangs on to as she continues her search for extraterrestrial intelligence. She knows that,

intellectually, the cards are stacked against her, that all she has to go on is her conviction that she experienced something real. But, rather than allow the same Occam's Razor she used earlier with Palmer to defeat her, she is determined to discover something that will defeat the razor's edge itself.

This, to me, gets to the very core of science as a human endeavor. Critical thinking alone is almost inhuman in its cold impartiality. On the other hand, creativity on its own leads down a path of fantasy and delusion. But when the two are combined, we have a powerful way of using science and the imagination to find meaning in the universe we're a part of, and to chart a course toward a future that celebrates who we are and what we might become.

This is what we see playing out in *Contact*, and why to me it's such a powerful reflection of the soul at the heart of science, not simply the process. It's also where we see the "humanity" of science beginning to shine. This is where science emerges as a disciplined pathway to awe and wonder, and a rigorous way to develop new knowledge that enriches lives and empowers people. Here, it's the humanity of science that also leads us to not just ask if we *can* do something, but whether we *should*, and, if we do, what the consequences might be, together with how we might ensure that they work to the good of society rather than against it.

As we've seen throughout this book, these are tough questions that demand careful thought and input from everyone with a stake in the game. When we're dealing with science that potentially touches everyone, we all become stakeholders in the process. We've seen this with technologies that potentially change who we are: cognitive enhancers, genetic modification, body augmentation, and brain-machine interfaces, for instance. We've also seen it in technologies that might transcend us and lead to life that is beyond what we consider "human," including intelligent machines. But what about technologies that may lead to the discovery of life that didn't even evolve on Earth?

## What If We're Not Alone?

In 1961, a group of ten scientists got together to discuss the search for extraterrestrial life—among them were Carl Sagan and the astrophysicist Frank Drake. What came out of that meeting was an equation that the group felt gave the best stab at estimating (at least to an order of magnitude) the number of intelligent civilizations

within our galaxy that are capable of communicating with us. Over a couple of intense days, the group discussed what factors would affect the possibility of planets existing that could harbor intelligent life, the likelihood of intelligence emerging, and the chances of them getting a signal to us that we detected. And what emerged was the now-famous Drake Equation.

The Drake Equation is a wonderful piece of scientific back-of-the-envelope mathematical speculation that any physicist should feel immediately at home with. The original equation consists of seven factors, or things the group thought were important in estimating the number of intelligent and contactable civilizations. Because they had no evidence for what values to give any of these factors, they guessed. Or, to be more precise, they came up with order of magnitude estimates.

At that first meeting of what came to be known as the Order of the Dolphin (the group had a somewhat offbeat sense of humor), they estimated that there were probably between a thousand and a hundred million intelligent civilizations in our galaxy alone. Even allowing for the rather large range, this is a massive number. And this is in just one of the hundreds of billions of galaxies in the universe. Since then, the Drake Equation has been modified and new estimates for the various factors made. But the reality remains that, even with conservative estimates, the galaxy we live in is so vast that it is almost inconceivable that the conditions haven't occurred elsewhere for intelligent life to evolve.

To Sagan, Drake, and others, this back-of-the-envelope estimate drove their belief that we are not alone. Indeed, it plays into Sagan stating that, "The universe is a pretty big place. If it's just us, seems like an awful waste of space" (something that both Ellie and her father repeat in *Contact*). The professional and scientific intuition of the Order of the Dolphin suggested that intelligent life existed beyond Earth, and all that was needed to prove it was the evidence that would inevitably come from better science.

We're still looking for the evidence that Sagan hoped for. But over the past few years, there have been profound changes in our understanding of the universe that have gotten us closer to realizing that we are probably not alone. And topping these out is the discovery of large numbers of planets circling other suns in the galaxy, or "exoplanets."

The earliest evidence for exoplanets dates back to the 1980s. But the game-changer came when NASA launched the Kepler space observatory in 2009. Kepler enabled the search for planets around distant stars by measuring reductions in light from these far-off suns as orbiting planets came between the star and the Earth. And the results were eye-popping. At the time of writing, NASA's exoplanet exploration program had confirmed the existence of over 3,700 exoplanets in the galaxy, with more than 4,400 additional possible candidates.

But that's not all. So far, over eight hundred of those planets could be similar to Earth.

To someone who grew up reading science fiction and studying science, this is a jaw-dropping discovery. And we've only just started on this scientific journey. We are just beginning to realize that we live in a universe that's rich with Earth-like planets which could be home to living organisms, and possibly, intelligent life.

Sadly, Sagan died in 1996—a year before *Contact* was released, and thirteen years before Kepler was launched. But had he been alive, he would have been thrilled at how the scales are beginning to tip toward the likelihood of life existing elsewhere. Yet, even if the universe is teeming with life, the possibilities of us detecting alien beings are small, given the times and distances involved. The chances of making contact with an alien intelligence are even smaller. For distant stars, there's a good chance that if we ever did receive a signal, the beings that sent it would have long since moved on. Yet this convergence between dreams and science does shine a spotlight on the question of what we would do if we *did* discover alien intelligence, and how our world would change as a result.

I must confess, I have a sneaky suspicion that it would be a seven-day wonder; a "that's nice—what's for dinner" type of event. And the reason is simply that, in my experience, we humans have a near-infinite *inability* to remain awed by new discoveries.

This may sound a little cynical, but just think of how quickly the awesome becomes the mundane in our lives. Start with the mind-blowing biology that makes us what we are, the unimaginable vastness of the universe, the majesty of our neighboring planets, the incredible ingenuity of nature. And then there are the inventions that we rely on every day: Cars, planes, smartphones, computers, modern agriculture. We live in a stunning, awe-inspiring, pretty damn

amazing world, with a million and one things that are just as mind-blowing as discovering aliens. And yet most of us simply don't care.

This amazing ability to go from "wow" to "meh" in a matter of days turns out to be a really important survival mechanism. Without it, we'd all be walking around with our mouths open, forgetting to look where we're going. Because of this, I suspect that we'll see the same wow-to-meh trend if we ever detect evidence of alien intelligence. Sure, such a discovery will be life-changing to start with, at least until the next seven-day wonder comes along. But soon, the everyday realities of life will swamp the larger significance of the discovery, much as they swamp the discovery that, unless we change how we behave, the earth's climate's going to overheat, or that we're building urban sprawls in areas prone to environmental disasters, or that our eating habits are slowly killing us.

Of course, there is the question of how such a discovery would affect religious beliefs, and organized religion more broadly. Among intellectuals who like to think about these things, the question of what happens if we threaten God's existence, either through our own inventions or through the discovery that we're not special, is an important one. It's so important, in fact, that academics love to speculate about what people think about the risks of "playing God" (if we're creating life in the lab), or "debunking God" (if we discover that we're not special). But even here, I suspect that the religious response to a signal from the stars will ultimately be somewhat ambivalent. In part, I think this will be the case because previous indications of life beyond Earth haven't had that much of an impact, even before they've been disproved. But mainly I suspect that this will be because religious beliefs, like people, are incredibly adaptable to the reality they exist in.

This is, of course, all highly speculative. Assuming that we are not alone, the sheer vastness of the universe does make it unlikely that a signal from another intelligence will reach us before we've blown ourselves up or suffered some equally gruesome fate. But, at the same time, the question of how we might react to discovering we're not the only life around is a profoundly important one, not necessarily because of the possibility of life existing beyond Earth, but because we're edging closer to creating our own "aliens" here on Earth. Whether through genetic engineering, AI, or advanced human augmentation, it's quite possible that we'll one day be faced with something that has not evolved in the conventional way, and yet is, in every way, alive.

The question is, when we do reach this technological breakthrough—and we're well on the way to achieving this—how will we respond to these home-grown "aliens"?

My fear is that these will be yet another passing wonder. If so, this would be a problem, for two reasons. First, while we may be ambivalent toward claims that someone's created an artificial cell/plant/animal, or that they've developed a smarter/more intelligent computer, these *will* change our lives. And the less the majority of us care about this, the more we give those that *do* care the opportunity to do what they like, even if it ends up harming us. It's all well and good hoping that scientists and technologists act responsibly. But responsibility here also means that we collectively need to give a damn about the future we're creating, and whether it's the future we want for ourselves and for generations to come.

This is important—it's partly why I wrote this book. But there is a second problem. This is the risk of us slipping into complacency, and not reveling in the awe and wonder of the world we're building. Because, make no mistake, our scientists, engineers, and technologists are catching up with the wild imaginations of science fiction movie writers and directors awfully fast. If you open your eyes and really look at what we are achieving, it's truly mind-blowing!

*Contact*—and every other movie in this book—is a reminder that science and technology are more than a little dangerous if not approached carefully, and that a "meh" response probably isn't the best strategy for handling them. But it's also a reminder of the awesomeness of science and technology, and what we can achieve if we get things right. And it's an exhortation to never let go of our dreams, and to embrace the wonder that comes from exploring the universe we find ourselves in.

# CHAPTER FOURTEEN

# LOOKING TO THE FUTURE

> *"Don't panic."*
> —*The Hitchhiker's Guide to the Galaxy*

As I'm writing this, I'm looking out over the Firth of Clyde, from the Scottish island of Arran. I first came here nearly thirty-four years ago, in 1984, and it's been an occasional getaway for me ever since. Over this time, there have been changes, but the island still has that comfortable feel of a place largely untouched by the frenetic pace of modern innovation. As if to remind me of this, I've been traveling along crumbling roads over the past few days, in a rental car that modern automotive technologies seem to have completely bypassed, while grappling with patchy Wi-Fi and even patchier cell-phone coverage. It all feels a long way from the cutting-edge technologies that have threaded through the previous chapters.

As an outsider, Arran still feels to me as if it belongs to a previous age. Take away the intermittent internet and cellular phone system, and to my off-islander eyes, I could still be in 1984. Yet I find this strangely comforting. Despite sitting here wrapping up a book on the profound changes that emerging technologies are likely to bring about, it gives me hope that there's life outside the frenzied technological pace at which we sometimes seem to be living our collective lives. And it affirms my belief that happiness lies not in the latest technology, but in the more basic things of life, like food, shelter, warmth, and good company.

Yet there's a part of me that knows that these dreams of a slower, more pleasant past are a sentimental illusion. Much as I enjoyed my few days of potholed roads, rickety transportation, and intermittent internet connections, I suspect that there are plenty of permanent residents on Arran who have very different opinions about how things are there. Despite the siren-call of nostalgia for a simpler, less technologically complex time, the reality is that emerging

technologies, when developed and used responsibly, can and do improve lives in quite powerful ways. There are far too many people in today's world who are living disadvantaged lives because they *don't* have access to technologies that could make them better, and I worry that, if we're tempted to start renouncing technologies from a position of privilege, we risk denying too many people without the same privileges the chance to make their own decisions. I would go so far as to say that we have an *obligation* to explore new ways of using science and technology to improve the world we're living in and the lives people lead.

This is an obligation, though, that comes with some tremendous responsibilities. These include working hard to ensure the technologies we develop benefit people without harming them. But they also include learning how to live responsibly in a world that, through our own drive to invent and to innovate, is constantly changing.

These are tough challenges, and they're ones that it's all too easy to leave to "experts" to grapple with. Yet I fear that this is, in itself, an abdication of responsibility. Some of the technological challenges we are facing are so profound, so life-changing, that the questions they raise are ones that we cannot afford to leave solely to people like scientists, innovators, and politicians to answer. The reality is that, if we want to thrive in the technology-driven future we're creating, and we want to equip our children, and our children's children, to do the same, we *all* need to be able to wrap our collective heads around what's coming our way and how it might affect us. This is no mean feat, though. It's one that will require a journey of discovery that uncovers the often-hidden links between ourselves and our technologies, and how we can nudge them toward the future we want, rather than one that someone else decides for us.

Through this book, I've set out to show how science fiction movies can help point the way along this journey, flawed as they are. As I've been researching and writing it, I've developed a deeper appreciation of how the movies here can expand our appreciation of the complex relationship between technology and society, not because they are accurate or prescient, but precisely because they are *not* tethered to scientific accuracy or to realistic predictions of the future. It's their creativity, and dare I say it, their entertainment value, that helps open our eyes to seeing the world in new ways which, when seasoned with feet-on-the-ground thinking, can help us better understand what innovating responsibly means.

Yet, for all their usefulness, there are dangers in getting too wrapped up in science fiction movies as we think about the future. Moviemakers draw on what we can imagine now, based on what we already know; they cannot invent what's yet to be discovered. And in most movies, science and technology are simply devices that are used to keep a human-centric plot moving along. This is precisely *why* they excel at revealing insights into our relationship with technology. But at the same time, it makes them a poor guide to the technology itself, unless, like here, they're used as a stepping-off point for exploring new and emerging developments. There is another danger, though, and this is that, without a good dose of scientific facts and social realism, science fiction movies can leave us with a misplaced impression that we're careering toward a hopelessly dystopian technological future, and there's not a lot we can do about it.

---

In 1978, the British Broadcasting Corporation first broadcast Douglas Adams' original radio series *The Hitchhiker's Guide to the Galaxy*. *The Hitchhiker's Guide* quickly gained a cult following and introduced millions of listeners to the fictional guide of the title. In 2005—four years after Adams' death—*The Hitchhiker's Guide* was given the Hollywood treatment. It wasn't the best movie ever made, truth be told. But with its irreverent look at life in a complex galaxy, and an even more complex society, it does provide a fitting book-end for this particular journey.

I am, I must confess, a great admirer of the skill with which Adams creatively melded together odds and ends of ideas from very different places to create new ones in his work. He was, of course, well known for his often-absurd humor. But beyond the humor (especially in the book and radio series), *The Hitchhiker's Guide* provides a remarkably astute commentary on our relationship with technology. More importantly, though, the fictional "*Hitchhikers Guide to the Galaxy*," on which the series/book/film is based, has the words "Don't Panic" inscribed in large friendly letters on its cover.

In today's socially and technologically complex world, this is sage advice. Of course, we shouldn't be complacent—far from it. Without a doubt, there are deep pitfalls on the road before us as we build our technological future. As we've seen in the preceding chapters, there are a multitude of ways in which we can well and truly make

a mess of things if we don't think about what we're doing. And yet, I'm optimistic enough to believe that we have the collective ability to develop new technologies in ways that work for us, not against us. And here, "Don't Panic" is as good a piece of advice as any.

There are, of course, many problems that we cannot solve with science and technology on their own. Just like you can't buy love and happiness with money alone, you can't simply "science" your way to them either. But if we're smart about it, we *can* use science and technology to make love and happiness—and the many other things that are important to us—that much easier to achieve. If we can keep a clear head about us, and don't fall prey to panic, or become so enamored by the tech itself that we become blind to its potential downsides, we have a decent chance of building a better future together by developing and using emerging technologies in ways that do more good than harm.

Because of this, I feel the words "Don't Panic" are particularly apt here. There is, though, another passing resemblance between this book and Adams' fictional *Hitchhiker's Guide to the Galaxy*, and this is the way that neither claims to be a comprehensive, infallible, all-encompassing guide.

Adams' *Hitchhiker's Guide to the Galaxy*—a sort of *Lonely Planet* guide for galactic travelers who are looking for a great time on a low budget—doesn't even pretend that it can reveal and explain the vast complexity of the galaxy to its readers. Instead, it focuses on what galactic hitchhikers *really* need to know, like how to get from A to B while having a good time, how to avoid getting killed, and where to get the best drinks. This, of course, is a long way removed from this book. Yet, when I started to write it, two things quickly became very clear. The first was that, for most people, what they *really* want when looking for a guide to the future is something that helps them get from A to B while having a good time, how to avoiding getting killed, and where to get the best drinks. The second thing was that no one *ever* reads an overlong, overweight, and utterly incomprehensible guide.

Sadly, this book fails miserably on the "where to get the best drinks" front. But I'd like to think that the preceding chapters, and the movies they're based on, have taken you on an interesting journey, and one that provides at least a glimpse of how we can work toward creating a technologically sophisticated future, while not creating more problems than we solve on the way.

That said, much like its galactic counterpart, the book is a very incomplete guide. Over the past few years, I've had the privilege of being one of the contributors to the annual list of Top Ten Emerging Technologies published by the World Economic Forum, and I can safely say that, out of the seventy emerging technologies we've highlighted to date, there are only a handful that appear here. There are no self-driving cars in this book, and no advanced nuclear reactors. There's no precision medicine, or hydrogen-powered vehicles, or quantum computing. And there's absolutely no mention of blockchain. The reason, of course, is that the world of technological innovation is so vast, so complex, and so fast-moving that any guide that attempted to explain everything would end up achieving nothing.

Rather, I set out to focus on how we *think* about technological innovation, society, and the future, while exploring some intriguing, but by no means comprehensive, developments on the way. And by drawing on the imagination and creativity of science fiction movies, I hope this book achieves this. It may not teach you how "deep learning" works, or the intricacies of CRISPR-cas9 gene editing. But the journey it covers, starting with *Jurassic Park* and de-extinction, and ending with *Contact* and the search for extraterrestrial life, has hopefully left you with a new appreciation for how science and technology intersect and intertwine with society, and how, working together, we can help use this to build a future that everyone benefits from.

# ACKNOWLEDGMENTS

Over the years, I've had the privilege of talking and working with many amazing people whose ideas and insights have informed and inspired me, and helped guide this book. Sadly, they are too numerous to list, but I am deeply indebted to them, as I am to the script writers, directors, actors and producers of the movies featured here, and who provided the creative inspiration for *Films from the Future*. Without them, this book would not exist. In addition to these founts of knowledge and inspiration, this book wouldn't have become what it did without an army of friends and colleagues who graciously allowed me to ply them with early drafts, and equally graciously provided critical feedback that reduced my chances of making a fool of myself: Michael Bennett, Diana Bowman, Michael Burnam-Fink, Ariel Conn, Lindy Elkins-Tanton, Joey Eschrich, Jane Flegal, Elizabeth Garbee, Sarah Geren, Jess Givens, Darshan Karwat, Lauren Keeler, Eric Kennedy, Jon Klane, Sean McAllistair, Nicole Mayberry, Philip Maynard, Stephen Maynard, Becca Monteleone, Anna Muldoon, Hilary Sutcliffe, Lucy Tournas, and Jamie Winterton. Of course, having offered their services this time round, they're going to find it hard to escape being drafted in to do the same with the sequel to *Films from the Future*. I also want to gratefully acknowledge the wonderful encouragement, guidance, and support, of my editor Hugo Villabona and the whole team at Mango—without whom this book would probably still be no more of a reality that some of the sci-fi futures it explores. And of course, none of this would have been possible without the support and encouragement of my family, and especially my wife, Clare.

Thank you.